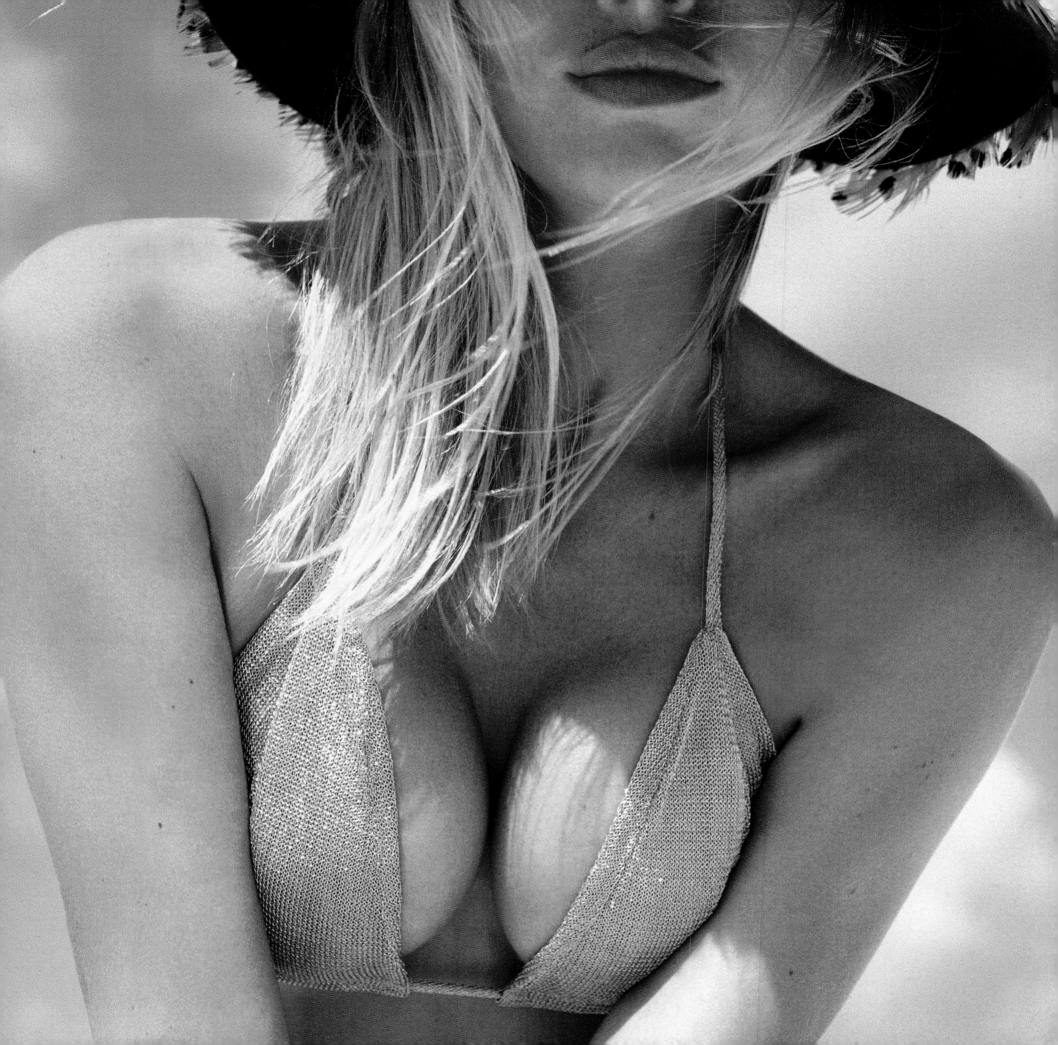

SPORTS ILLUSTRATED

KNOCKOUTS

FIVE DECADES OF SWIMSUIT PHOTOGRAPHY

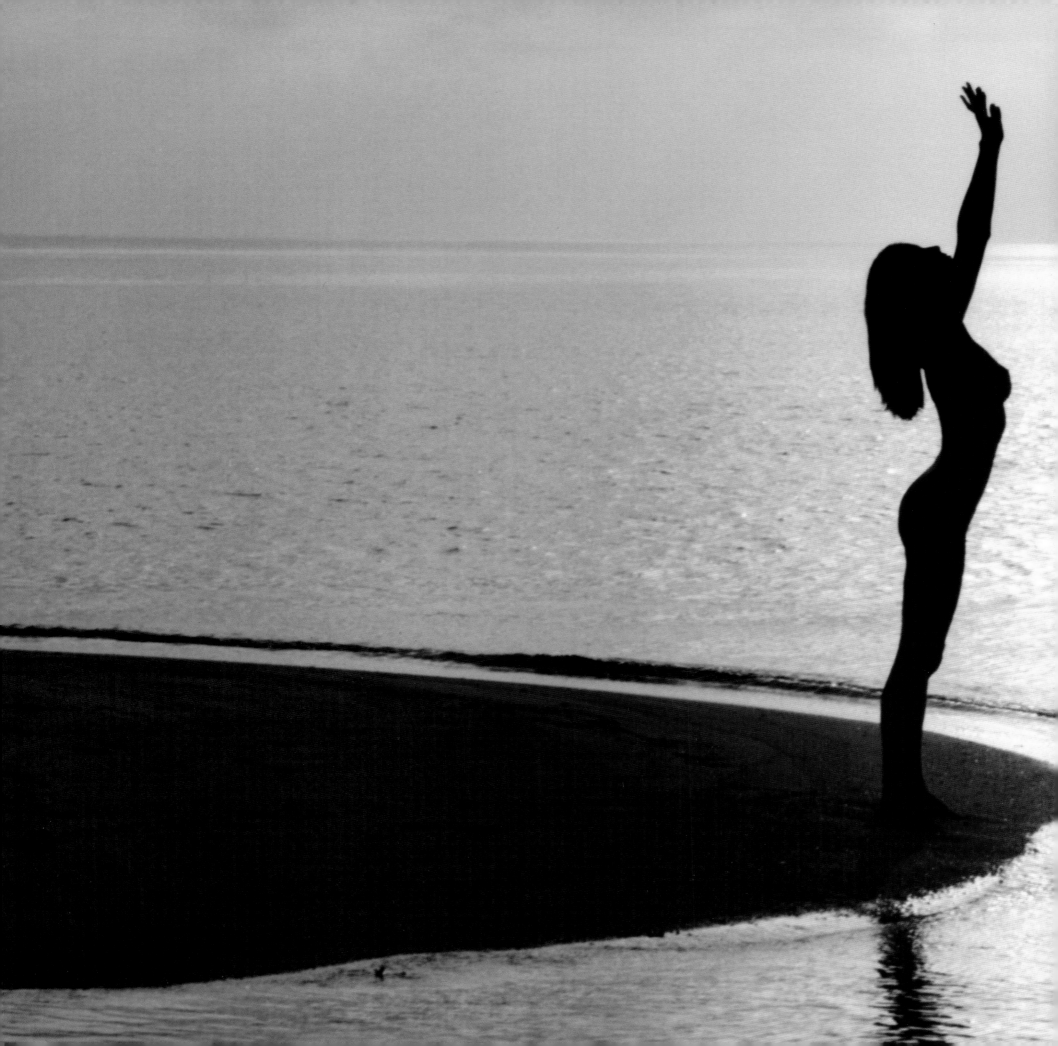

SPORTS ILLUSTRATED

KNOC

FIVE DECADES OF SW

KOUTS

MSUIT PHOTOGRAPHY

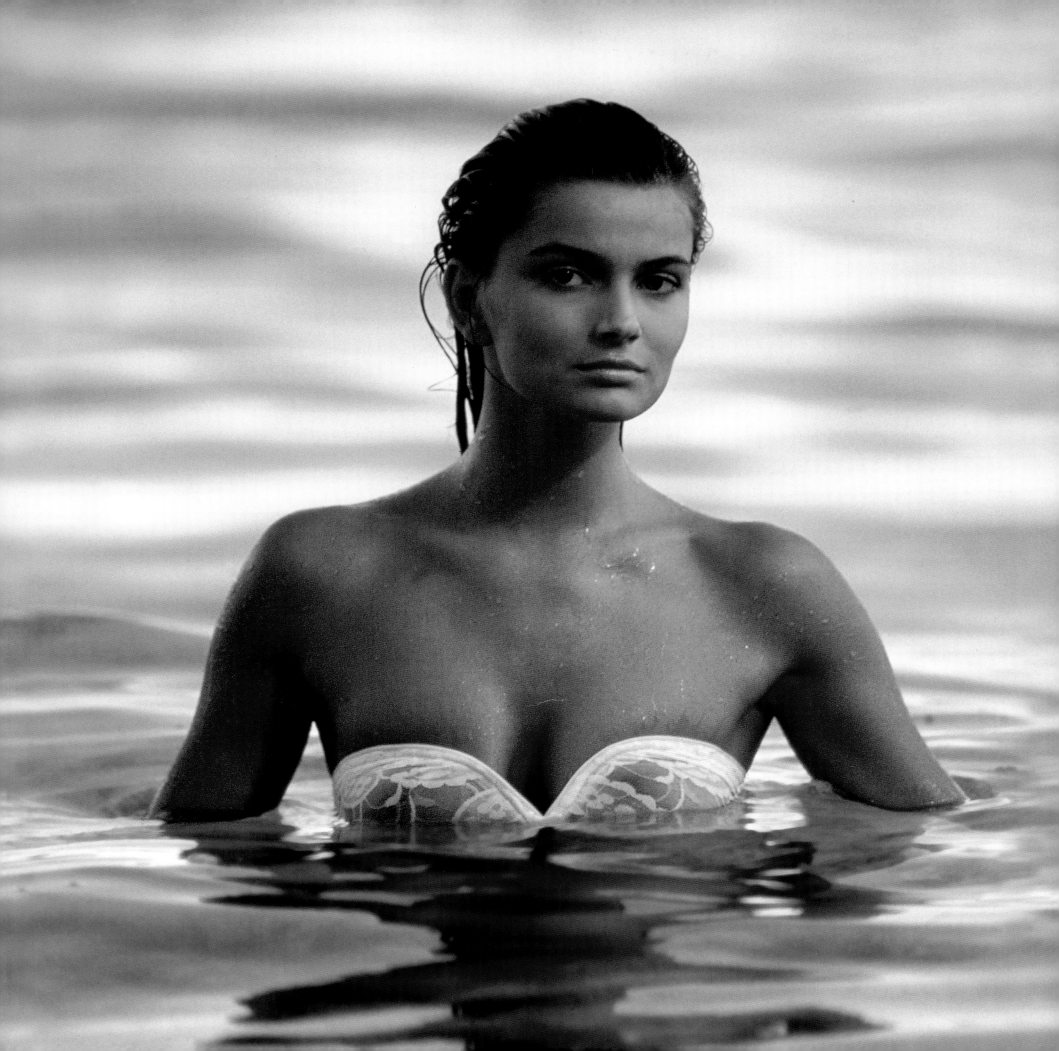

Shall I compare thee to a summer's day?
Thou art more lovely and more temperate:
Rough winds do shake the darling buds of May,
And summer's lease hath all too short a date:
Sometime too hot the eye of heaven shines,
And often is his gold complexion dimmed,
And every fair from fair sometime declines,
By chance or nature's changing course untrimmed;
But thy eternal summer shall not fade
Nor lose possession of that fair thou owest,
Nor shall Death brag thou wander'st in his shade,
When in eternal lines to time thou growest:
 So long as men can breathe or eyes can see,
 So long lives this, and this gives life to thee.

—WILLIAM SHAKESPEARE

The curve is more powerful than the sword

—MAE WEST

Paulina Porizkova BY ROBERT HUNTZINGER. *Spain 1992.*

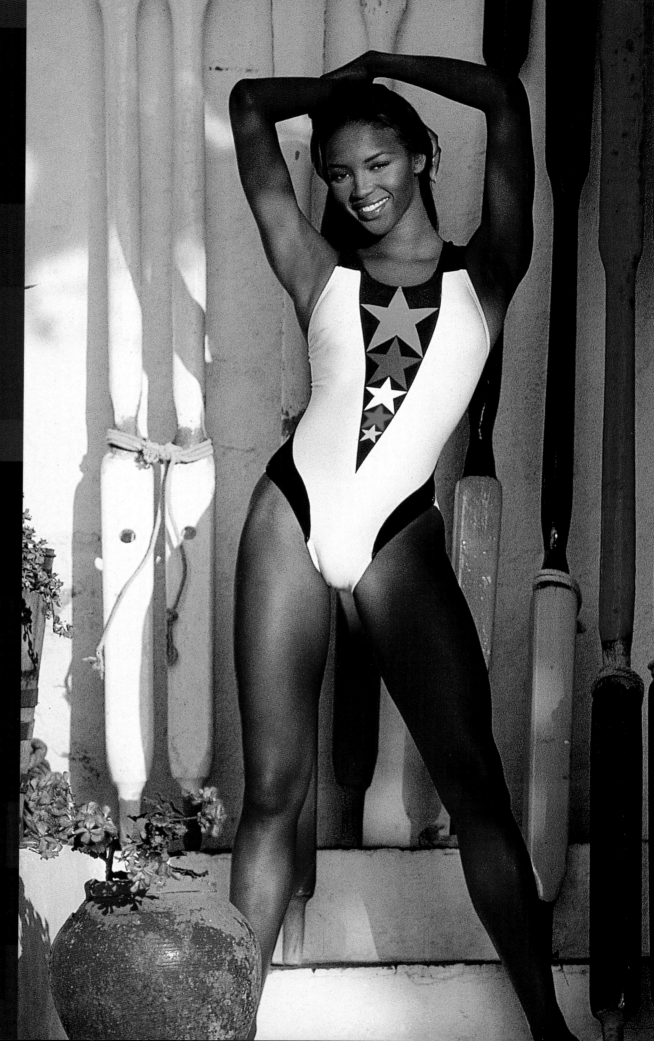

Naomi Campbell BY ROBERT HUNTZINGER. *Port Lligat 1992.*

creative director	STEVEN HOFFMAN
swimsuit editor	DIANE SMITH
art director	MIKI SAKAI
associate editor	LUIS FERNANDO LLOSA
picture research	KAREN CARPENTER
	M.J. FIGEL
	JENNIFER STERN
design associate	NEIL JAMIESON
project coordinators	STANLEY WEIL
	JOSEPH CLEMENTE
	MICHELLE PARASCONDOLA
	ROB GURSHA
copy editor	KEVIN KERR
prepress technicians	ROBERT M. THOMPSON
	DAN LARKIN

with special appreciation to founding sports illustrated swimsuit editor, JULE CAMPBELL, the original knockout

thanks also to :

word mavens ROB FLEDER, BOB ROE, PETER CARRY and GABE MILLER

GEOFF MICHAUD, MARY MOREL and the sports illustrated imaging staff

BARBARA, DEXTER and GEORGIA

KNOCKOUTS

KAREN ALEXANDER
KIM ALEXIS
CAROL ALT
TYRA BANKS
SABRINA BARNETT
JAMEE BECKER
MICHELLE BEHENNAH
ELSA BENITEZ
SUNNY BIPPUS
ROBIN BRANCH
CHRISTIE BRINKLEY
MONIQUE MOURA DE CARAVALHO
LAETITIA CASTA
AURELIE CLAUDEL
CHARISSA CRAIG
CINDY CRAWFORD
ROSIE DE LA CRUZ
YAMILA DIAZ-RAHI
KELLY EMBERG
ANGIE EVERHART
LUJAN FERNANDEZ
ERIN GRAY
KRISTY HINZE
VICKY HOWARD
RACHEL HUNTER
KATHY IRELAND
MALIA JONES
HEIDI KLUM
SHAKARA LEDARD
ANA PAULA LEMES
NOEMIE LENOIR
ELLE MACPHERSON
JOSIE MARAN

BABETTE MARCH
JUDIT MASCO
VALERIA MAZZA
PETRA NEMCOVA
CHANDRA NORTH
SARAH O'HARE
JEAN PELTON
DANIELA PESTOVA
PAULINA PORIZKOVA
AUDREY QUOCK
ASHLEY RICHARDSON
RACHEL ROBERTS
REBECCA ROMIJN-STAMOS
SHEILA ROSCOE
STEPHANIE SEYMOUR
INGRID SEYNHAEVE
MOLLY SIMS
AMBER SMITH
SUZY SMITH
BERI SMITHER
YVETTE SYLVANDER
YVONNE SYLVANDER
NIKI TAYLOR
CHERYL TIEGS
ULLA
PATRICIA VELASQUEZ
VENDELA
VERONICA VAREKOVA
MANON VON GERKAN
AKURE WALL
ESTELLA WARREN
ROSHUMBA WILLIAMS
STACEY WILLIAMS
KARA YOUNG

PHOTOGRAPHERS

WALTER CHIN
HOWELL CONANT
PAOLO CURTO
SANTE D'ORAZIO
DONNA DEMARI
ROBERT ERDMANN
HANS FEURER
LOIS GREENFIELD
MARCO GLAVIANO
ANTHONY GORDON
ERNST HAAS
MARC HISPARD
ROBERT HUNTZINGER
WALTER IOOSS JR.
DOMINIQUE ISSERMANN
RUSSELL JAMES
CHRISTOPHE JOUANY
PAUL LANGE
BRIAN LANKER
ANDREW MACPHERSON
KOURKEN PAKCHANIAN
MIKE REINHARDT
MYERS ROBERTSON
PATRIC SHAW
STEWART SHINING
J. FREDERICK SMITH
ANTOINE VERGLAS
JOHN G. ZIMMERMAN

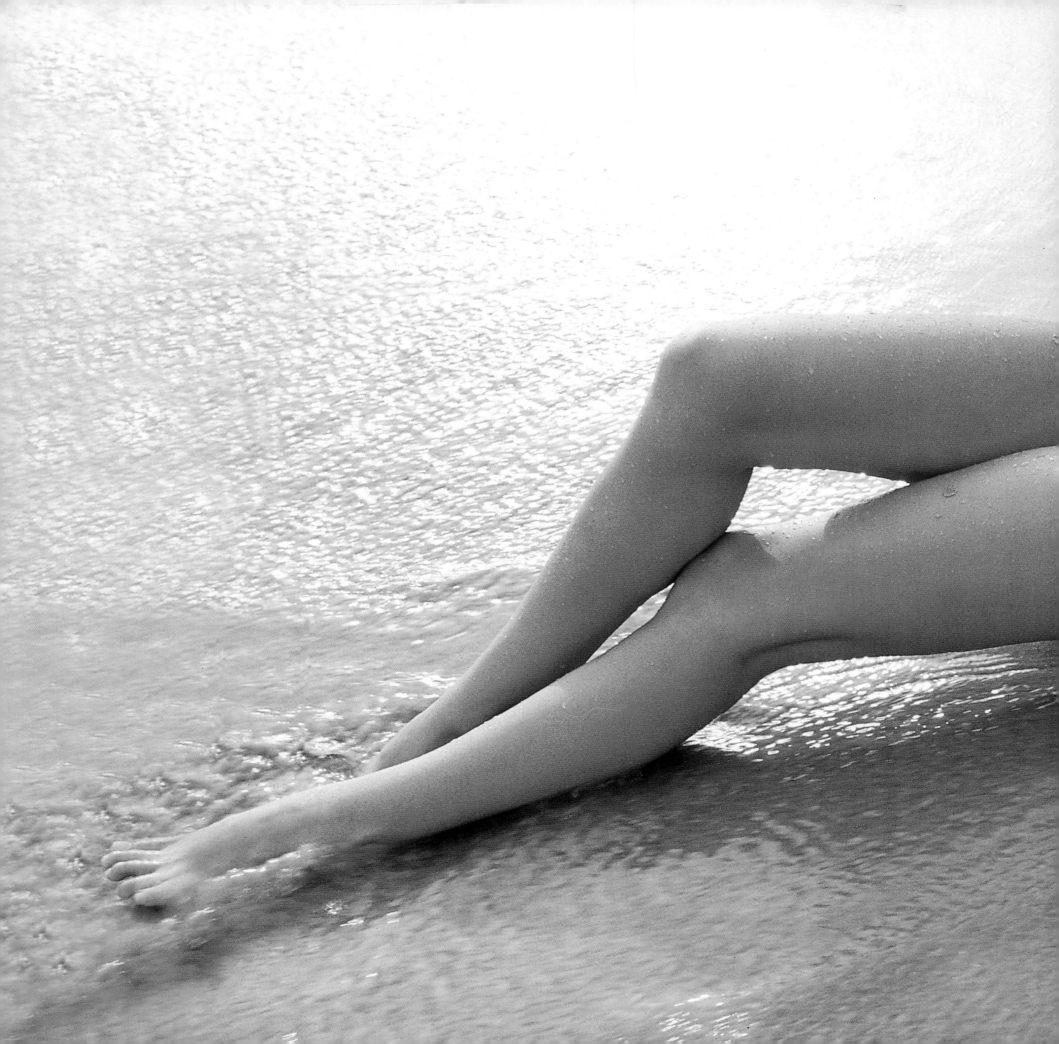

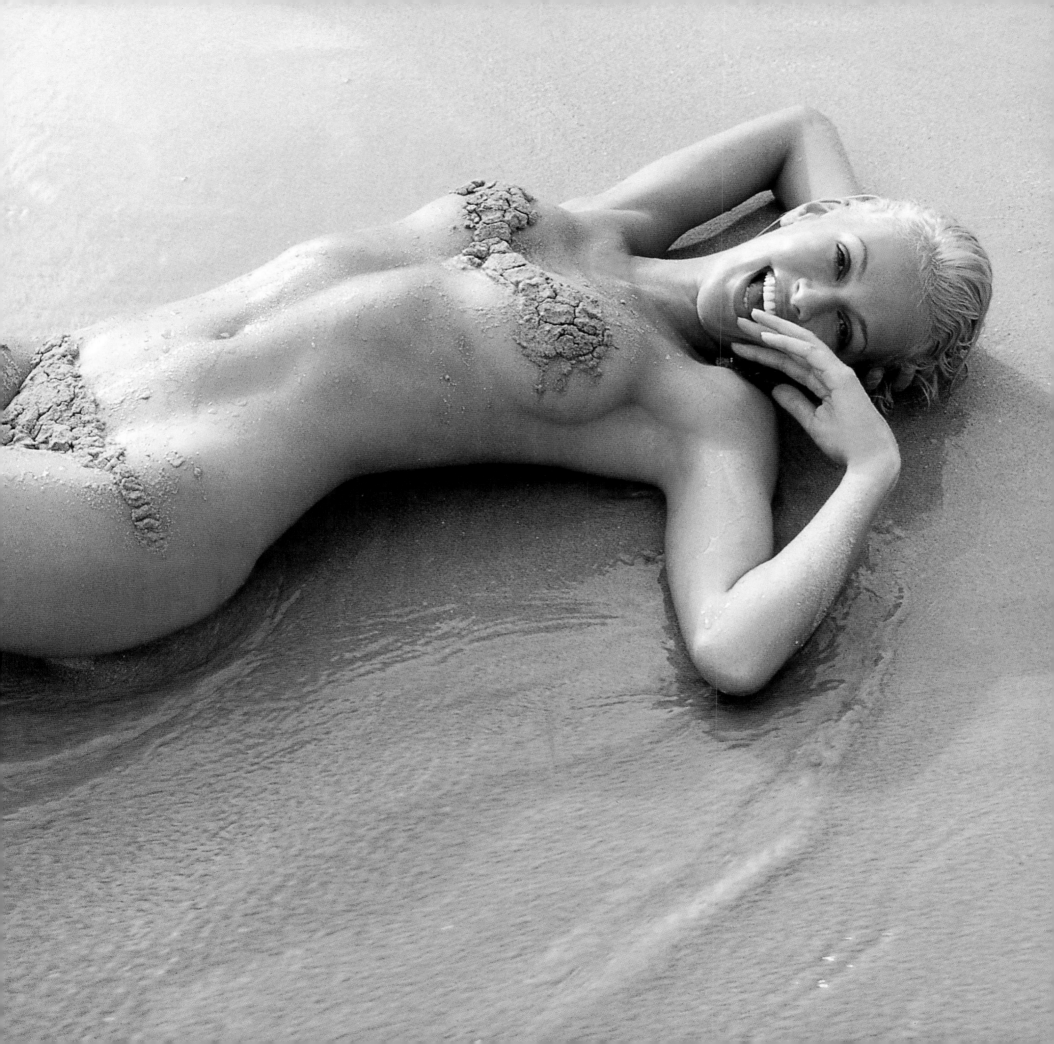

It was a blonde. A blonde to make a bishop kick a hole in a stained glass window.

—RAYMOND CHANDLER, *"Farewell, My Lovely"*

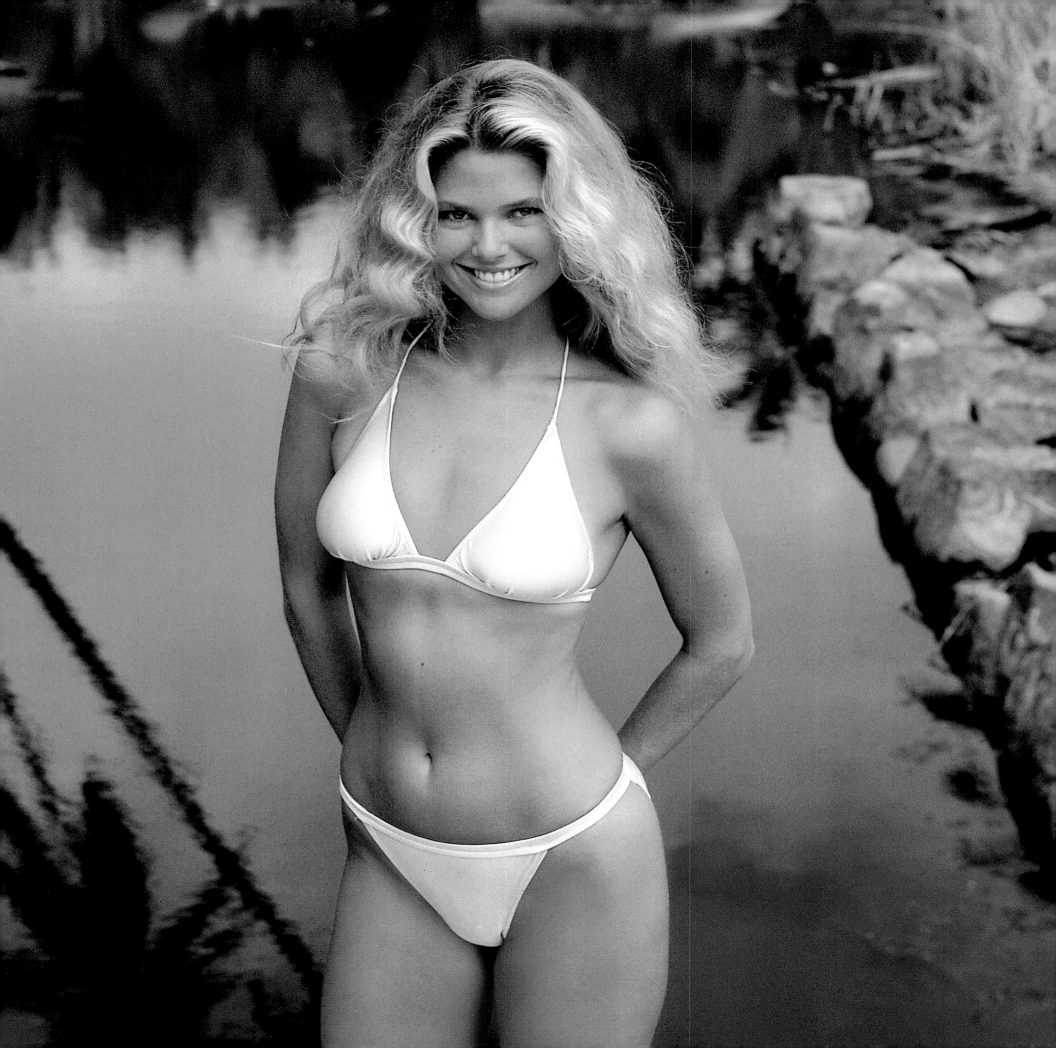

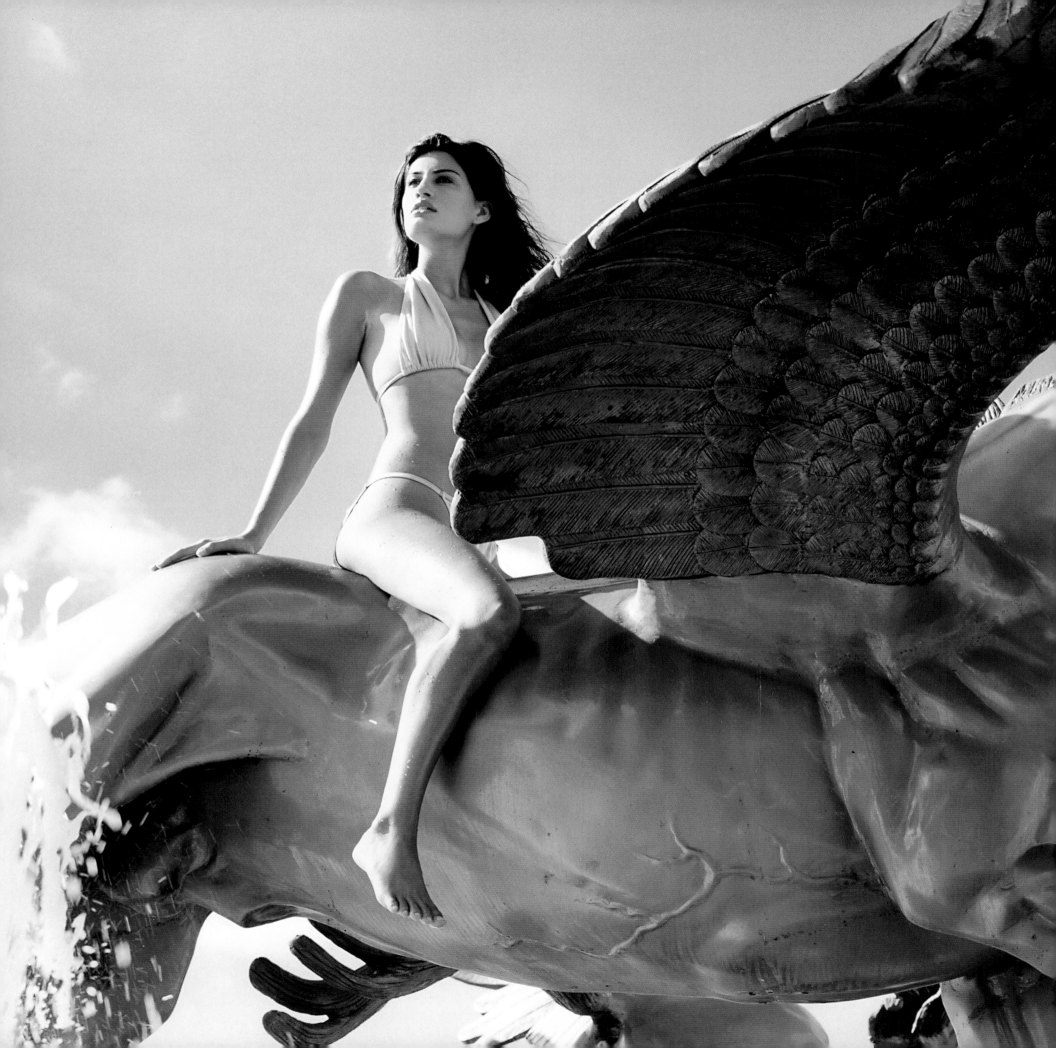

The Bare Facts

a foreword by **FRANK DEFORD**

Yamila Diaz-Rahi BY PATRIC SHAW. *The Bahamas 2001.*

THE SPORTS ILLUSTRATED SWIMSUIT ISSUE BEGAN SERENDIPITOUSLY and grew into a success, and then a phenomenon and, finally, became an institution. It has gained a place in the winter calendar—not so large as Valentine's Day, perhaps, but certainly greater than Groundhog Day and, probably now, too, the Chinese New Year and St. Patrick's Day. The Swimsuit Issue works because it boasts, after Coca-Cola, the cleverest commercial formula ever concocted in the United States. Basically, that has consisted of walking a fine line between smoldering sex and suitable taste, lust and love, seduction and salubriousness. That is, the Swimsuit Issue knows how to be *just so*, which is, sadly, a disappearing art in a tawdry world of excess and humbug. Being around water also helps it more than one might imagine. The Swimsuit Issue stars beautiful women, which everybody knows. It has also always been plotted by smart women, which not so many people know. If men ran the thing, they would have taken it over the top and spoiled it. The women have, however, wisely, let men take most of the photographs of the models. Also, everybody makes a ton of money.

All the other stuff aside, though, it is just so pretty. The backgrounds are pretty and the swimsuits are pretty and, of course, the ladies in them are prettiest of all. Sometimes we forget nowadays that, if done properly, pretty can be enough all by itself.

Then, too, if beauty isn't skin deep, skin certainly does help. It always has. Gorgeous women, encouraged by water to place their charms on display—this is not original. In fact, if there are patron saints to the Swimsuit Issue, they would be the Three A's of pulchritude—Artemis, Agnès and Annette—each of whom contributed a major historical element to make the modern-day formula work. First: Artemis, the Greek goddess of the hunt, who was the original bathing beauty (although she was of a more private disposition than, say, Kathy Ireland or Heidi Klum would be). When Artemis spied Actaeon spying on her at her bath, she turned him into a stag and watched as his own hounds promptly ripped Actaeon apart. (Keep this in mind, stags, as you ogle the models. Moderation.)

Next: Agnès Sorel, the sublime mistress of Charles VII of France, who was known, simply, as the *dame de beauté*. When not inspiring her king to get off his duff and drive the English out of France, Agnès posed for paintings with one breast bared—a seminal act, which, writes Marilyn Yalom in *A History of the Breast*, changed forever the way we men look at women. "Stripped of its relation to the sacred," Professor Yalom writes, "the breast became the uncontested playground for male desire."

So then, fast-forward from 1450 to 1907, when Annette Kellerman, an Australian known as the Diving

Cindy Crawford BY MARC HISPARD. *Thailand 1988.*

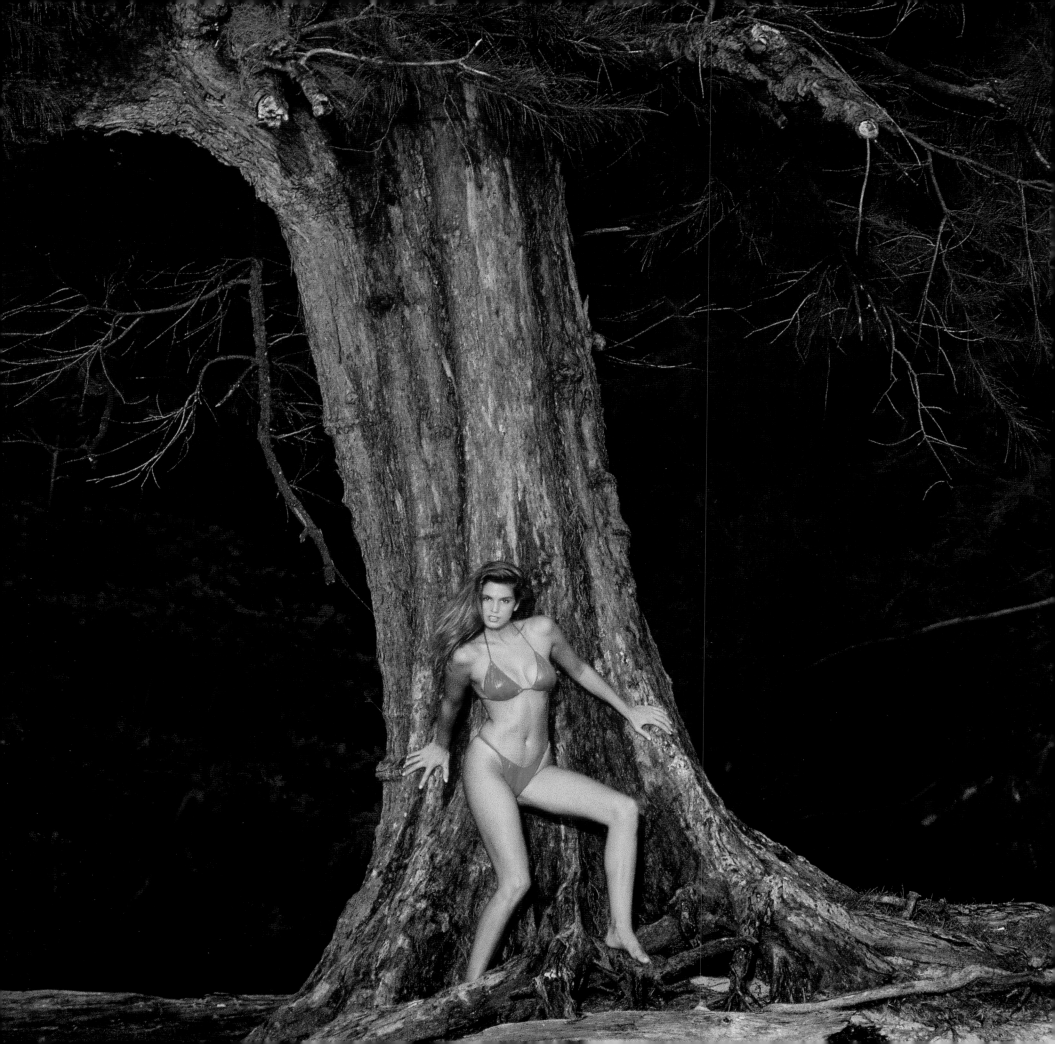

Venus, came to the United States with a sensational water-ballet revue. Naturally, in prudish Boston, on Revere Beach, she was arrested for showing too much skin. So Ms. Kellerman cleverly added stockings and sleeves, which satisfied the constabulary, as it also satisfied all her admirers. You see, now she was no less curvaceous, but dressed, for all intents and purposes, in what was the first one-piece bathing suit. Oh, in the years ahead, the daughters of Annette would wear smaller suits even as the daughters of Agnès would display larger breasts, but, really, everything was already in place.

The only detail left was, in 1947, for one E.B. Stewart to blow a gasket. He was the president of Catalina sportswear, which was a sponsor of the Miss America Pageant. "It's not a bathing suit, dammit," E.B. railed one day. "You bathe in a tub. You swim in a swimsuit." Miss America promptly started calling what its daughters of Artemis participated in the "Swimsuit Competition," and the new name stuck and soon developed, well, legs.

And so it was, one fine day in 1964, that Jule Campbell, a young editor at an emerging magazine named SPORTS ILLUSTRATED, got a call to come down and see the boss. His name was Andre Laguerre, a savvy, sometimes cantankerous Frenchman of an independent bent. When Ms. Campbell entered his office, these are the momentous words she heard Mr. Laguerre utter: "Jule, my dear, how would you like to go to some beautiful place and put a pretty girl on the cover?"

SPORTS ILLUSTRATED was in its 10th year in 1964, but its first in the black. The magazine had been somewhat schizophrenic, covering sports, yes, but also fashion, travel, conservation, even food. Mr. Laguerre had brought the magazine to profitability largely by centering more on hard sports, but he still kept a few travel stories in the mix. After all, in those innocent days, sports seasons did not go on in perpetuity, as they tend to today, and so especially in the depths of winter, after bowl games and before pitchers and catchers reported to the Grapefruit League, there wasn't a helluva lot going on.

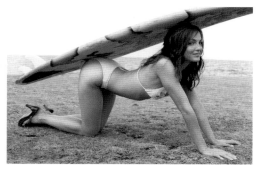

OR THE JAN. 21ST ISSUE IN 1963, VAMPING THE BEST HE COULD, Mr. Laguerre had ordered up a tropical travel feature in Puerto Vallarta, Mexico. The cover actually used a bathing beauty—although only her head was shown above the warm waters. Yes, we went to Mexico, but all we brought you back was this stupid picture of a woman's *head*. The next January, however, a model's body was shown from the knees up on the cover, for what was called, guilelessly, the FUN IN THE SUN issue. The model's name was Babette March, and, as you can see, it was pretty innocent stuff. So were the five inside pages of other models wearing fairly modest suits. Besides, you had to wade through a desultory 13 pages of "A Skin Diver's Guide to the Caribbean" just to get to the girlie shots.

And so now you know, that, as with so many of the other significant creations that affected the course of humankind, no one person was smart enough to have dreamed up the Swimsuit Issue. It just sort of

Chandra North BY WALTER CHIN. *Maui 2000.* **Elle Macpherson** BY MARC HISPARD. *Caribbean 1991.*

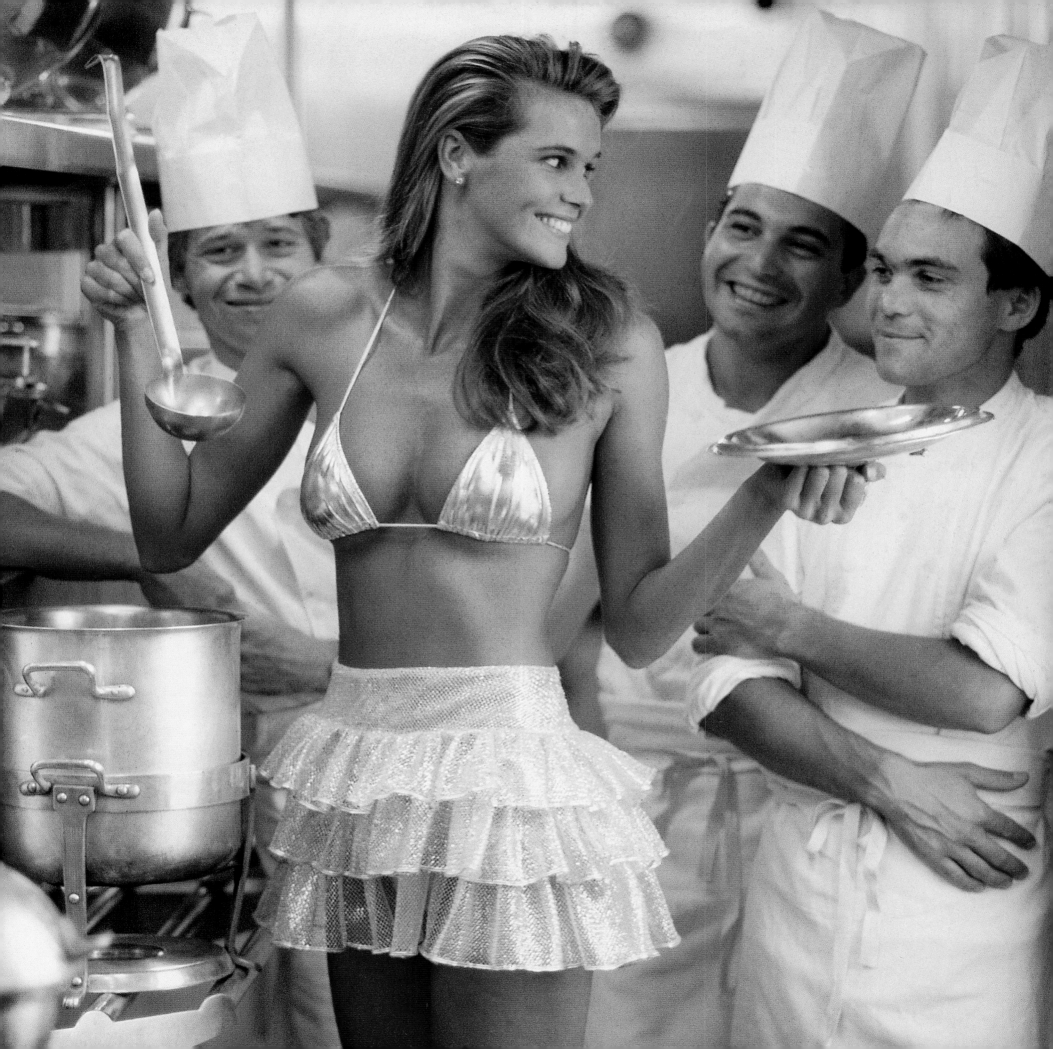

emerged, coalesced and then grew like Topsy. Indeed, the whole business might have died with boyish little Babette giggling cutely, except for—yes—*the letters*. The magazine dutifully printed a few, two of which, in retrospect, are prototypes for all the fevered correspondence that would follow down through the winters. In the first, two Yale boys took pen in hand to say they "could feel the clouds break up over New Haven" the instant they cast their eyes upon Babette. She was, they avowed, "an unbelievably 'shoe' girl"—shoe being a preppy term that meant . . . no, not sexy, not hot, not even glamorous, but more on the tepid order of, say, fashionably attractive. Audrey Hepburn was shoe. In the other letter, a horrified gentleman from Columbia, S.C., chastised SI for straying from "legitimate sports" to the moral detriment of "my young teenage son."

ONSIEUR LAGUERRE, THE SOPHISTICATED CONTINENTAL, WAS perversely amused by this provincial reaction. "I honestly don't think Andre had intended to do the issue more than once," says Jack Olsen, the magazine's most prominent writer of that time. Mr. Laguerre was also encouraged by the magazine's art director, Dick Gangel, who devilishly suggested they could push the envelope a little, get even sexier. "Oh?" mused Mr. Laguerre, pushing his glasses back up his nose.

And so it was that he asked Jule Campbell to come round to his office that day in 1964. "I'm sure all Andre wanted to do was stir the pot a little," Ms. Campbell says. "That's all. Just stir the pot a little."

The time was, though, felicitously ripe. Art had become pop and much of everything else was go-go, then a-go-go. Fashion was suddenly particularly outrageous. A leading apostle of daring was Courreges, a French designer, who had actually moved skirts above the knee and put women in vinyl. Another Frenchman, Louis Reard, had created the bikini way back in 1946, but in America, it was only about this time, in the wild 'n' crazy sixties, that the bikini finally began to emerge as decent pool attire. The signs were inescapable. What Agnès Sorel had wrought had finally found acceptance in the United States. Even little girls started playing with va-va-voom full-breasted Barbie dolls, and no less an authority than Dr. Joyce Brothers wrote (in the first person yet): "We have an unconscious desire to display our bosom."

The high-fashion industry, however, missed the cues. It kept using models that Ms. Campbell thought of as "cadaverous" and "forbidding." Instead, when she set forth on her quest for Mr. Laguerre, Ms. Campbell searched for younger, bustier women (though she euphemistically referred to them as "healthy girls"). Hips were also requisite. "Women really can't believe this," Ms. Campbell avows, "but you must have hips if you're going to look good in a swimsuit." Sue Peterson, the 1965 cover girl, possessed all the requisites and was the original of this type—followed in the '70s by Cheryl Tiegs, Christie Brinkley and Carol Alt.

The Campbell Girl became as discrete a type as the Gibson Girl had been generations before. Never

Elle Macpherson, Rachel Hunter BY MARC HISPARD. *Caribbean 1991.* **Yamila Diaz-Rahi** BY DOMINIQUE ISSERMANN. *Necker Island 1999.*

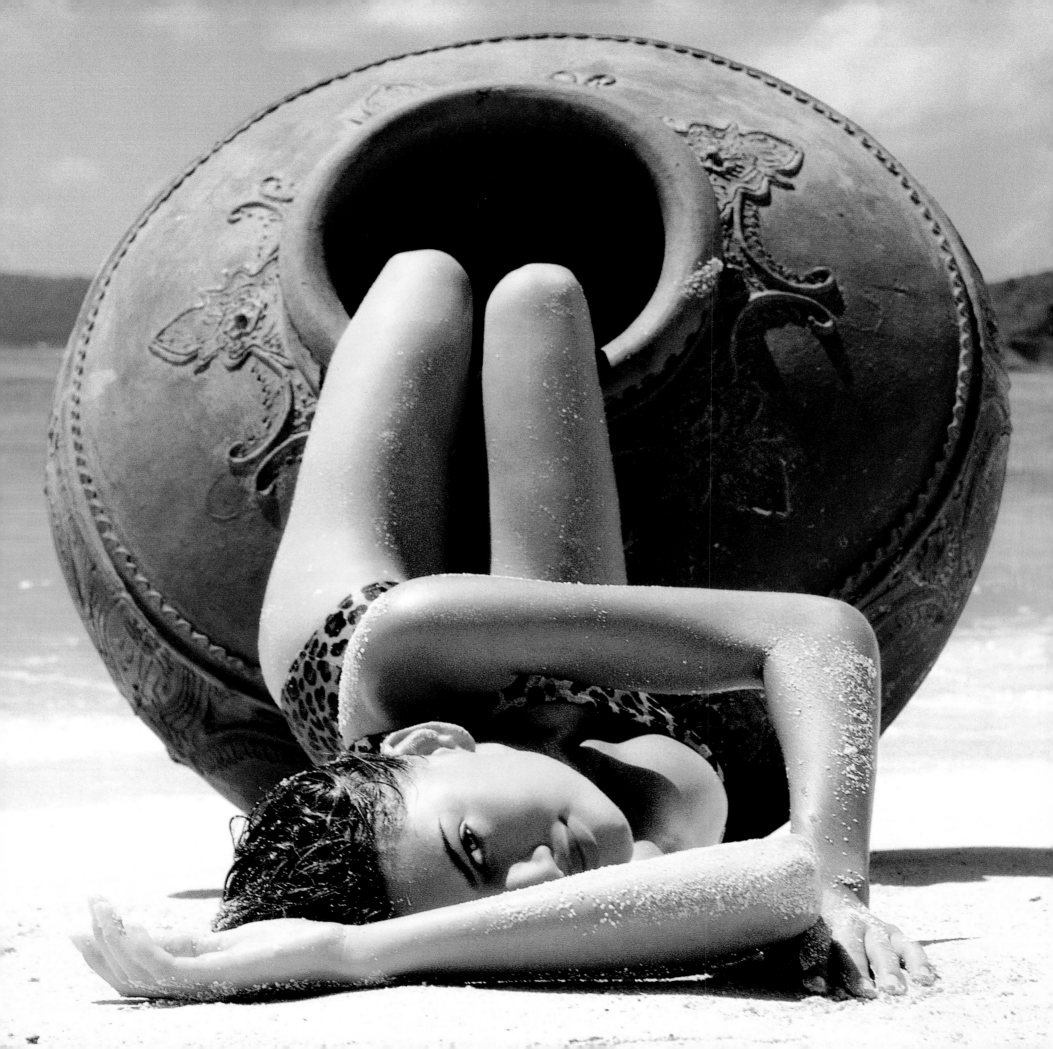

mind how much beach fashion might have changed since 1964, the ideal model remains very much what Jule Campbell found in Sue Peterson that year. Diane Smith, Ms. Campbell's incumbent successor as swimsuit editor, says: "The perfect SI girl has a body that's sexy and fit. She's shapely, but she's also athletic. Her personality is important, too. She appears to have a confident attitude."

While, of course, the Swimsuit Issue has been relentlessly attacked as dirty and sexist, it has coincidentally profited by the fact that the American woman has become vastly more athletic during the issue's lifetime. The body of the SPORTS ILLUSTRATED model and the body of the model athlete have grown closer together over that period. In recent years, in fact, several prominent athletes—notably Gabrielle Reece and Steffi Graf—have themselves posed in the Swimsuit Issue. Moreover, a spate of female athletes have chosen to go beyond the SI boundaries and pose topless or altogether nude, a circumstance which has driven distaff athletic purists into a state of apoplexy. Invariably, though, these athletes have defended themselves against charges of sullying women's sport by maintaining that they are proud of their figures and want to show them off, to prove that athleticism can also be sexy.

CERTAINLY IT IS INSTRUCTIVE THAT ALMOST A THIRD OF THE SWIMSUIT Issue's "readership" (a technical term, loosely applied in this context) is female. In fact, whereas arguments over the propriety of the issue used to almost entirely divide along a skirmish line in the war of the sexes, now these disputes have often become intragender, women debating women—while the men sit on the sidelines and, happily, watch. As a cultural anthropologist, John Lowe, wrote in *Self* magazine: "If one looks back ... it seemed that men were definitely driving the breast fixation. Nowadays, it's more tied in to women's thinking."

Indisputably, society accepts the Swimsuit Issue far more than it did when it first appeared. In those early years, the angry letters and newspaper columns were so wonderfully ripe and indignant. When Cheryl Tiegs wore a fishnet suit in 1978 that kinda sorta revealed her nipples, 340 cancellations poured in. Now cancellations are rare and the complaints so often seem tired and forced and dulled by an air of resignation. Much of this greater tolerance obviously has to do with changing cultural mores in the world at large, but it is also probably true that the Swimsuit Issue itself has influenced the way society has come to assess the morality of young women who choose to pose, provocatively.

After all, the Campbell Girl was revealed as not just a healthy babe who often became wealthy (because she appeared in the Swimsuit Issue). If not actually wise, too, she came across as having a distinct, winning personality. Those moony college boys who still write their letters of undying-love-from-afar to the swimsuit queens really do seem to have fallen for a whole person and not just her T&A. "The issue elevates familiarity," Diane Smith says. "It treats models like people, and so they come across as people."

Ashley Richardson BY MARC HISPARD. *Mexico 1989.* **Rebecca Romijn-Stamos** BY WALTER CHIN. *Kenya 1998.*

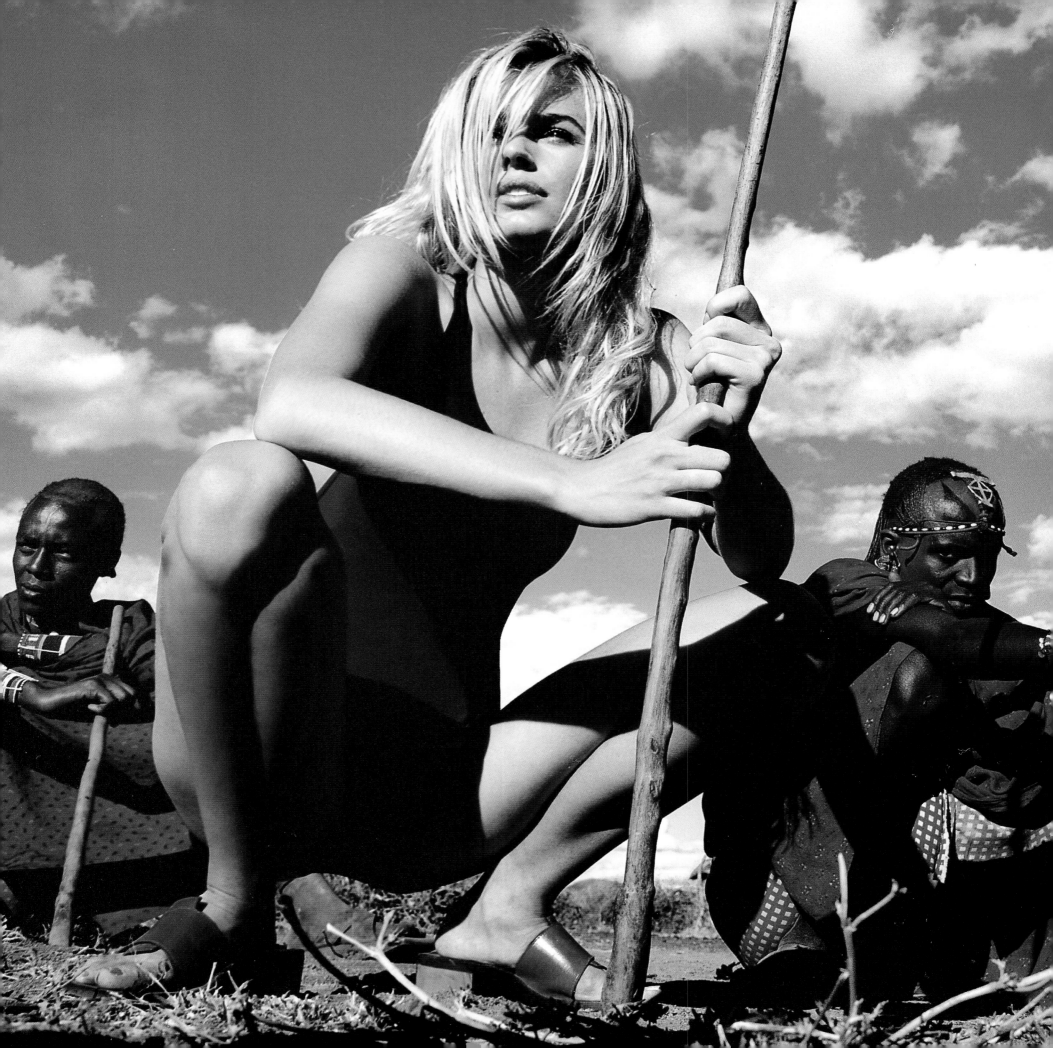

In a way the models select out themselves, too, for the job requires good sports, agreeable to working long and tedious hours on locations that are invariably too hot or too cold (sometimes both in the same day). "And you might end up with a monkey clinging to your bare breasts, too," Ms. Smith says. Oh, can you also see, that everyone must pose by the dawn's early light? That means four or five hours sleep, with wake-up calls around four a.m. By nine the sun is too high, and the roseate morning light—silver upon the water—is gone, replaced by a glare that gives the models what are called "nose shadows" and "owl eyes" in the trade. Shooting usually can not resume till after three in the afternoon, when the light starts to modulate again, with oranges and golds in ascendance.

Certainly, Elle Macpherson, Rachel Hunter and Tyra Banks et al, do not need crystal blue waters to turn heads, but it is indisputable that the exquisite locations have contributed significantly to the classy mystique of the Campbell Girl. It is not a reach to say that the natural color and light of the Swimsuit Issue has been to fashion photography what the impressionists were to art, when their newfangled tin tubes of oil paint allowed them to move their canvases outside their studios.

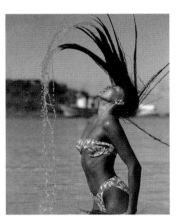

HE SWIMSUIT PICTURES WERE SURELY ENHANCED, TOO, IN THAT MS. Campbell risked using some sports photographers. John G. Zimmerman, Walter Iooss Jr. and Brian Lanker all have multiple swimsuit covers to their credit, as well as numerous hard-sports covers. "Look," says Diane Smith, "we're outside, trying to get the light and the girl just right, together. And if anybody can catch a moment, it's a sports photographer."

Until 1988 only one shooter a year was tapped for the one chosen location. As the issues have grown in size, though, multiple sites and photographers have been used. Indeed, in 1989, for the 25th anniversary of the project, and then again, since 1997, the swimsuit edition has been a full stand-alone issue. By now the 20 or so models who make the cut (from perhaps 80 candidates) will be photographed more than 100,000 times over five months of shooting. Meanwhile, manufacturers will make sure that Ms. Smith and her associates inspect more than 5,000 swimsuits, of which perhaps 500 will actually be taken on location. All this to find the best 80 photographs for publication.

And finally, the crucial cover decision will be made by the magazine's managing editor, choosing between the swimsuit editor's dozen or so finalist "selects." In the past few years, since the advent of the stand-alone special issue—which remains on the newsstands for months—a certain amount of market research on the cover has also been done. But ultimately, in 2001, as it was in 1964, the choice falls to one man. It is probably the closest any editor in the world gets to playing God, for being ordained the SPORTS ILLUSTRATED Swimsuit Issue cover girl can, of course, substantially change a model's life. Certainly, it certifies her. And probably the honor is worth even more now, inasmuch as so many fashion magazines

Akure Wall BY ROBERT HUNTZINGER. *Windward Islands 1990.* **Heidi Klum** BY ROBERT ERDMANN. *Malaysia 2000.*

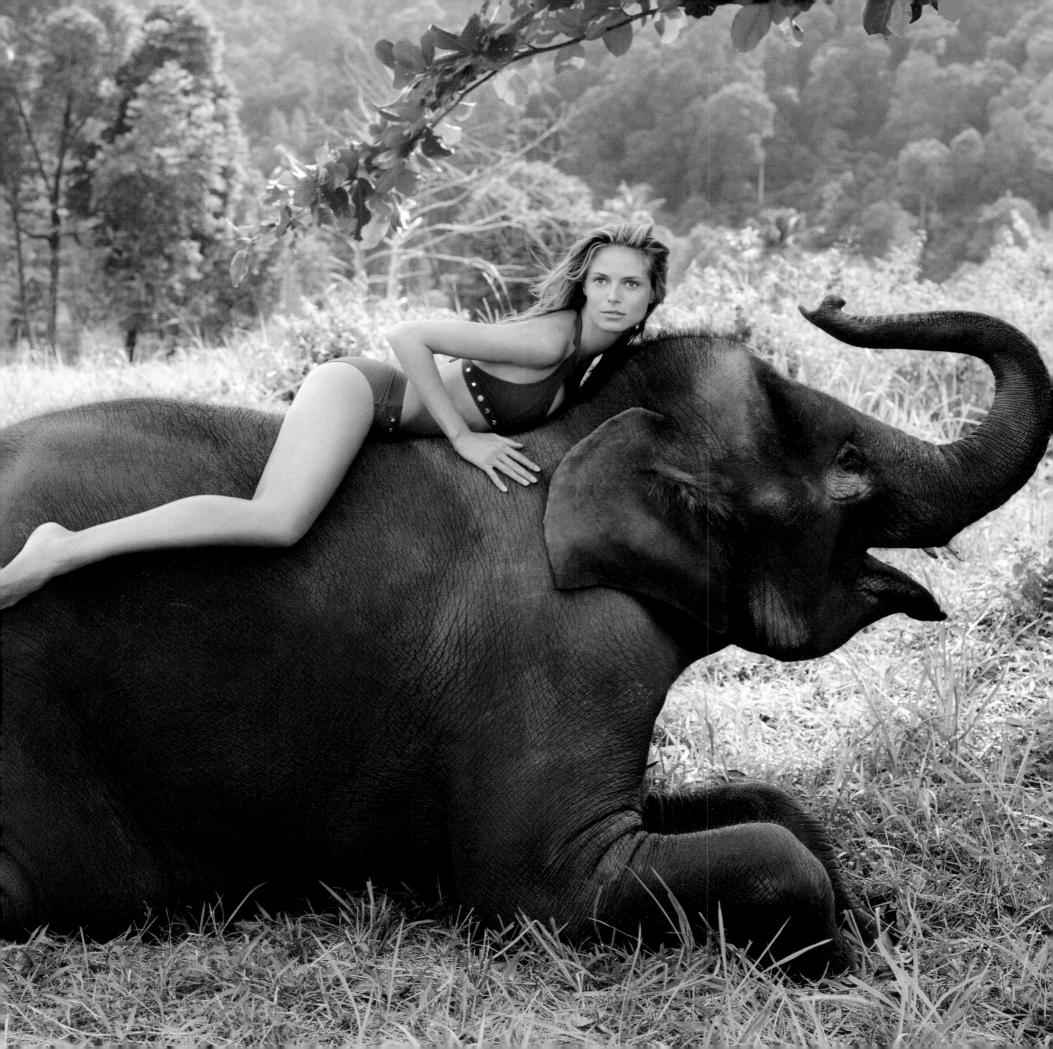

have stopped using models on their covers, preferring instead to feature celebrity entertainers.

Fifty-six million men and women, almost one third of the adult American population, will read the Swimsuit Issue, plus millions more in those 18 other countries—from South Africa to Korea—where the magazine is distributed in 11 languages. Moreover, there is no evidence that interest is waning. Back in 1980, Gilbert Rogin, the managing editor at that time, wondered out loud whether the Swimsuit Issue was on its last gams. That year, he ran 12 pages of photos and worried that he was laying it on too thick. Last year the issue was 214 pages long.

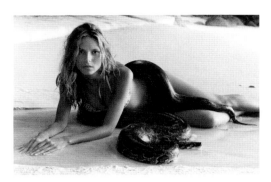

O

F COURSE, EVEN THE MOST POPULAR INSTITUTIONS, LIKE EMPIRES, eventually crumble and fall. Miss America, for prime example, which sold the same kind of wholesome girl-next-door bathing beauty appeal, got all hoity-toity and went into denial about sex. In a way, it was all downhill for Miss America after it stopped crowning its queens in swimsuits in 1948, choosing instead to put the tiara on a proper young lady in an evening gown. At the other extreme, Playboy and its imitators peaked a quarter century ago, even as they grew more sexually graphic, even as female nudity became commonplace in movies and bars and clubs.

Probably, in fact, the Swimsuit Issue thrives all the more in a more licentious world. Ironically, no one understood that better than Al Goldstein, the notorious publisher of *Screw* magazine. "Nudity is boring," he declared, even as *Screw* thrived. "The Swimsuit Issue is far more sensual. I'd rather have one copy of that than a thousand issues of the magazine I publish."

Blaze Starr, the famous stripper, once said that stripping began to decline in the U.S. precisely when X-rated movies and nude bars began to be welcomed by a more permissive society. And when was that, Blaze? "In the mid-sixties." She was saying, in effect, that the Swimsuit Issue became popular because it was the natural heir to burlesque. "When it comes right down to the bare facts," said Ms. Starr, "and, honey, I've heard this from men—they don't like to see a totally nude woman unless it's in a bedroom setting. They like to see some parts covered."

Beyond the tease, too, the swimsuit stars are more than just the sum of their parts, covered and uncovered, revealed and forbidden. We may laugh at dumb-blonde jokes, but the dream most men dream is that there is not only something more to see of a woman but something more to see in her, too. Beauty is in the eye of the beholder—but no less than fascination is in the same man's imagination.

And Jule Campbell and her successors who manage the Swimsuit Issue have known precisely how to play off that: Dress gorgeous women in lovely little, shadow them in coyness, but in the right light of rare places. And don't complicate things. It is the perfect combination of naughty and smart. ±

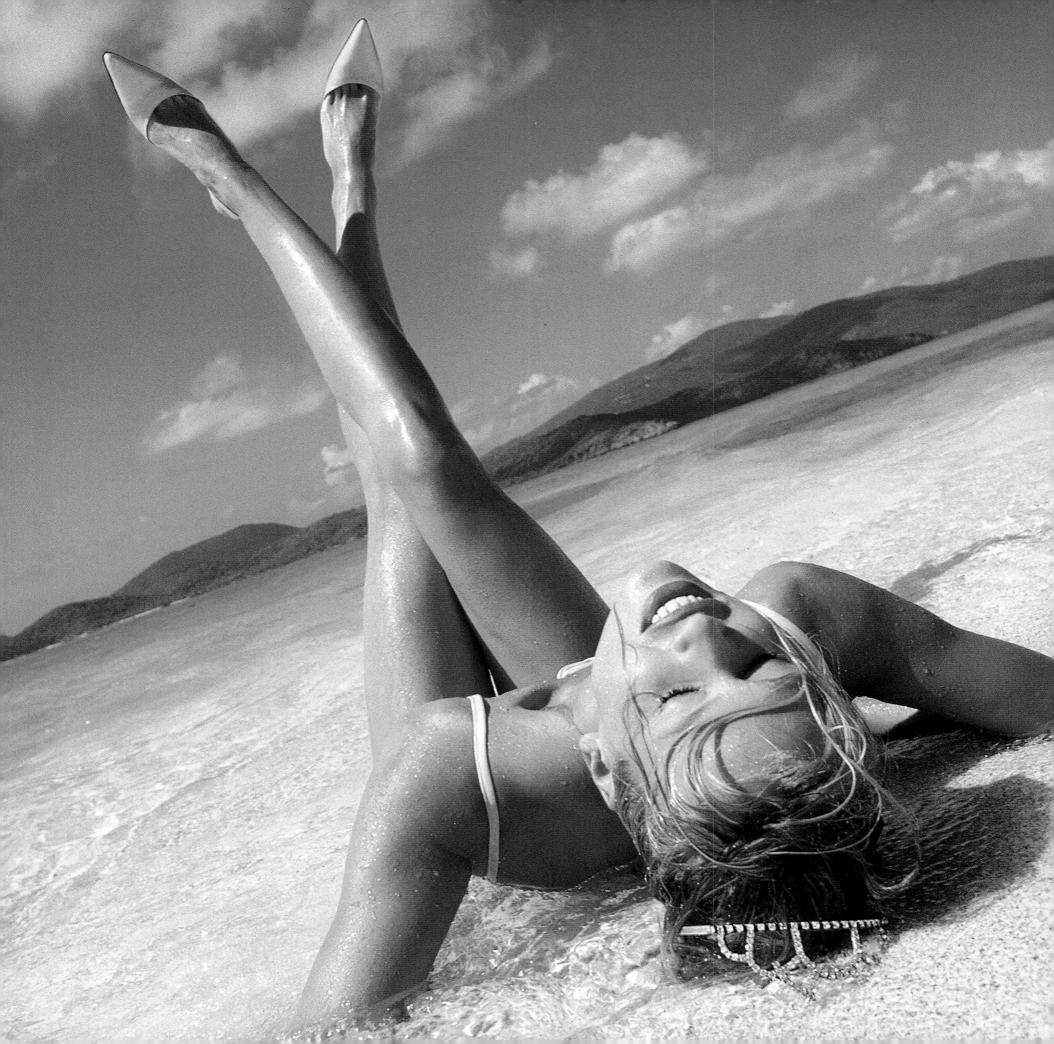

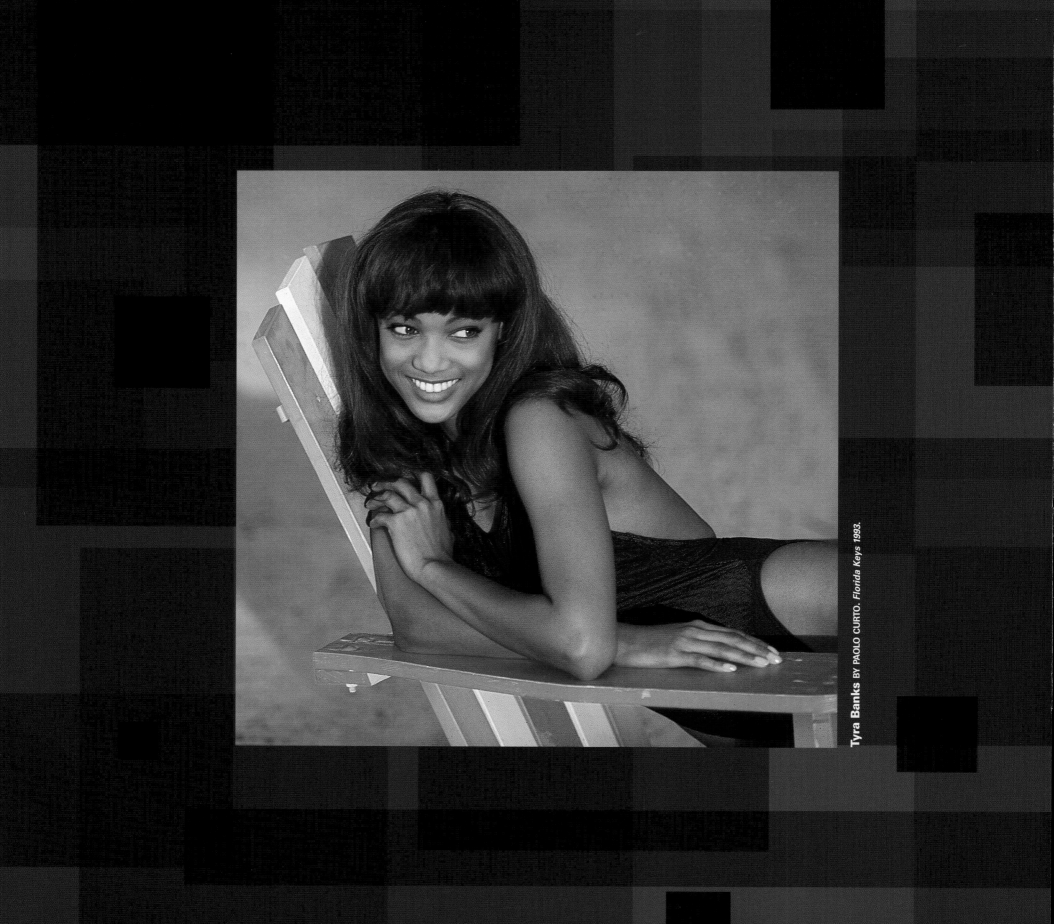

Tyra Banks BY PAOLO CURTO. *Florida Keys 1993.*

THE PHOTOGRAPHS

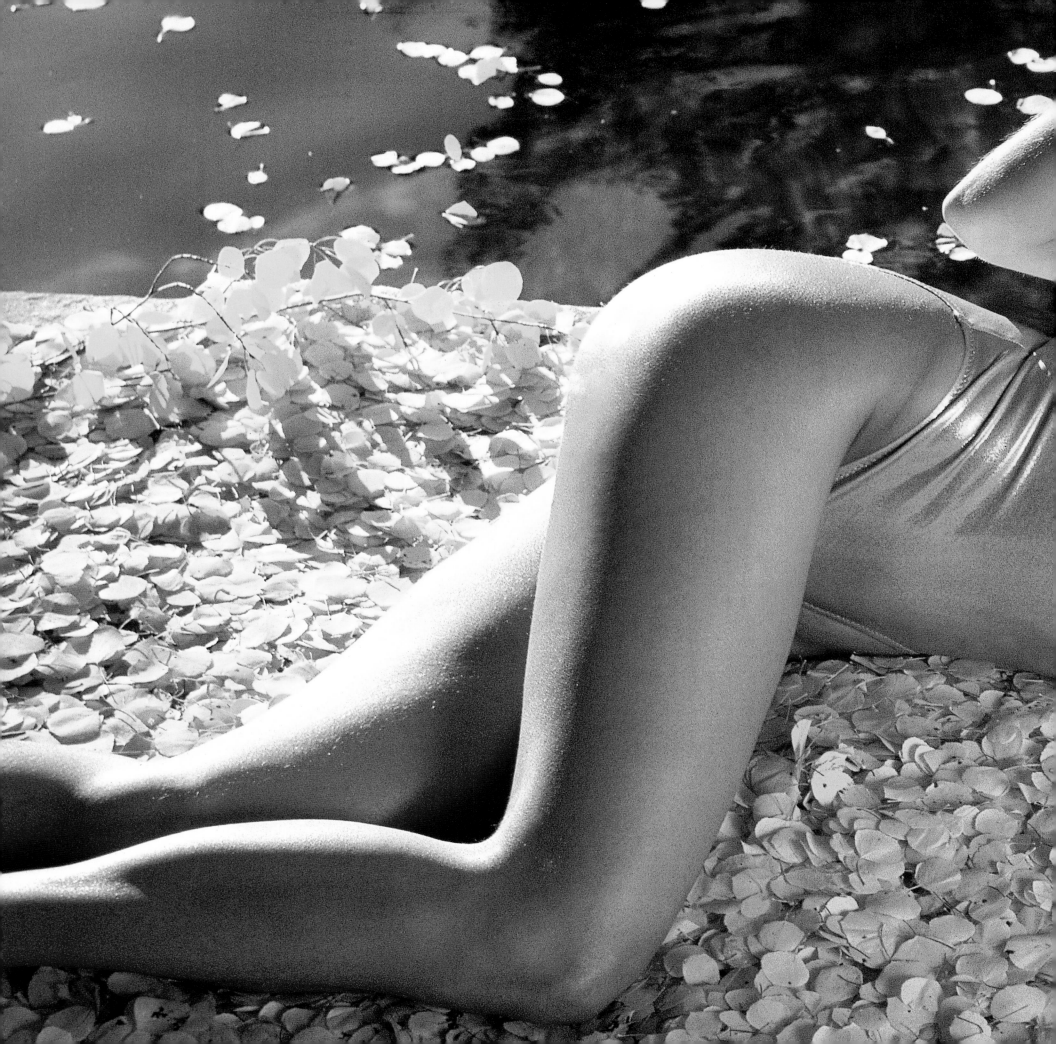

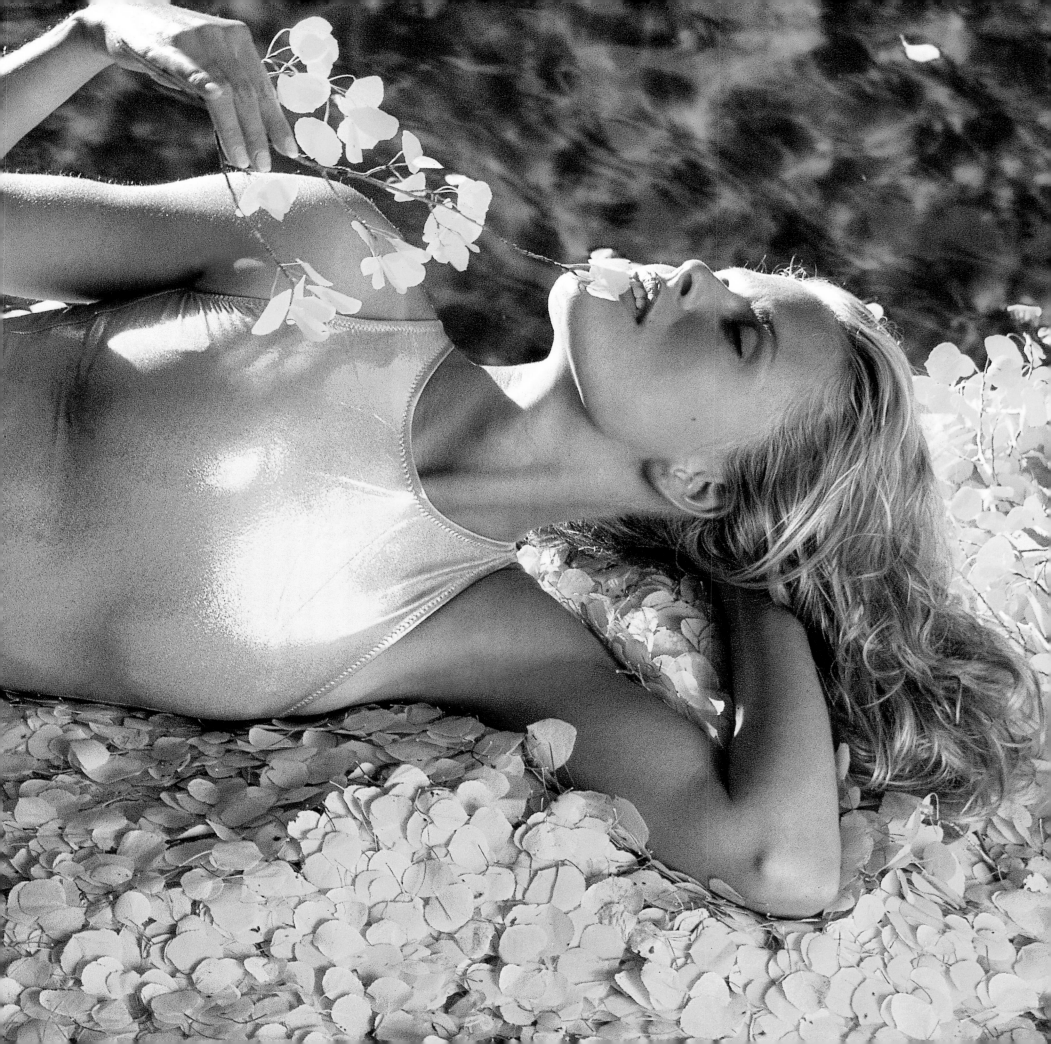

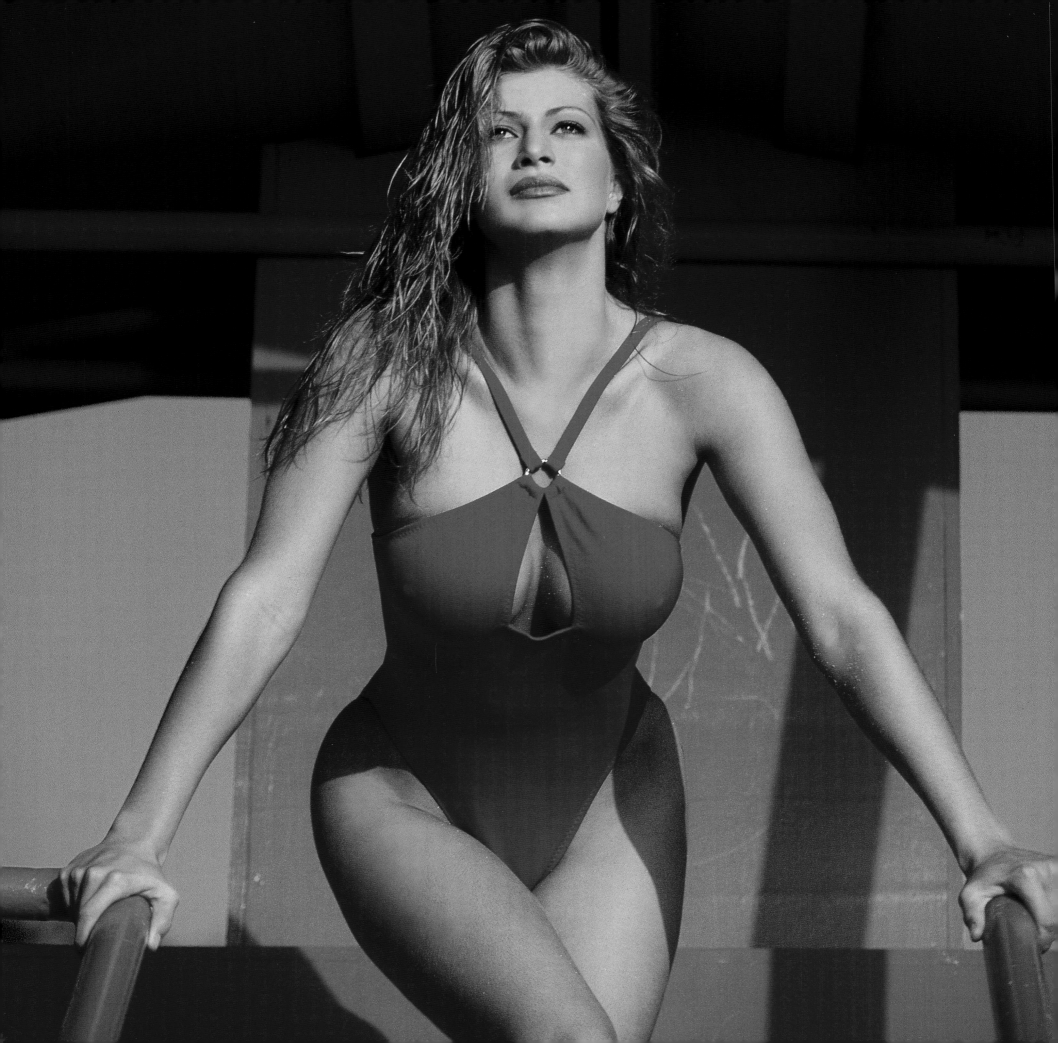

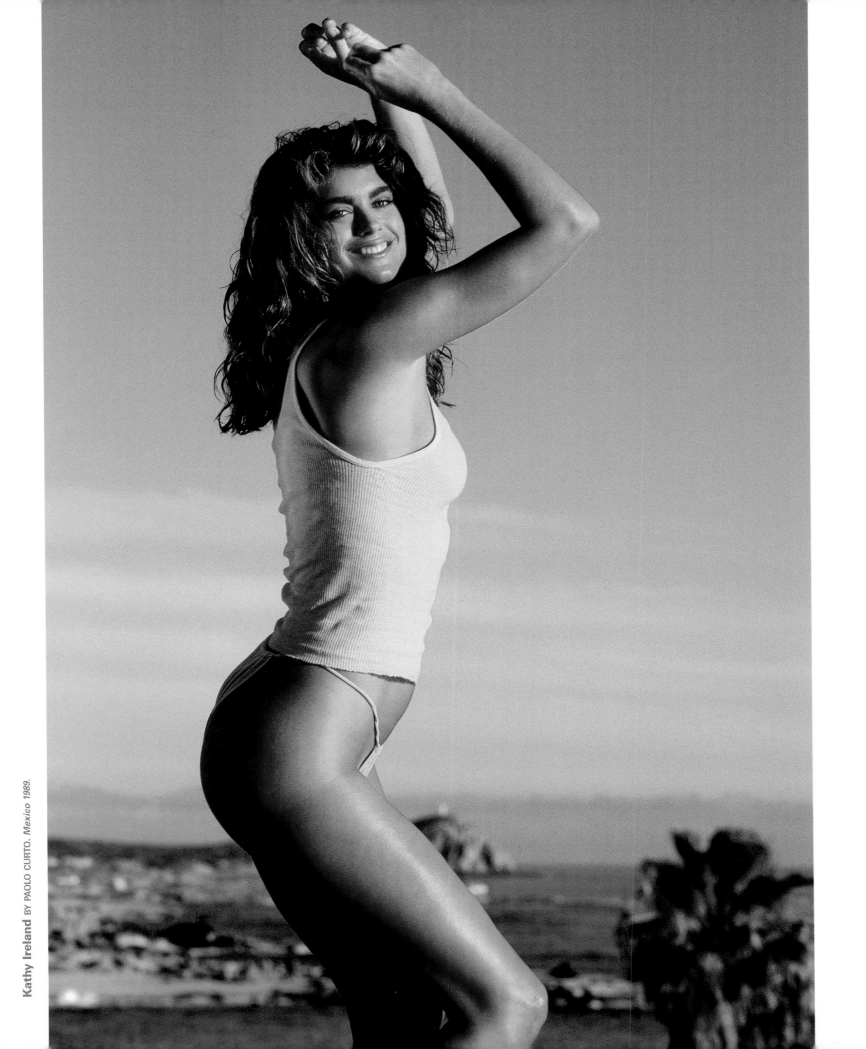

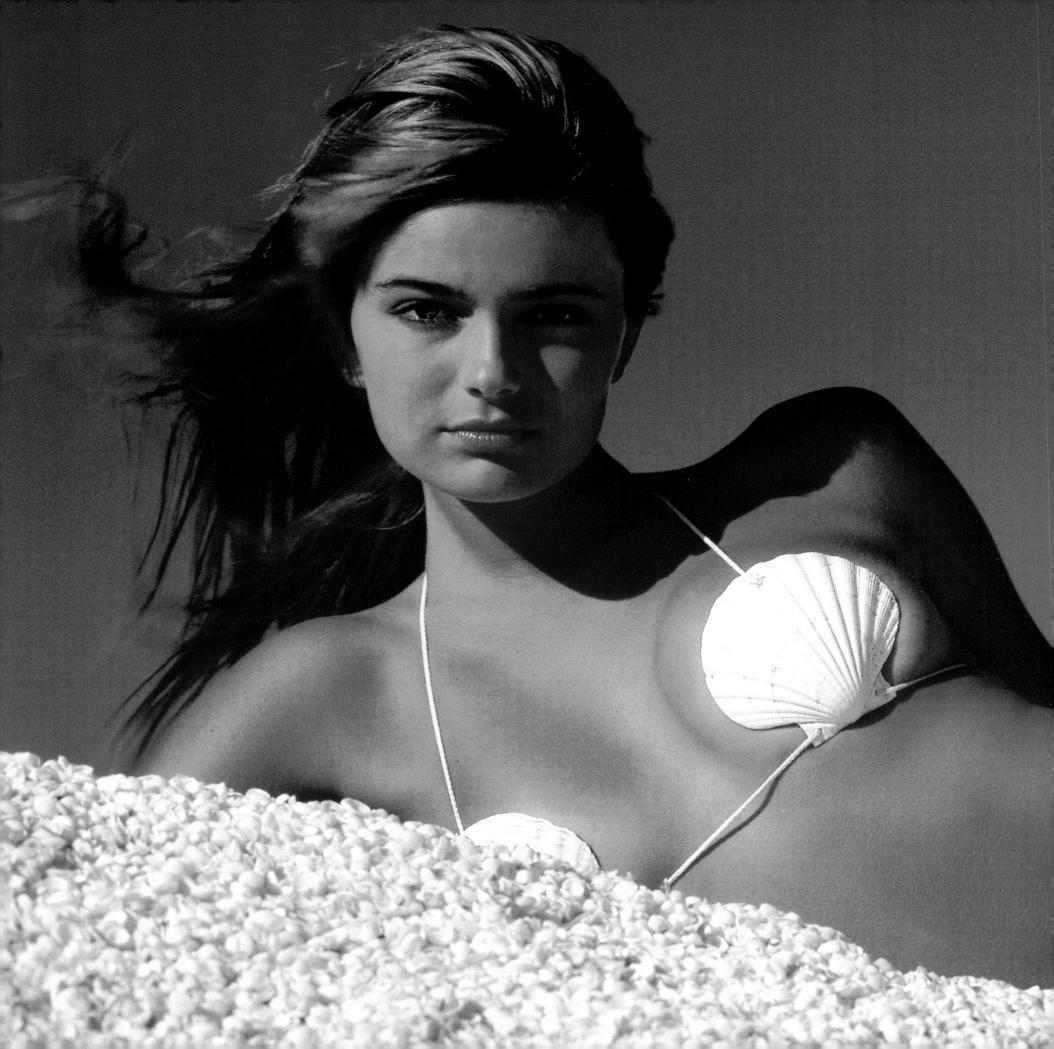

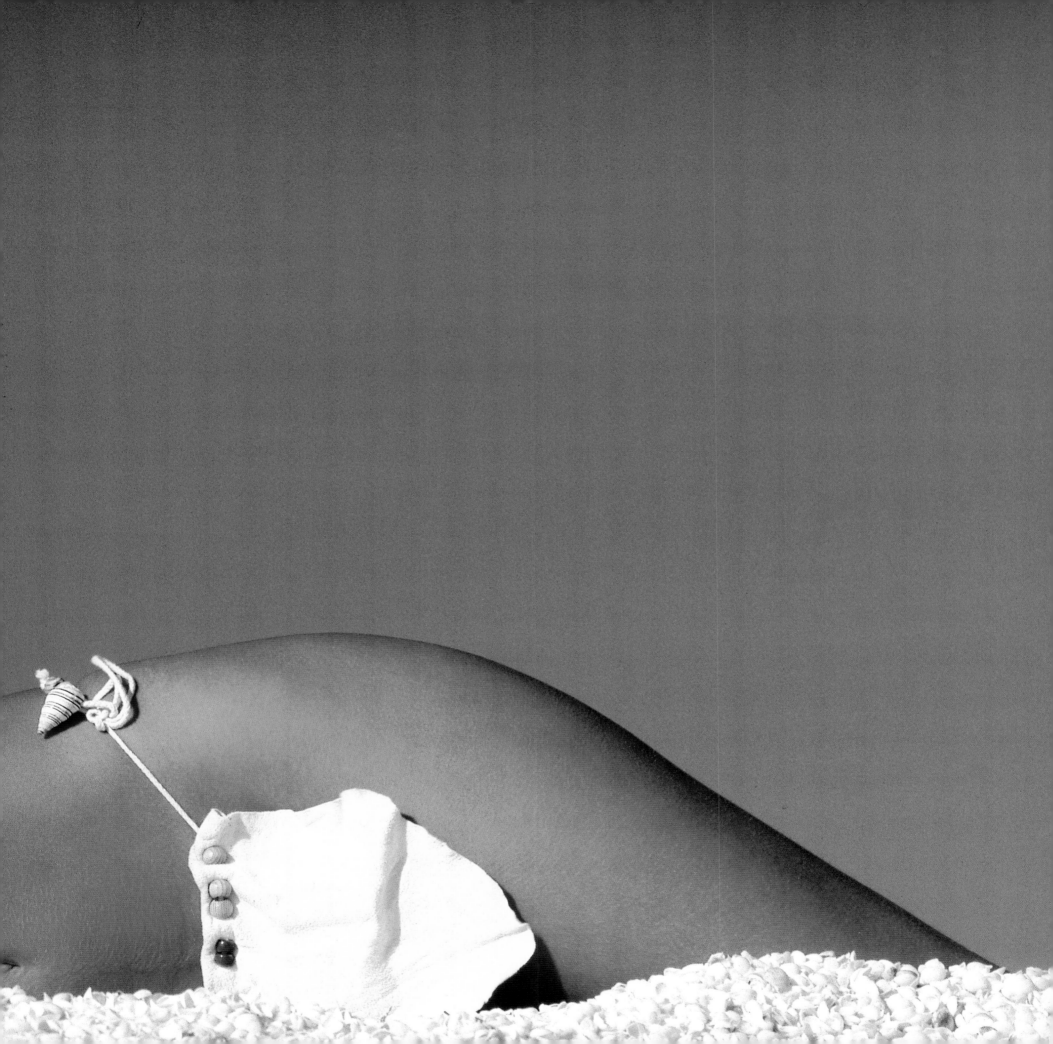

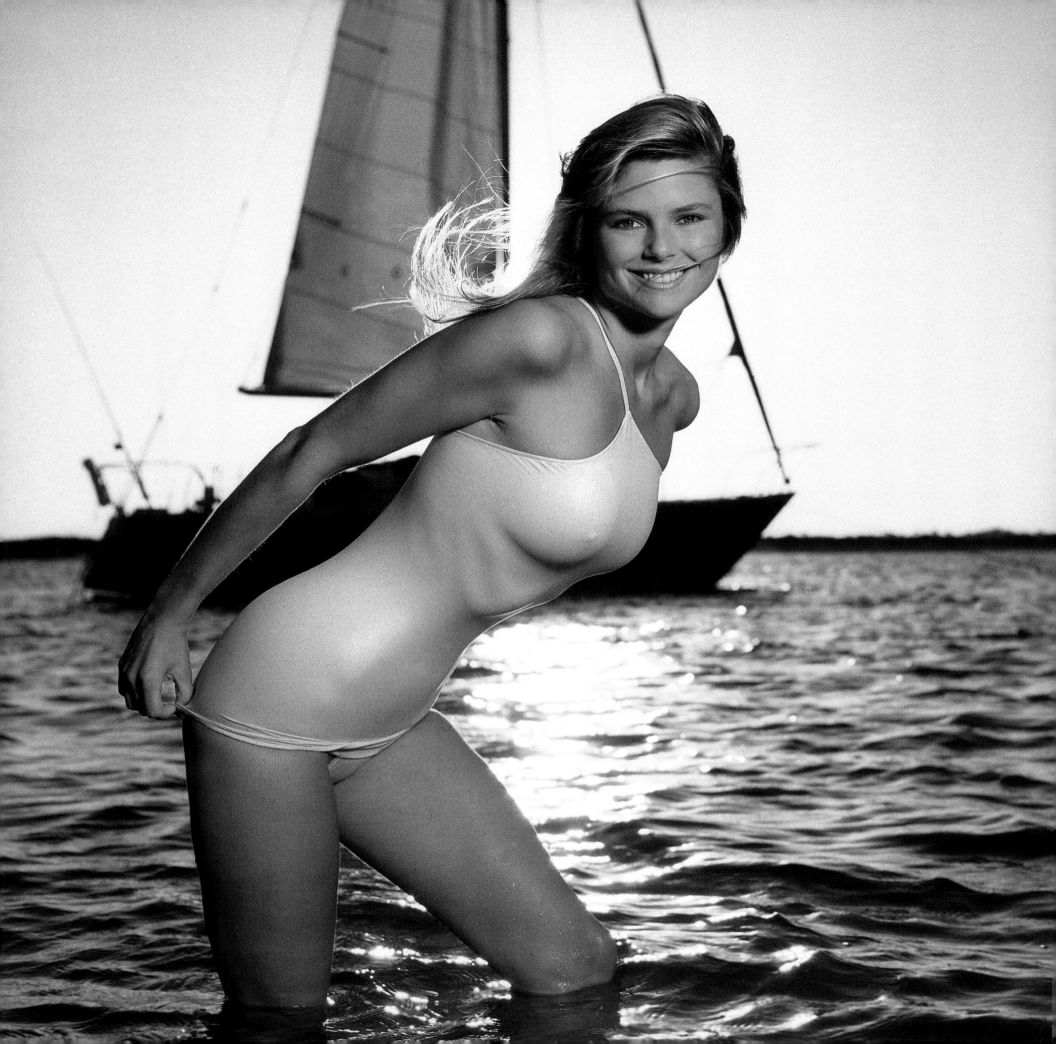

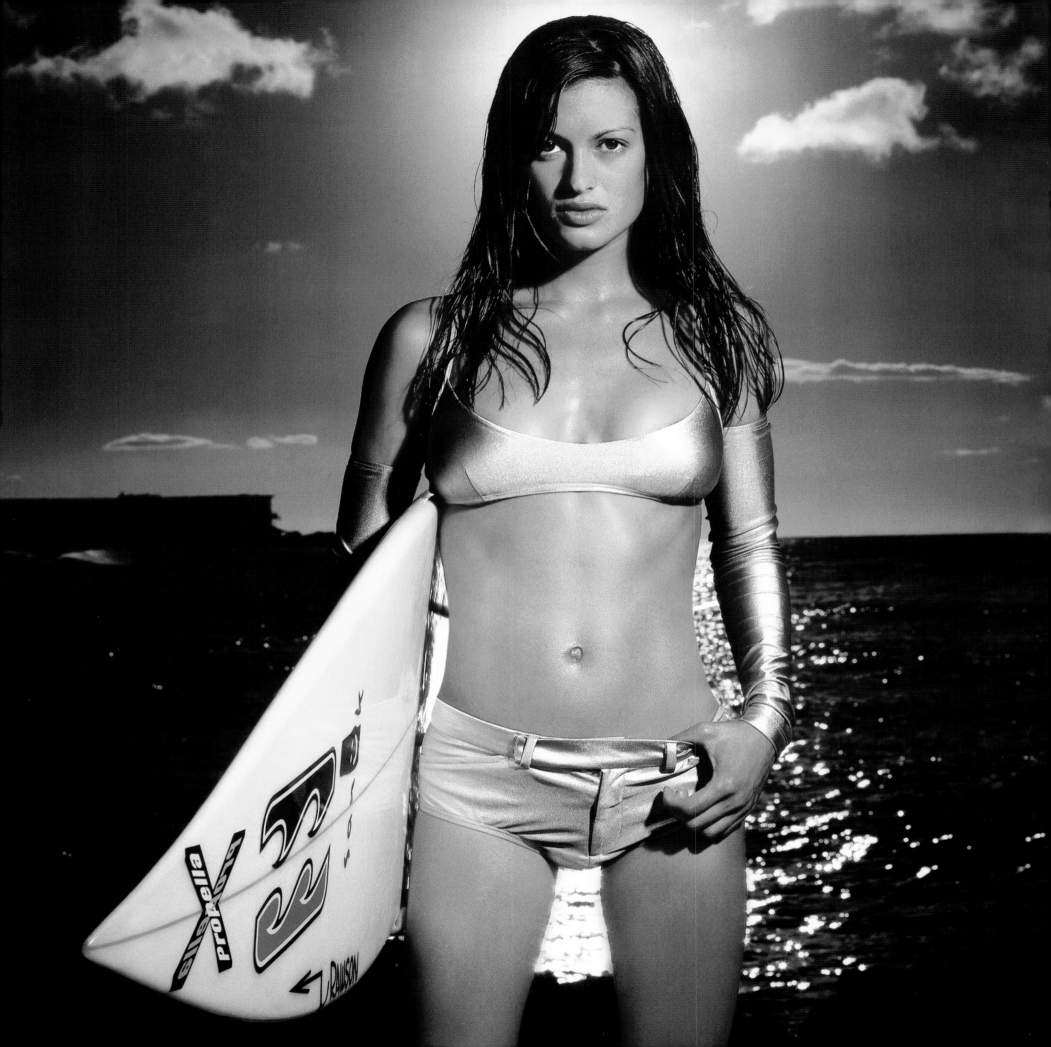

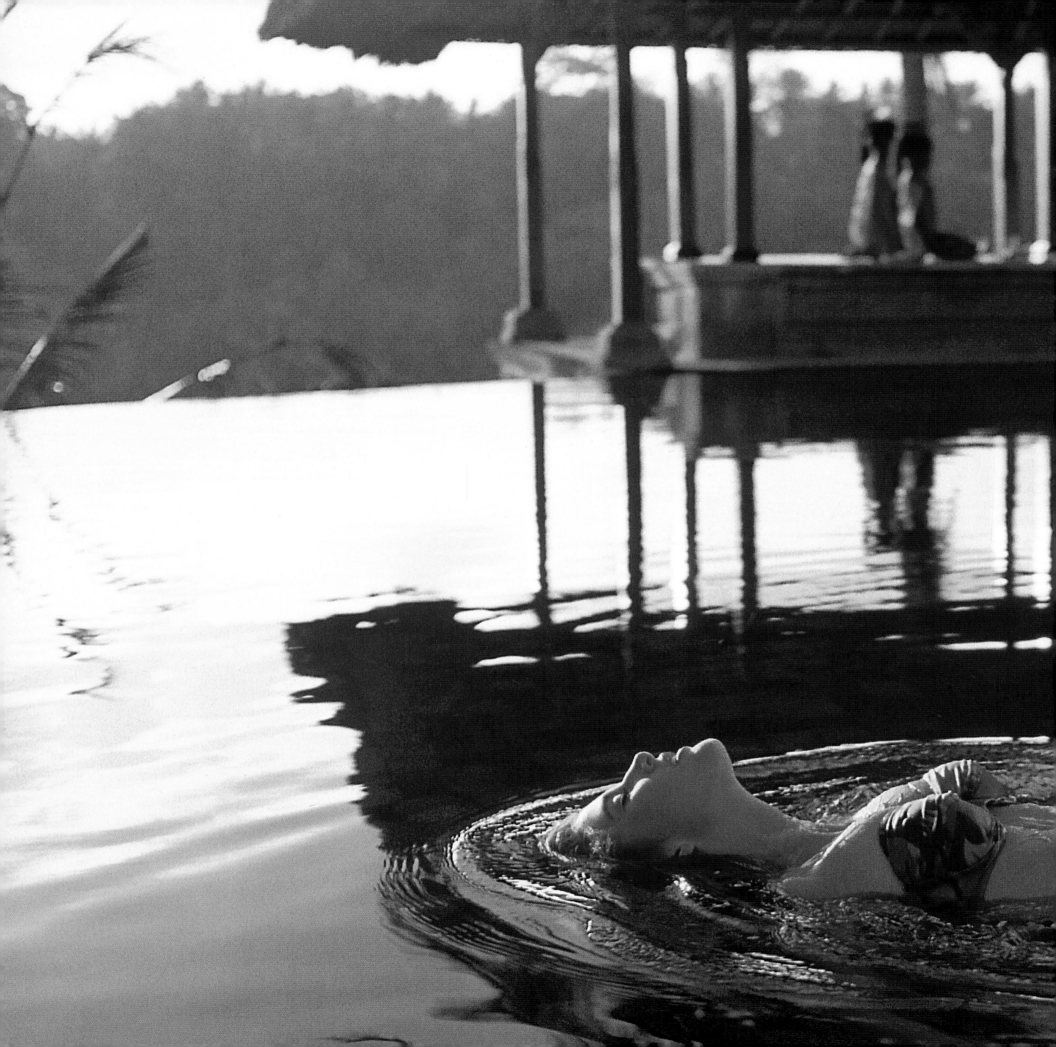

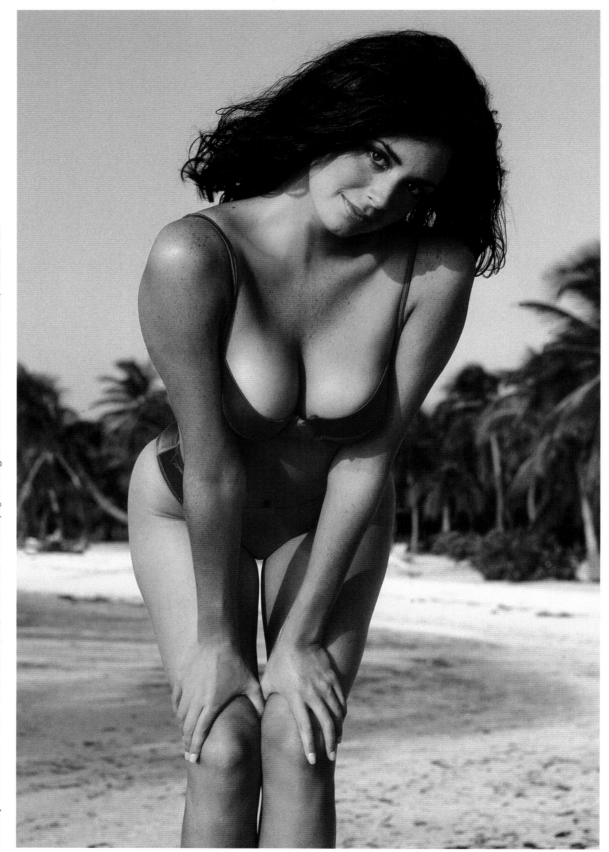

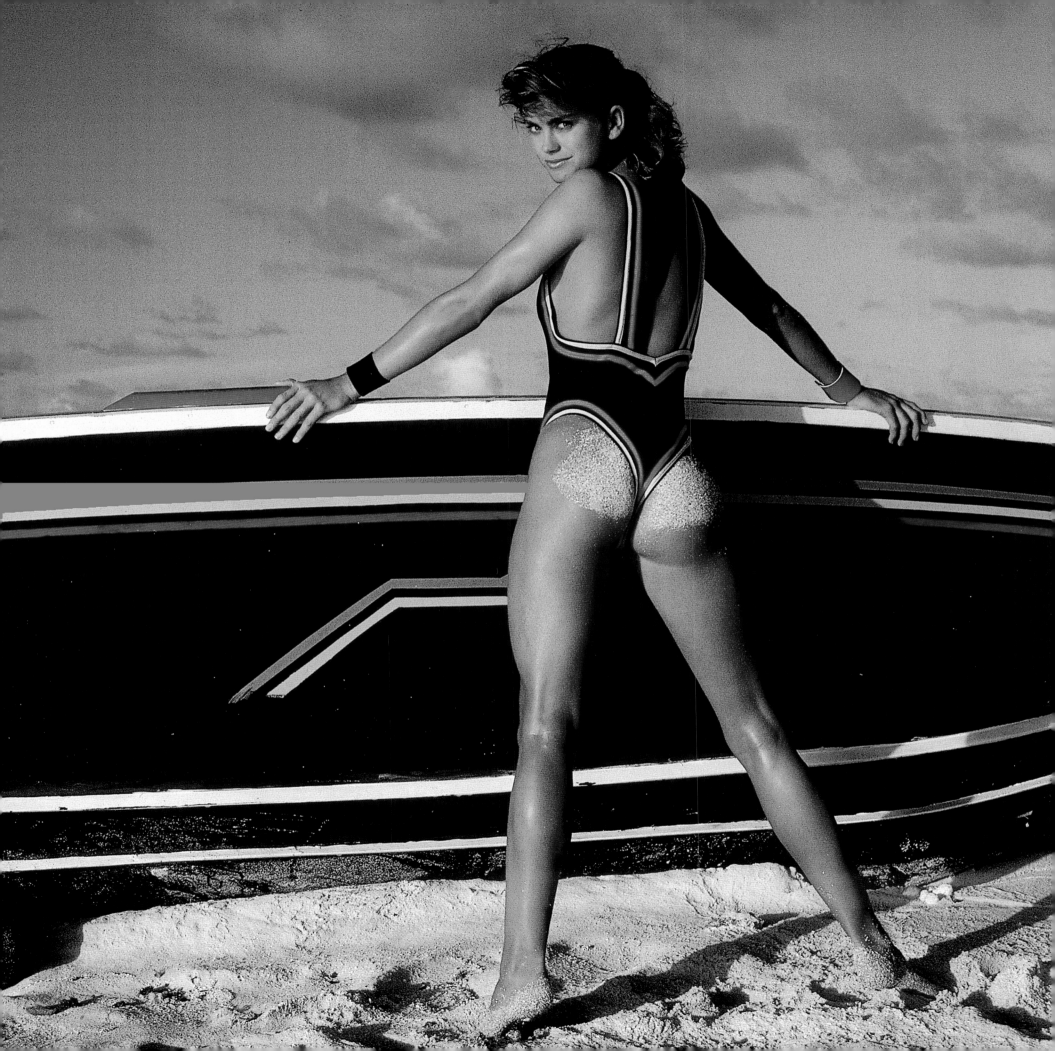

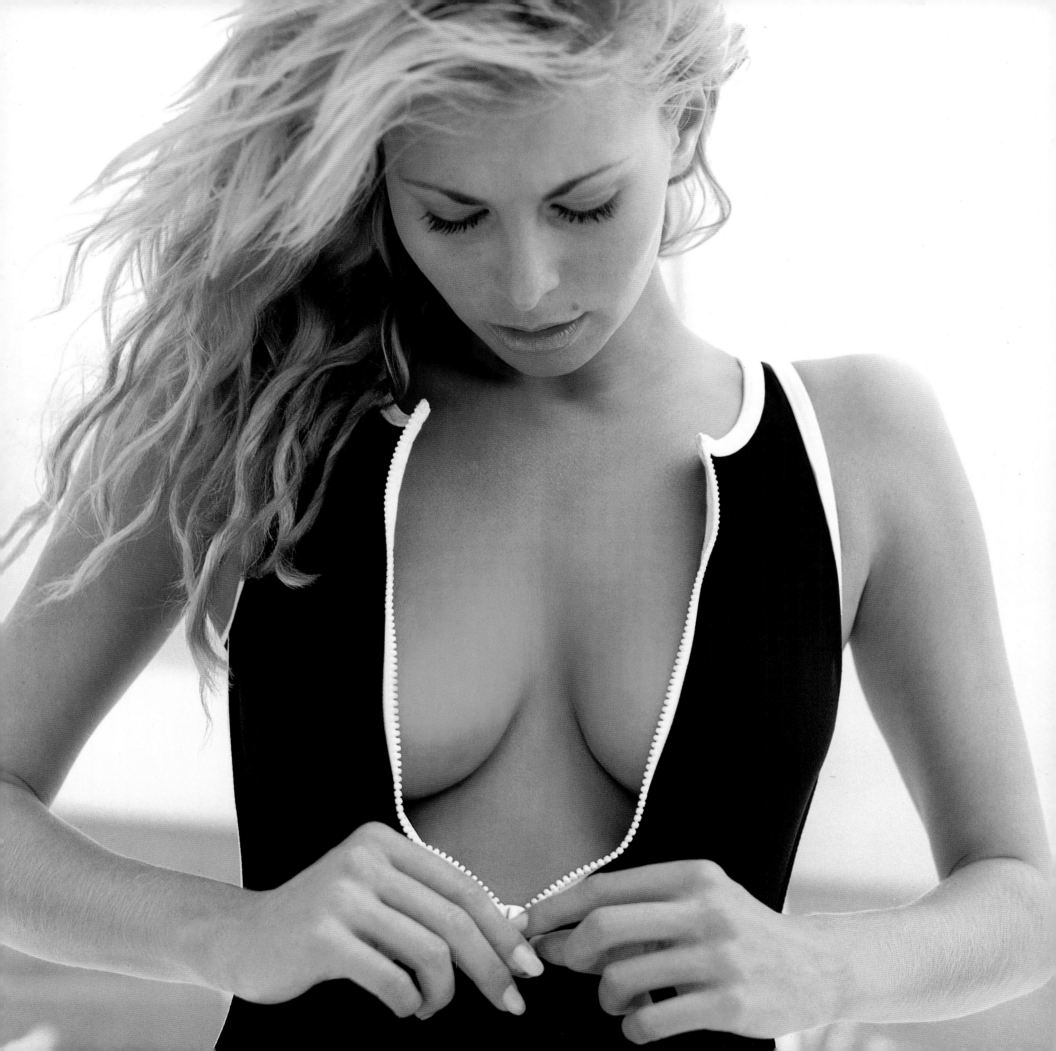

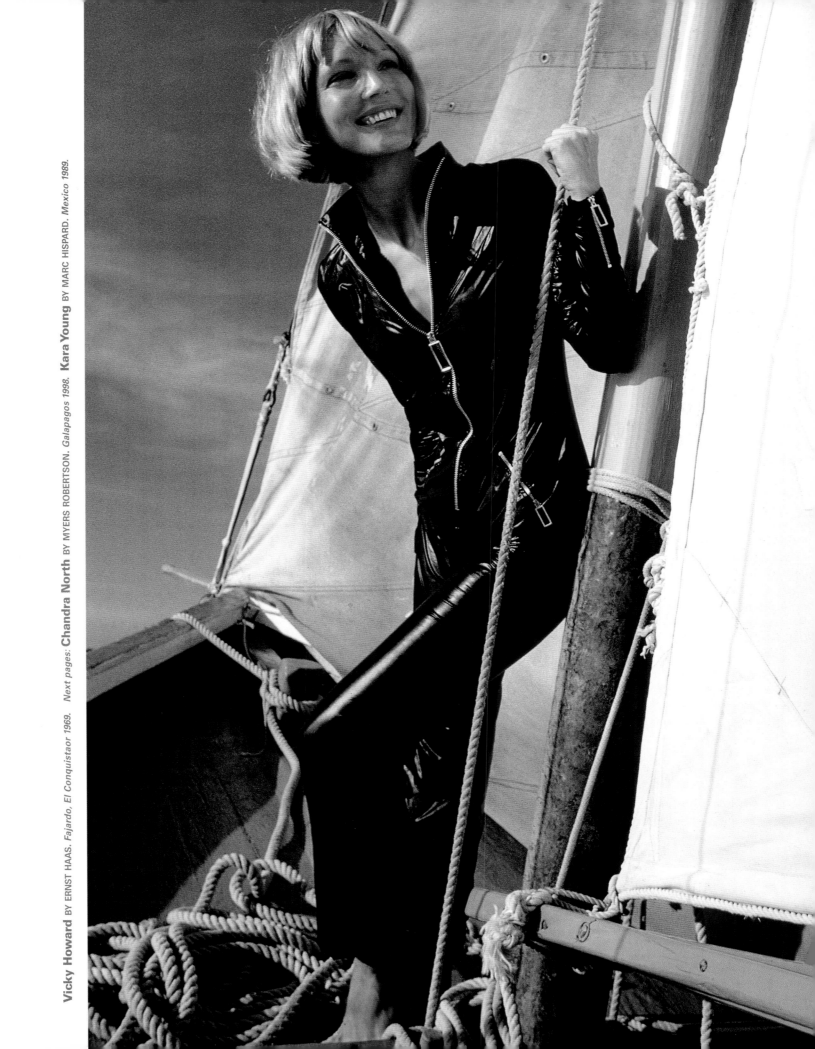

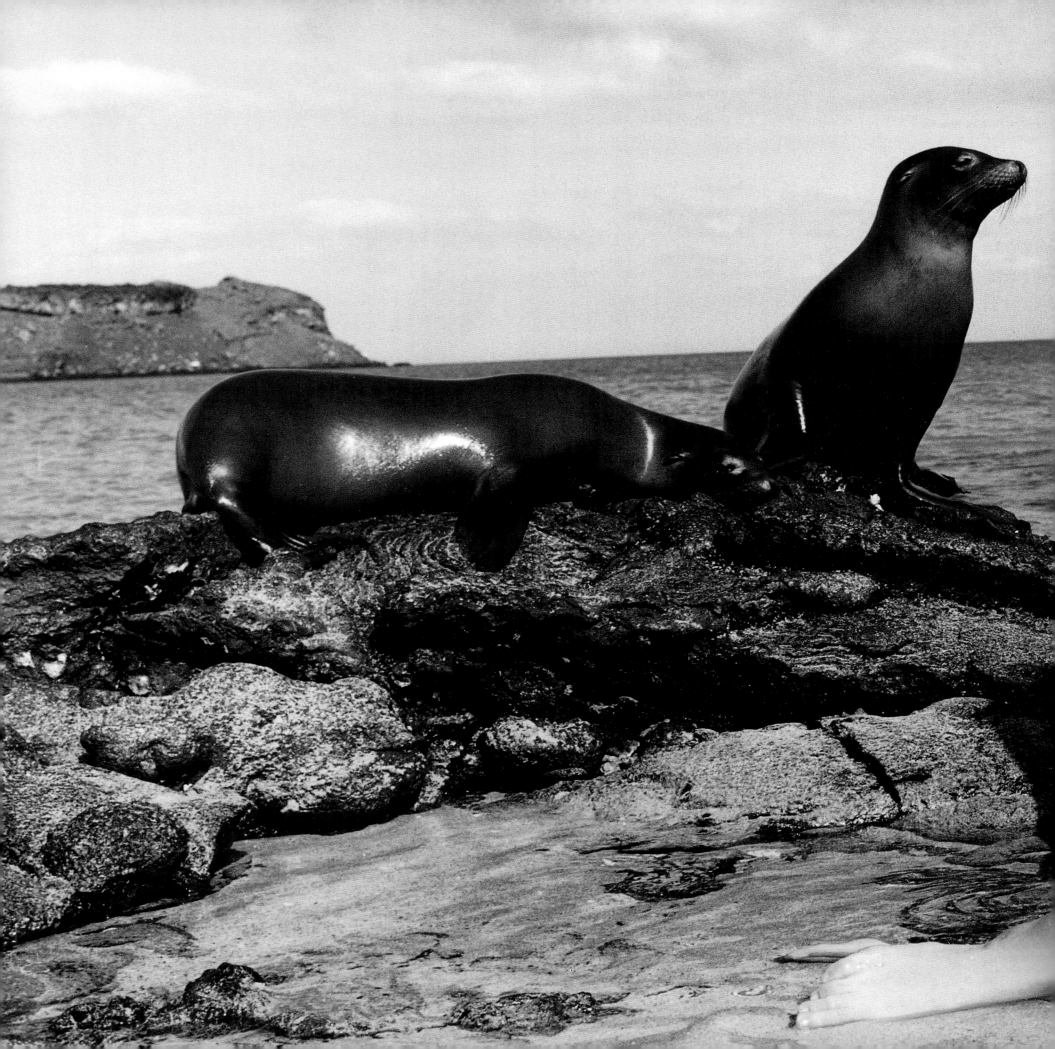

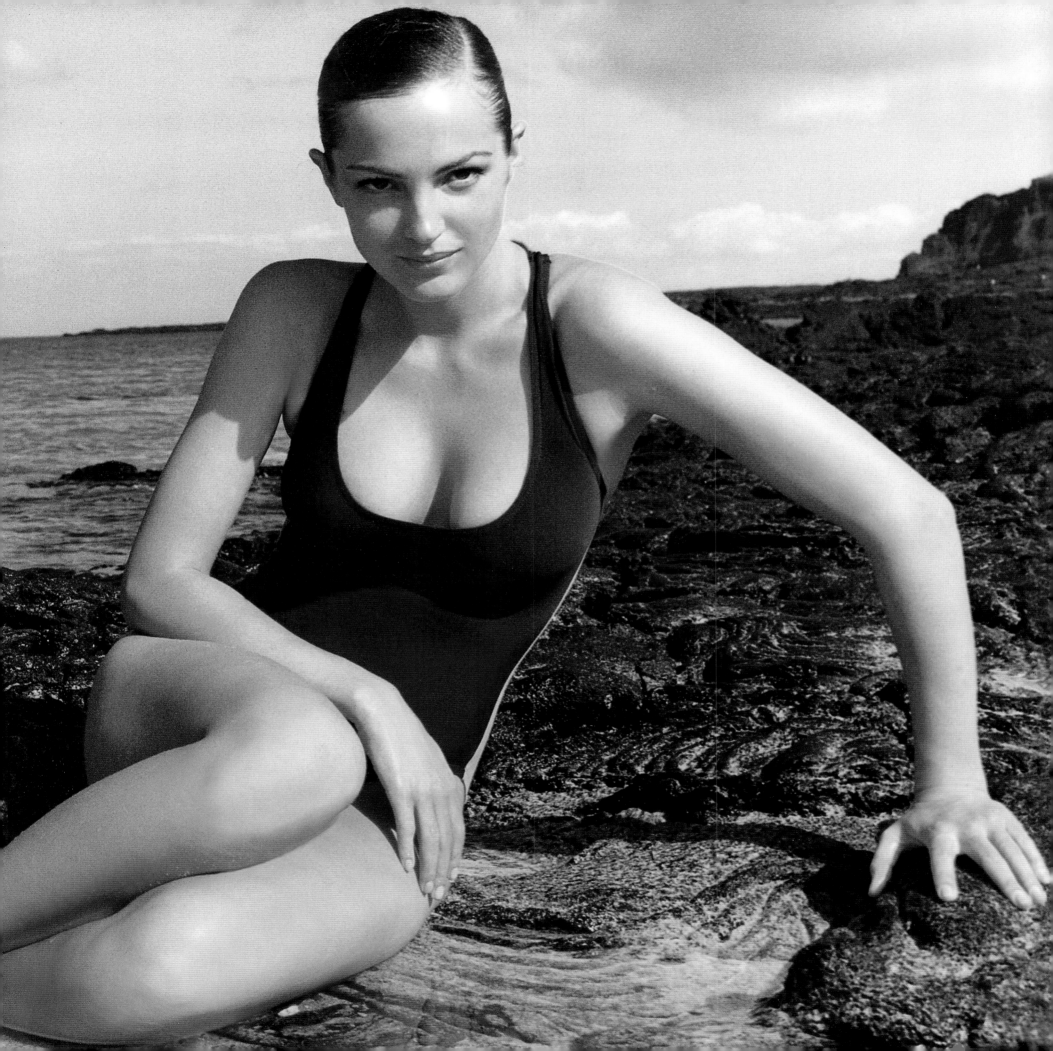

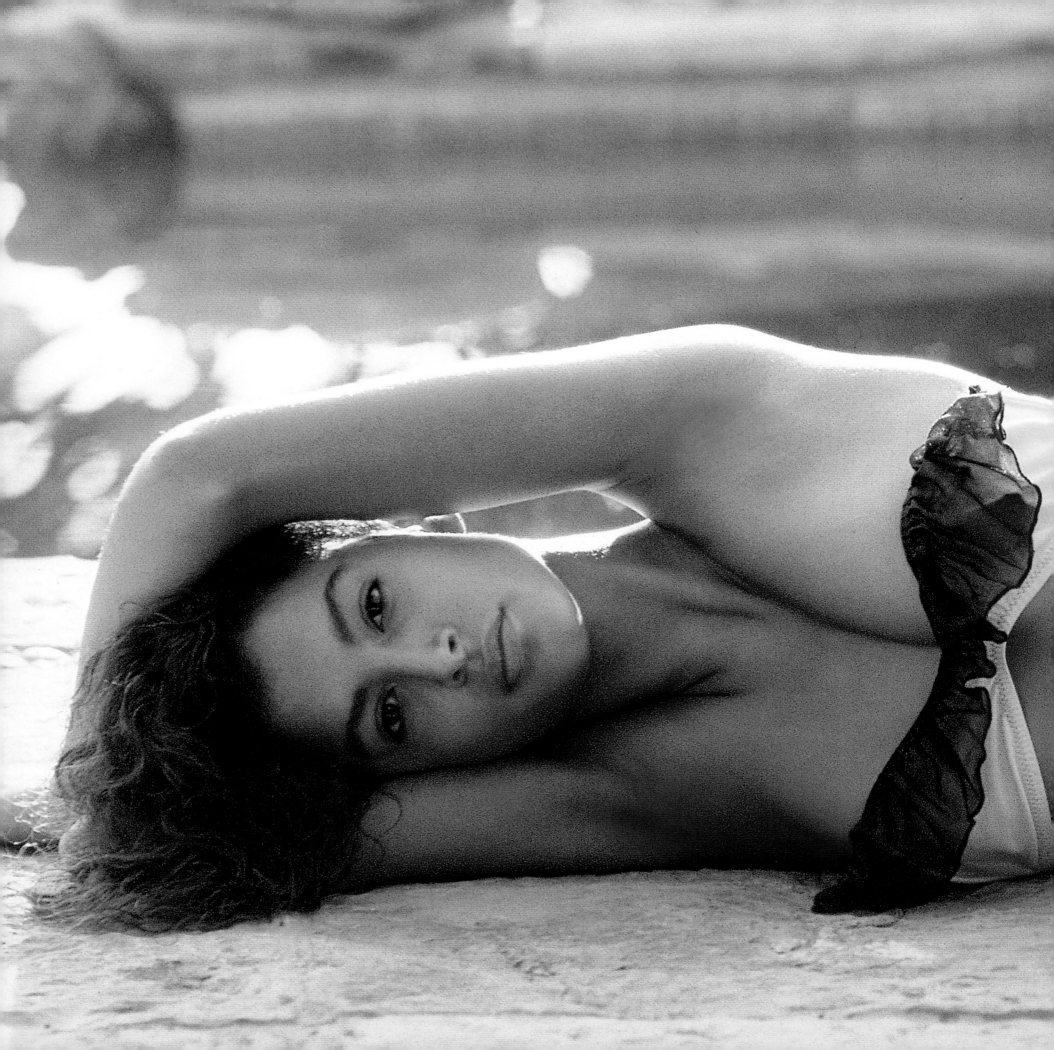

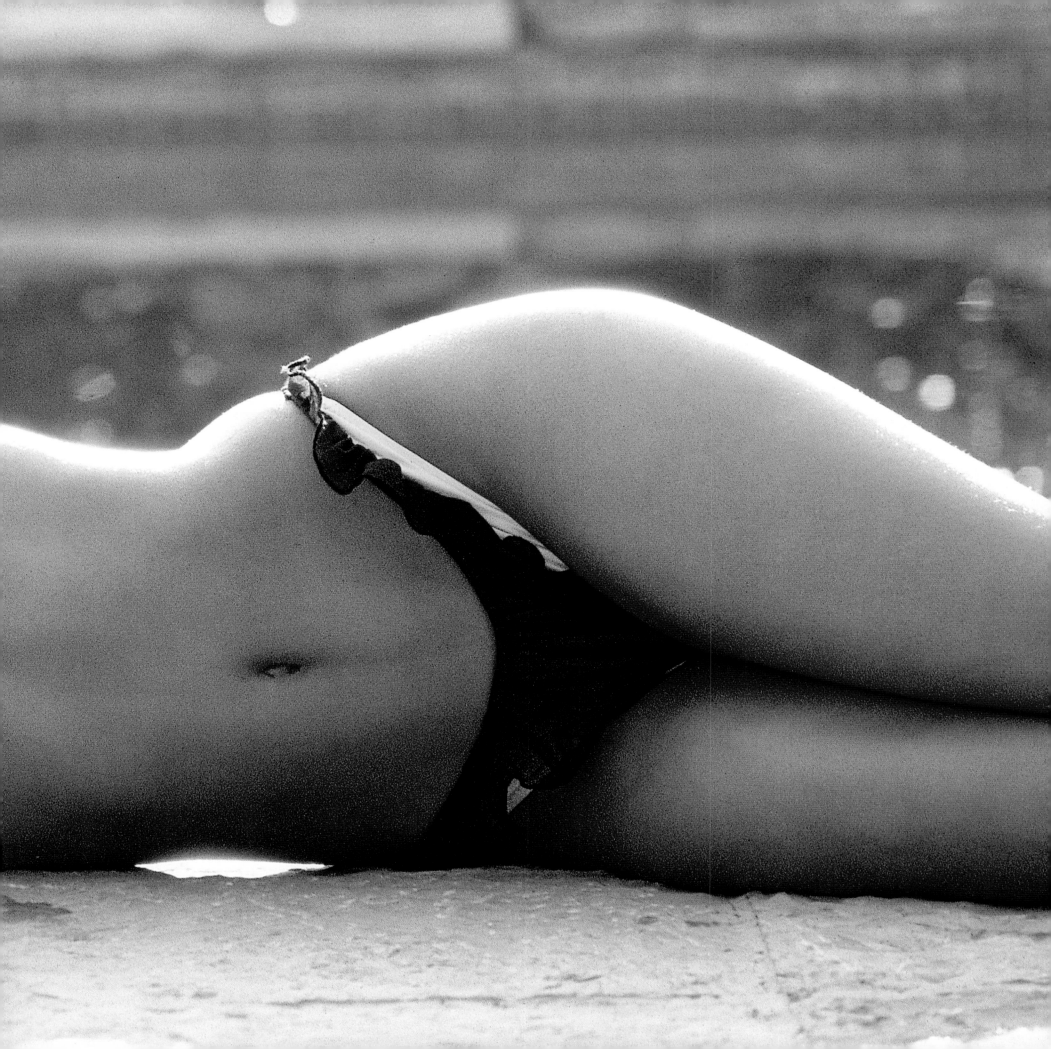

MILF

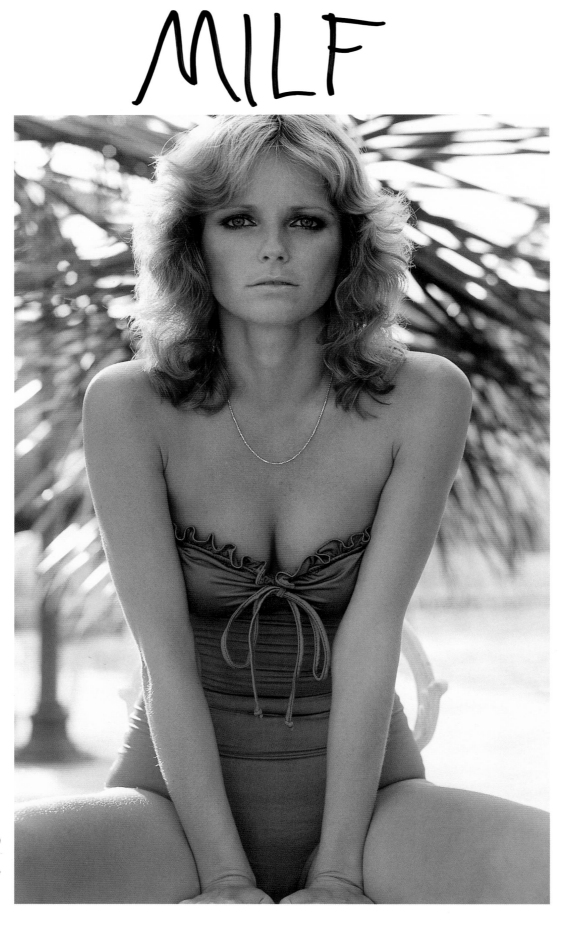

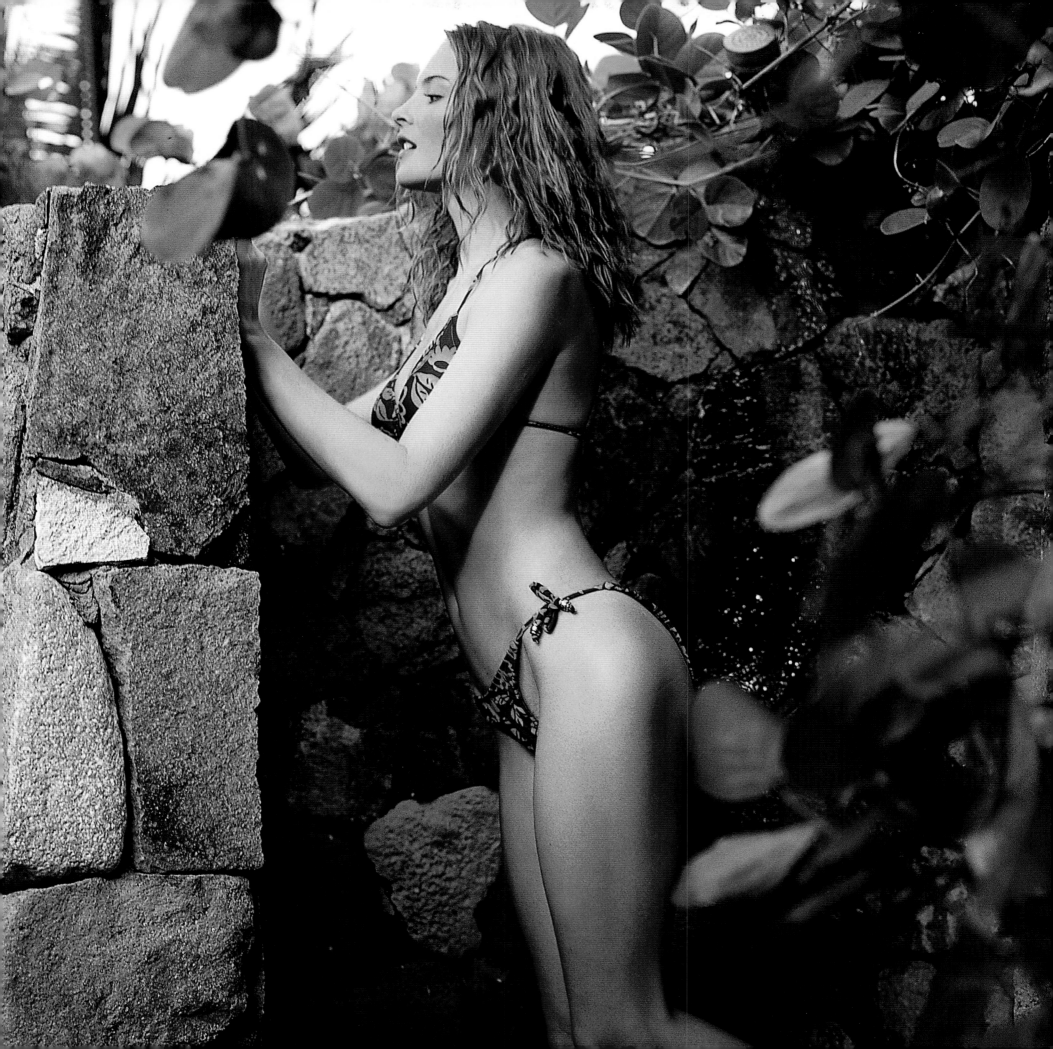

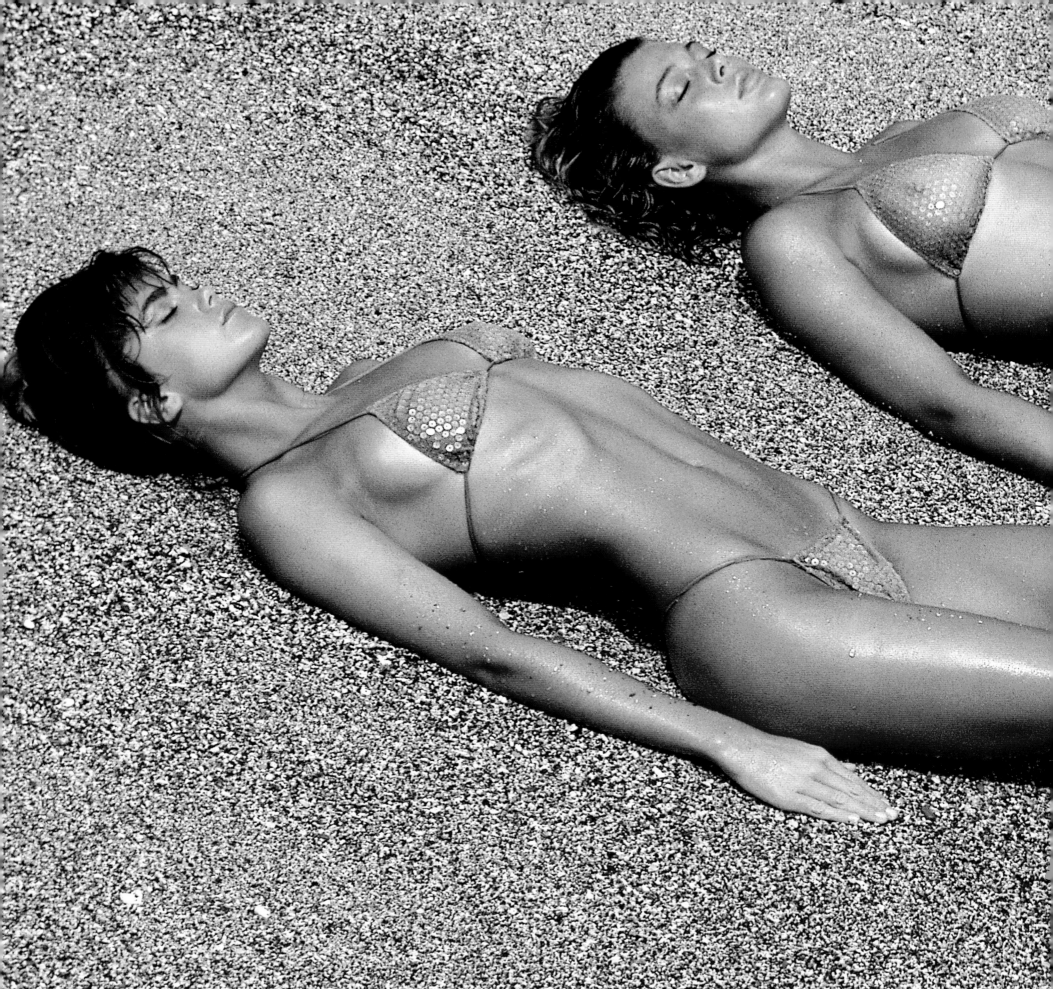

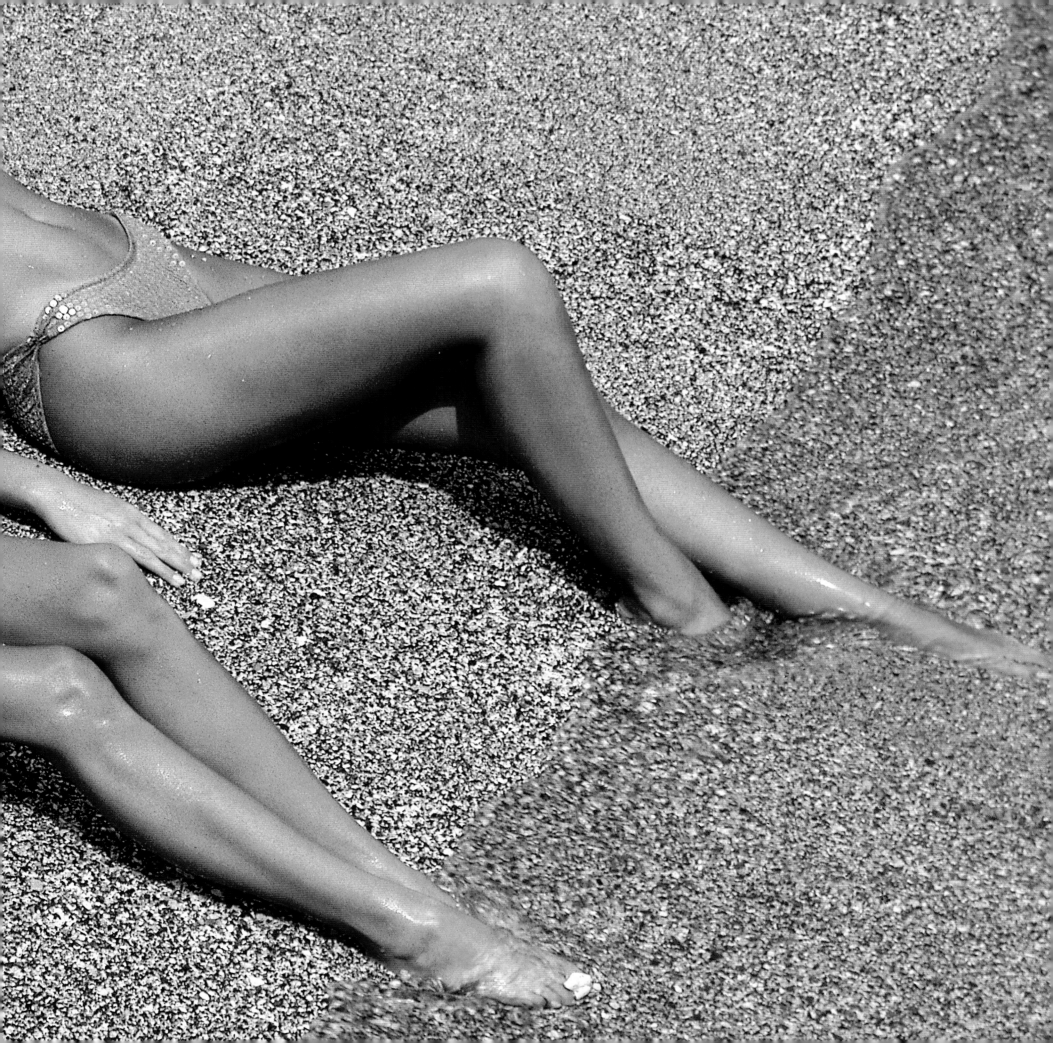

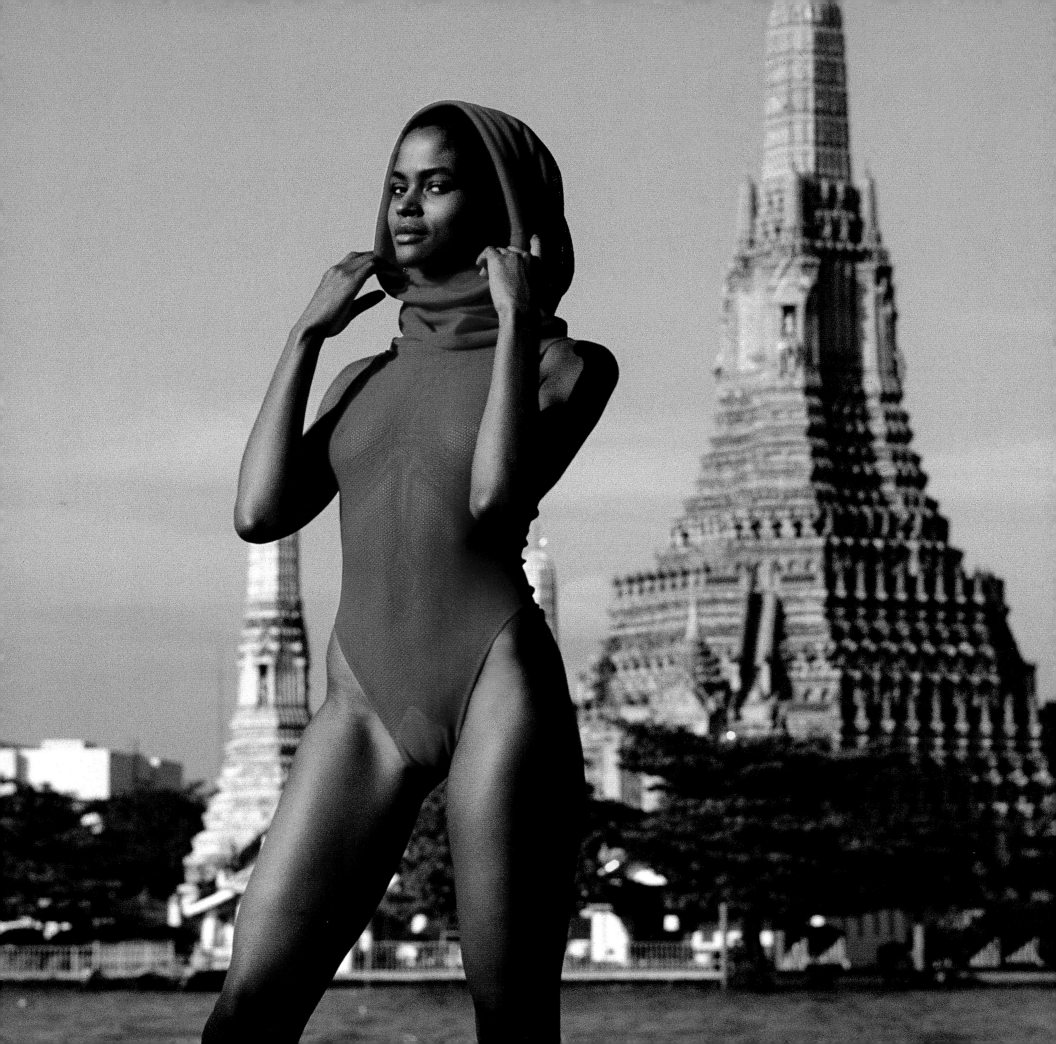

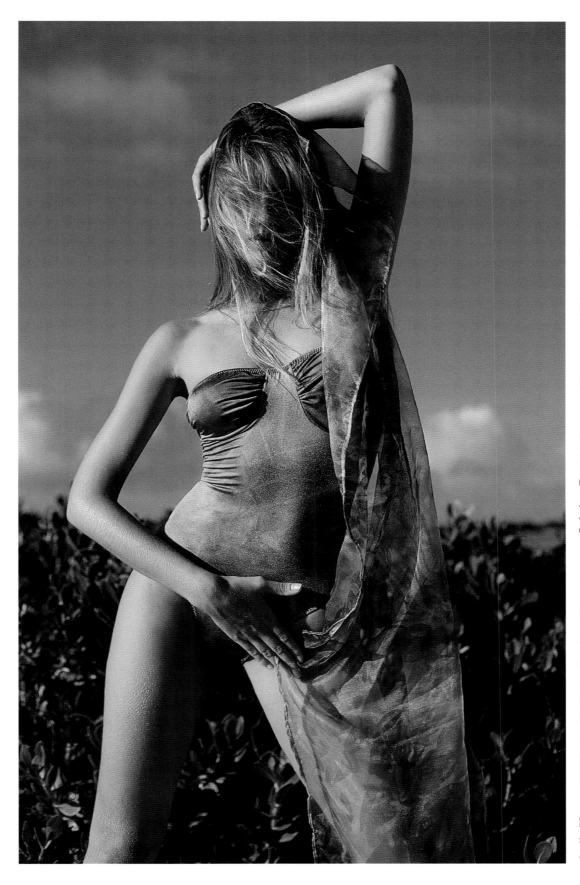

Judit Masco BY WALTER IOOSS JR. *Providenciales 1991.* Next pages: **Sabrina Barnett** BY ROBERT HUNTZINGER. *St Vincent, Caribbean 1990.*

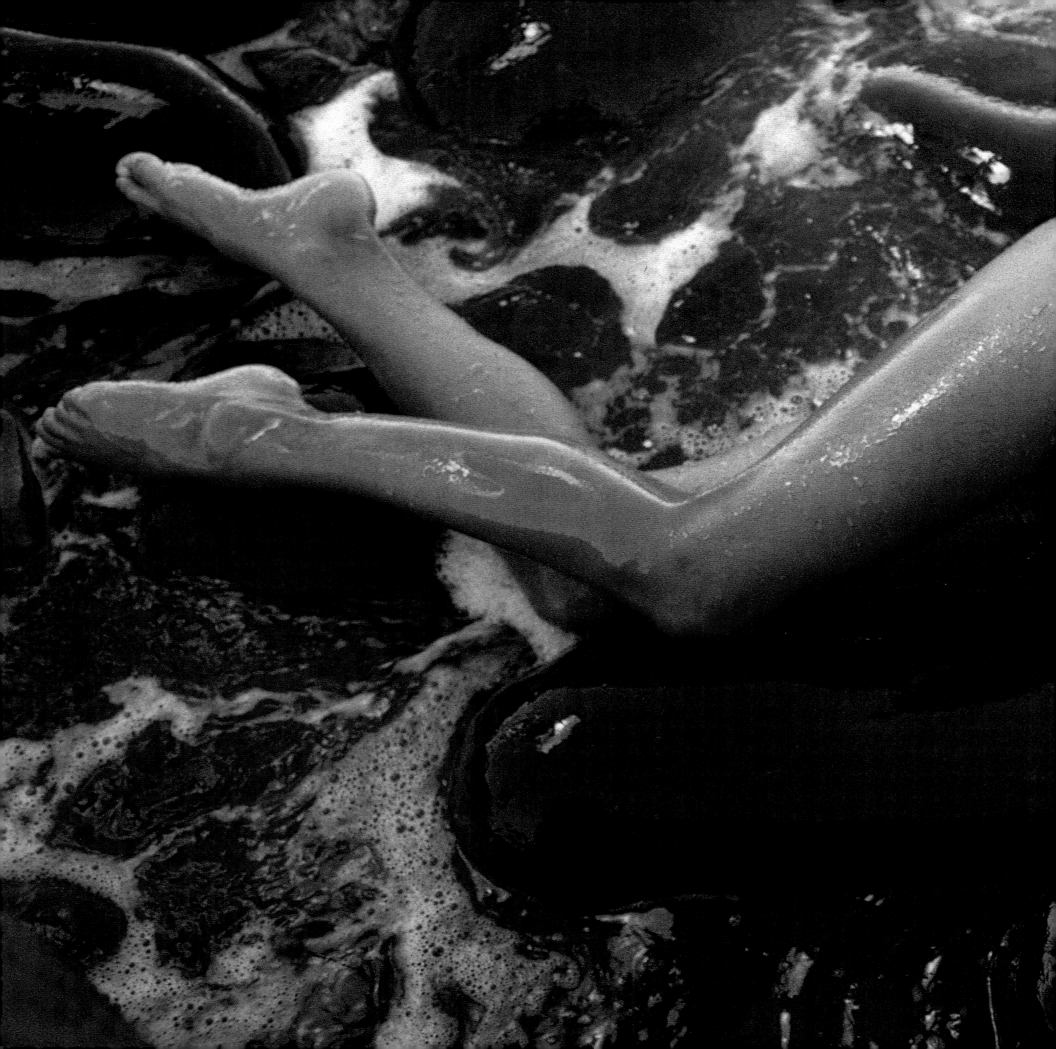

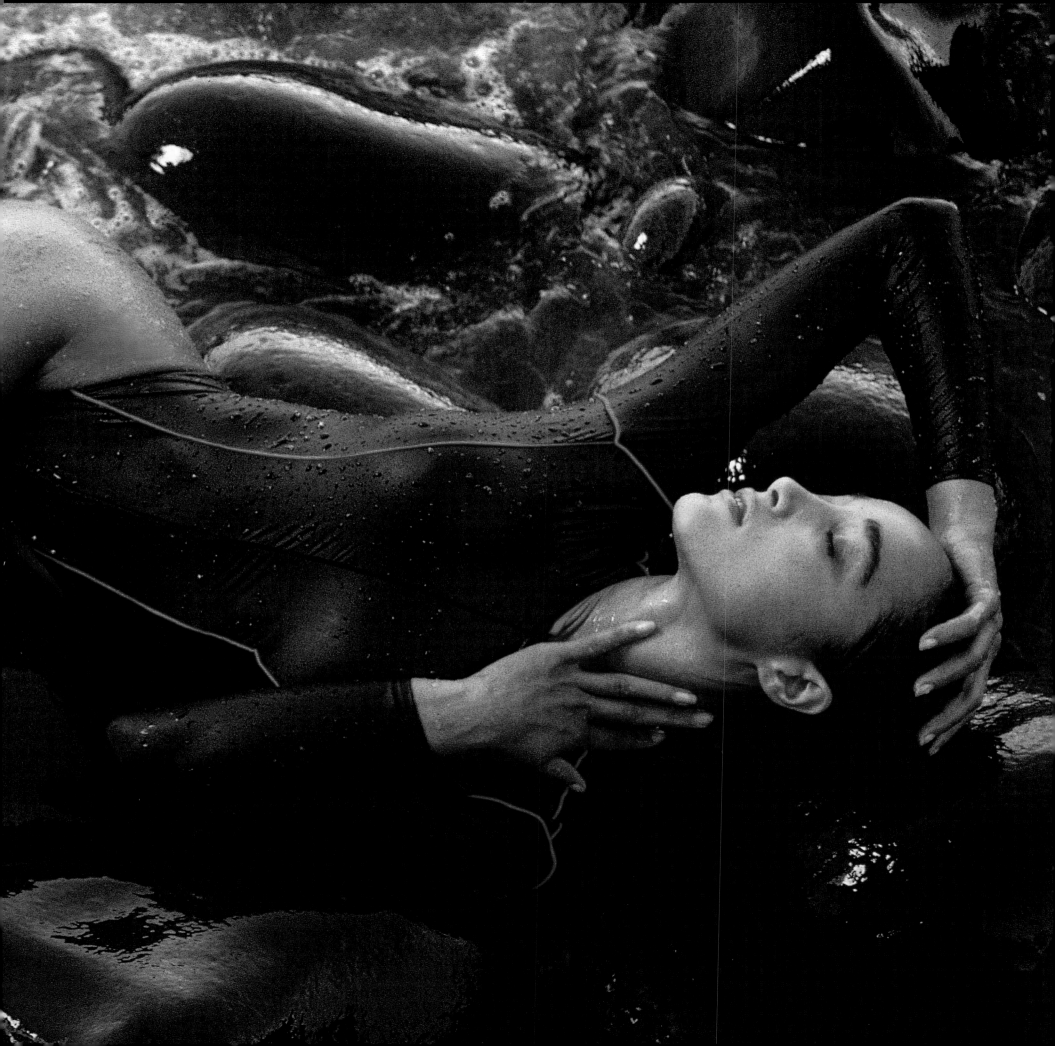

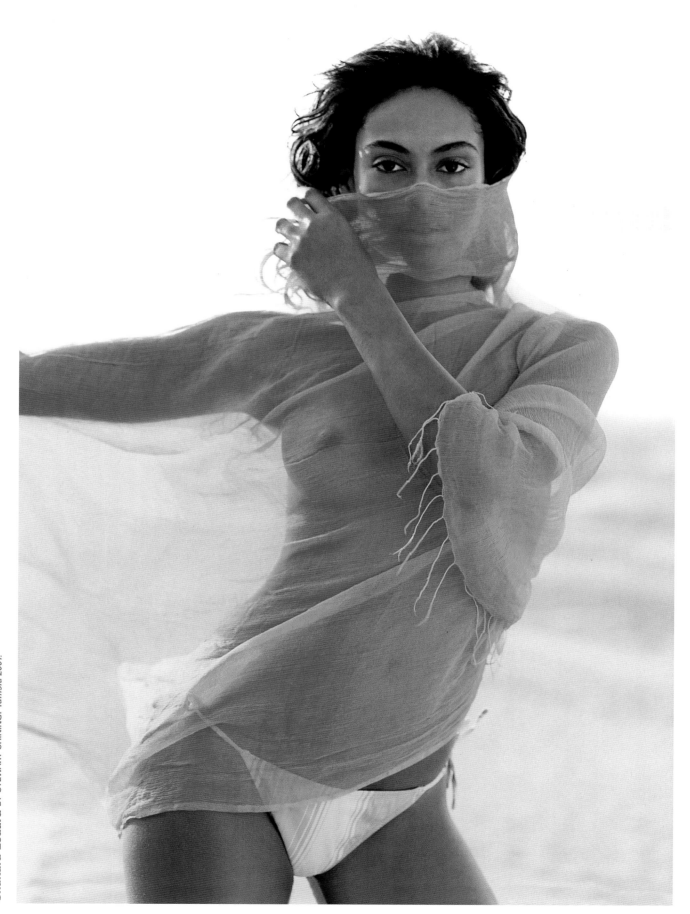

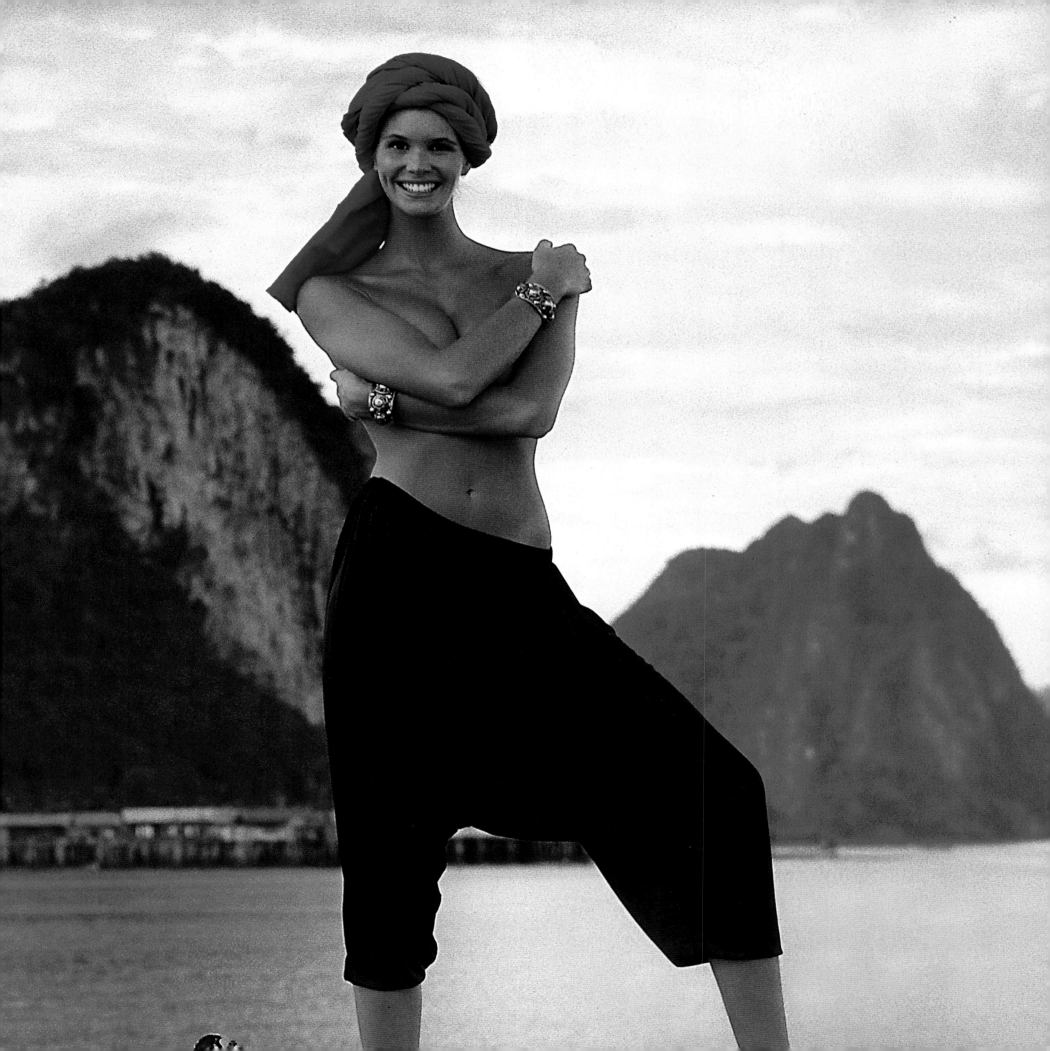

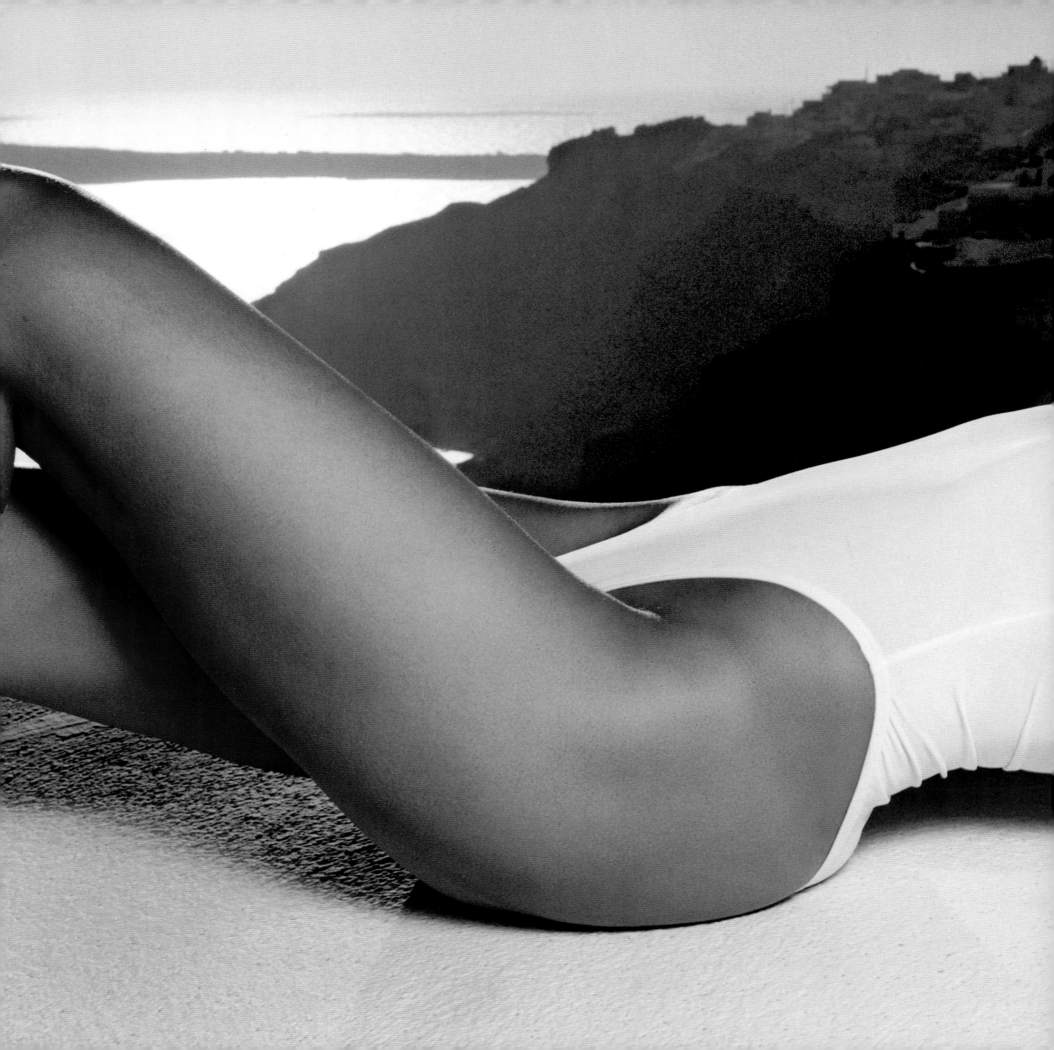

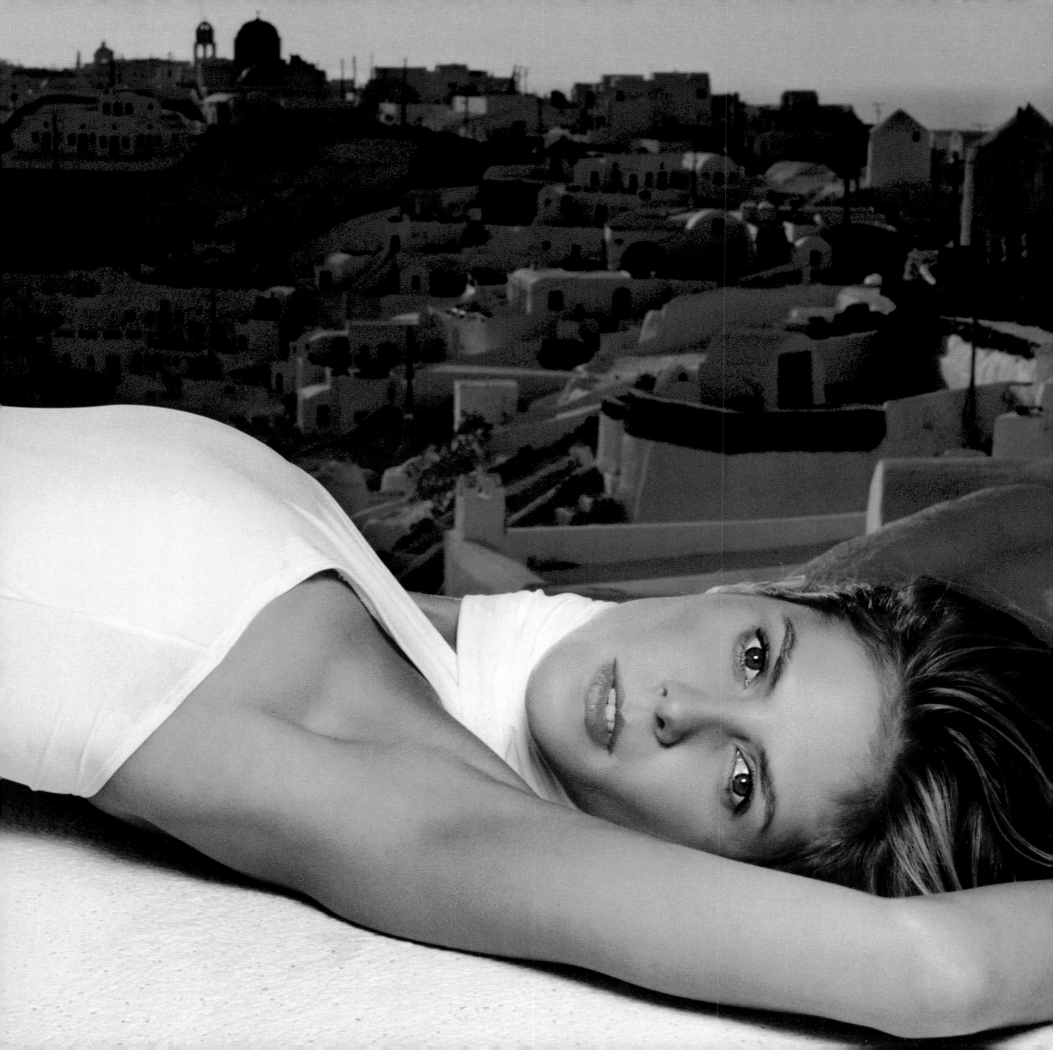

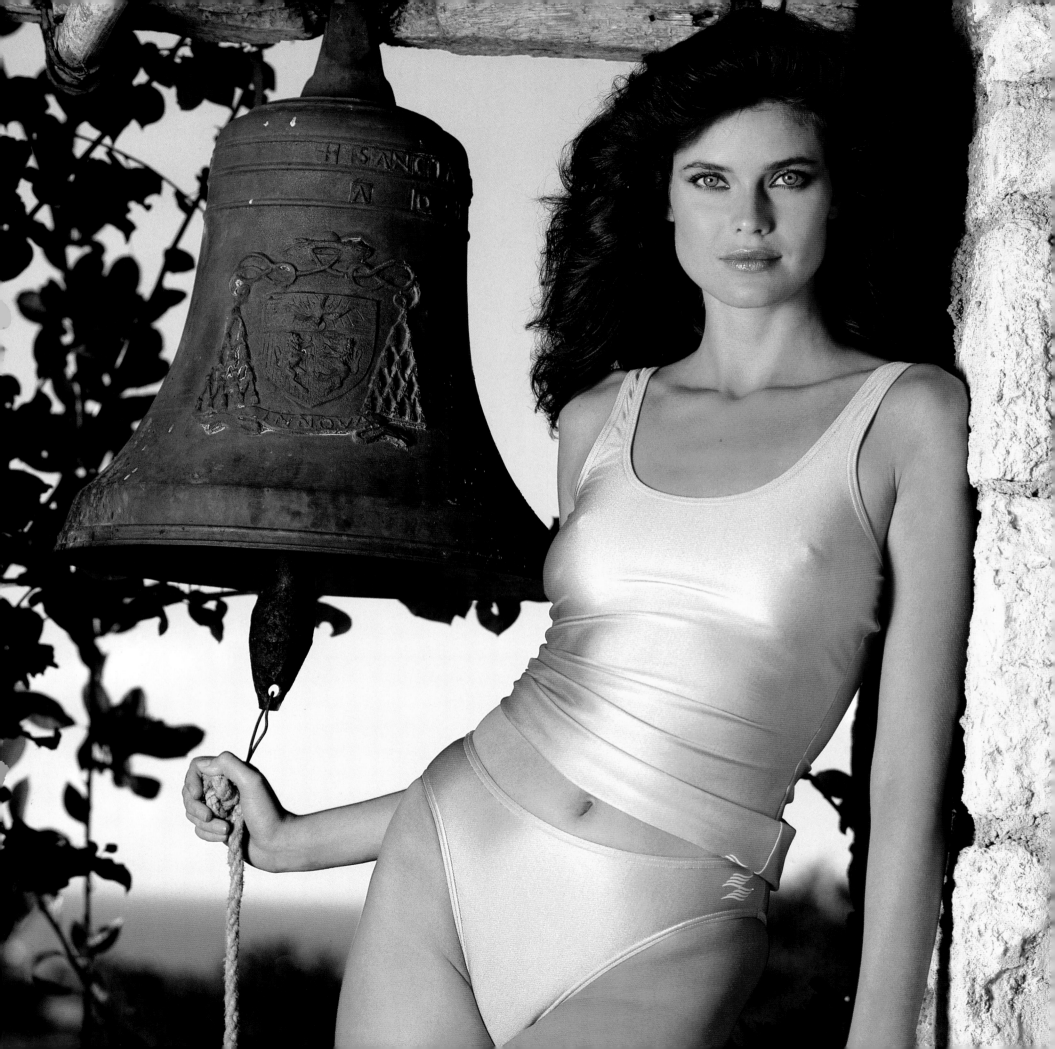

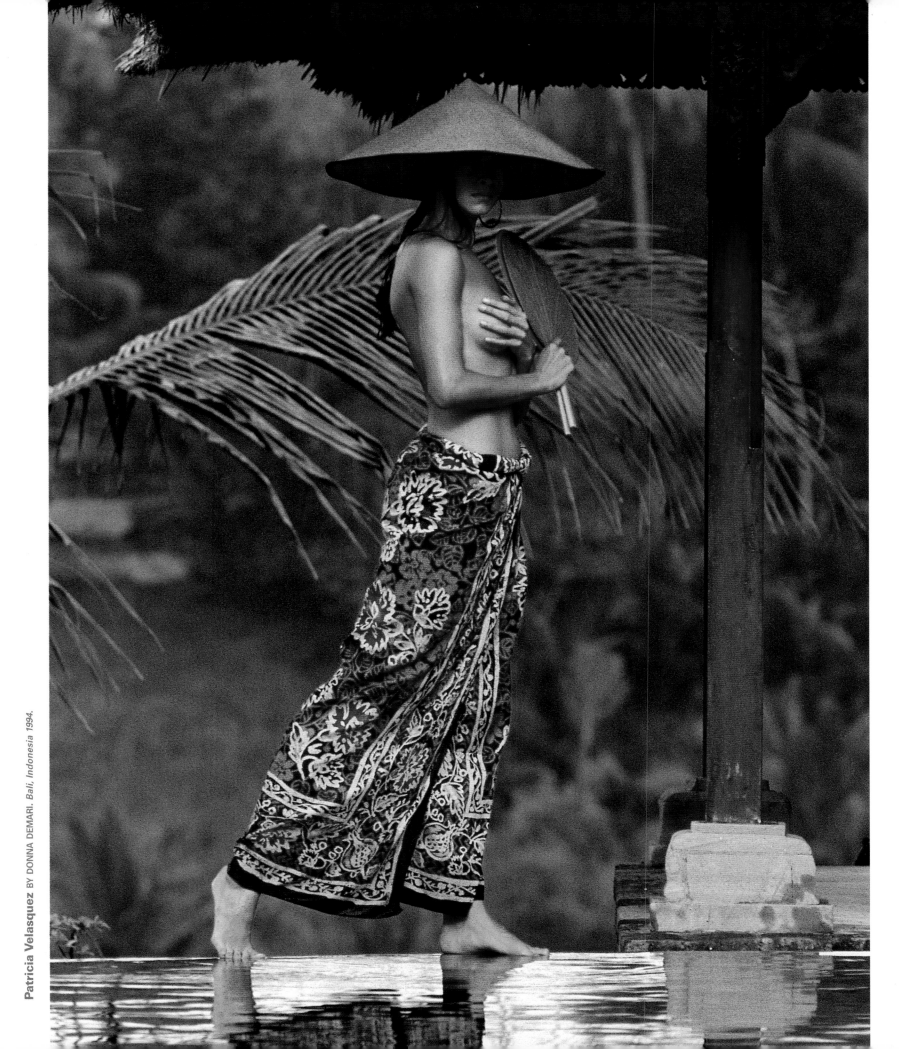

Patricia Velasquez BY DONNA DEMARI. *Bali, Indonesia 1994.*

Next pages: **Petra Nemcova** BY CHRISTOPHE JOUANY. *Italy 2001.* **Yvonne and Yvette Sylvander** BY KOURKEN PAKCHANIAN. *Baja California 1976.*

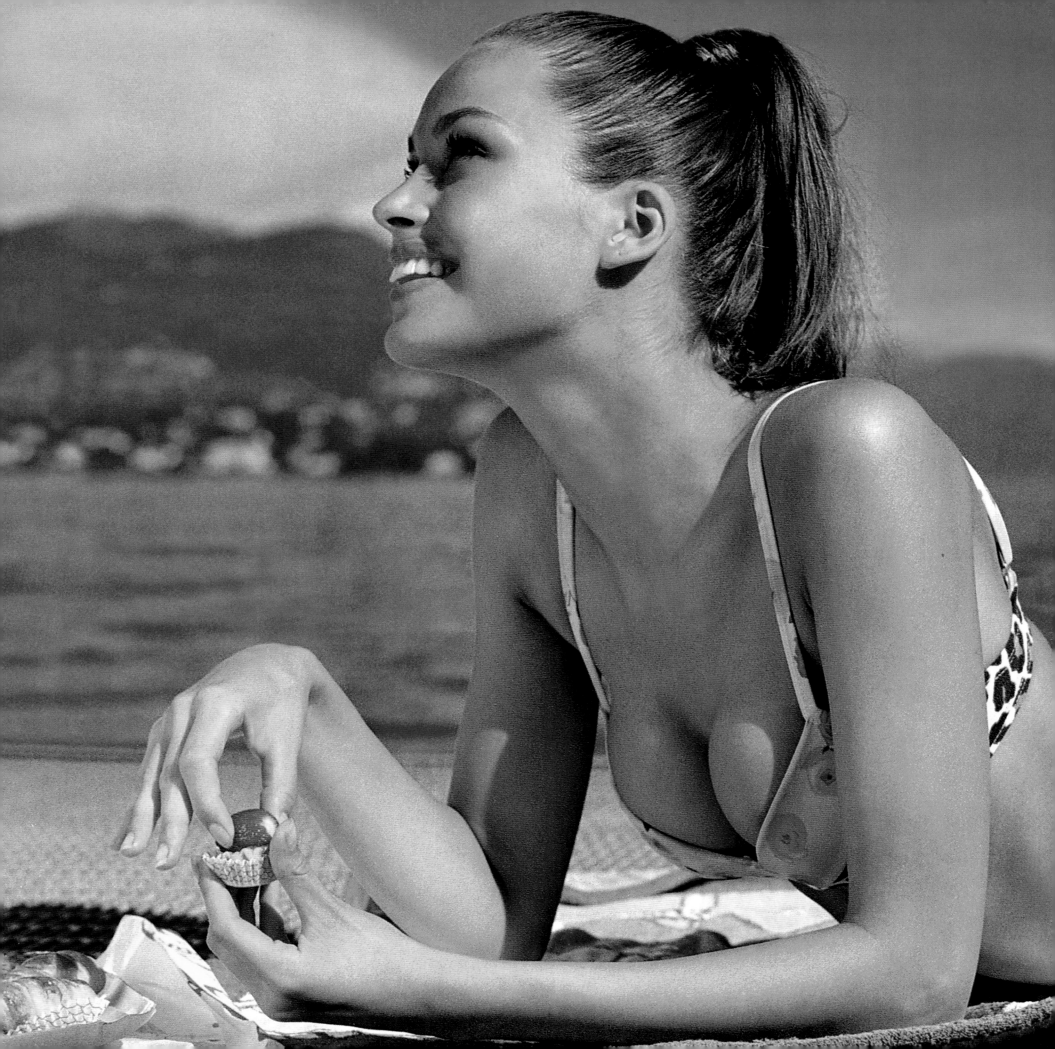

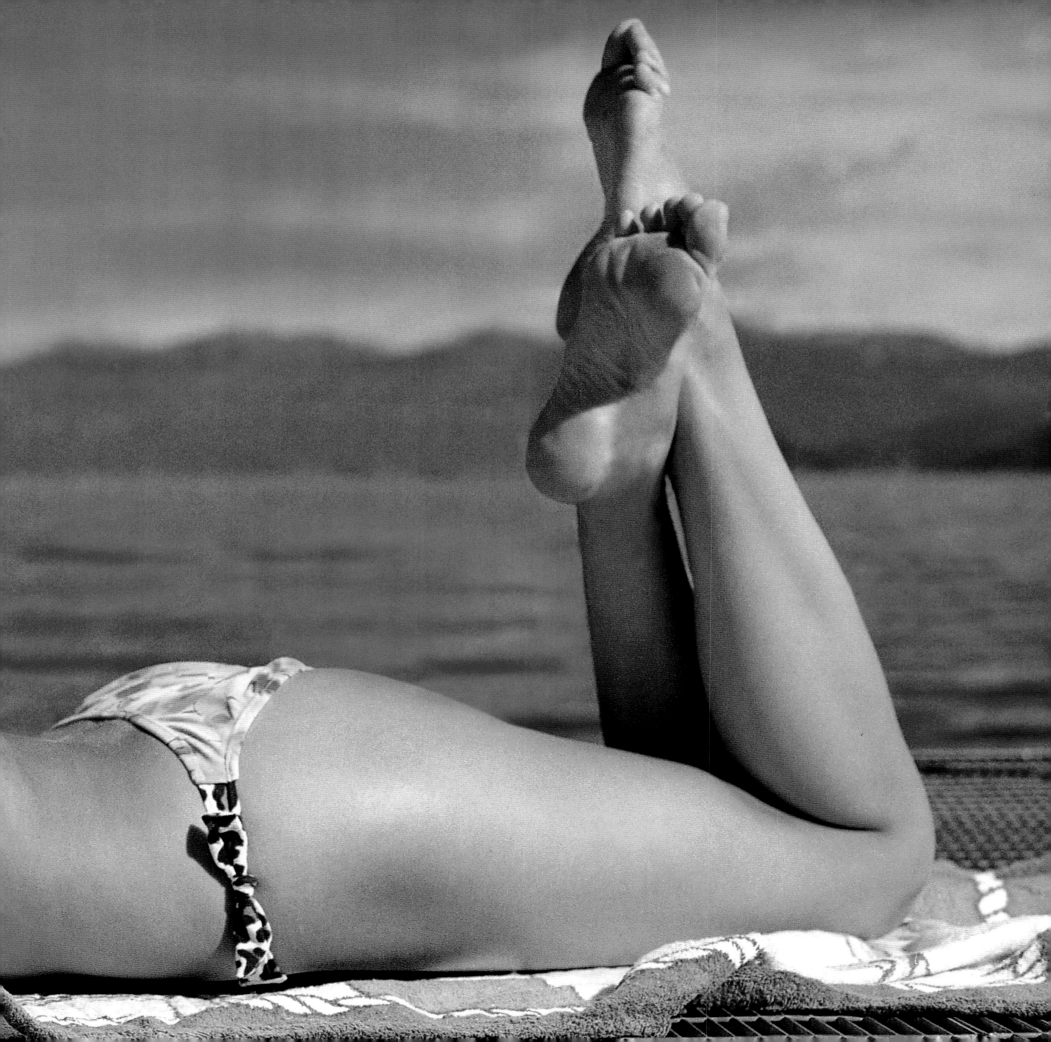

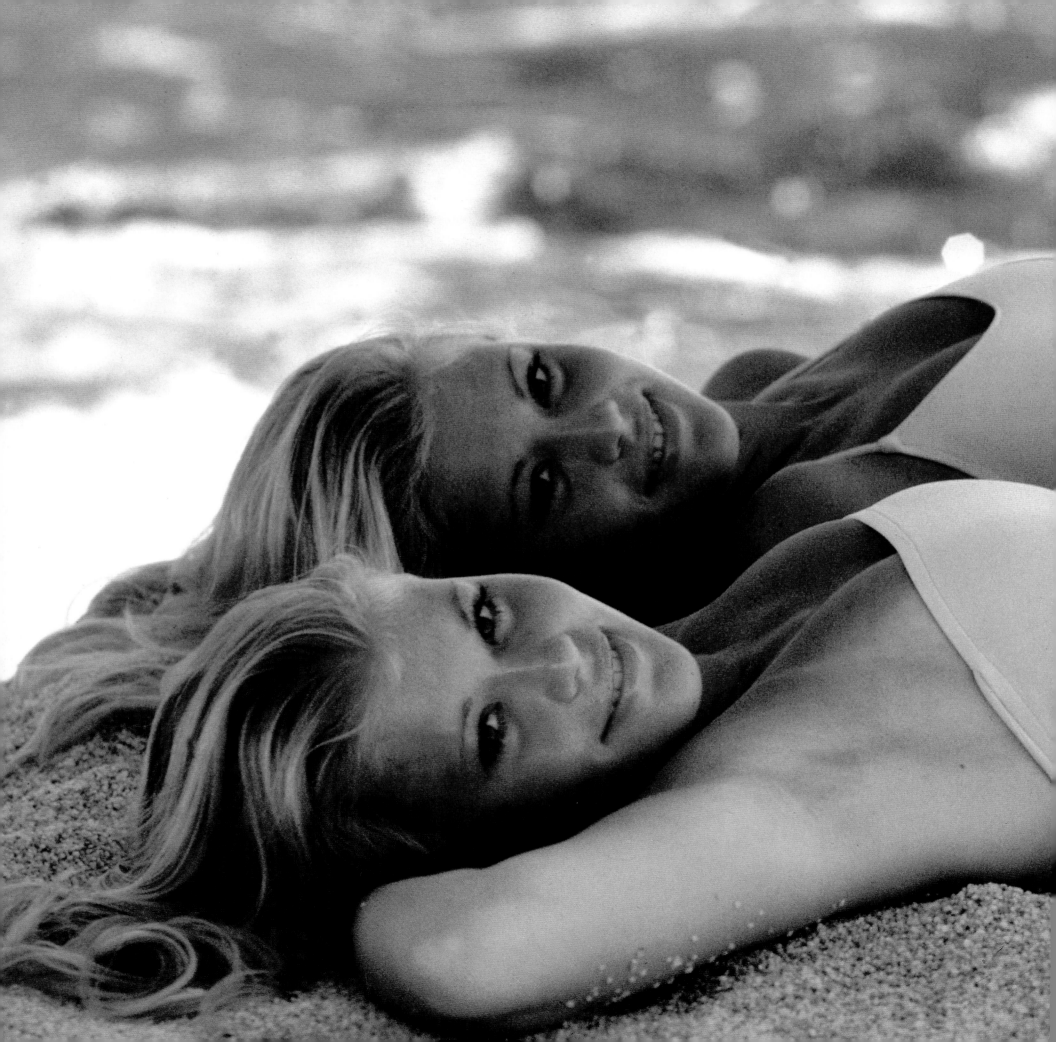

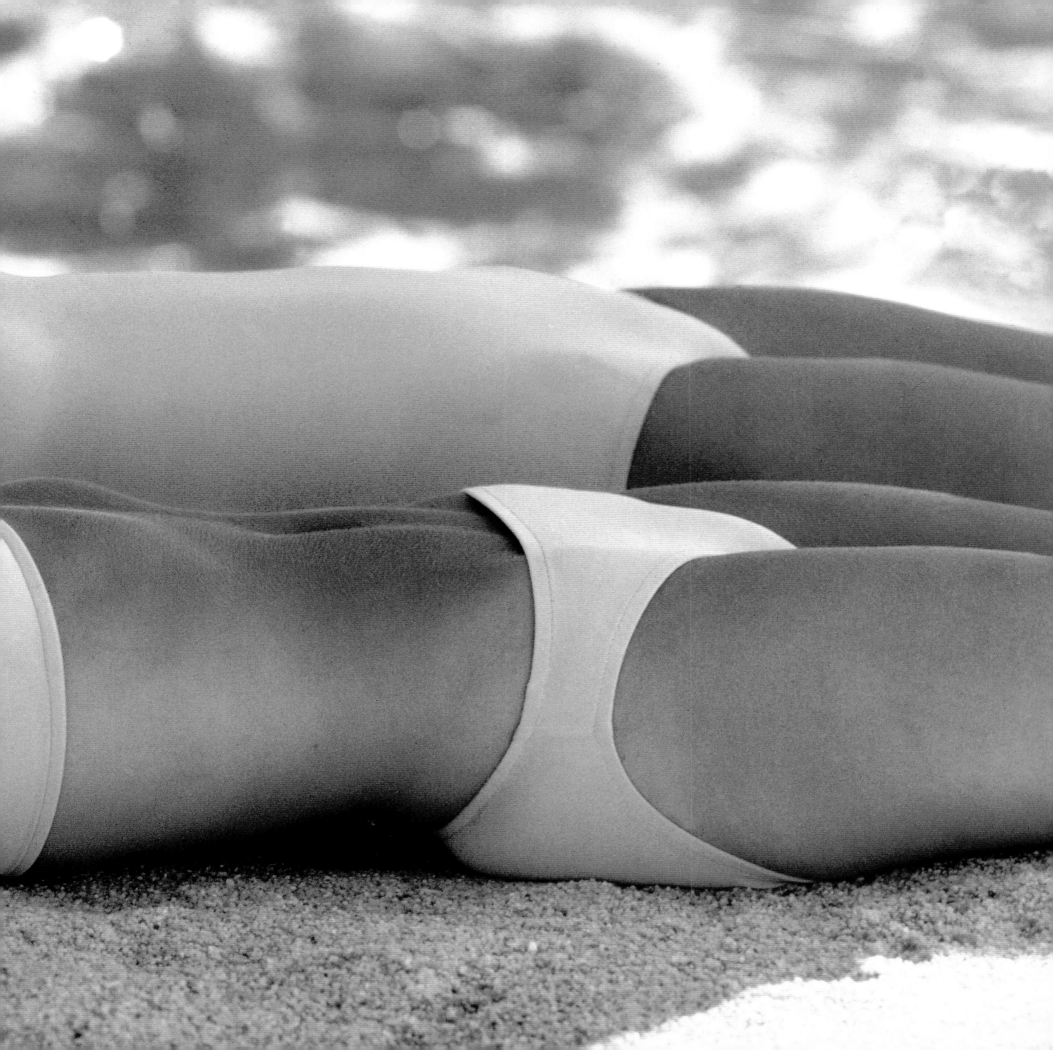

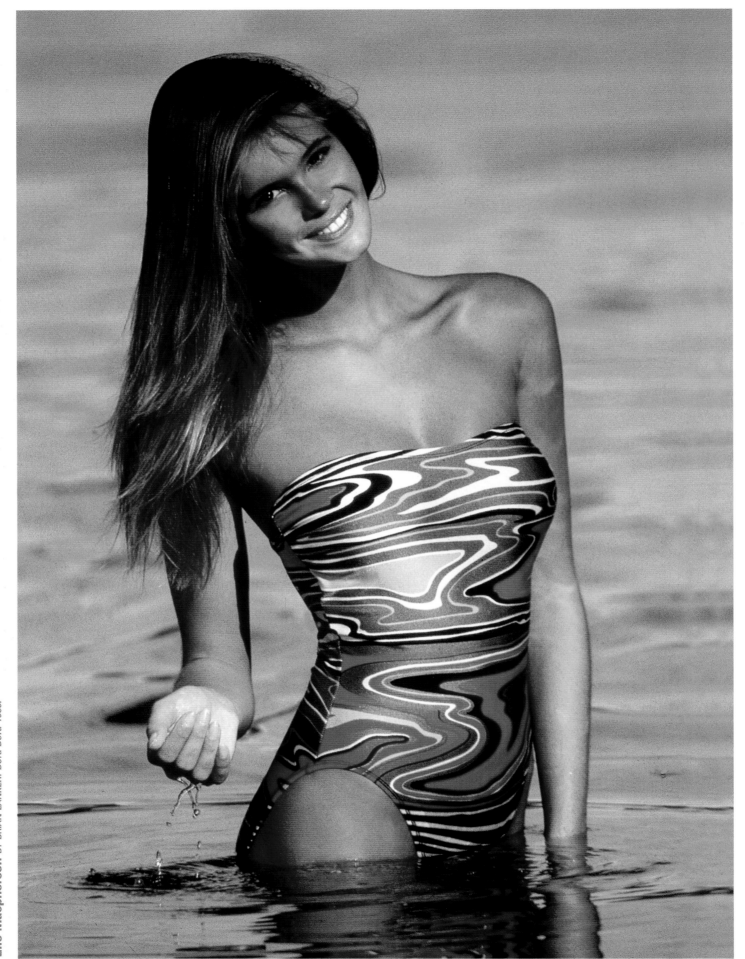

Elle Macpherson BY BRIAN LANKER. *Bora Bora 1986.*

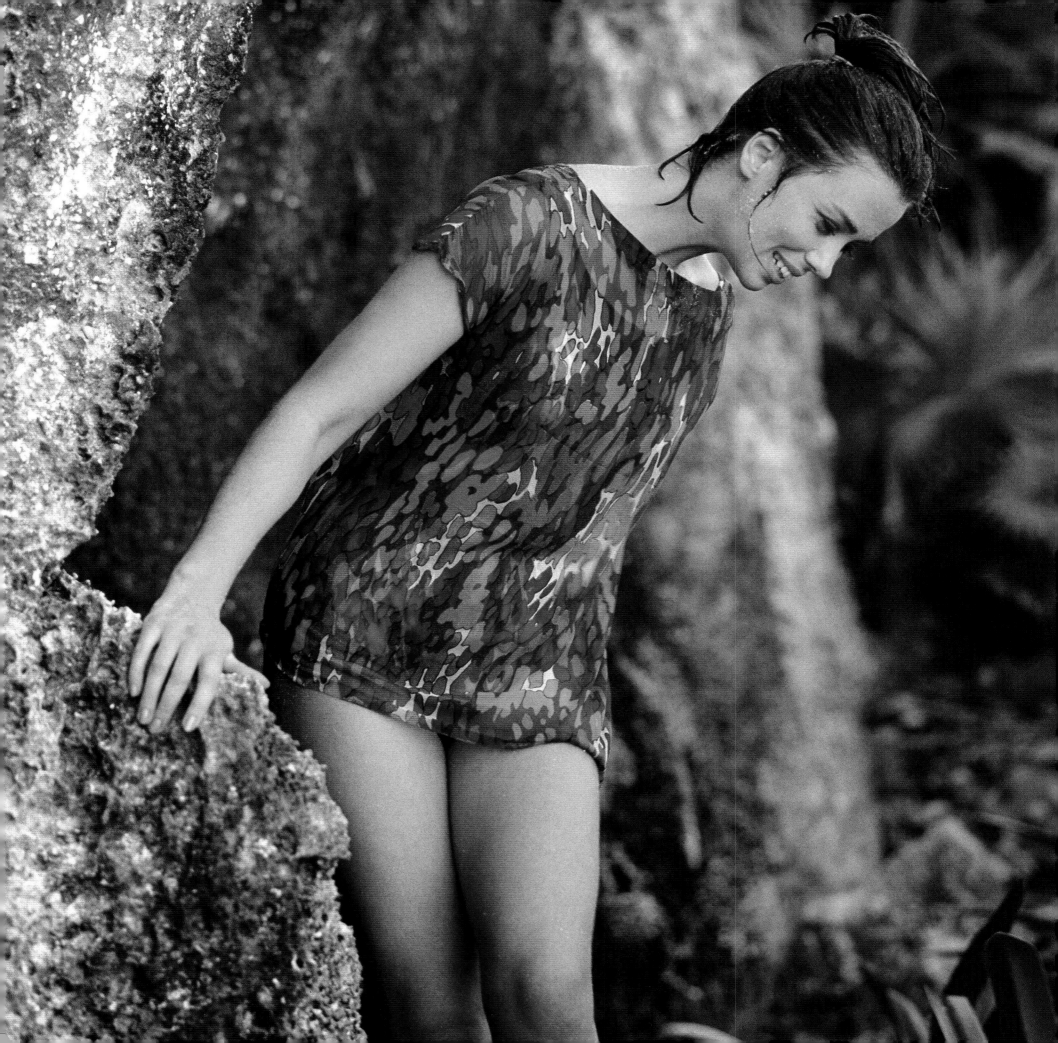

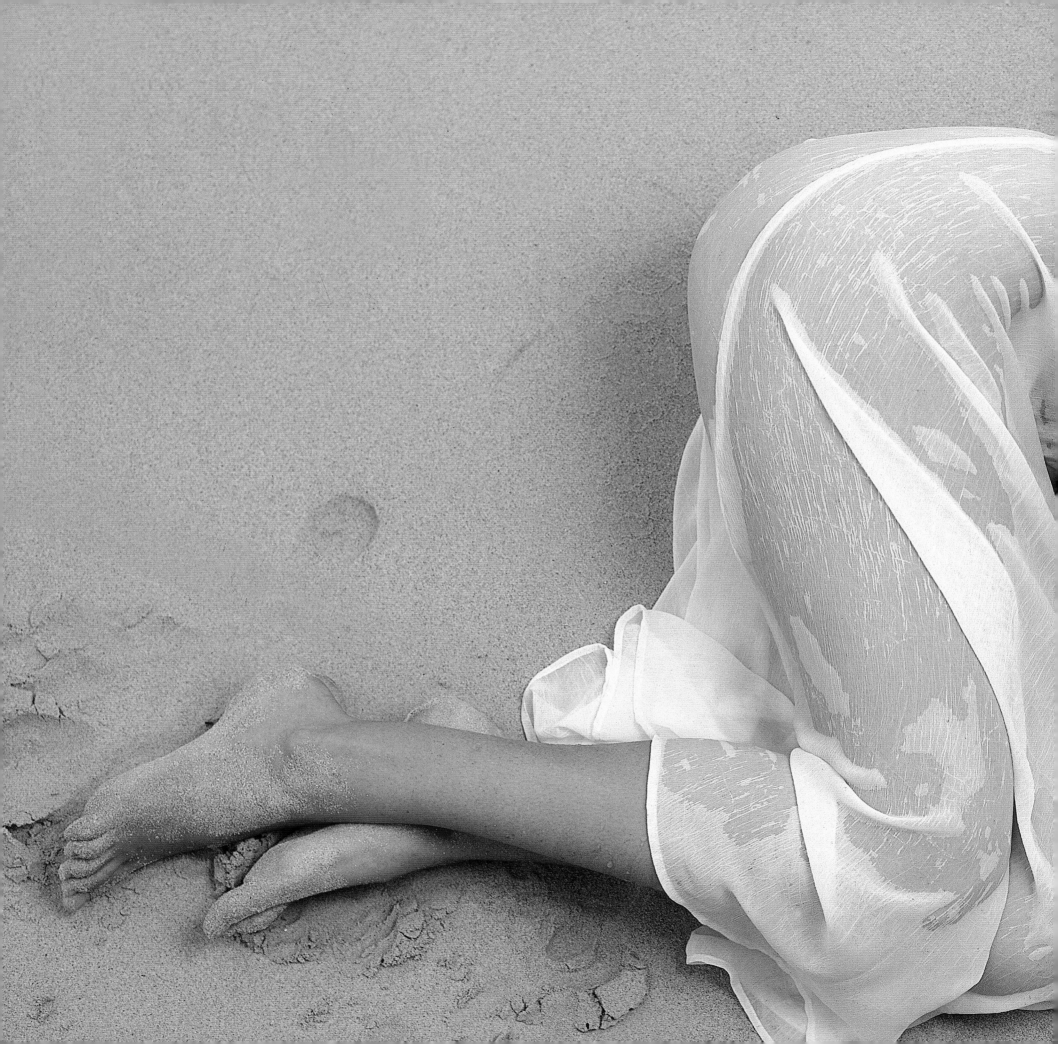

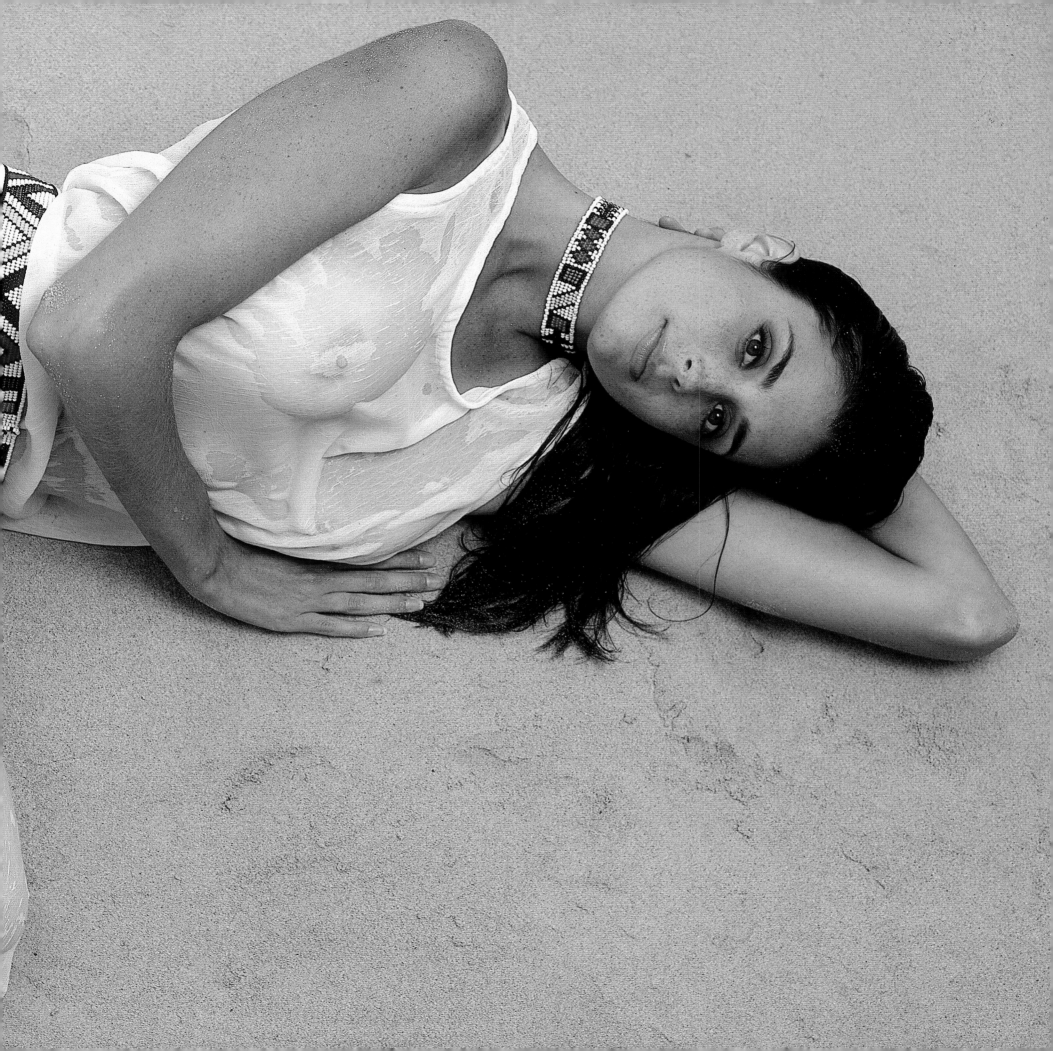

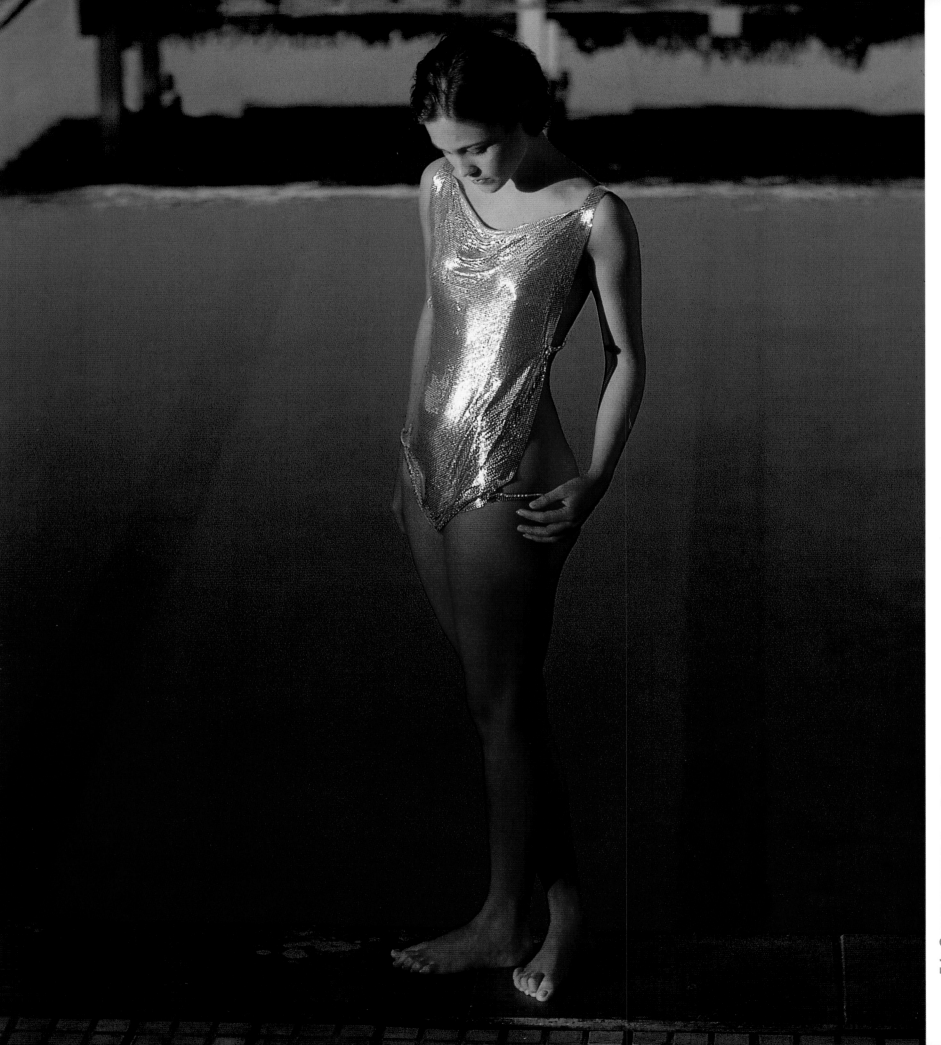

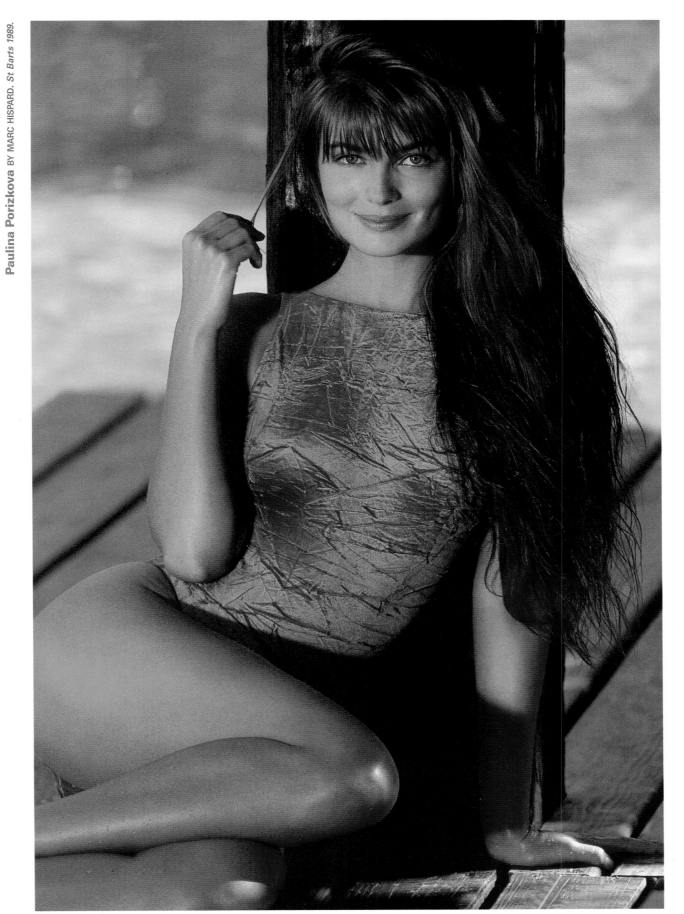

Paulina Porizkova BY MARC HISPARD. *St Barts 1989.*

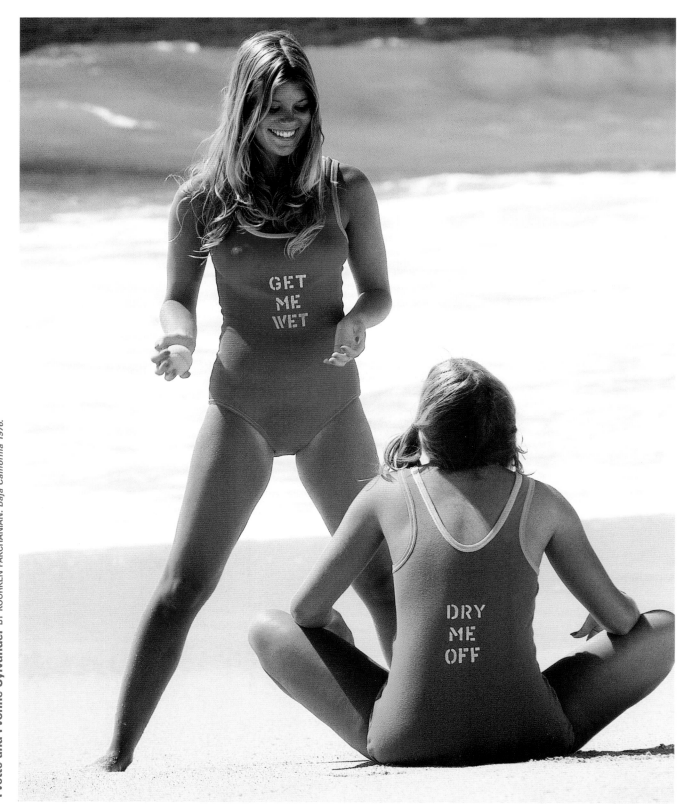

Yvette and Yvonne Sylvander BY KOURKEN PAKCHANIAN. *Baja California 1976.*

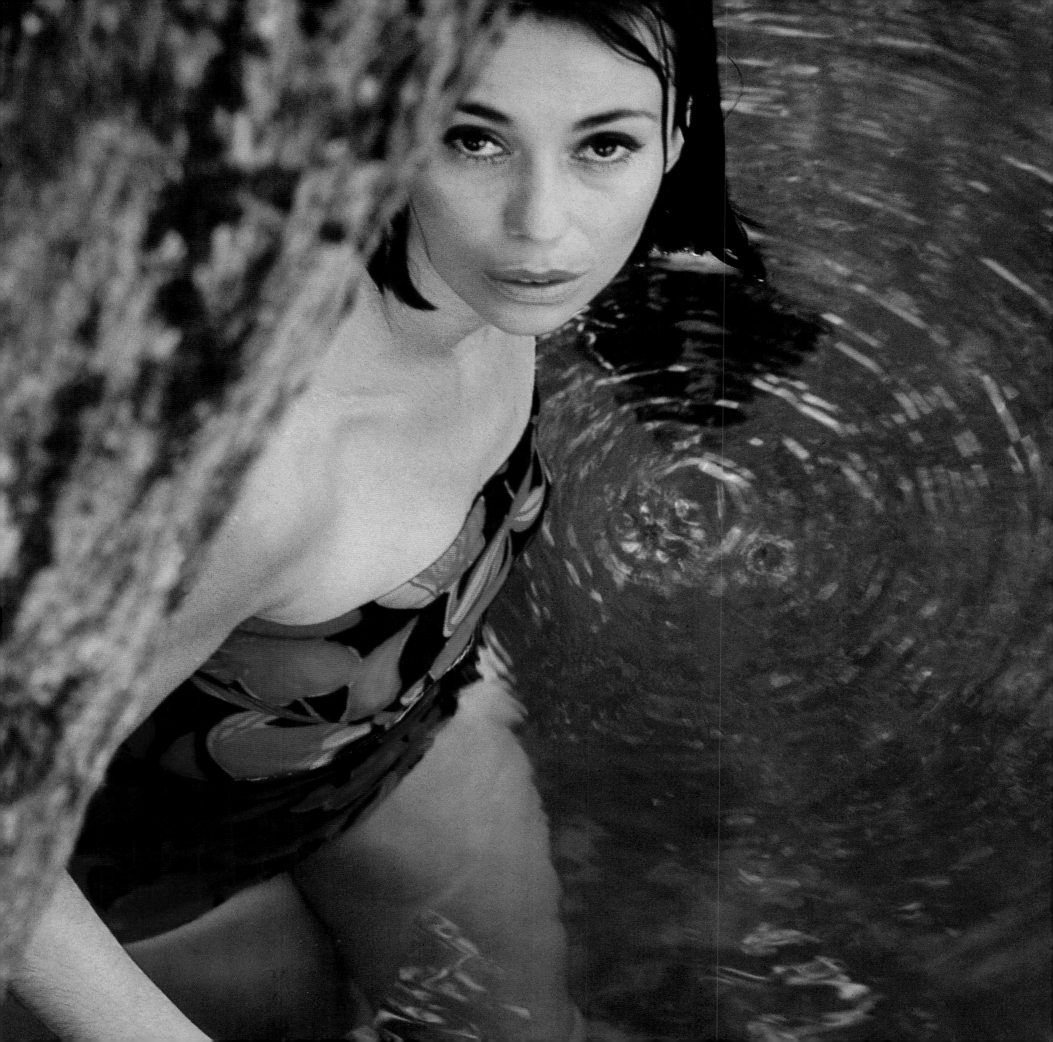

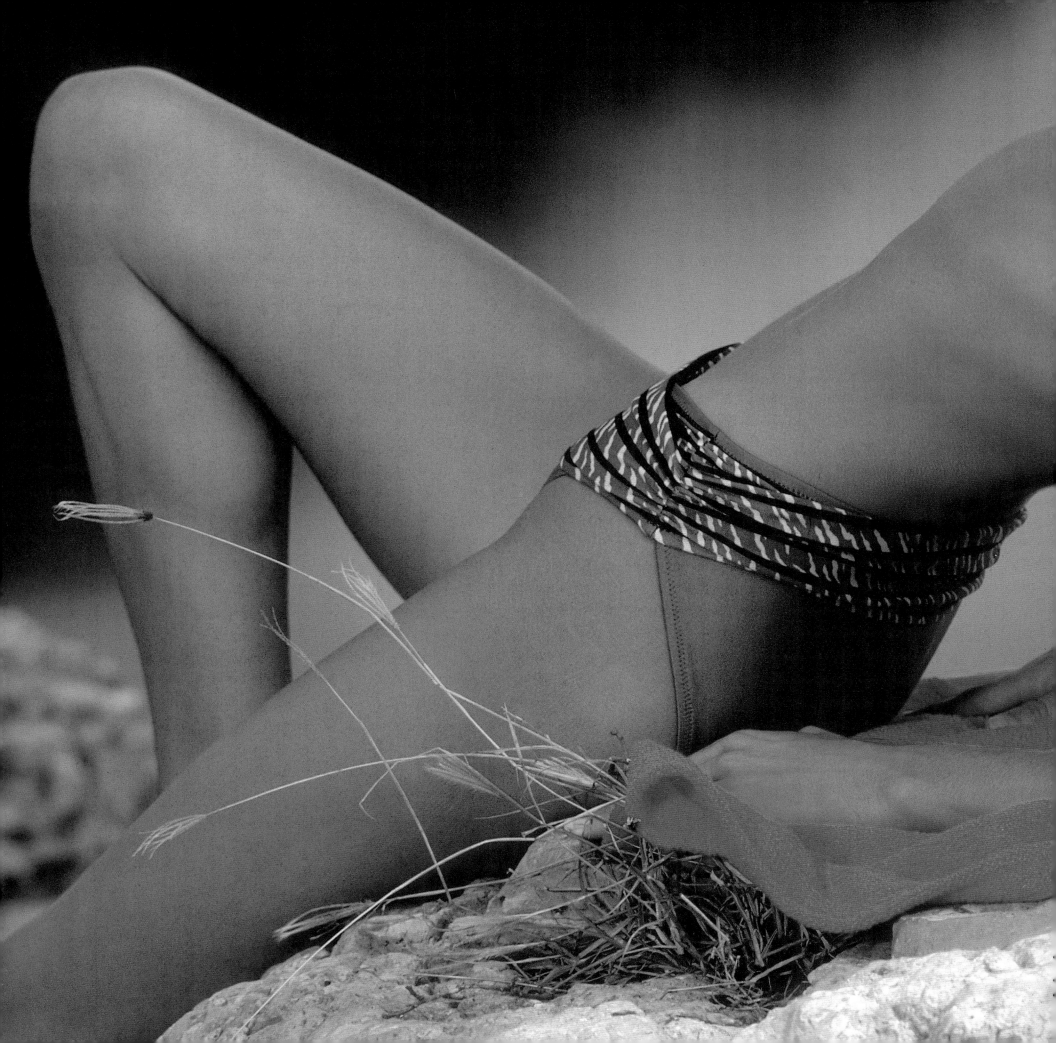

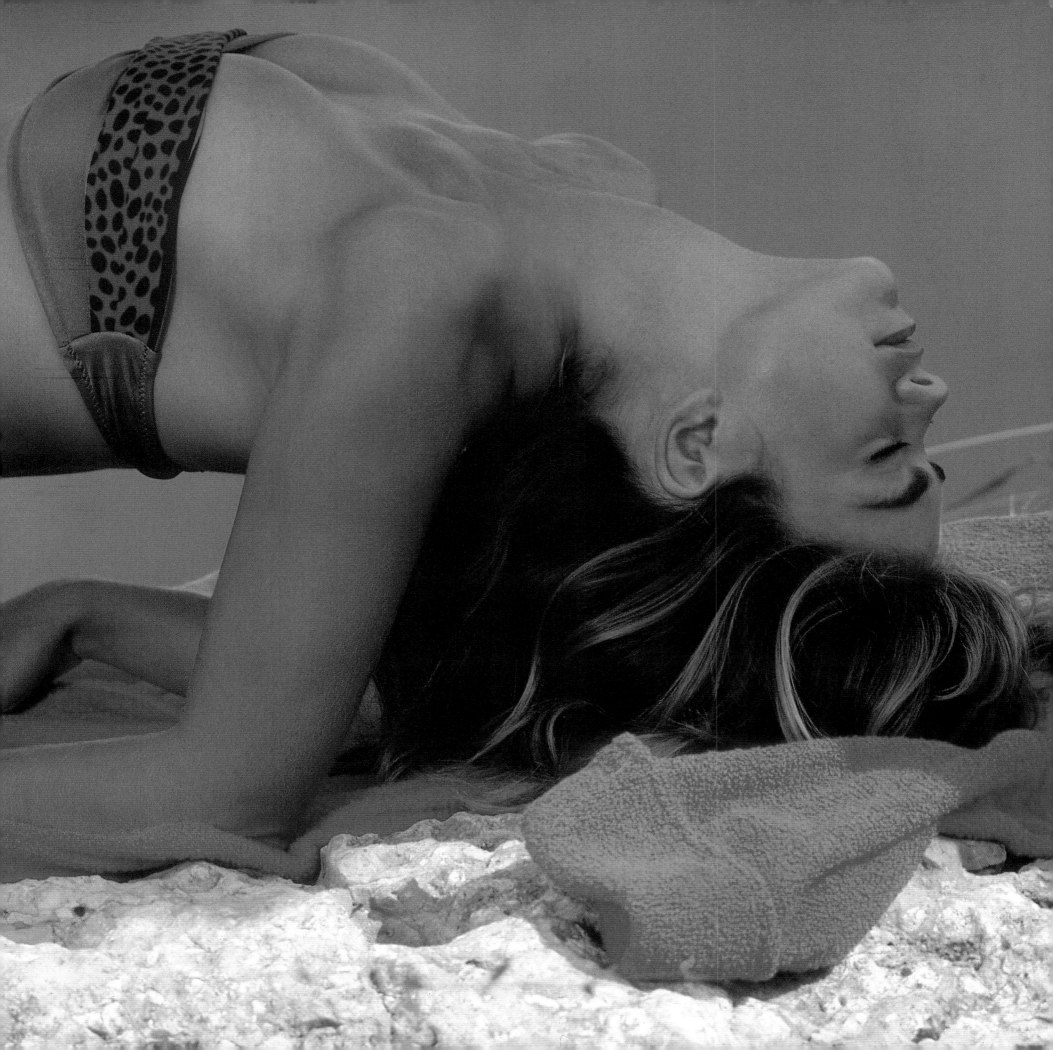

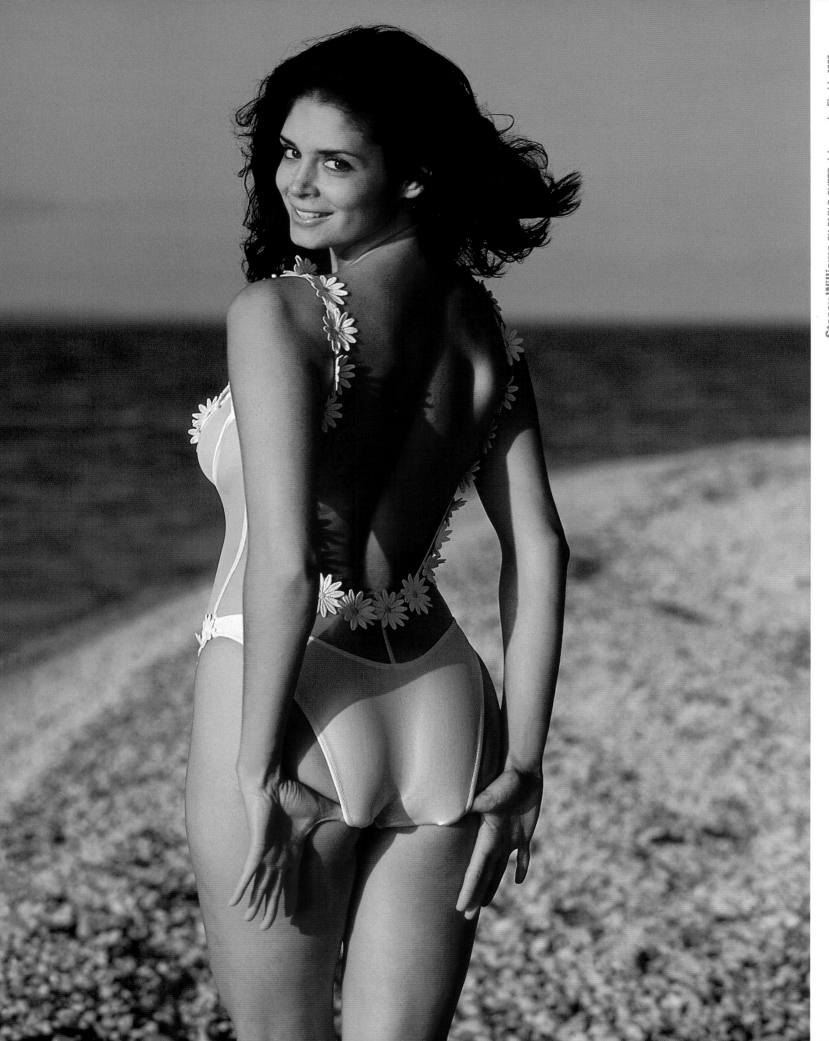

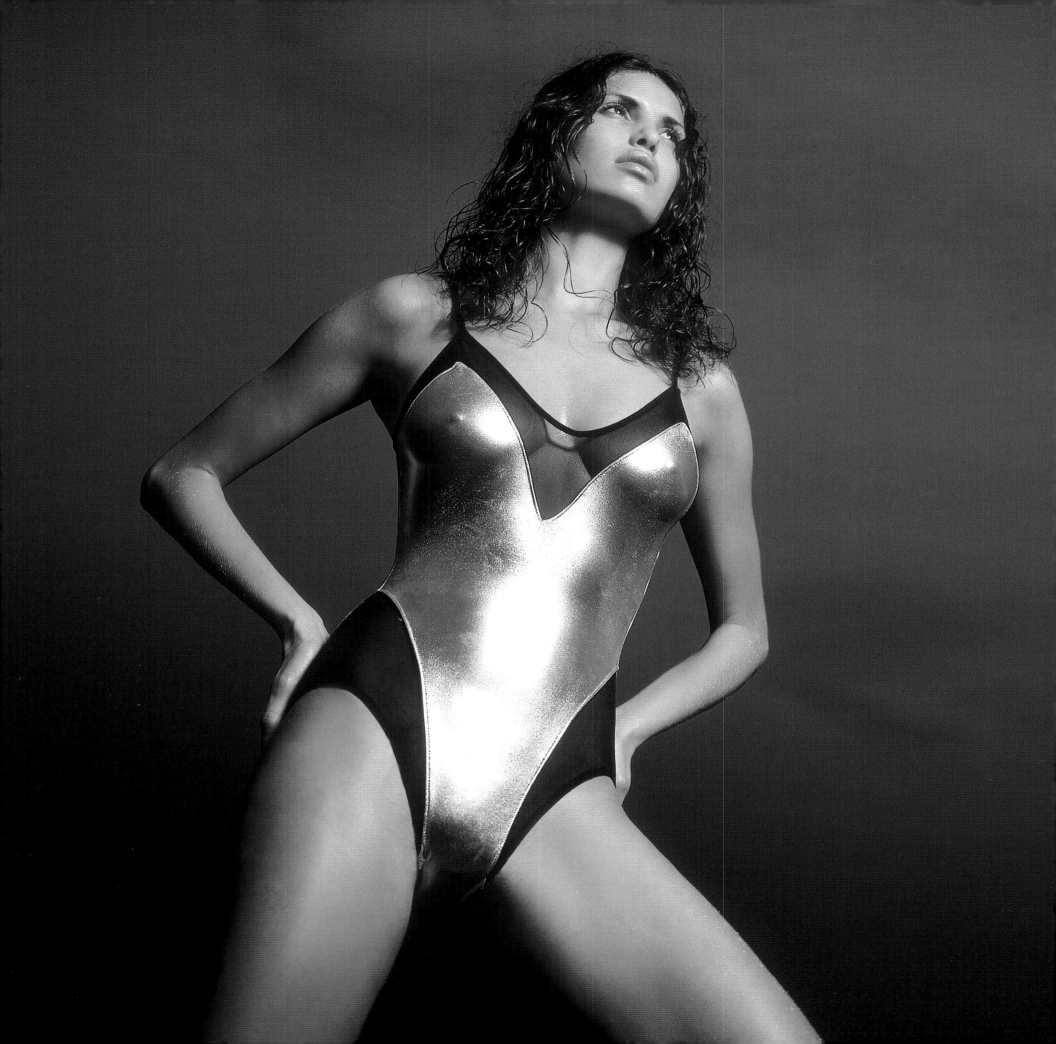

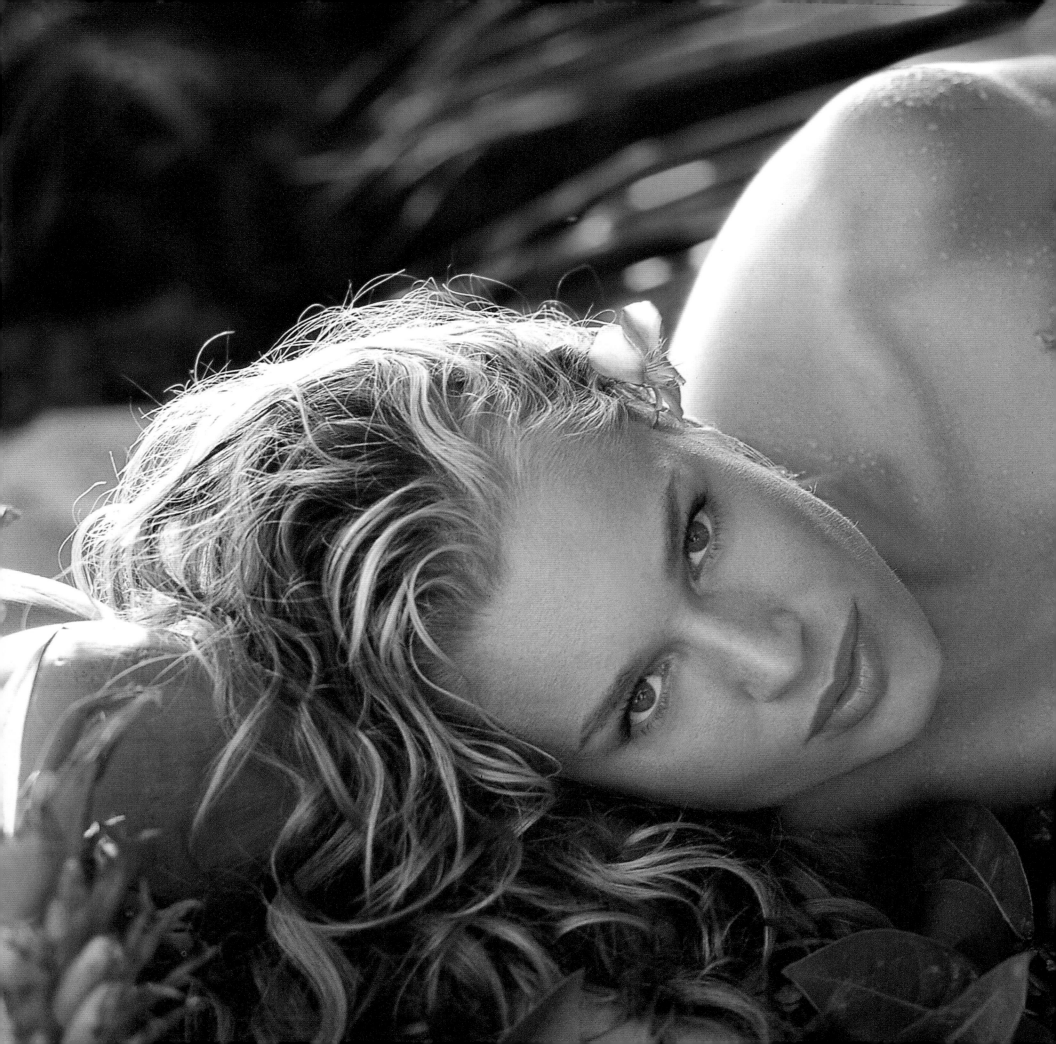

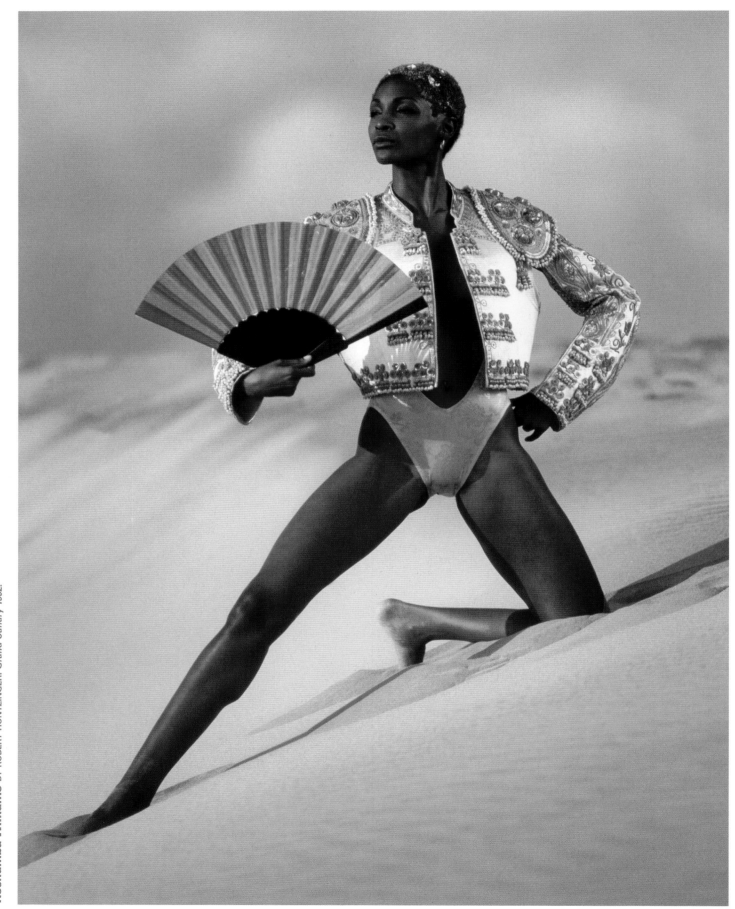

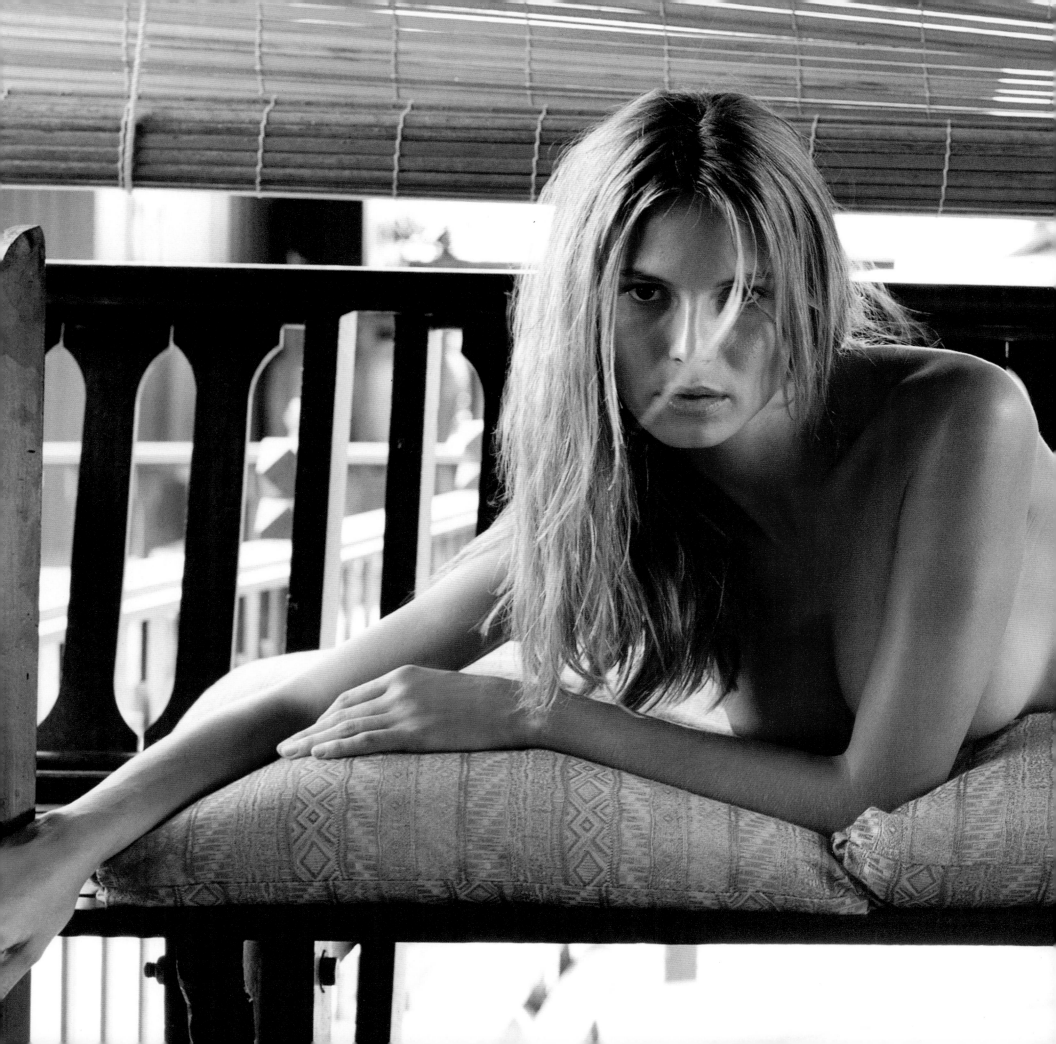

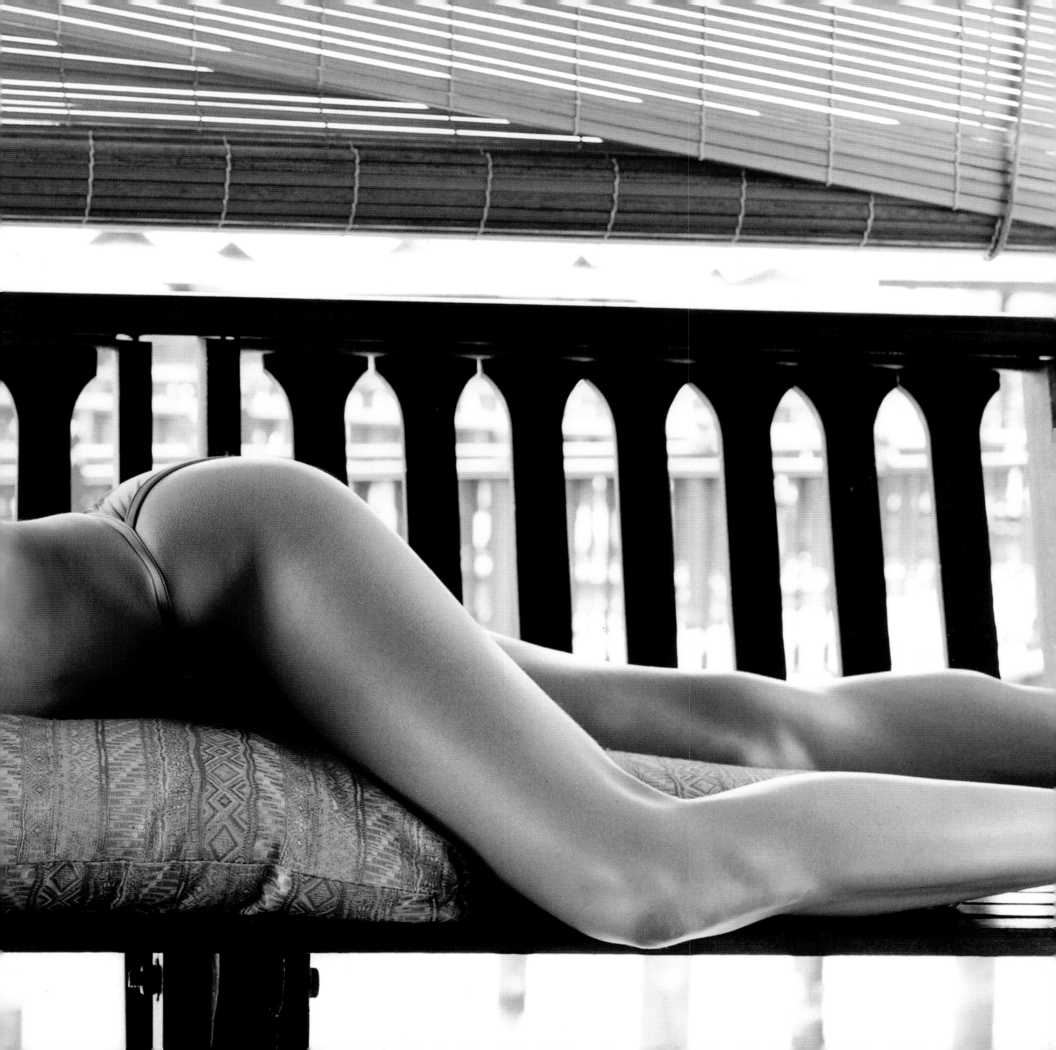

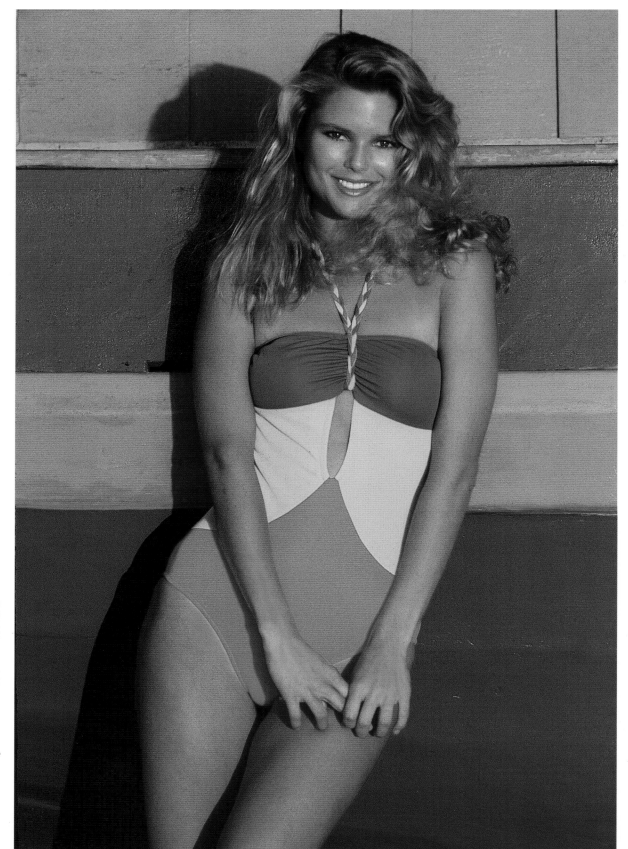

Christie Brinkley BY WALTER IOOSS JR. *Brazil 1978.*

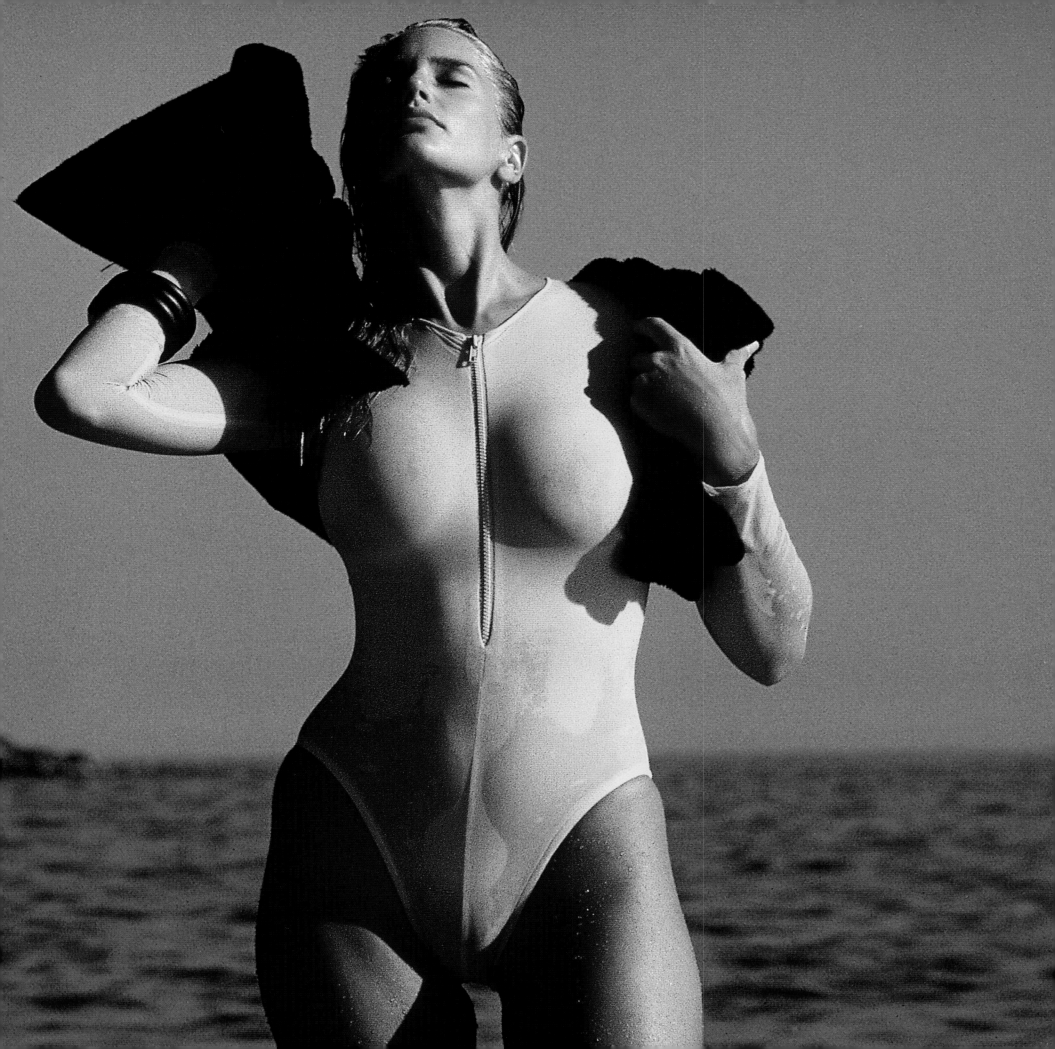

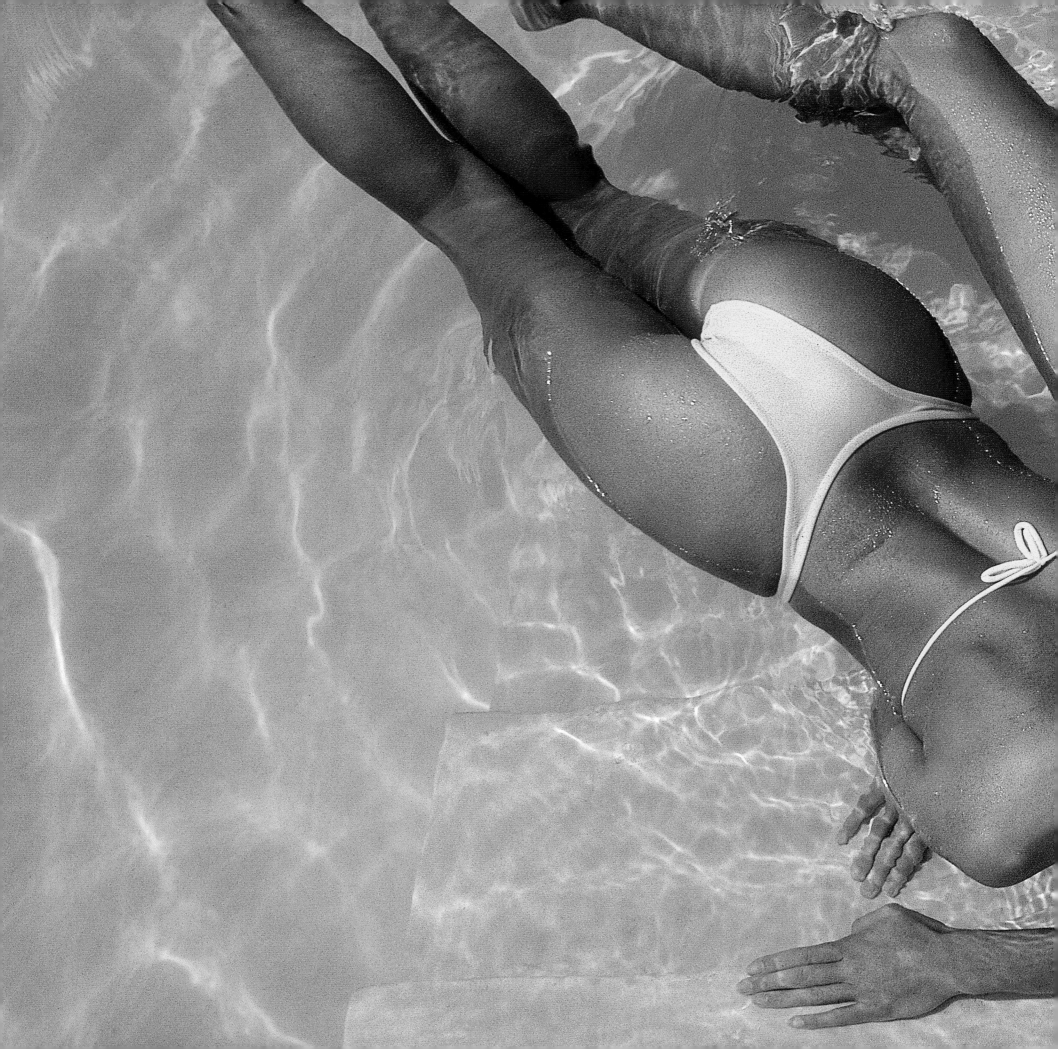

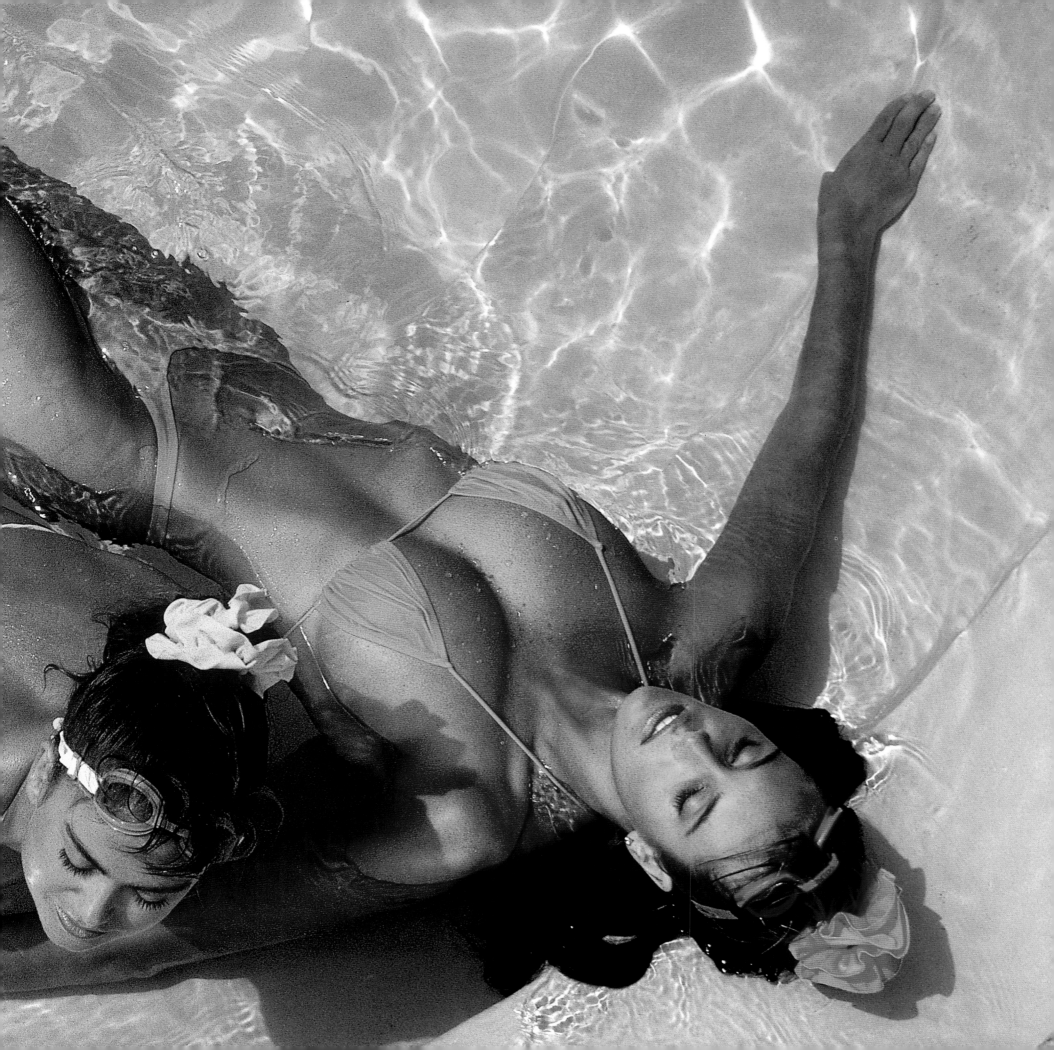

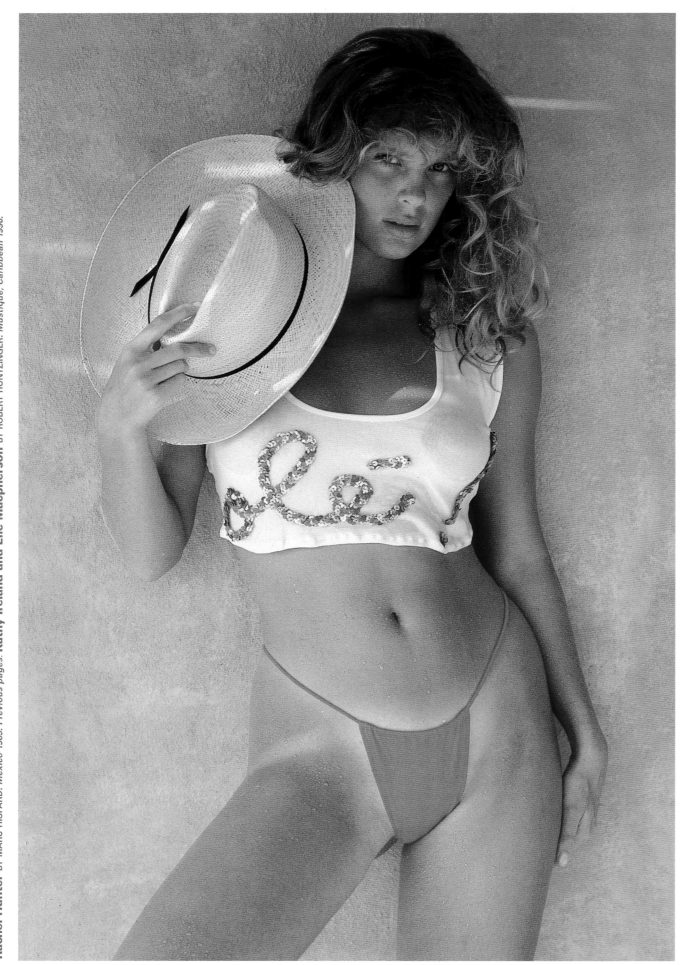

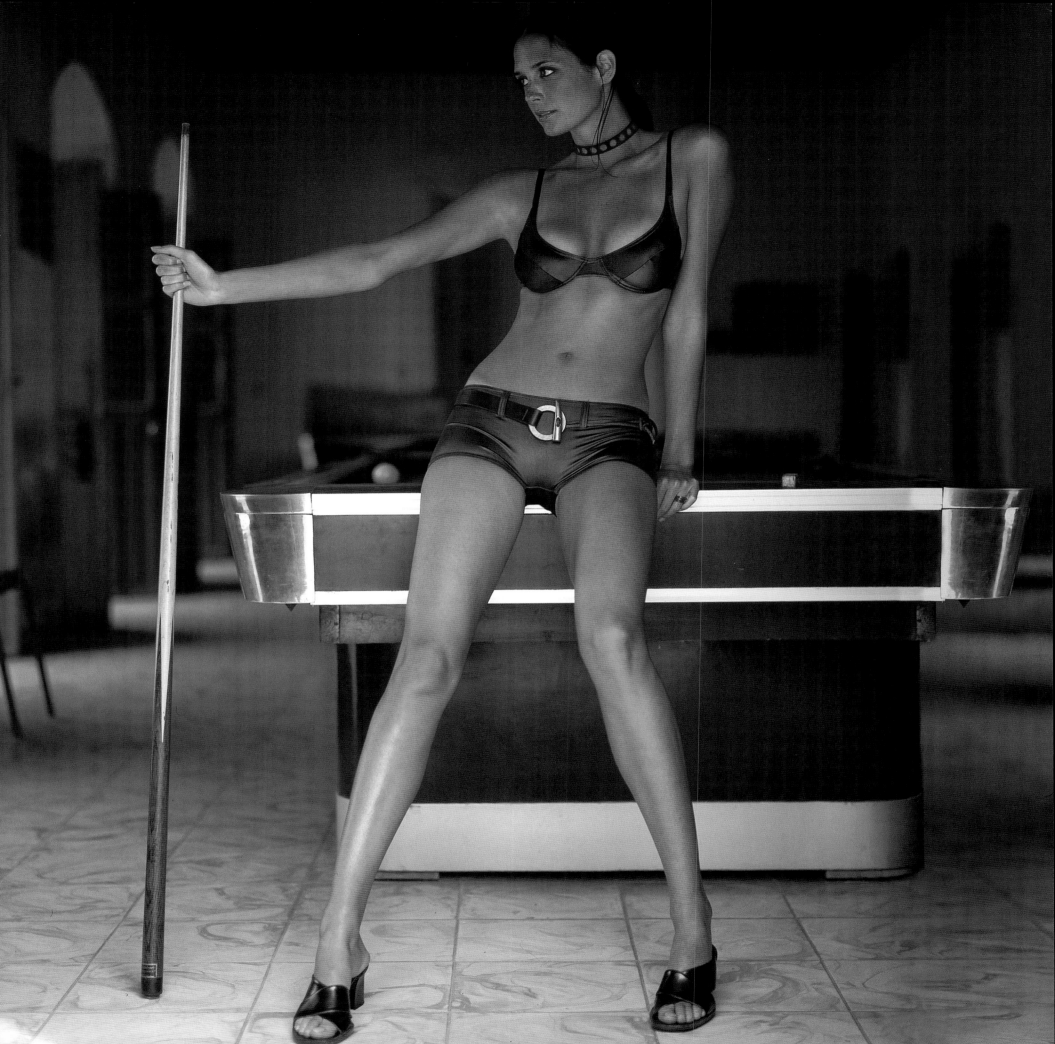

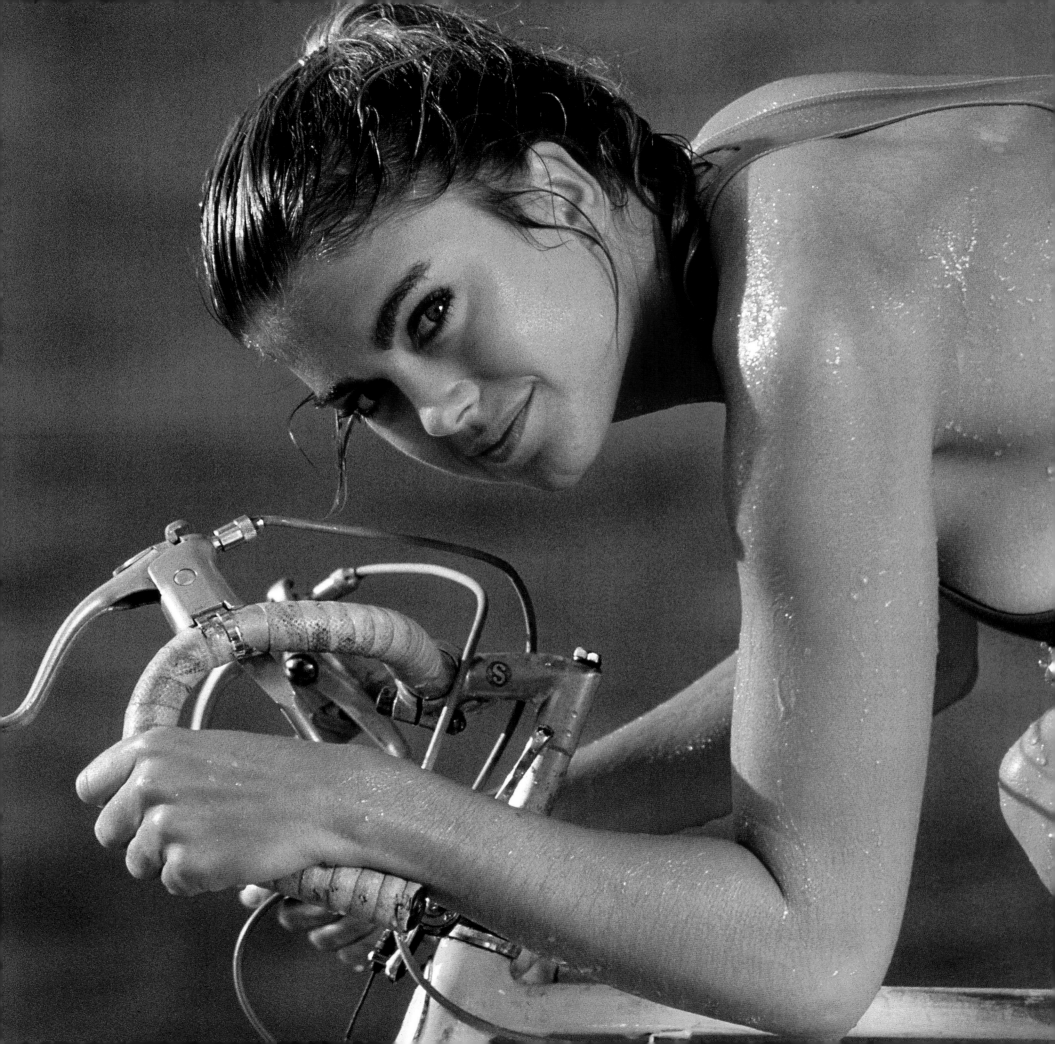

Plain women know
more about men than
beautiful ones do.
But beautiful women
don't need to know
about men. It's the men
who have to know
about beautiful women.

—KATHARINE HEPBURN

Sex appeal is 50% what you've got, and

> If women didn't exist,
> all the money in the world
> would have no meaning.
> —ARISTOTLE ONASSIS

> The first year with SI I was so chubby,
> and I dreaded doing bathing suits
> because they have no pockets. I didn't know
> what to do with my hands, so I was
> constantly squirming...and all I was doing
> was trying to find a place to stick my hands.
> —CHRISTIE BRINKLEY

0% what people think you've got. —SOPHIA LOREN

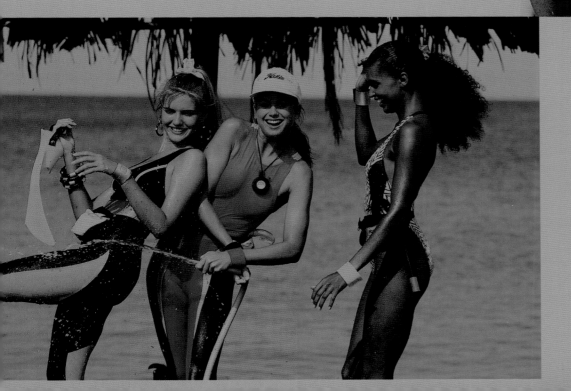

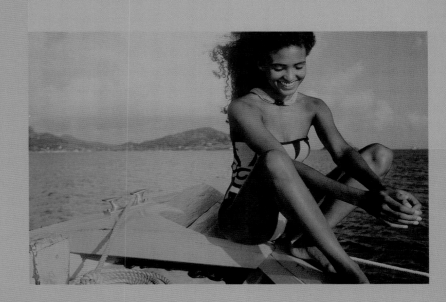

It is bust and thigh. But it is bust and thigh wit

Sir: We are students at St. Anselm's College.
Our patron, St. Anselm, was most notable for
originating the ontological argument
for the existence of God. After reading your
annual bathing-suit issue, we believe.
—MICHAEL SHEEHAN
DON DONOVAN
CHARLIE GILMORE
DAN DELANEY, *Manchester, N.H., 1981*

There is certainly no absolute
standard of beauty.
That precisely is what makes
its pursuit so interesting.
—JOHN KENNETH GALBRAITH

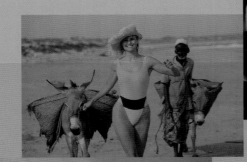

It caught me by surprise when Heidi
bit my ear, but I didn't mind
when I remembered that the last time
someone did that I got $35 million.
—EVANDER HOLYFIELD

Wheaties twist. —MARY ANN HOGAN, The Oakland Tribune, *on the SI swimsuit issue*

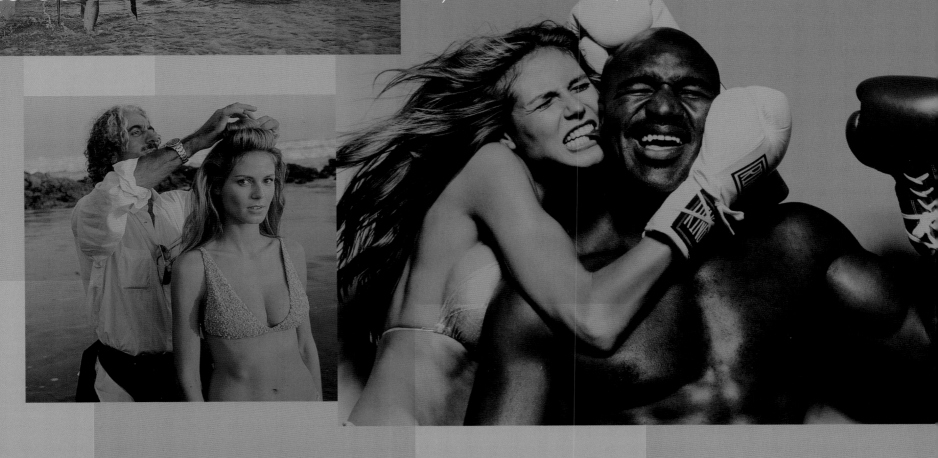

Nudity is boring. The swimsuit issue is far more sensual. I'd rather have one copy of that issue than a thousand issues of the magazine I publish.
—AL GOLDSTEIN
publisher of Screw *magazine*

Males cannot look at breasts

I guess it was sexy,... in a pretty sort of way. But I never thought there would be such a reaction. My breasts didn't even show through when the suit was dry. But then I got soaked in there with the iguanas and...
—CHERYL TIEGS

...nd think at the same time. —DAVE BARRY

When I leave the swimsuit shoot I'm going to get
back to New York and I'm going to wash off
all the cockroaches and scorpions and mud out
of my suitcases. I'm going to take
a long hot shower and call my mommy.
—STACEY WILLIAMS

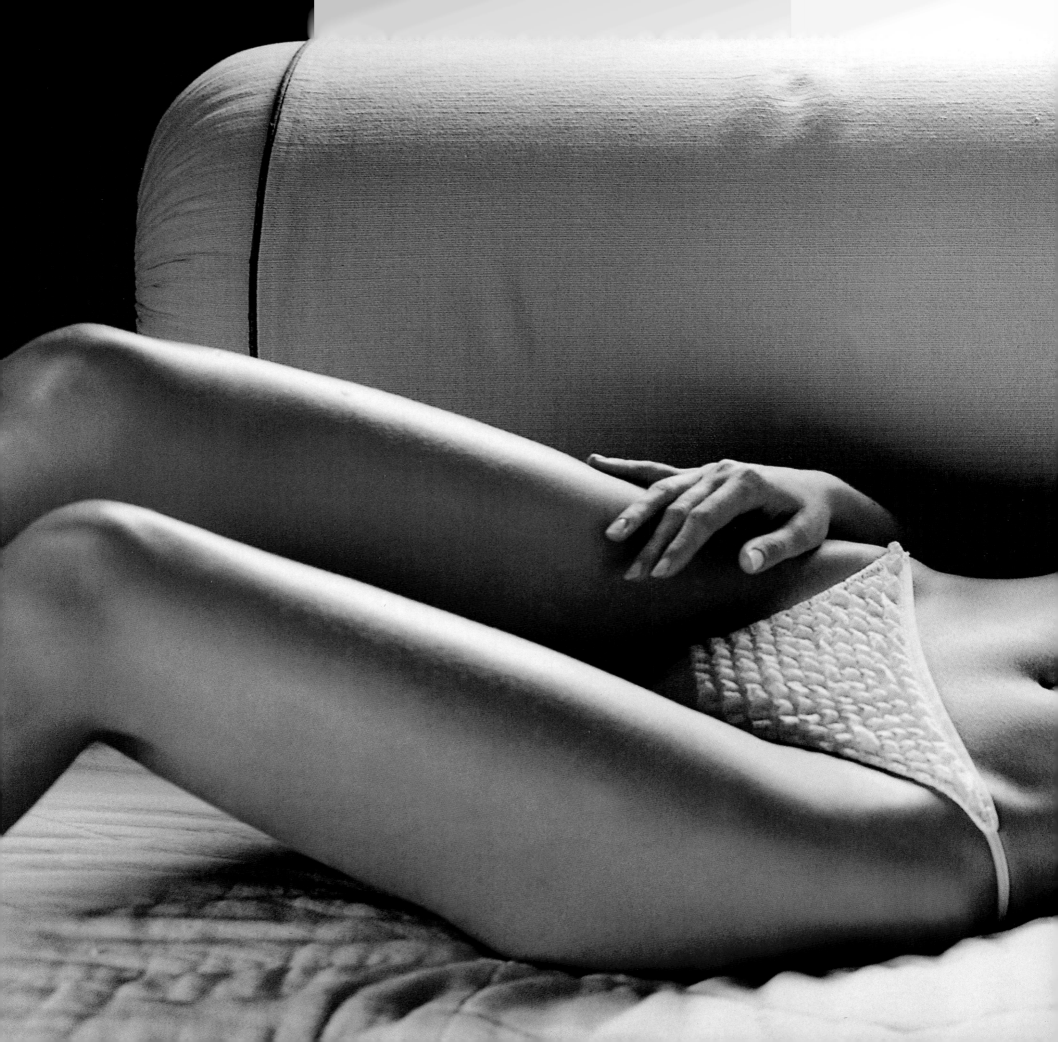

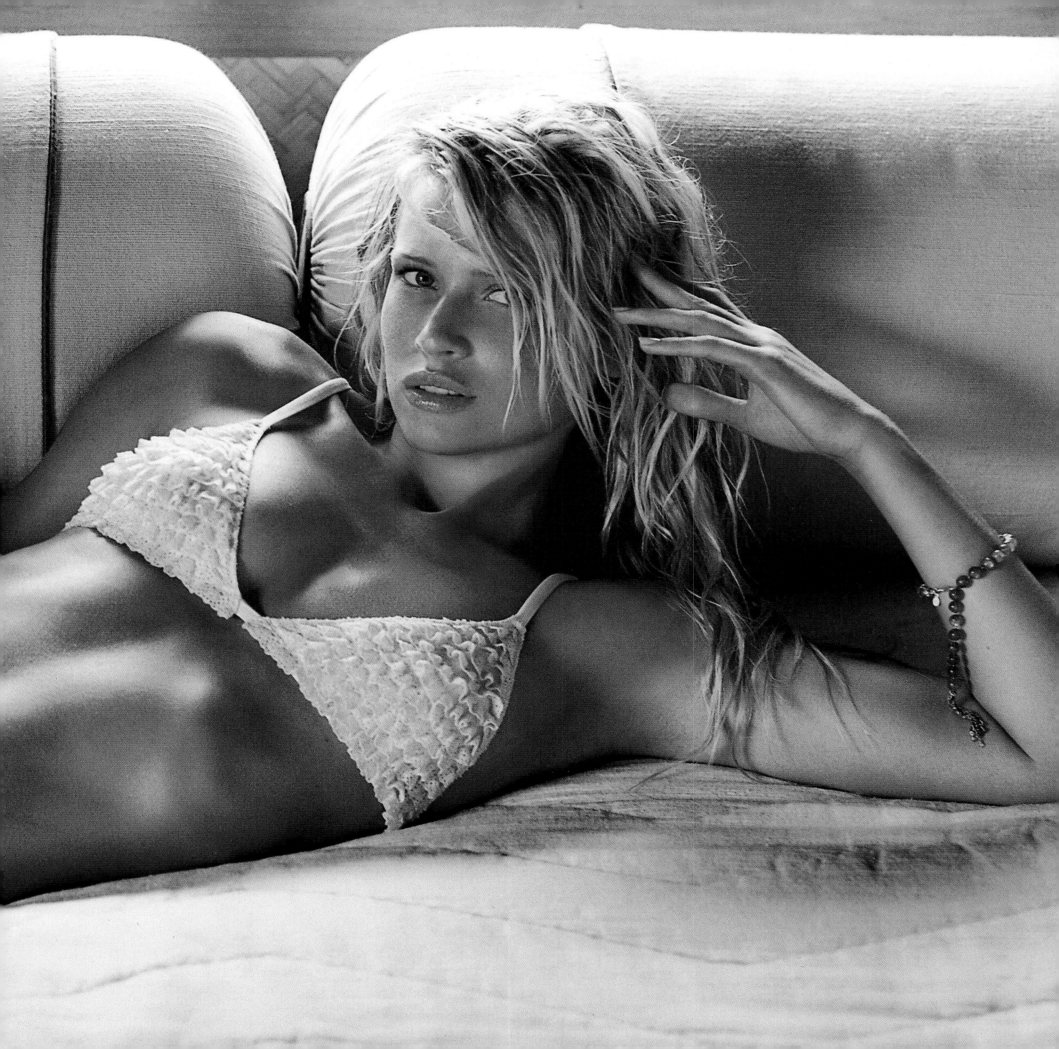

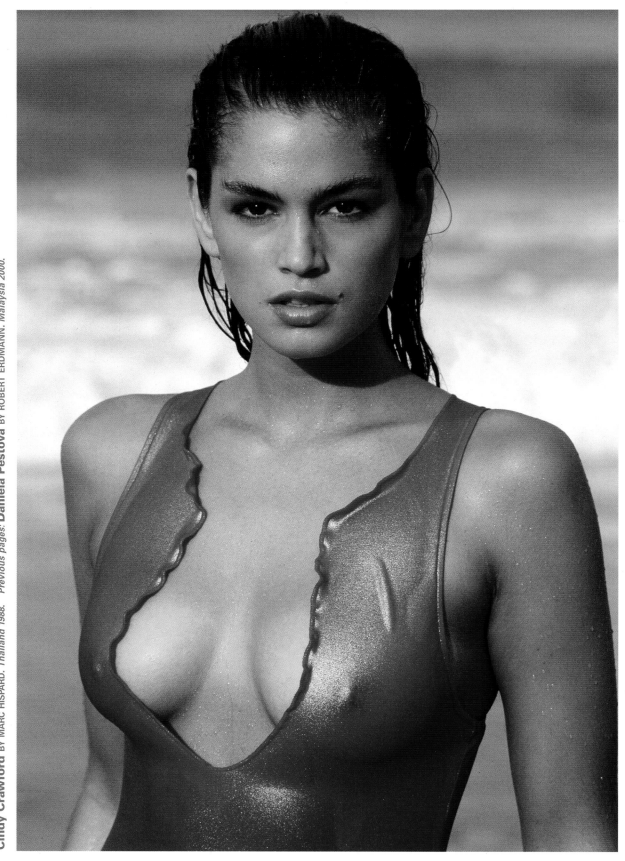

Cindy Crawford BY MARC HISPARD. *Thailand 1988.* Previous pages: **Daniela Pestova** BY ROBERT ERDMANN. *Malaysia 2000.*

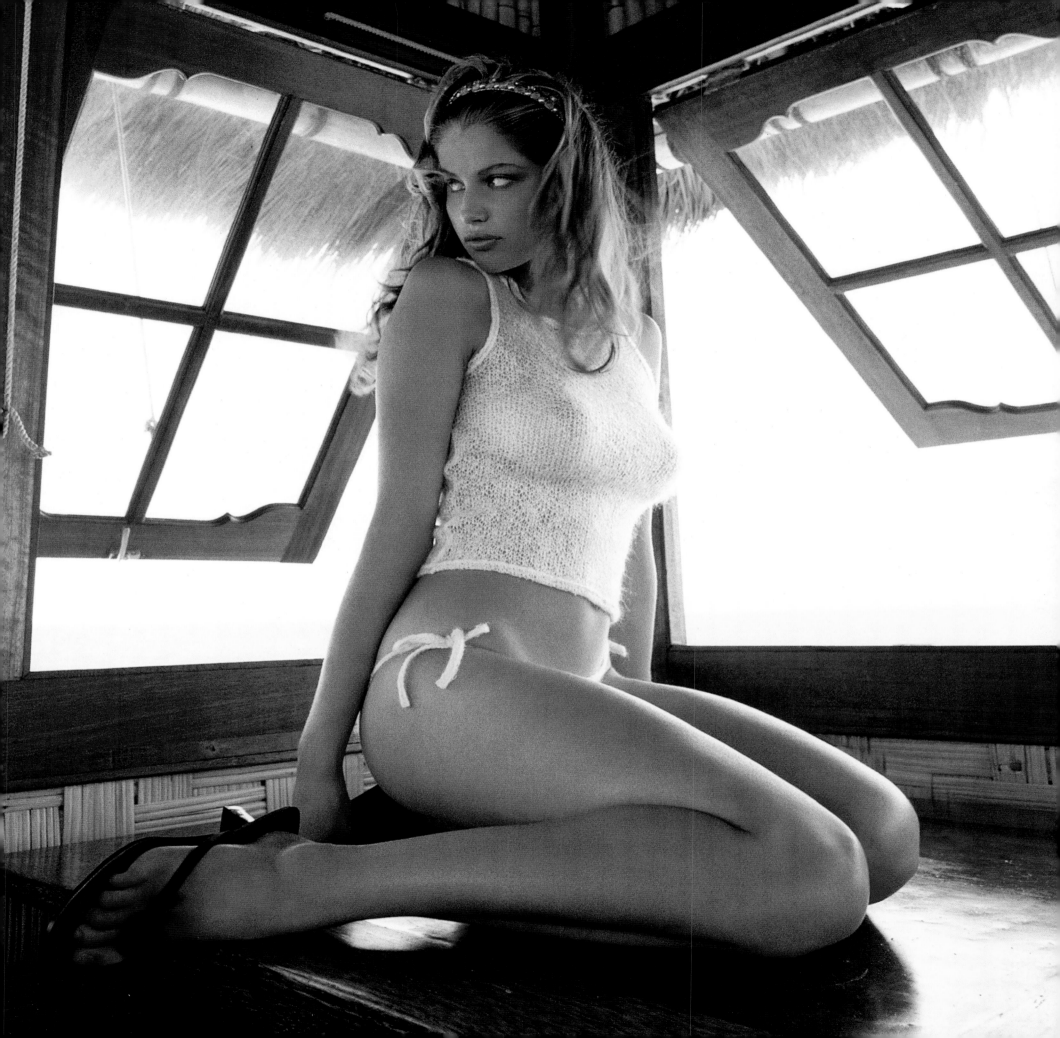

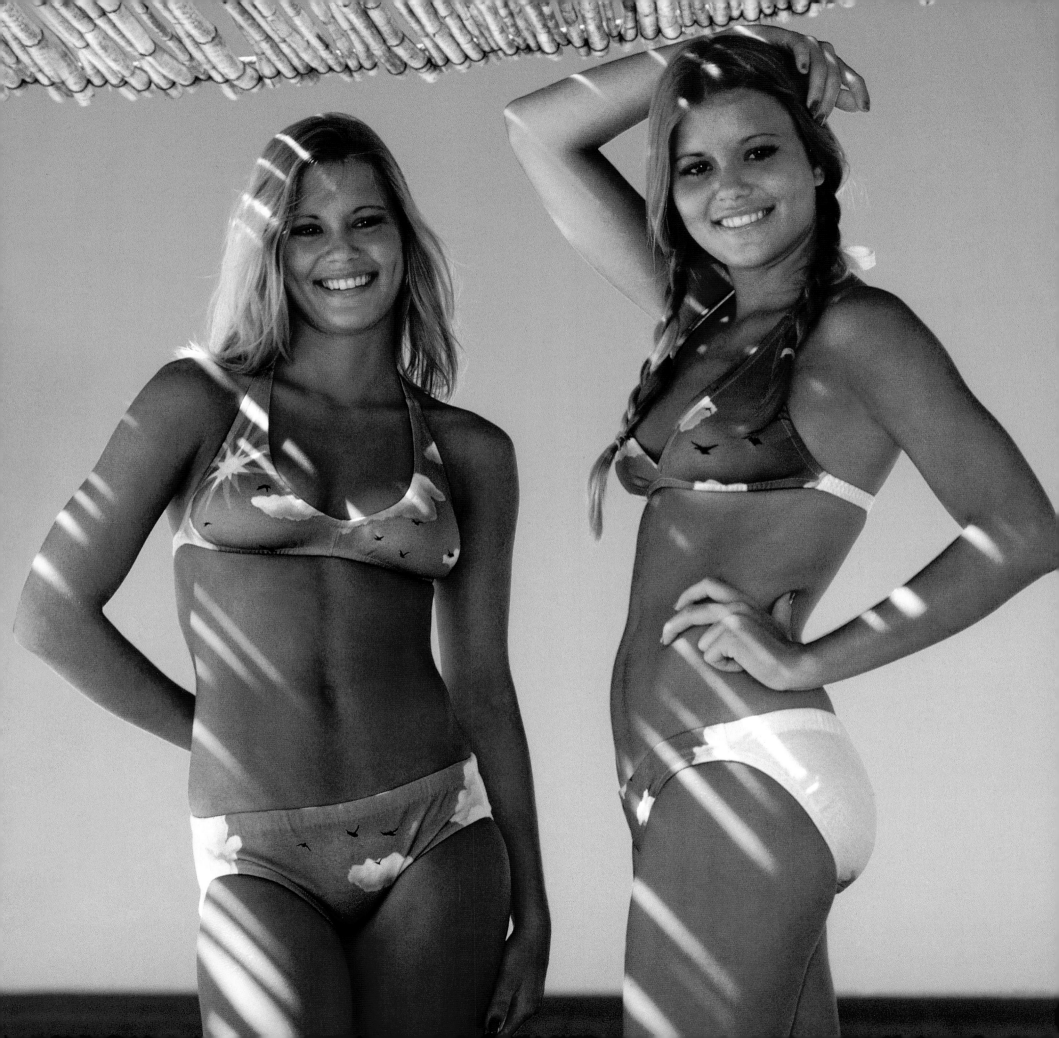

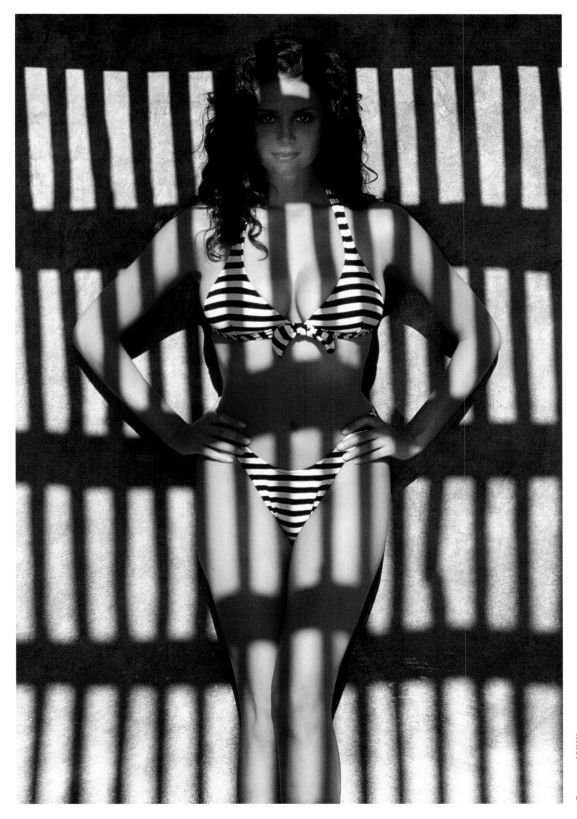

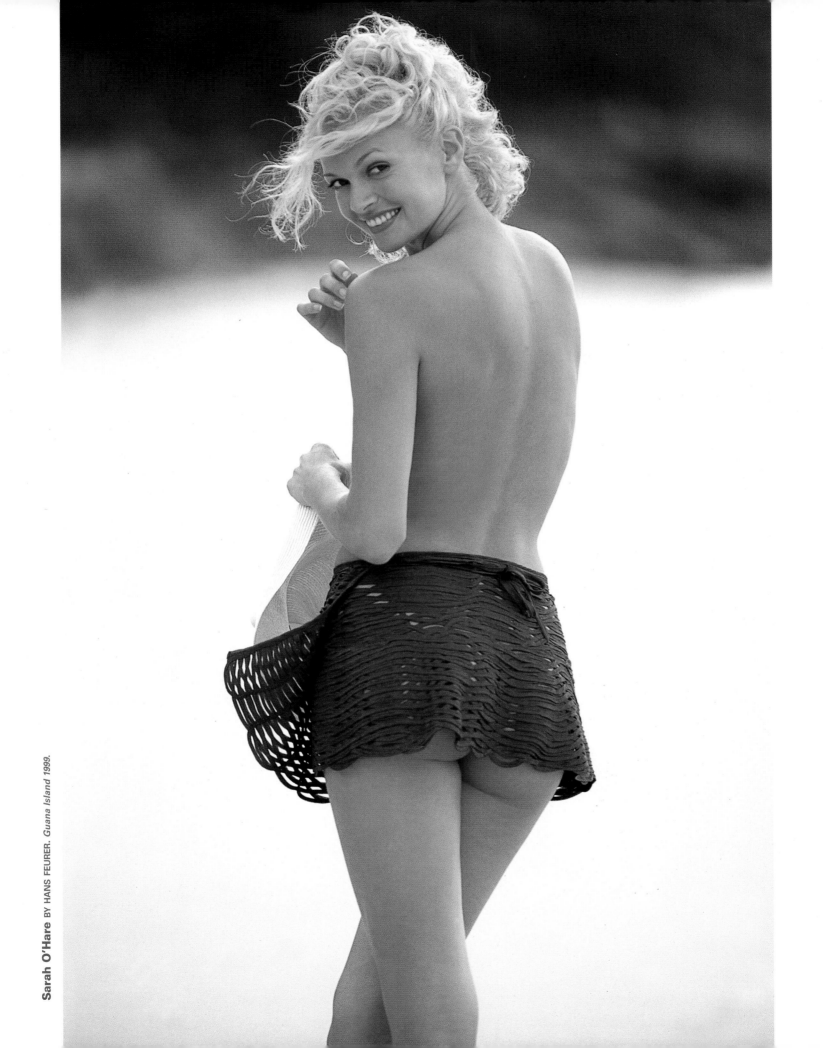

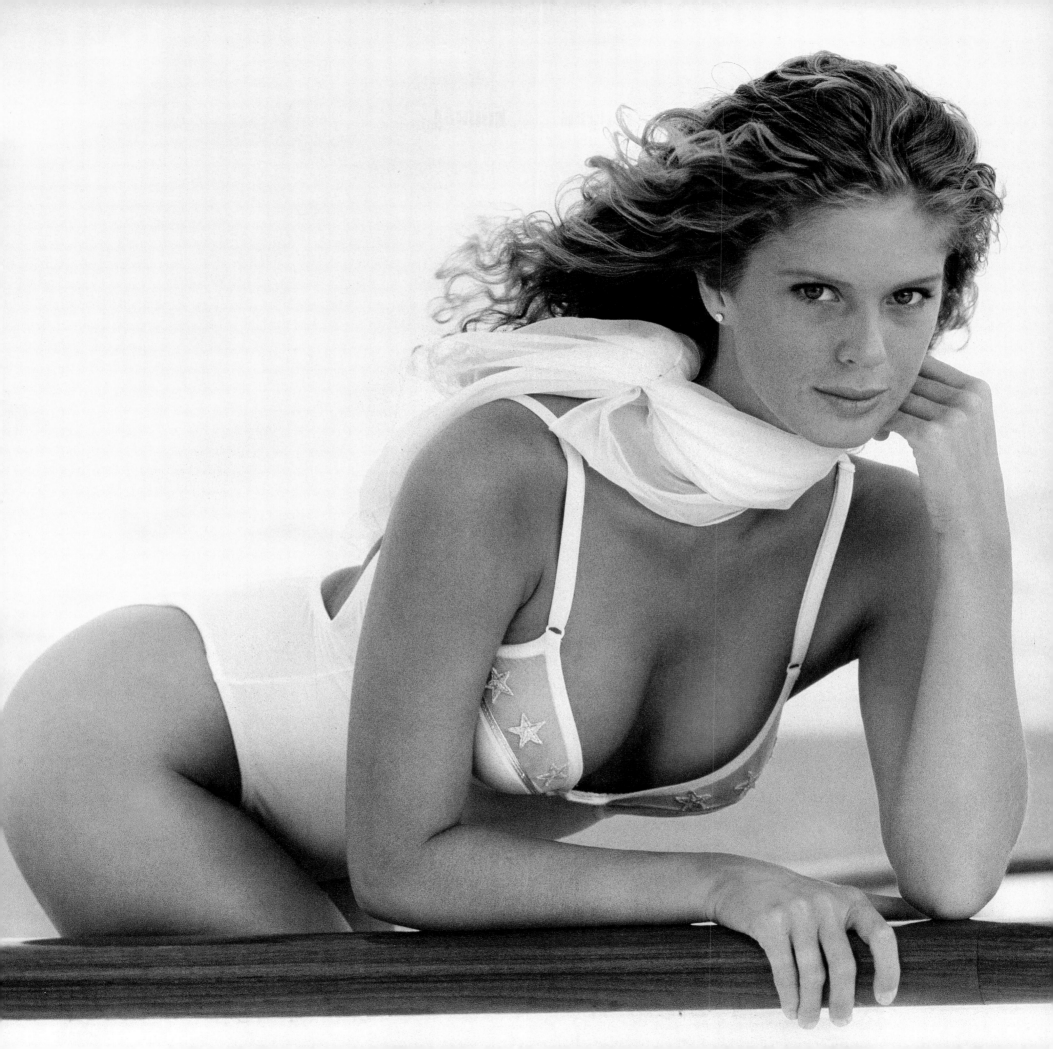

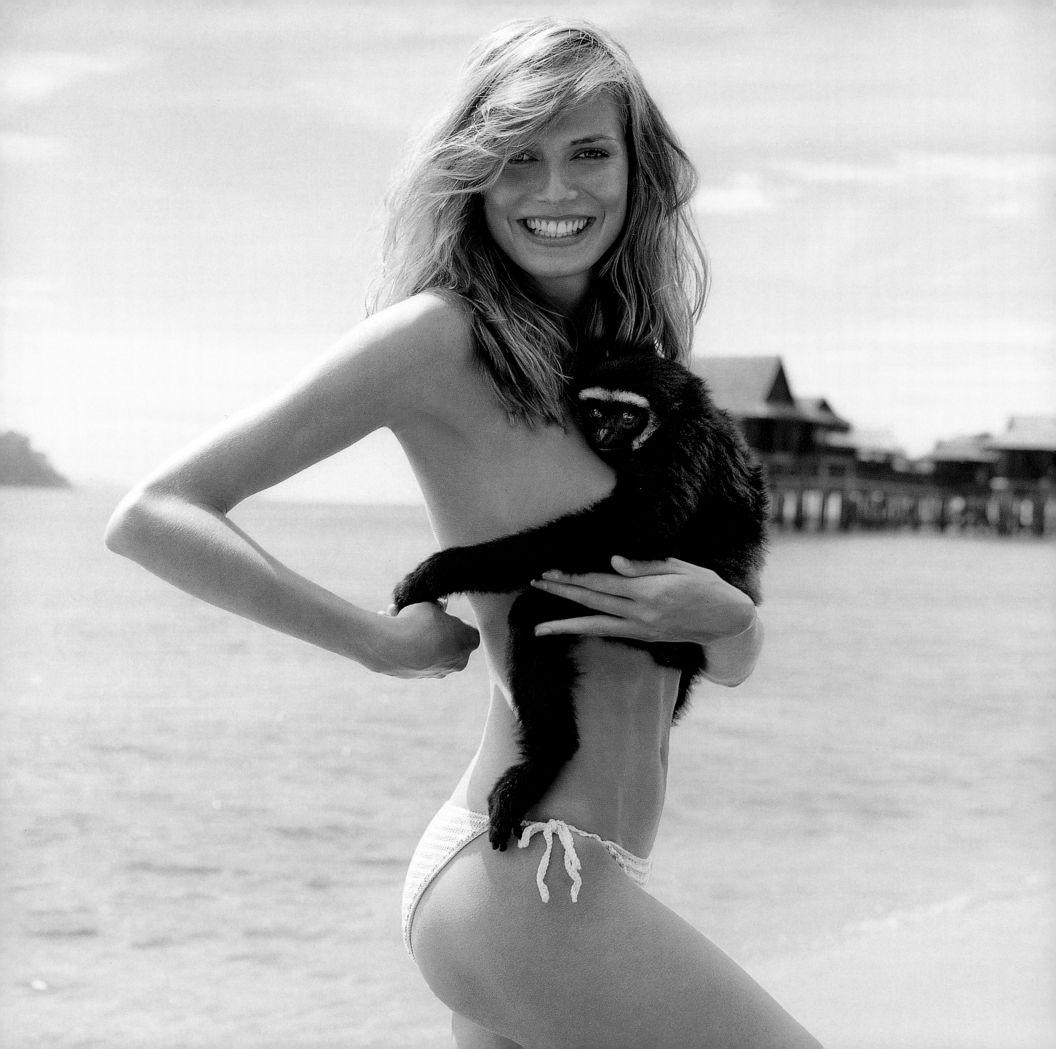

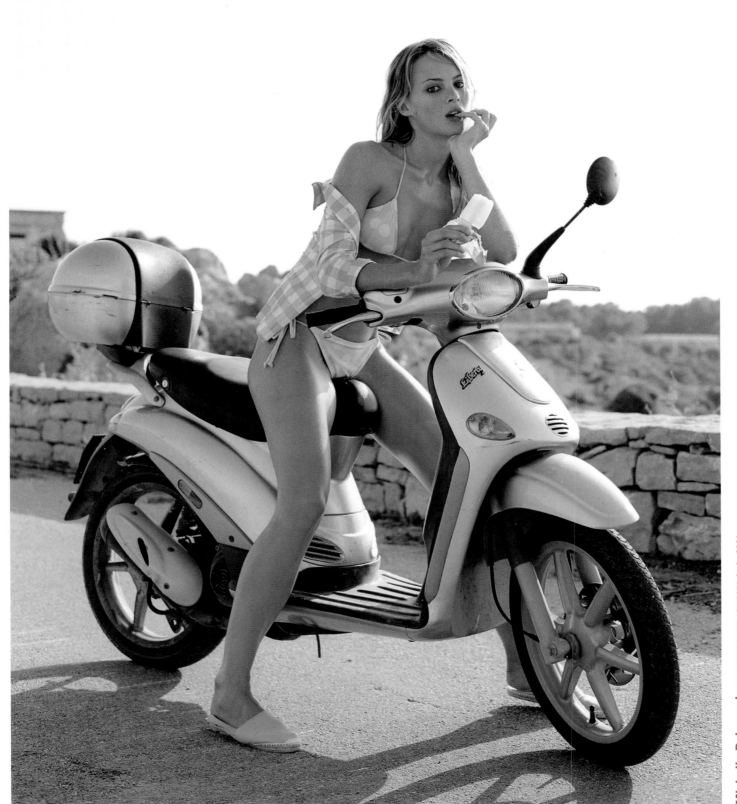

Heidi **Klum** BY ROBERT ERDMANN. *The Maldives 1998.*

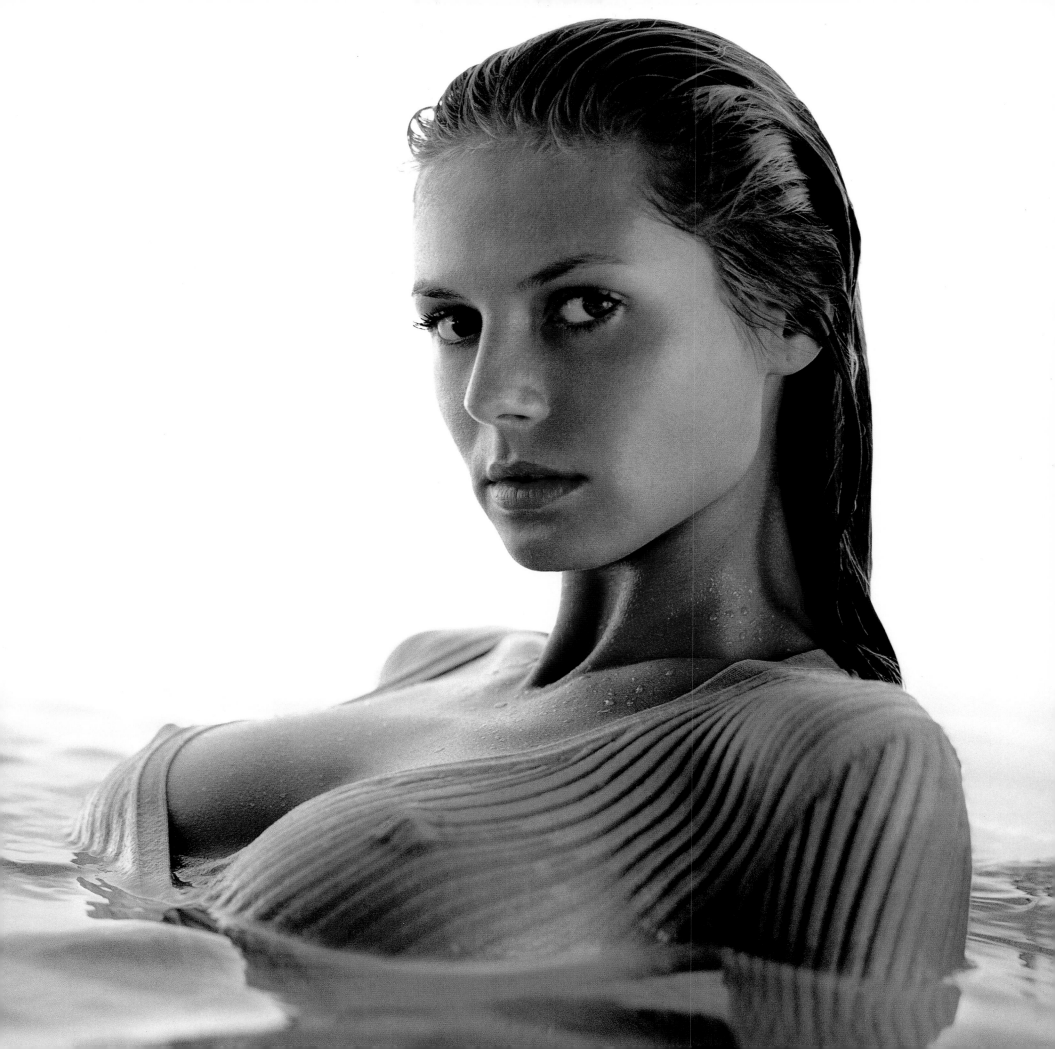

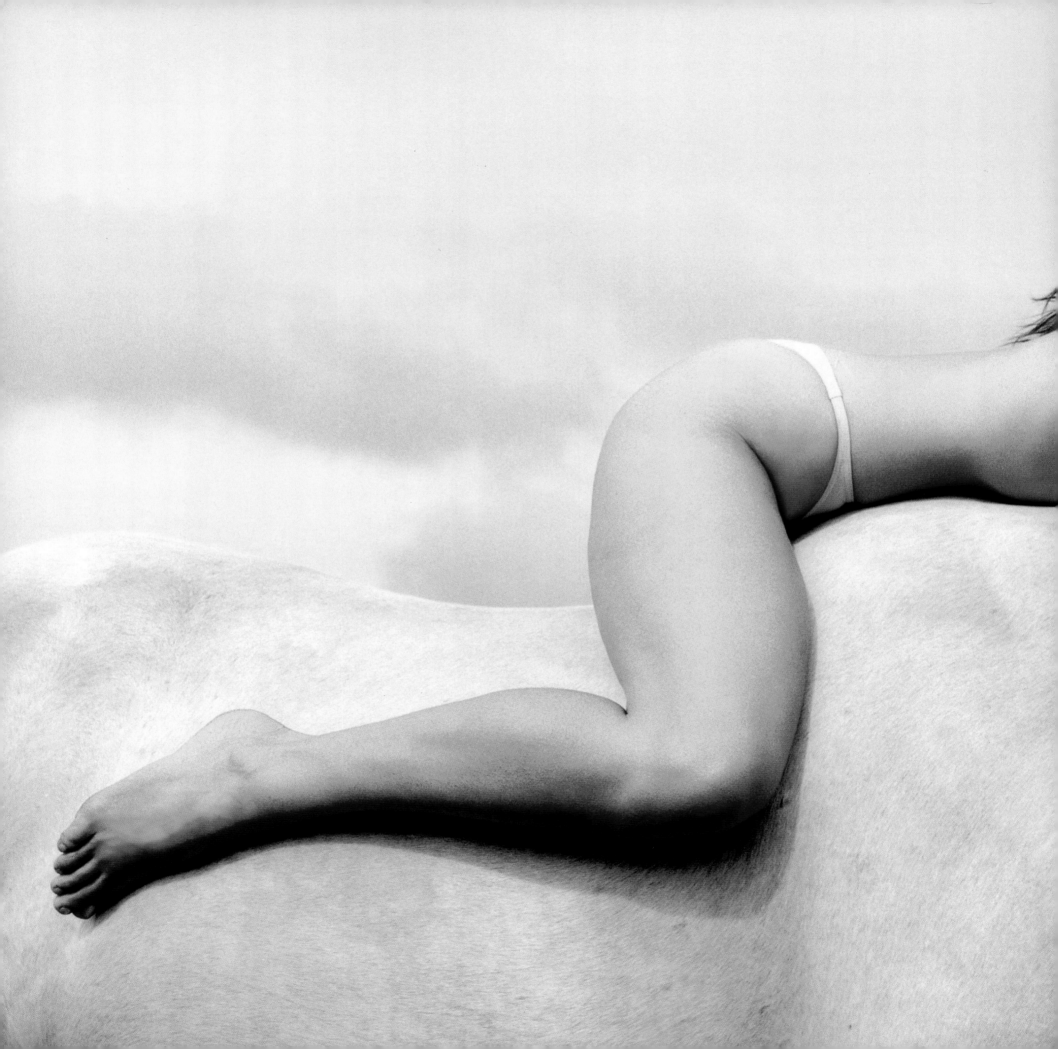

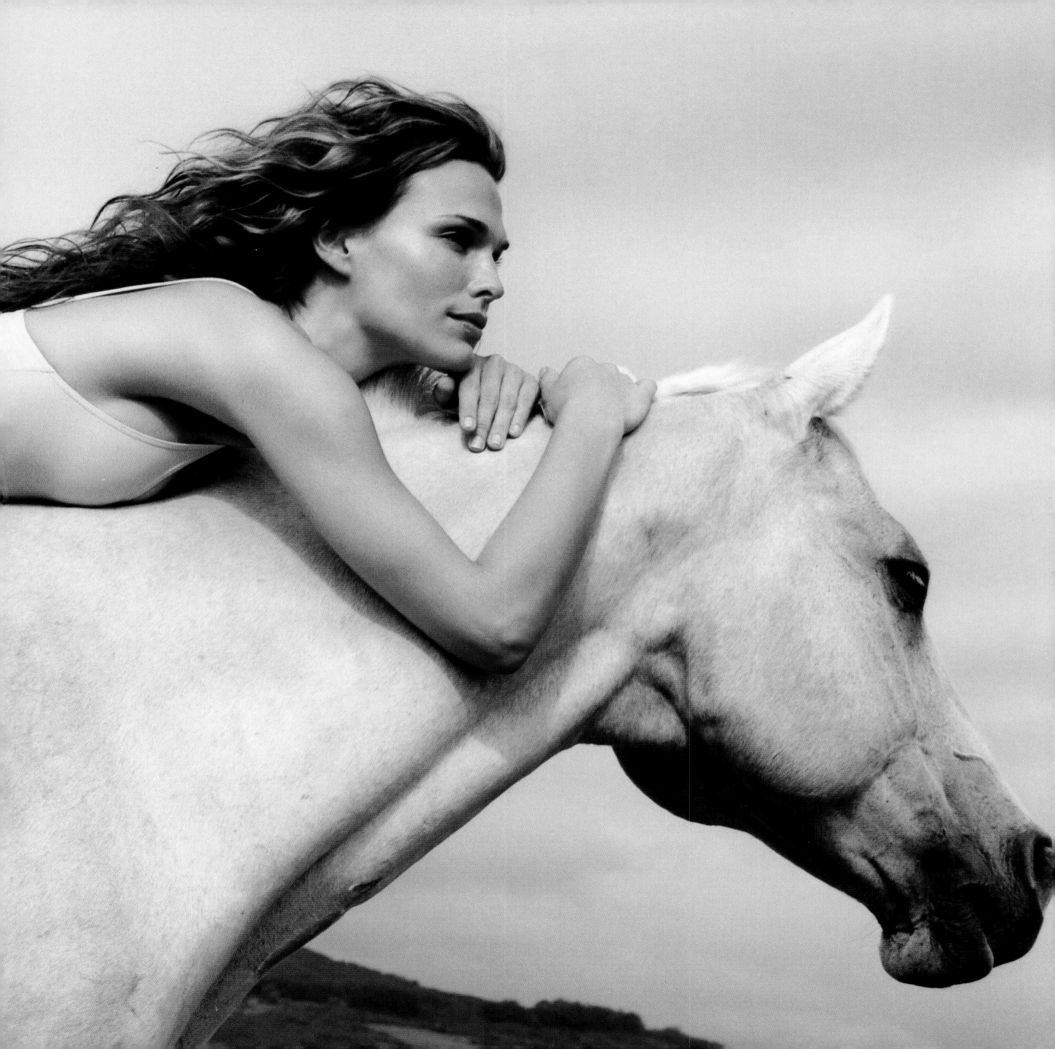

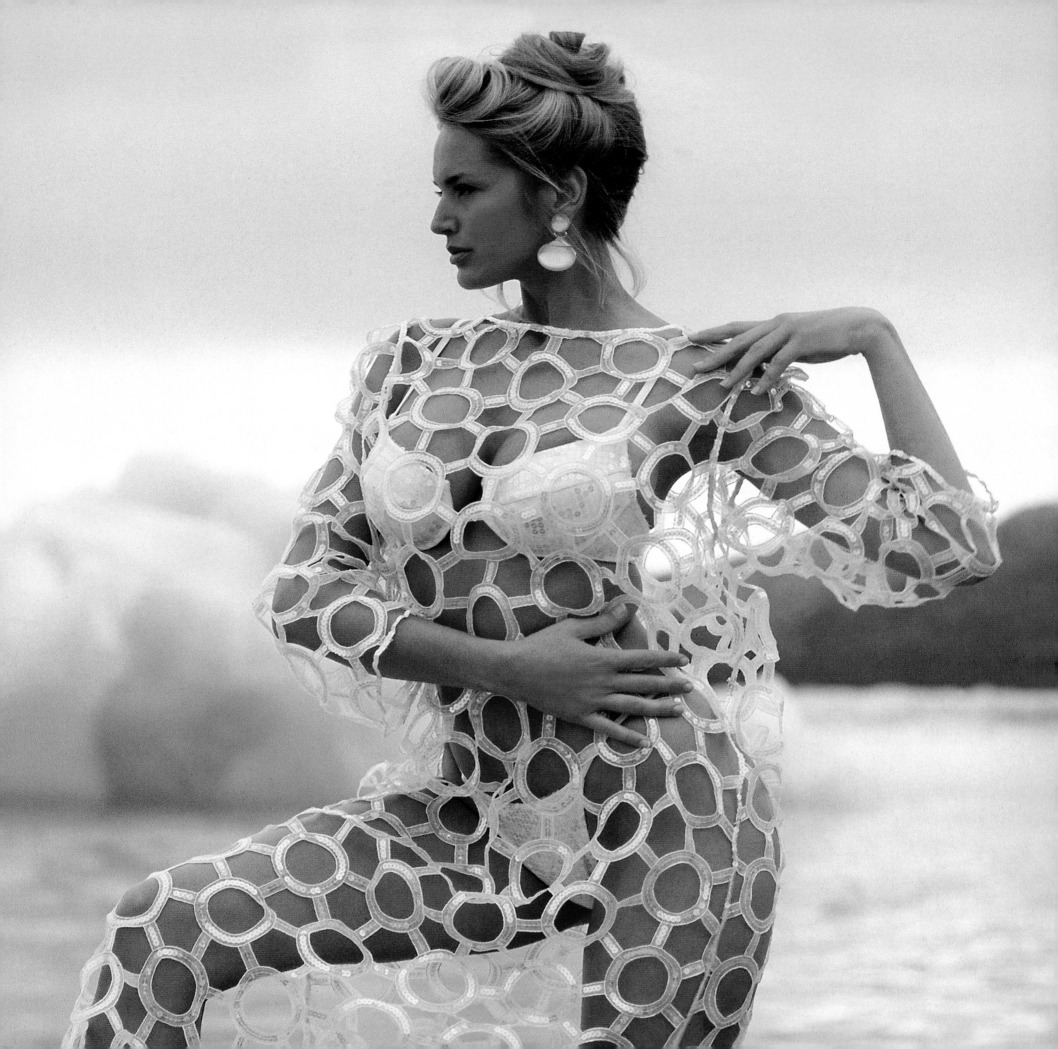

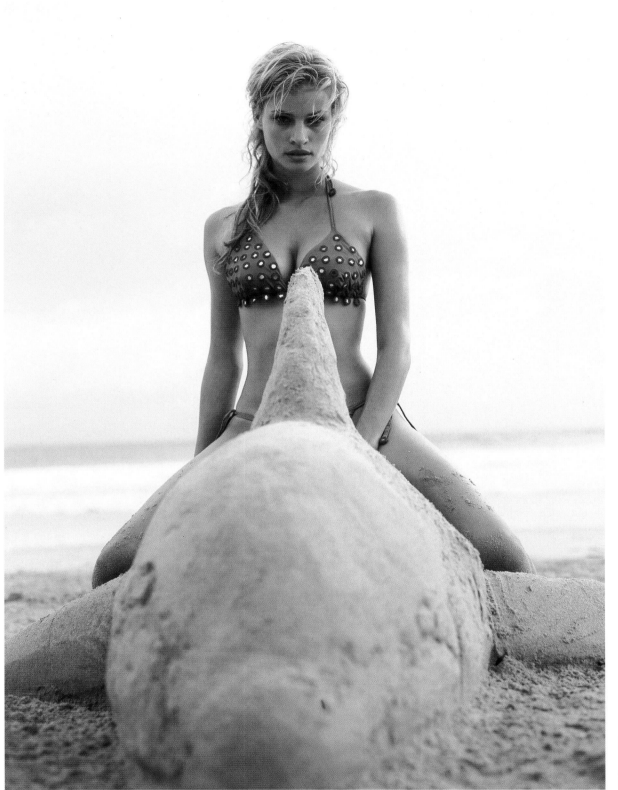

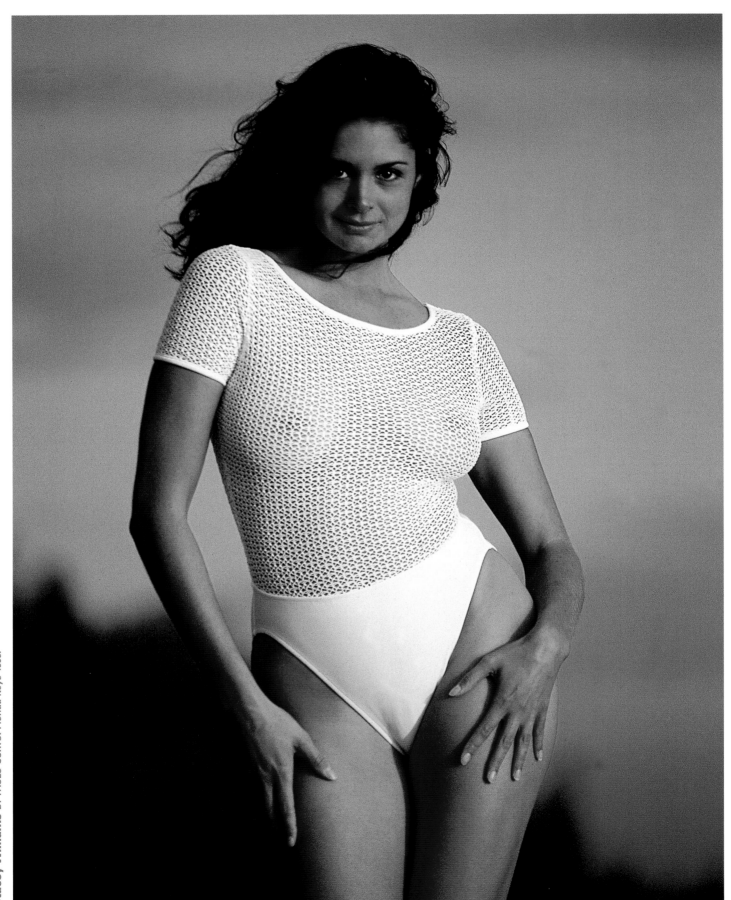

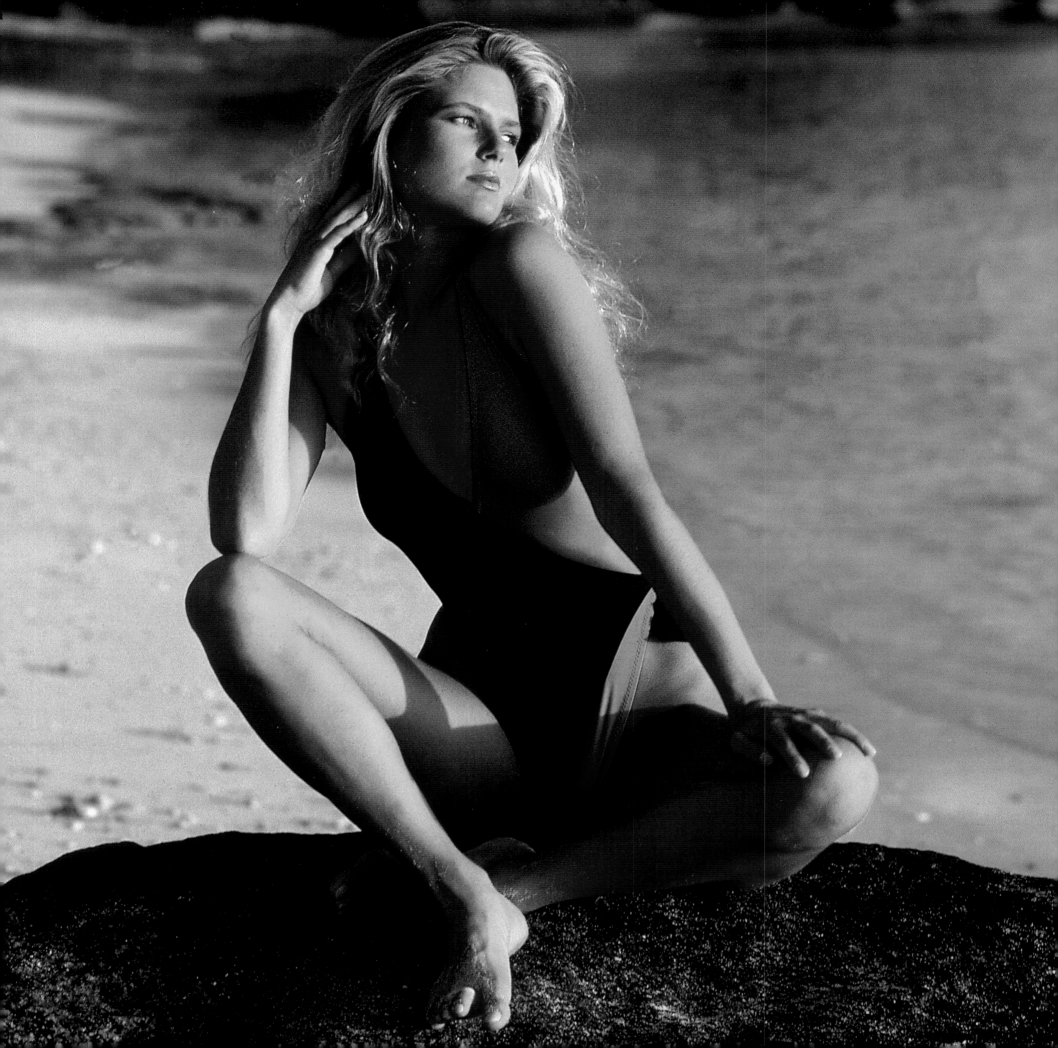

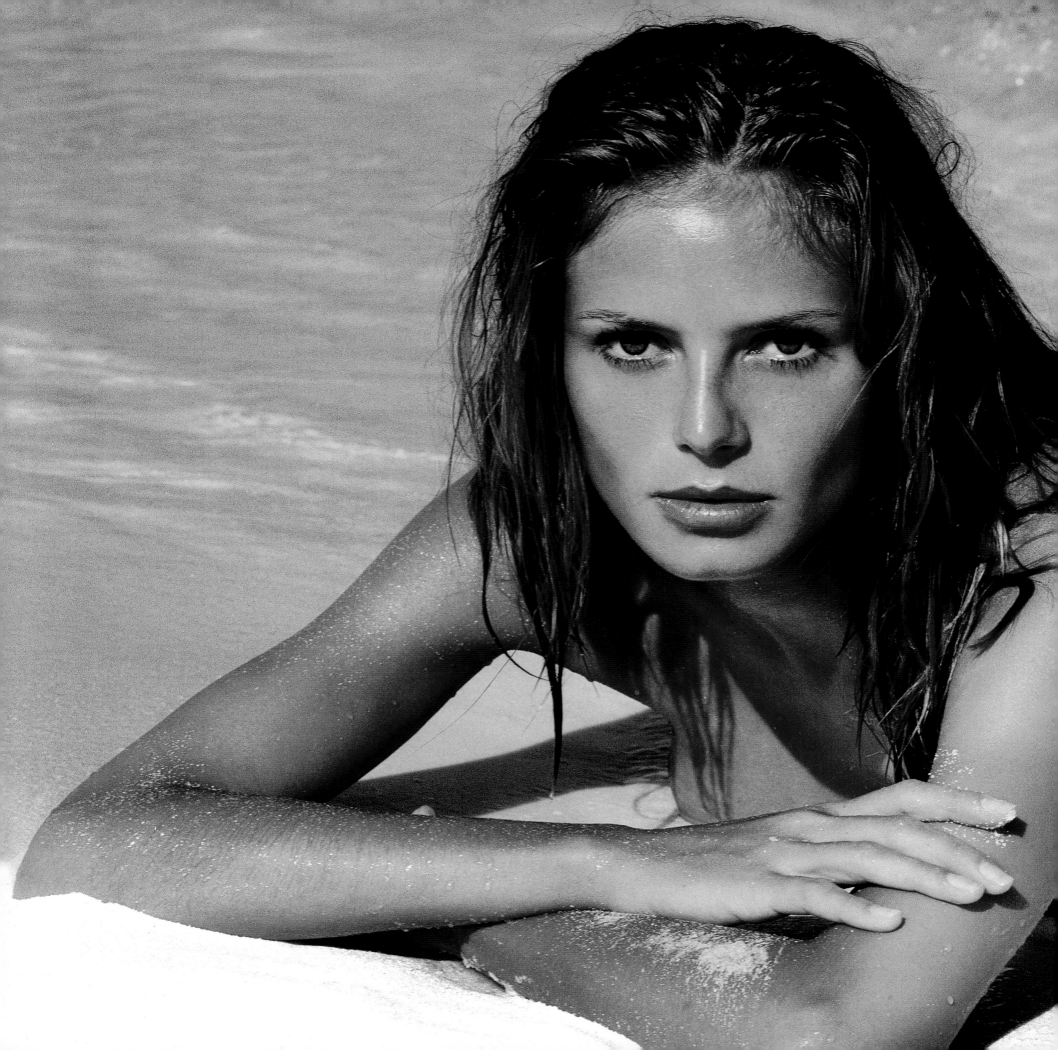

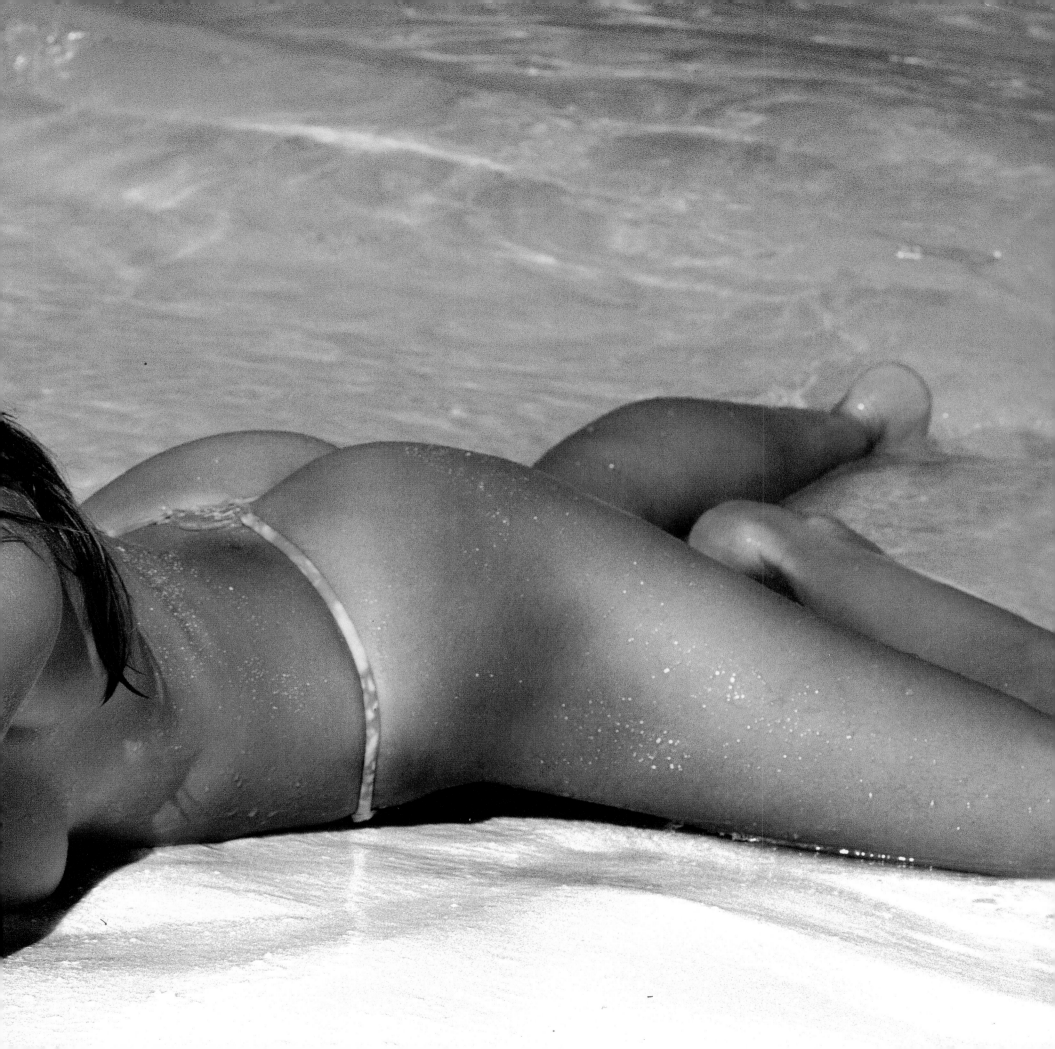

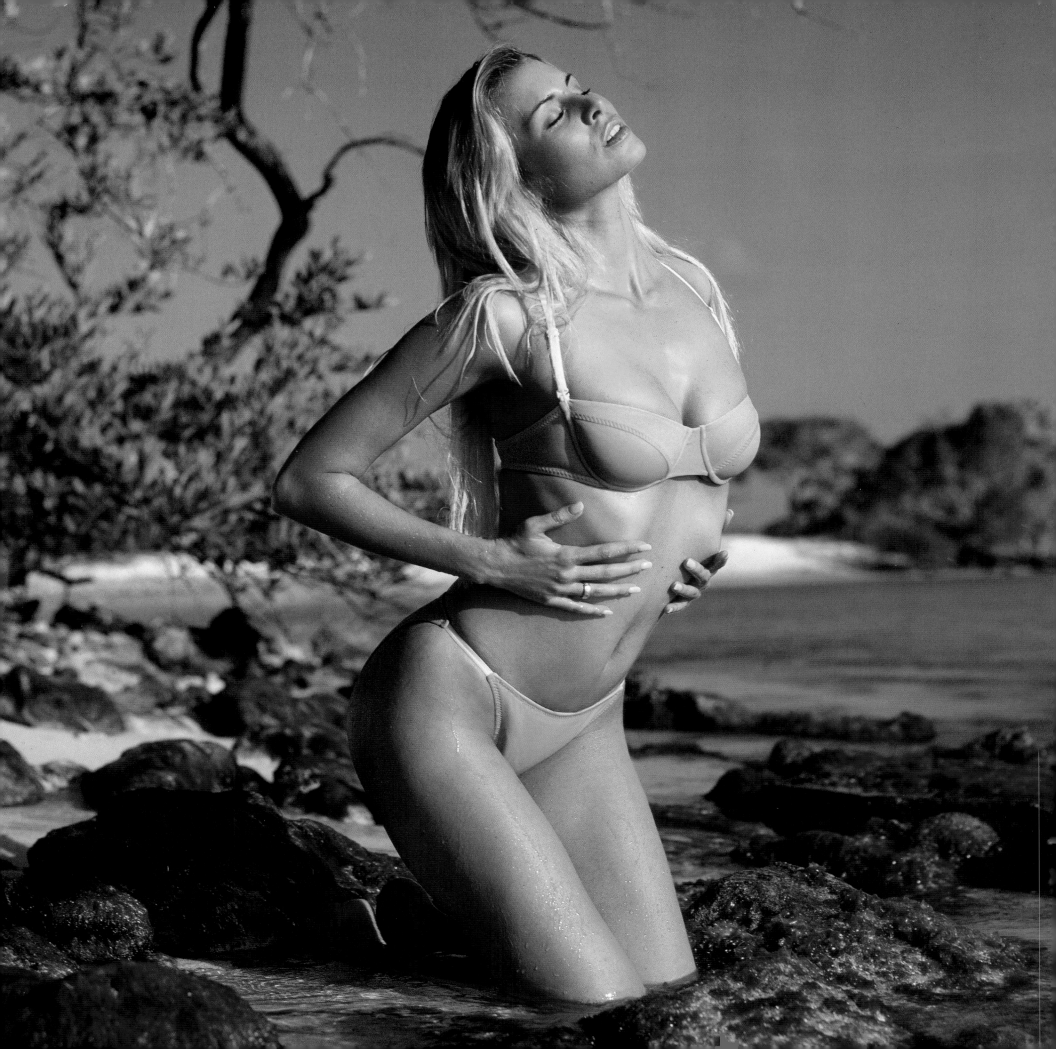

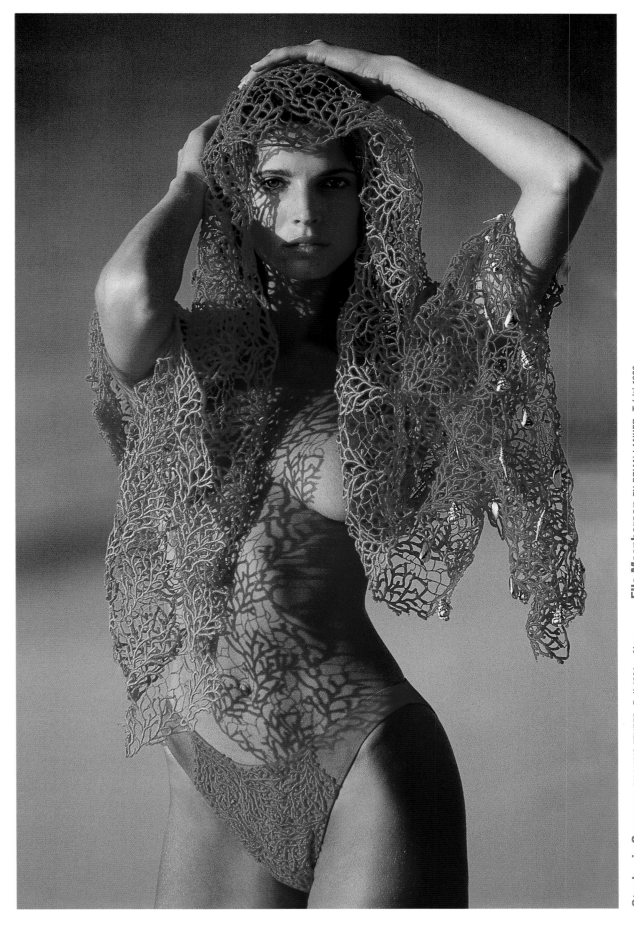

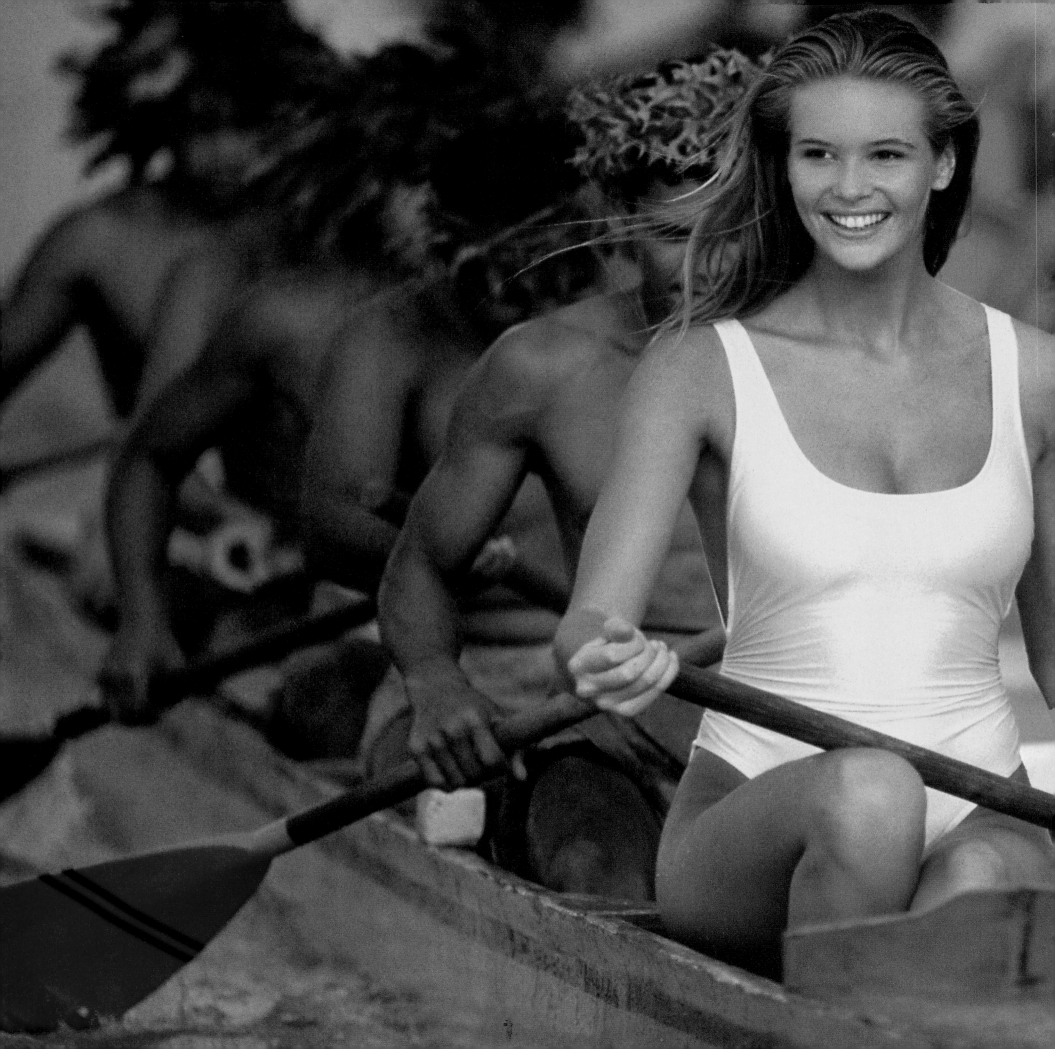

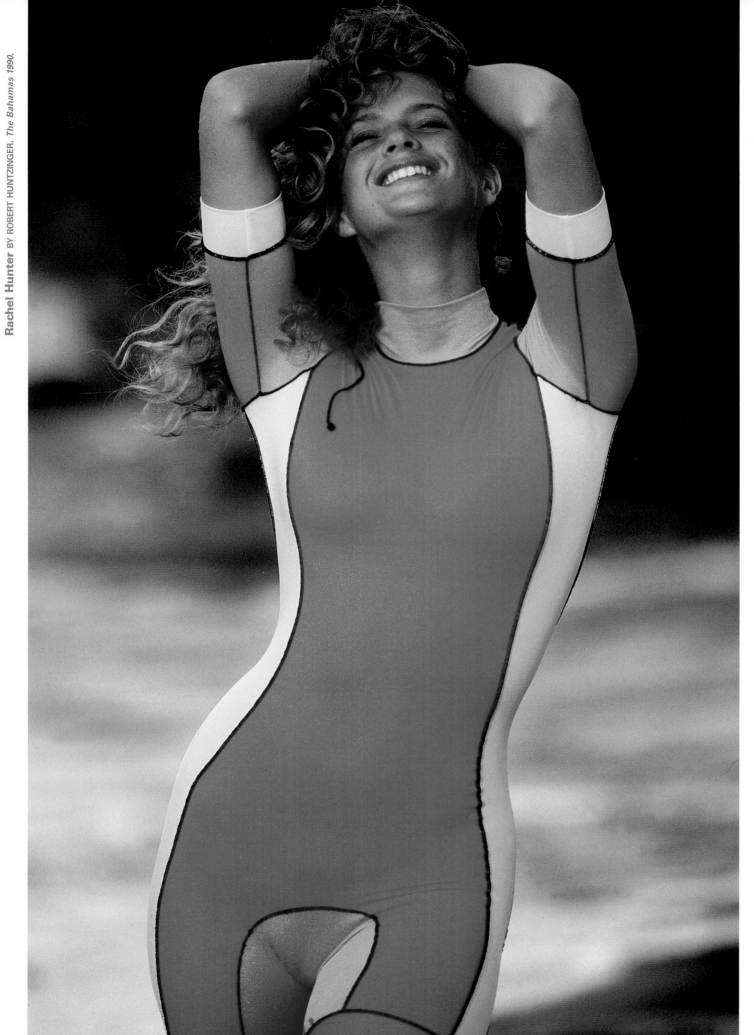

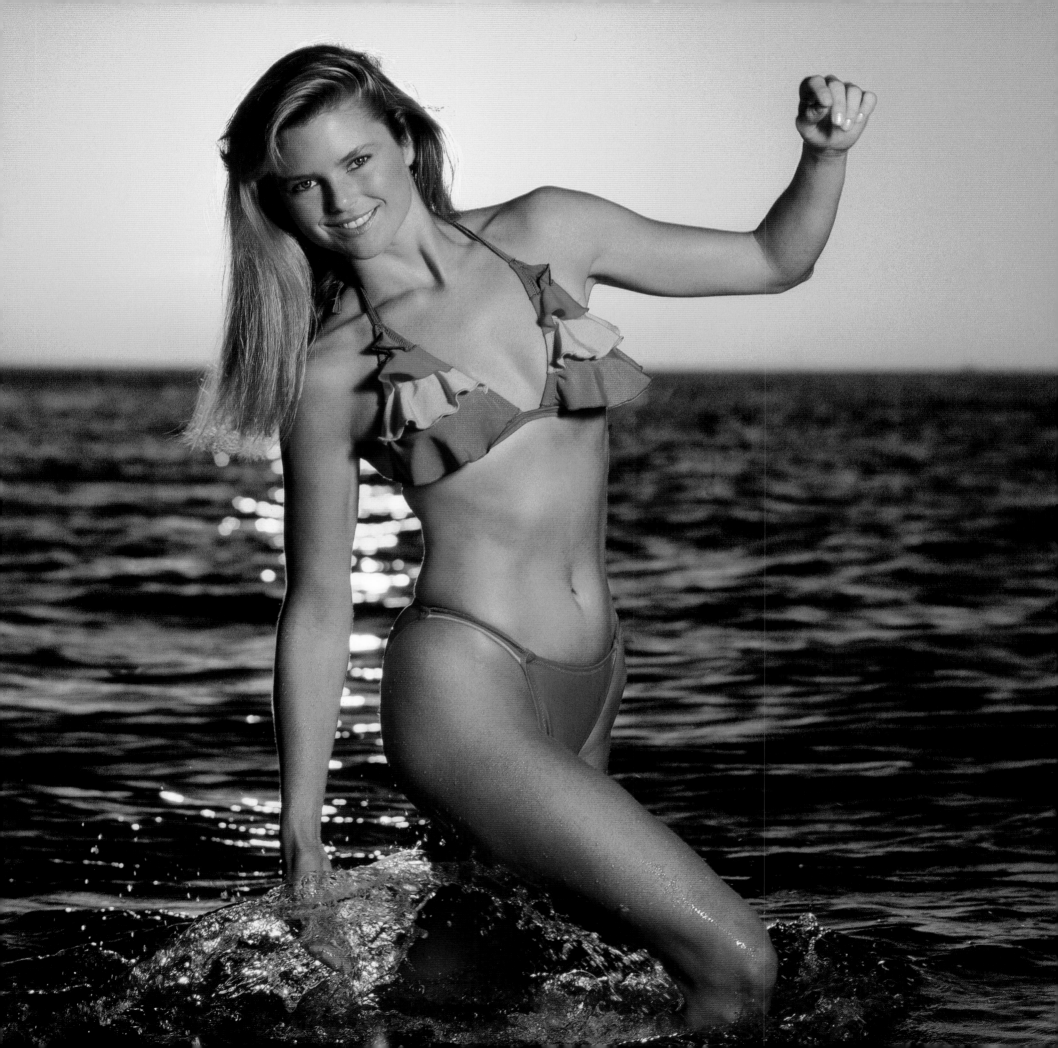

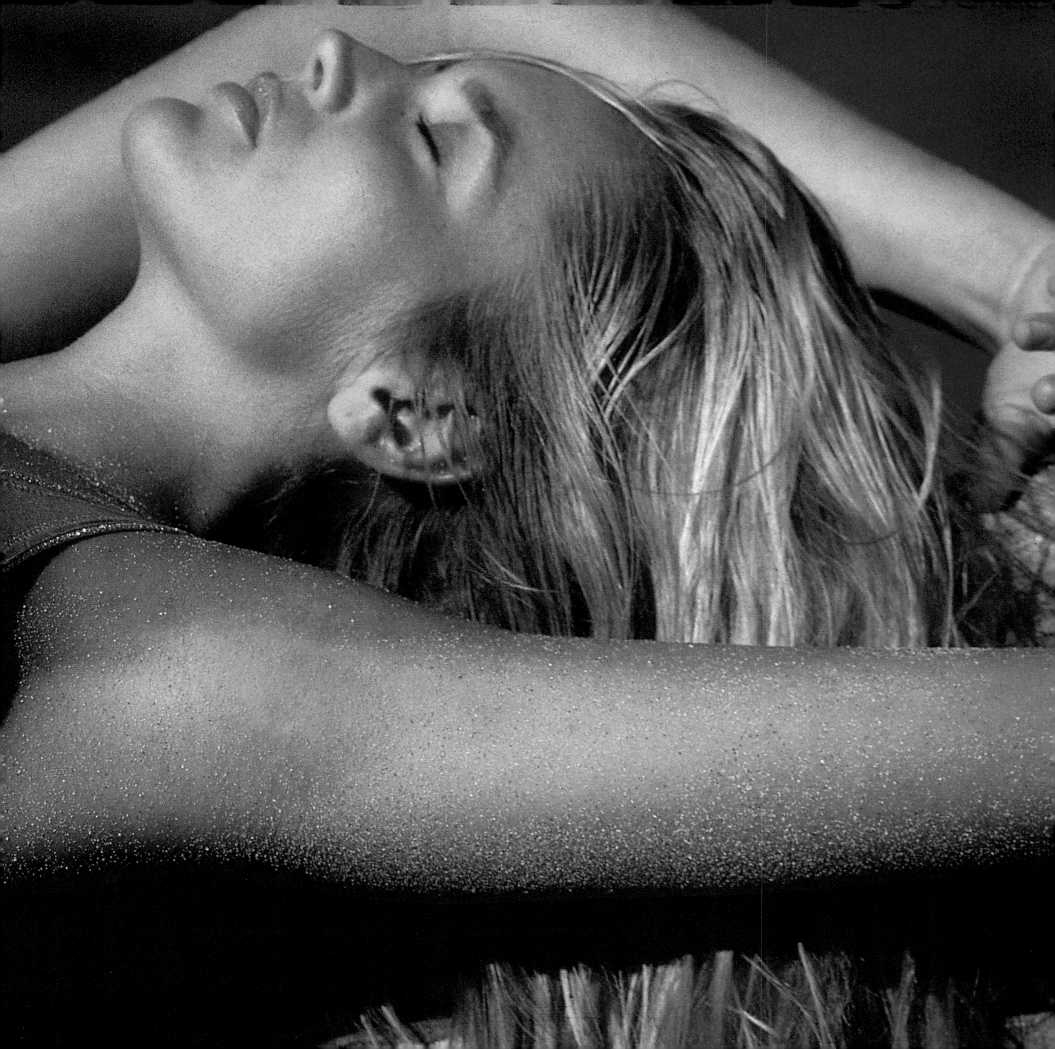

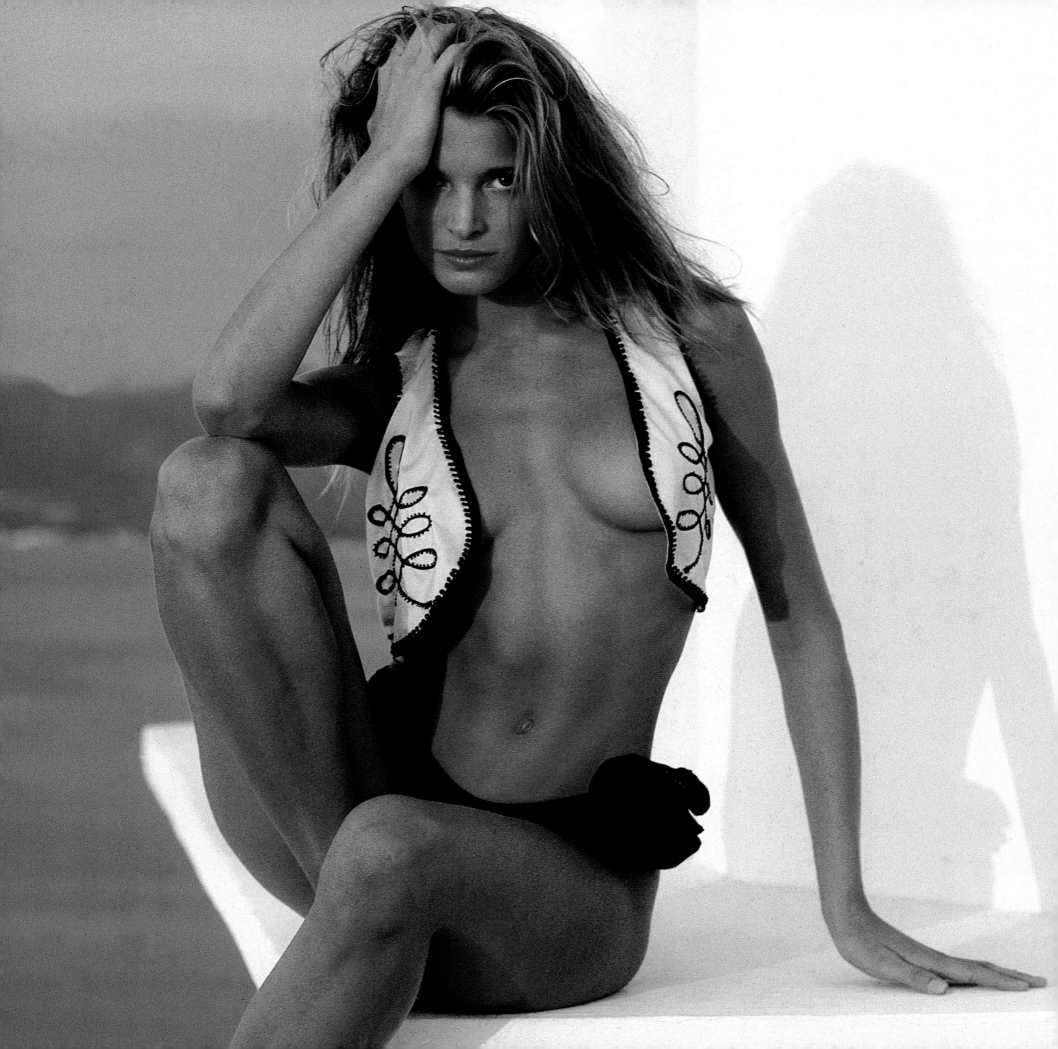

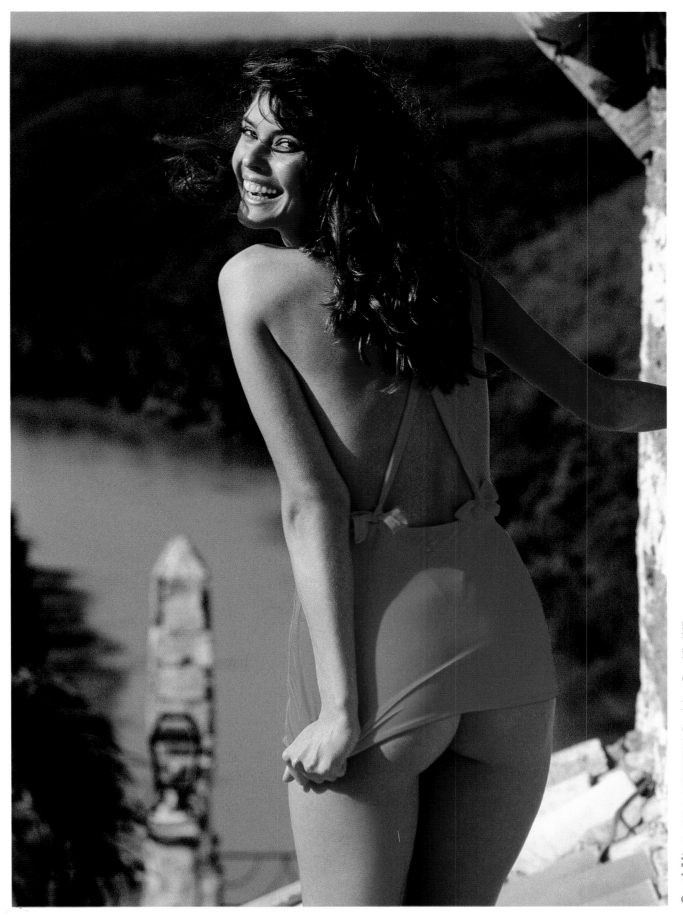

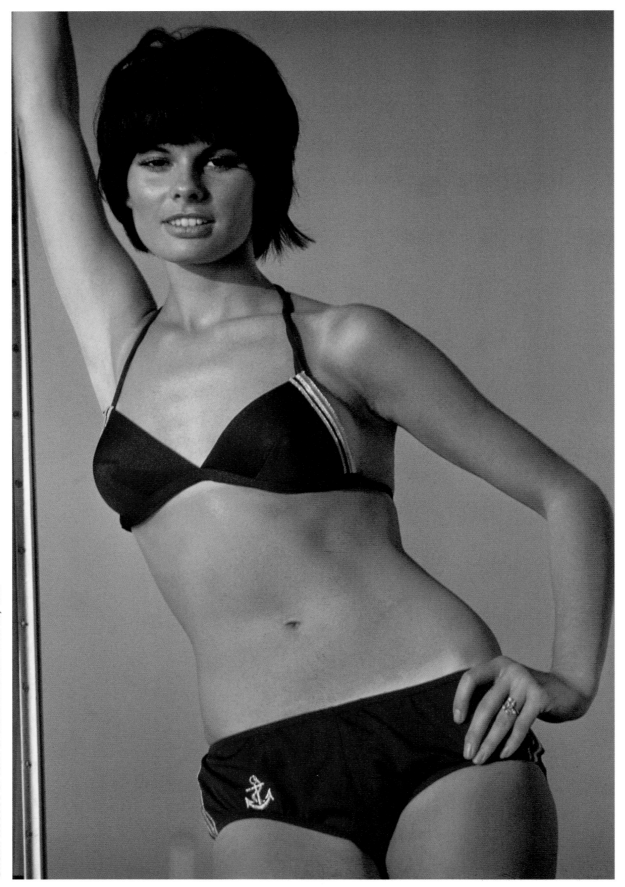

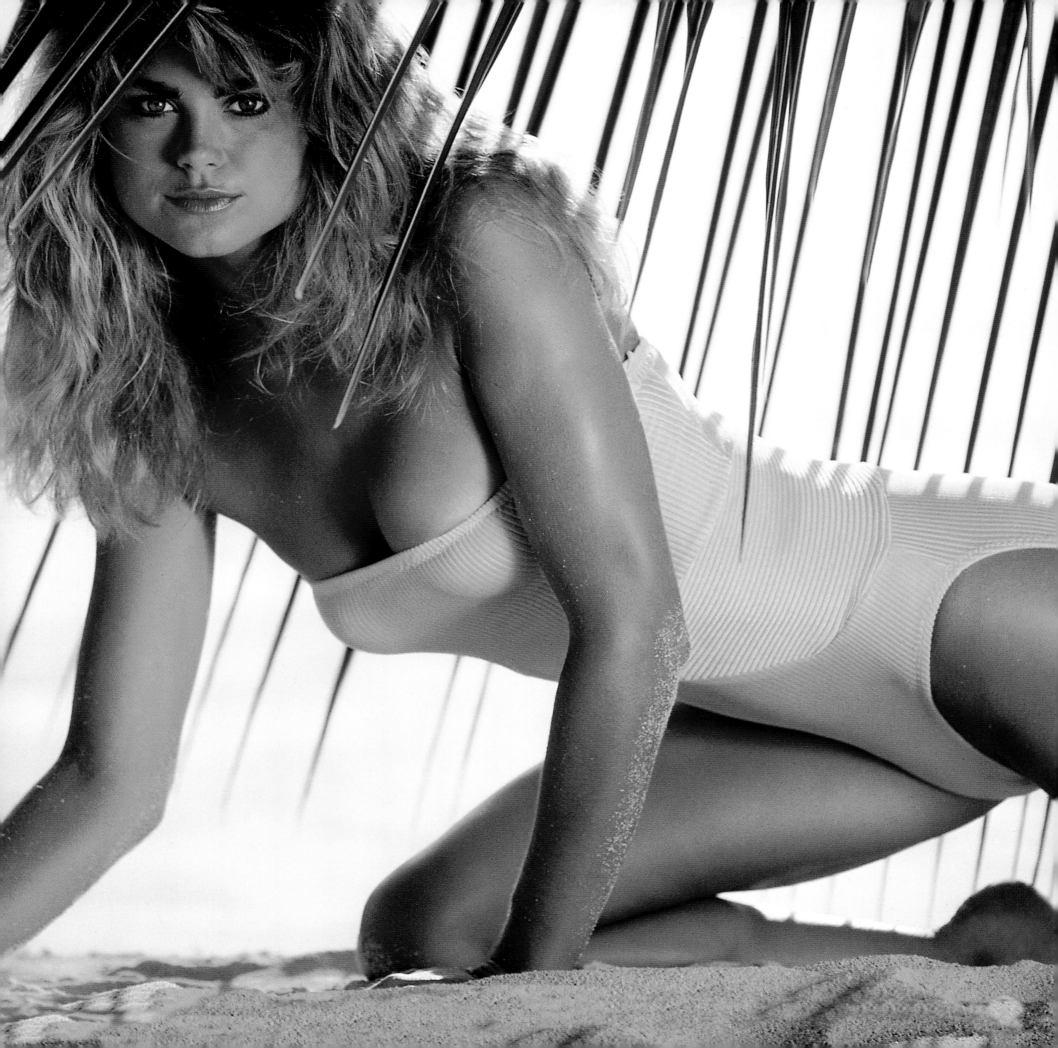

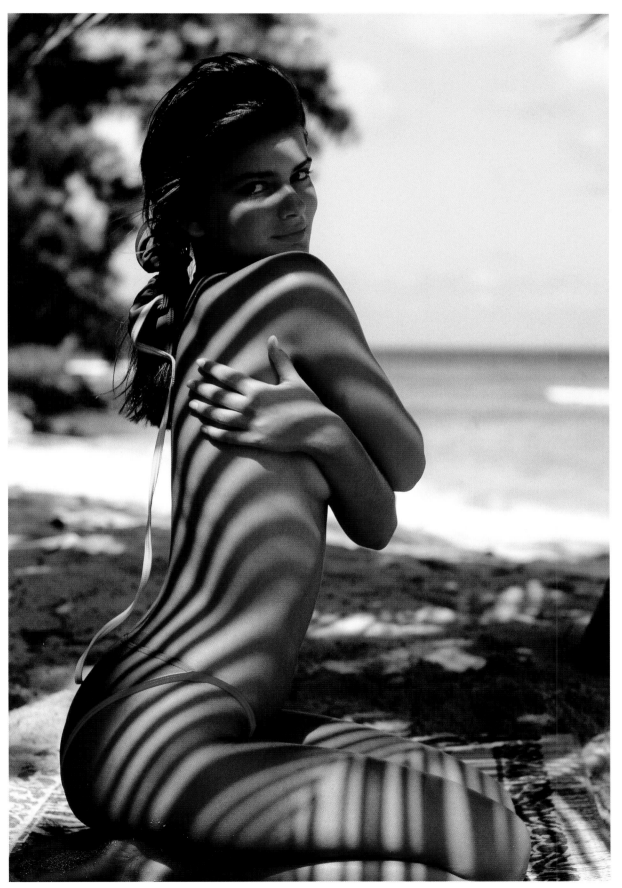

Paulina Porizkova BY WALTER IOOSS JR. *Montego Bay, Jamaica 1983.* *Next pages:* **Kathy Ireland** BY JOHN G. ZIMMERMAN. *Dominican Republic 1987.*

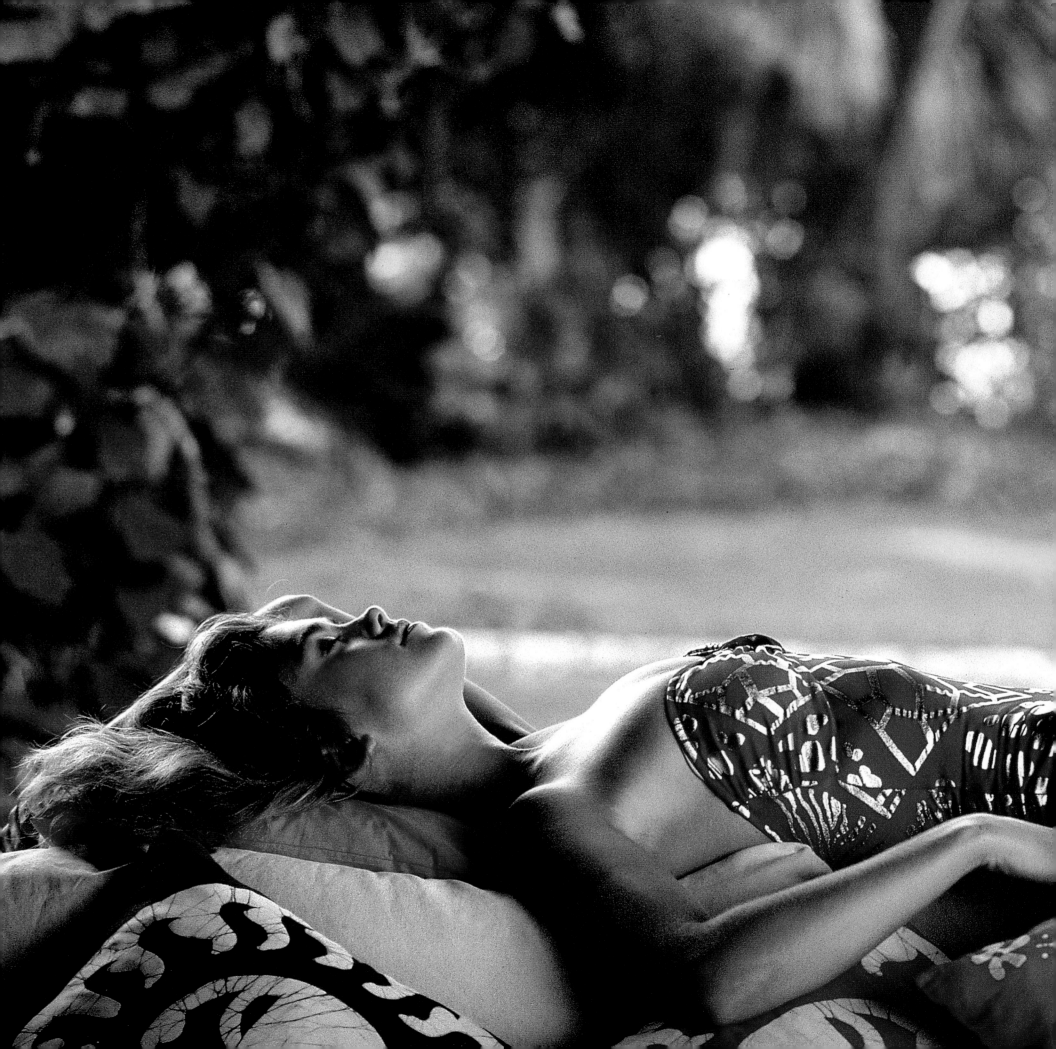

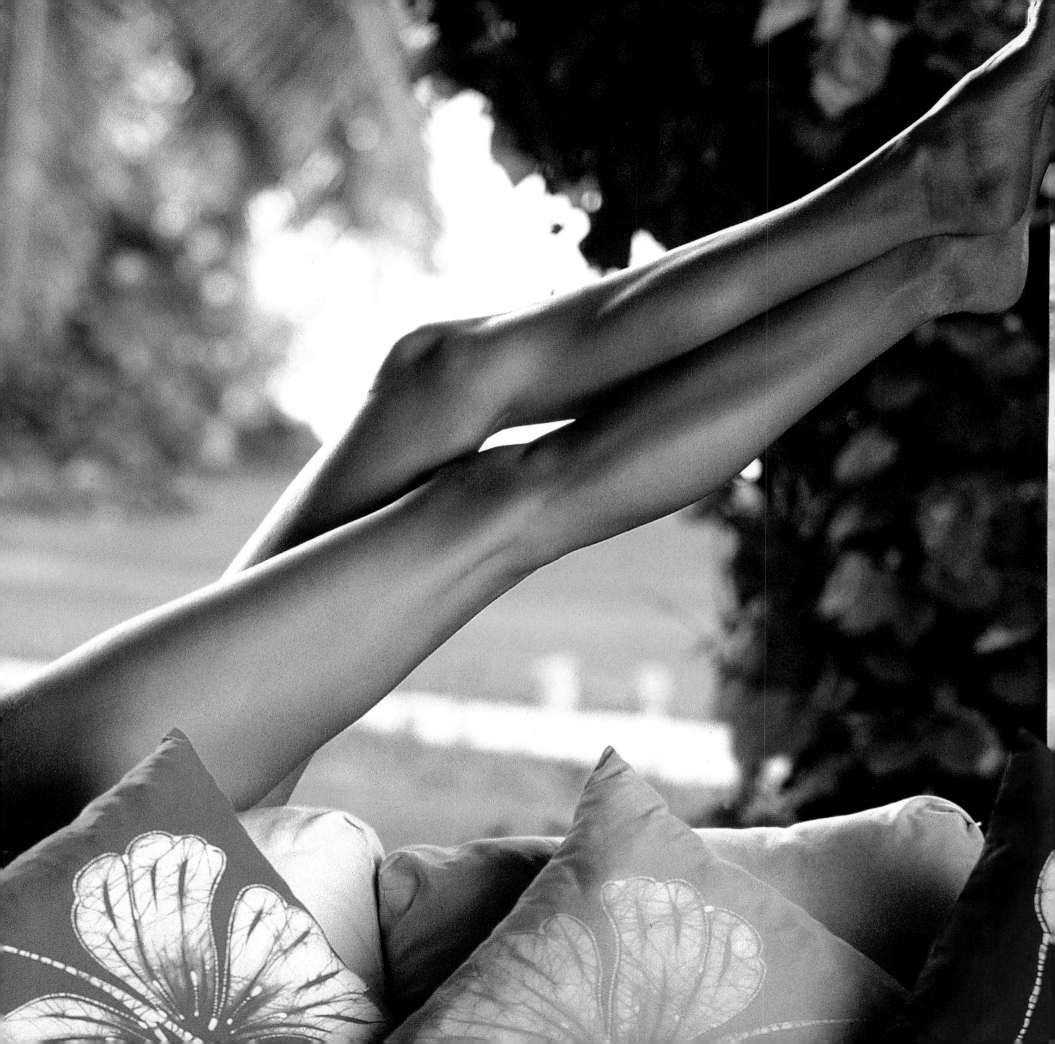

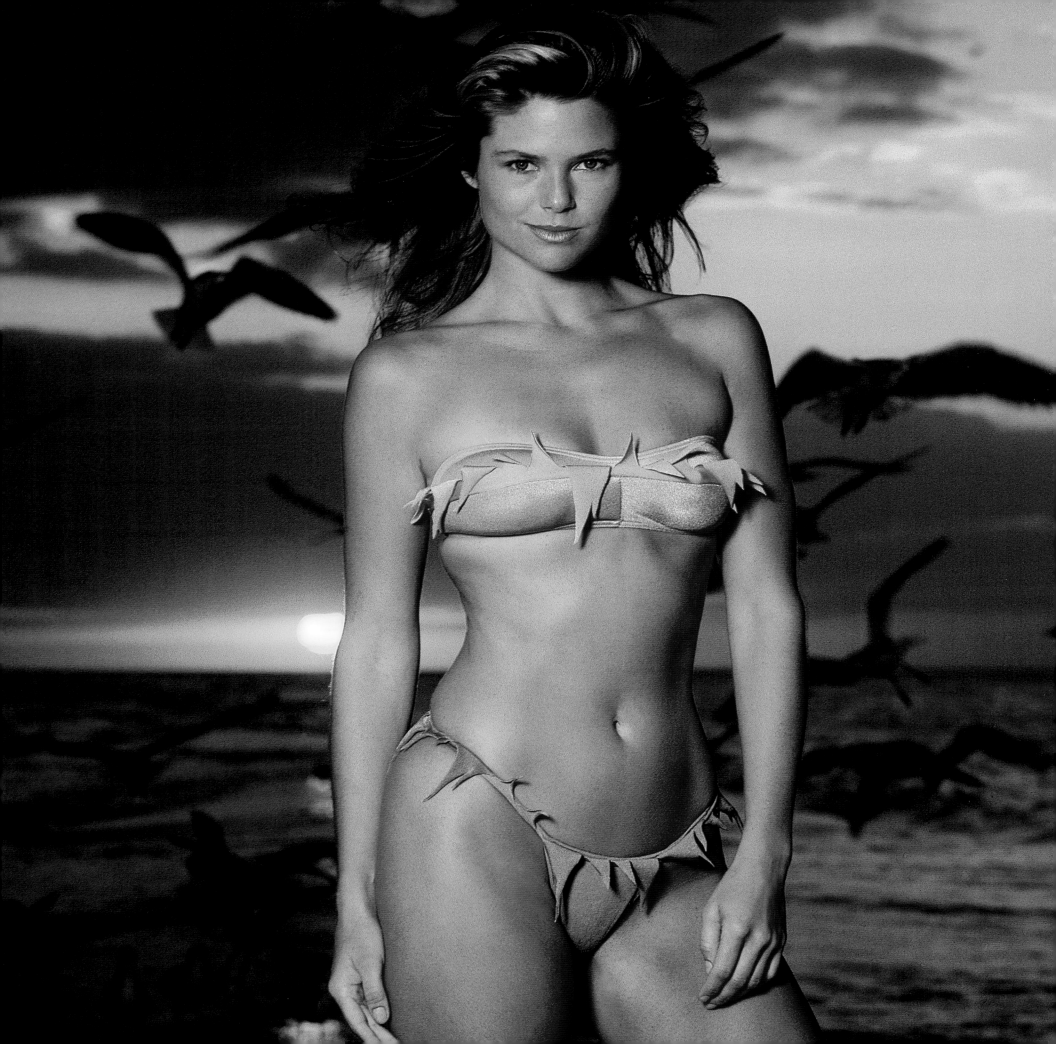

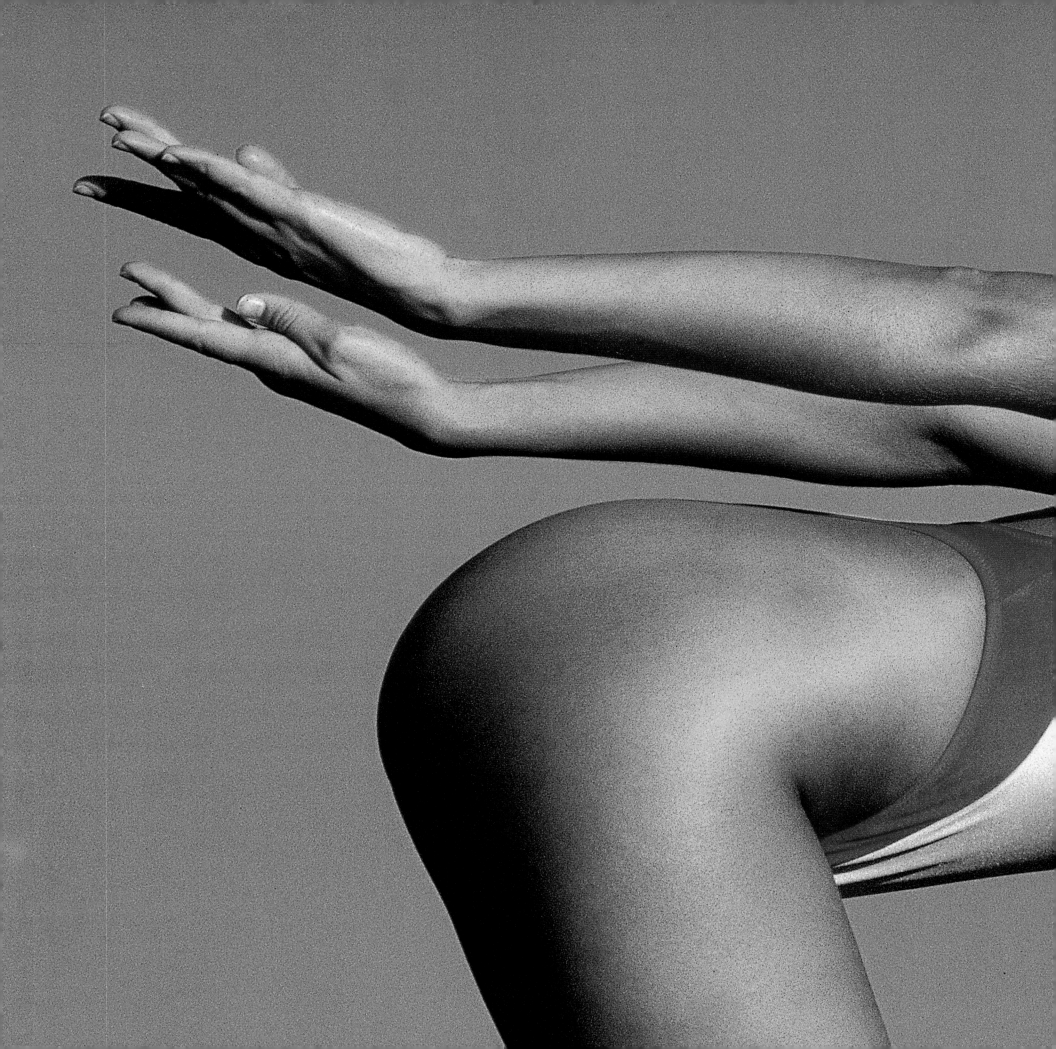

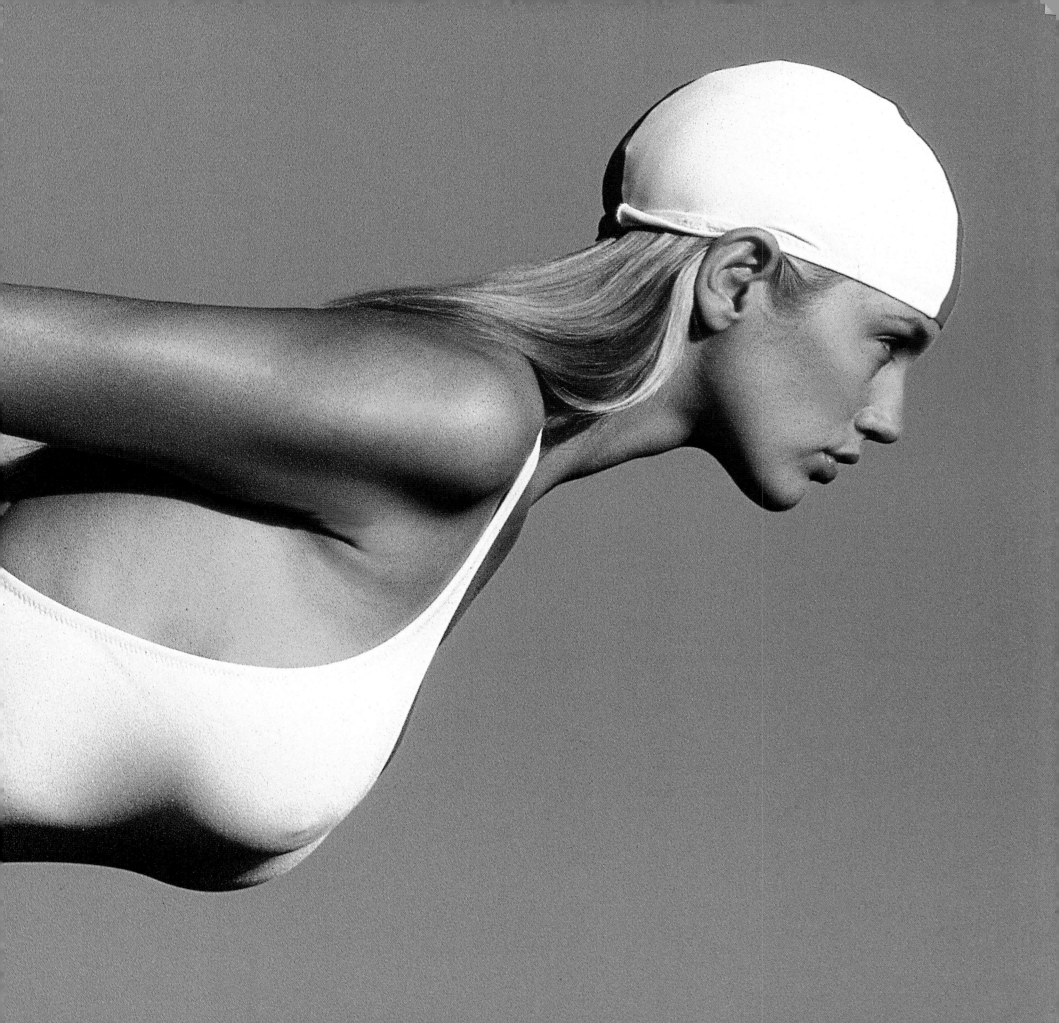

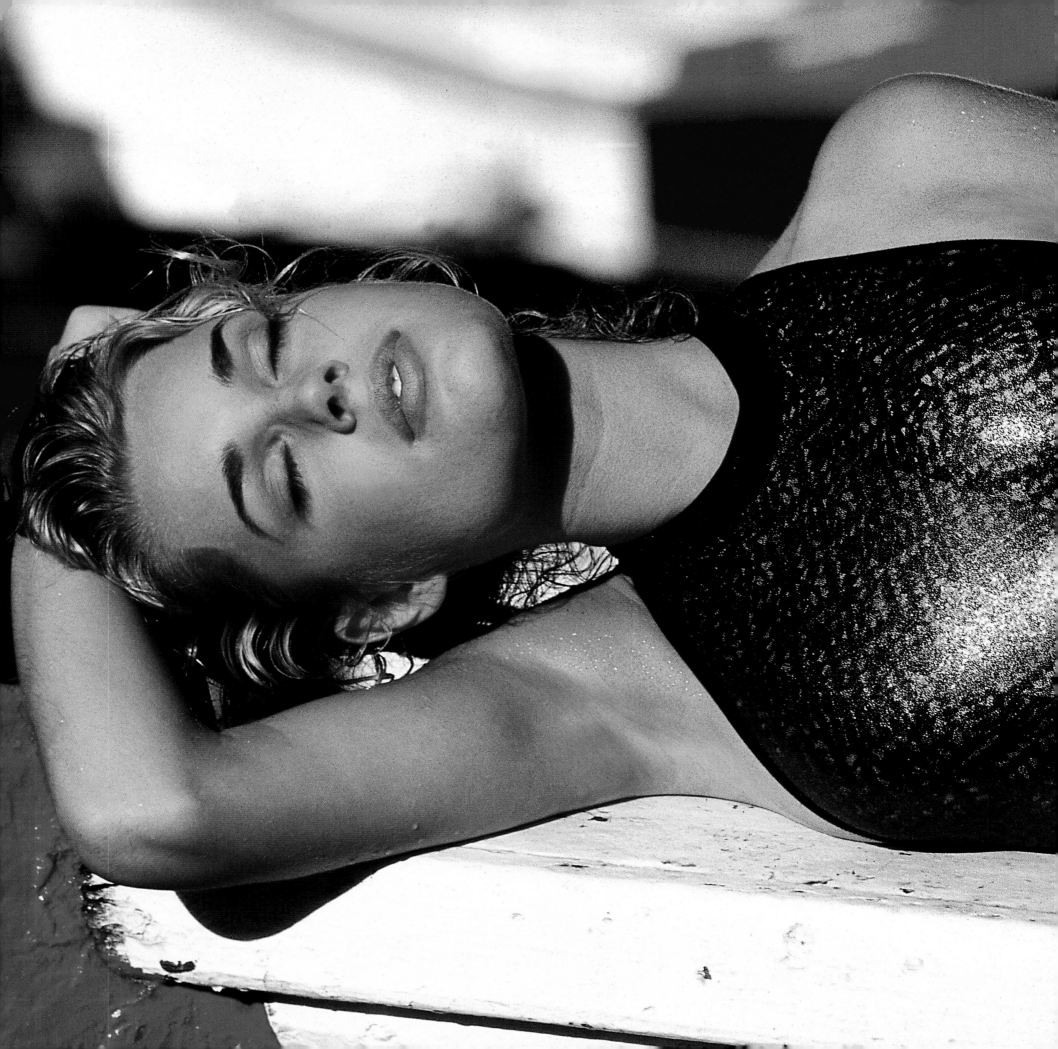

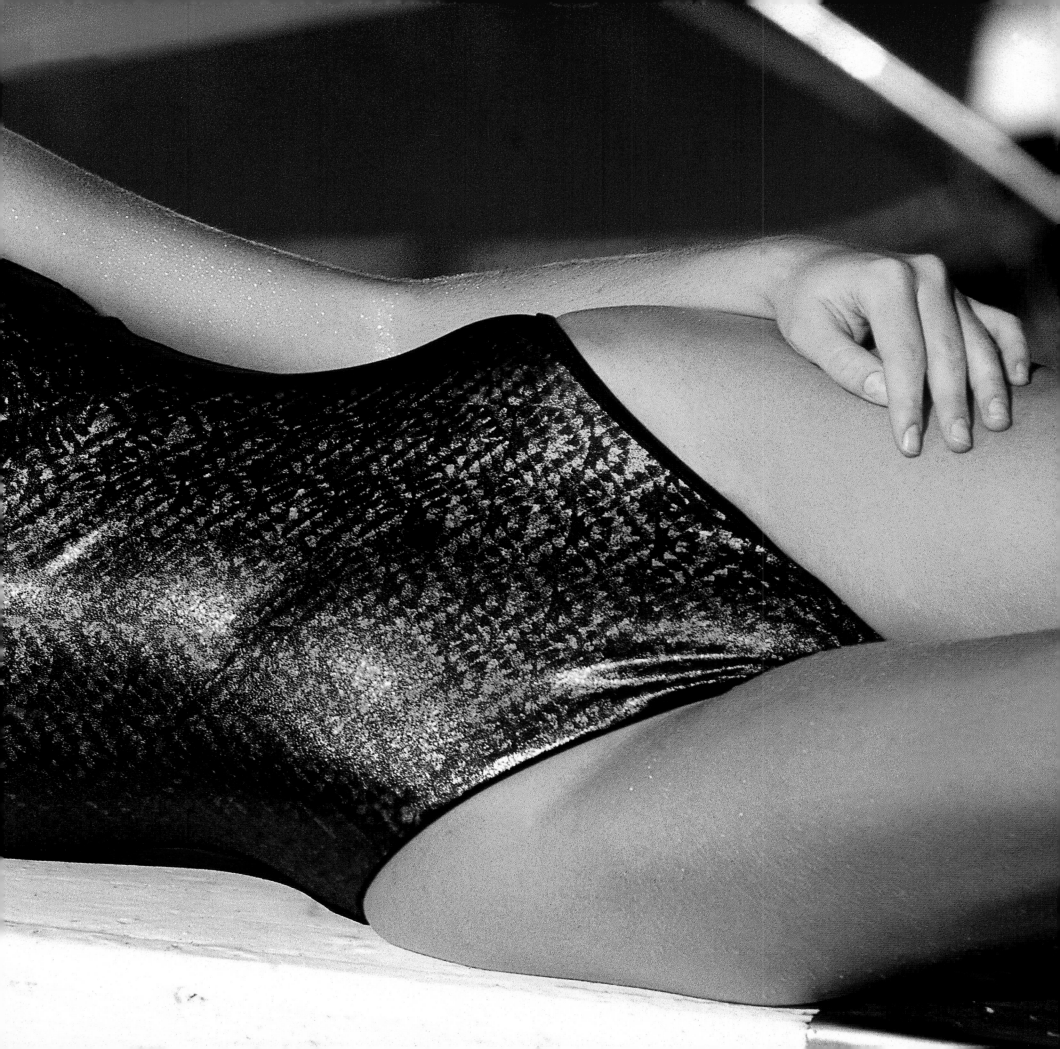

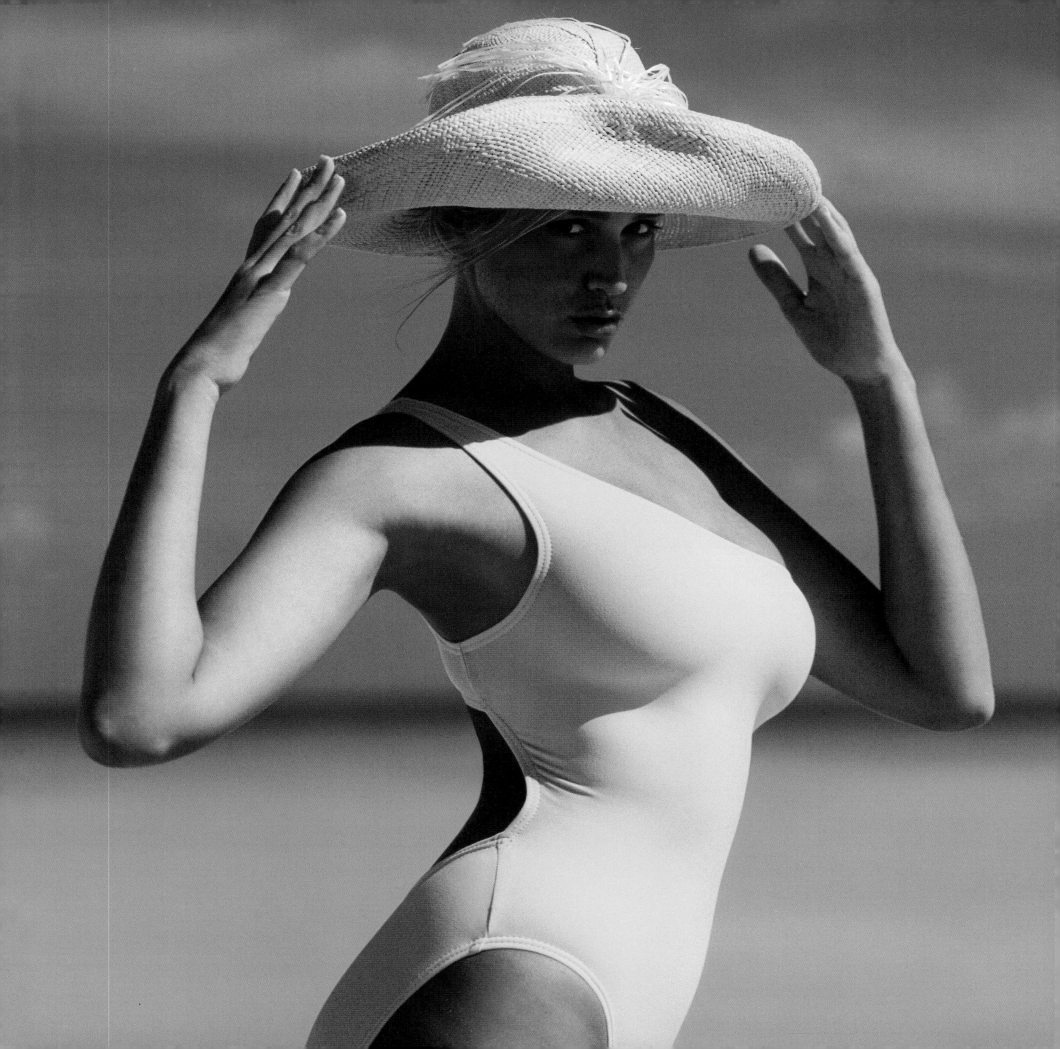

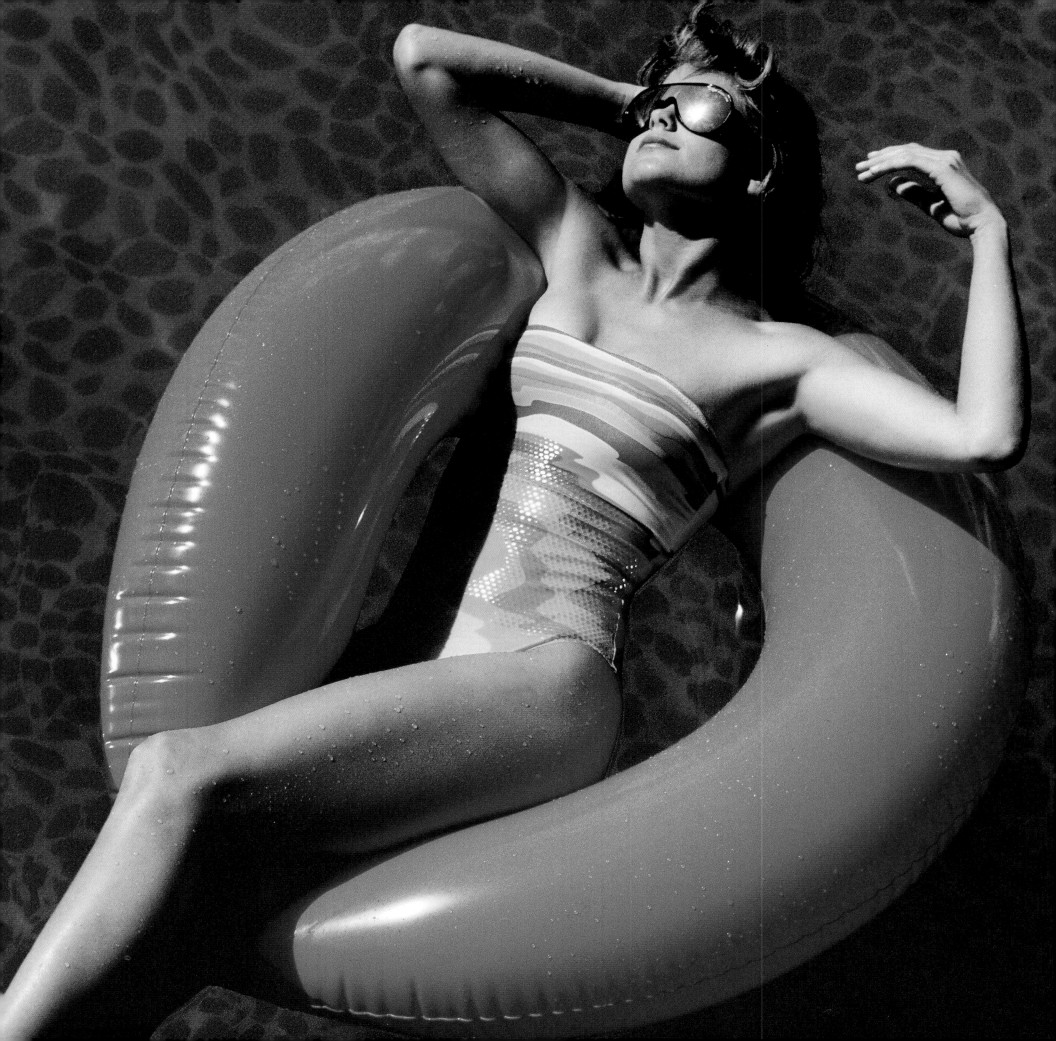

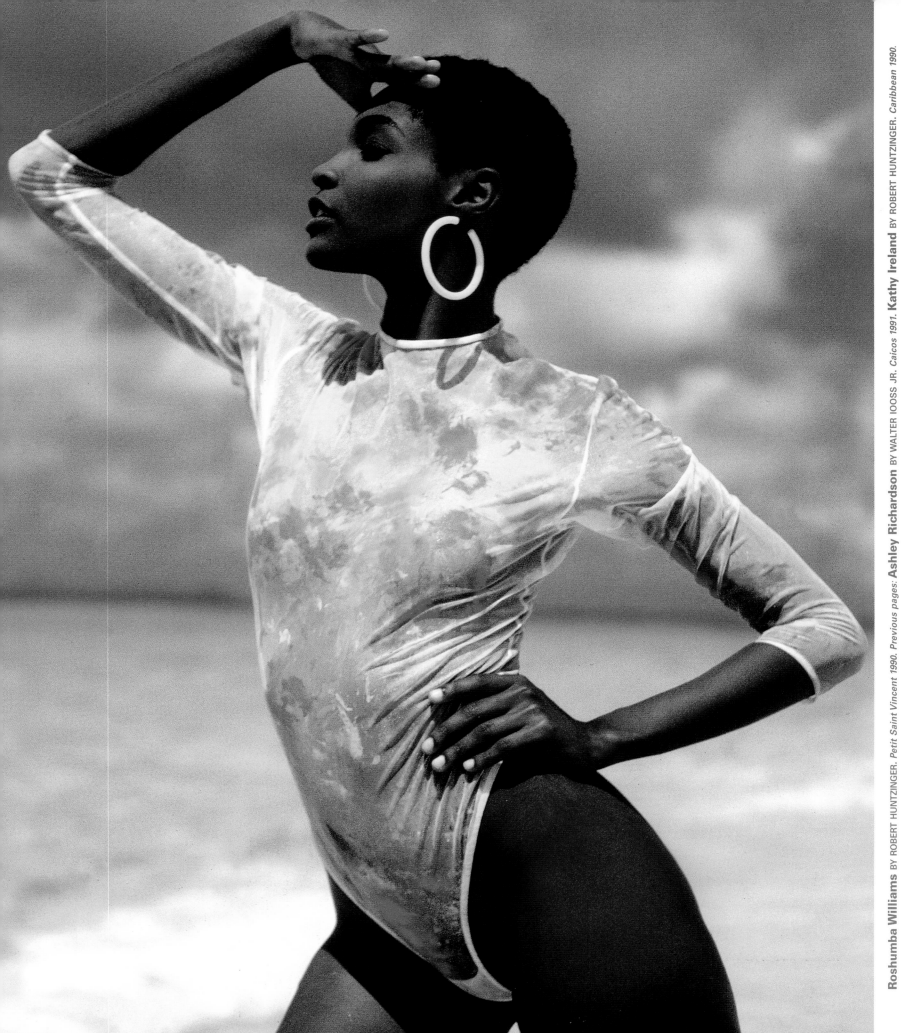

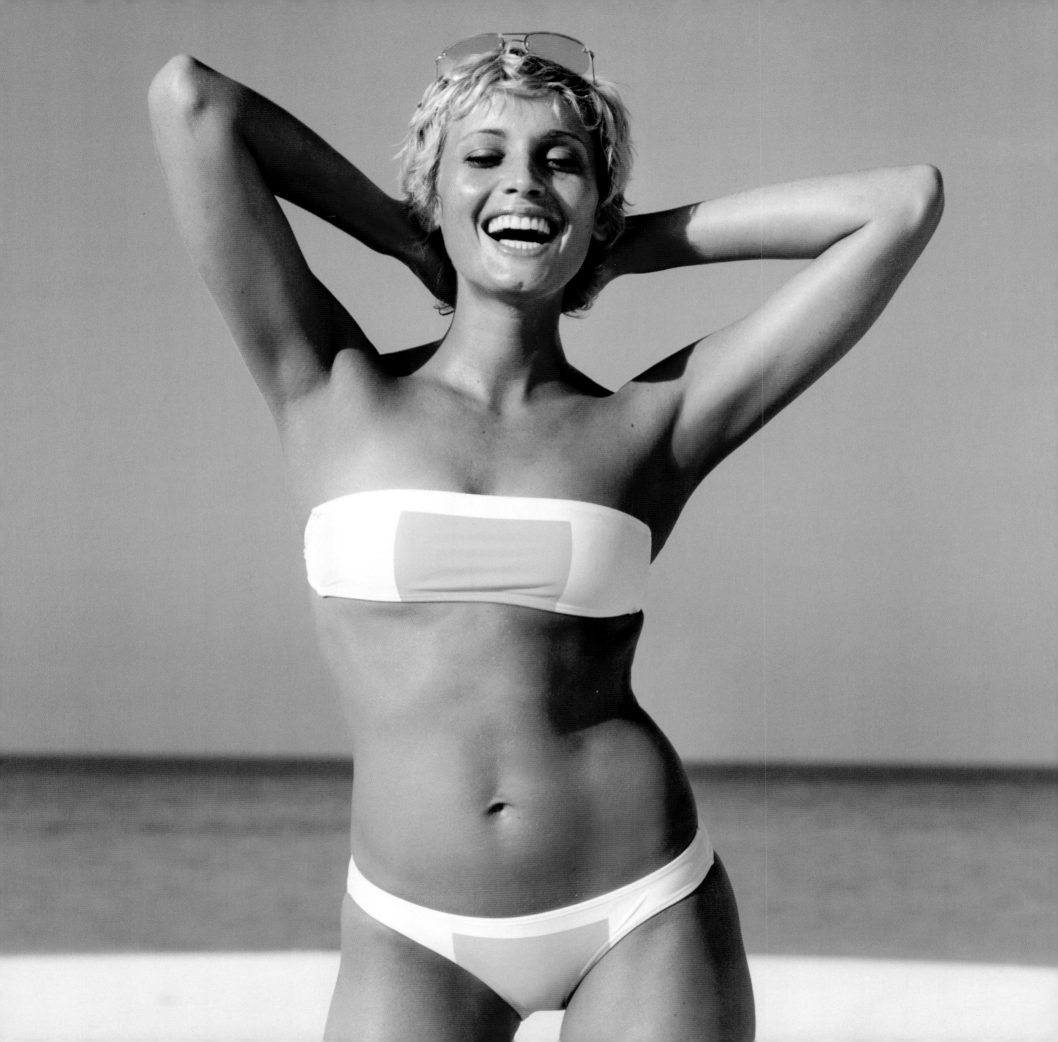

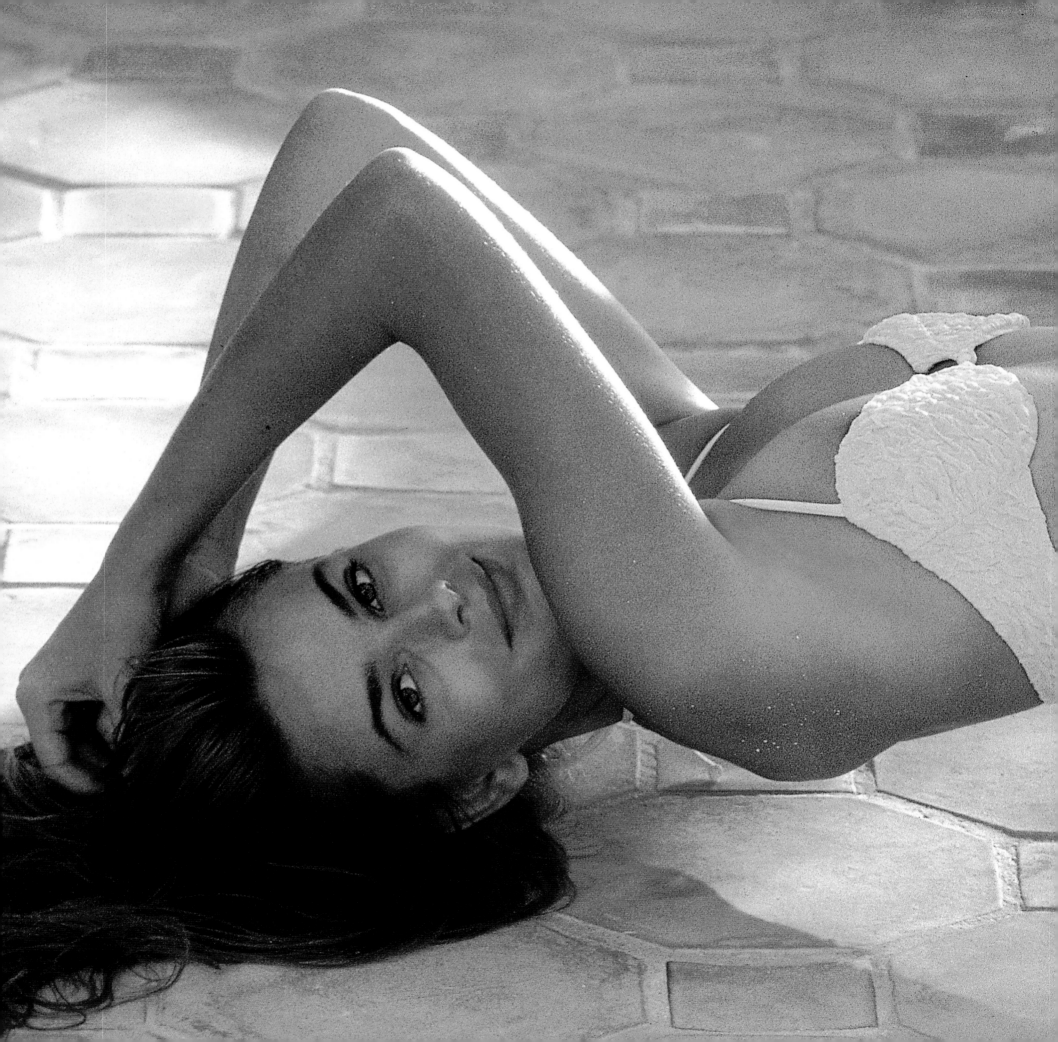

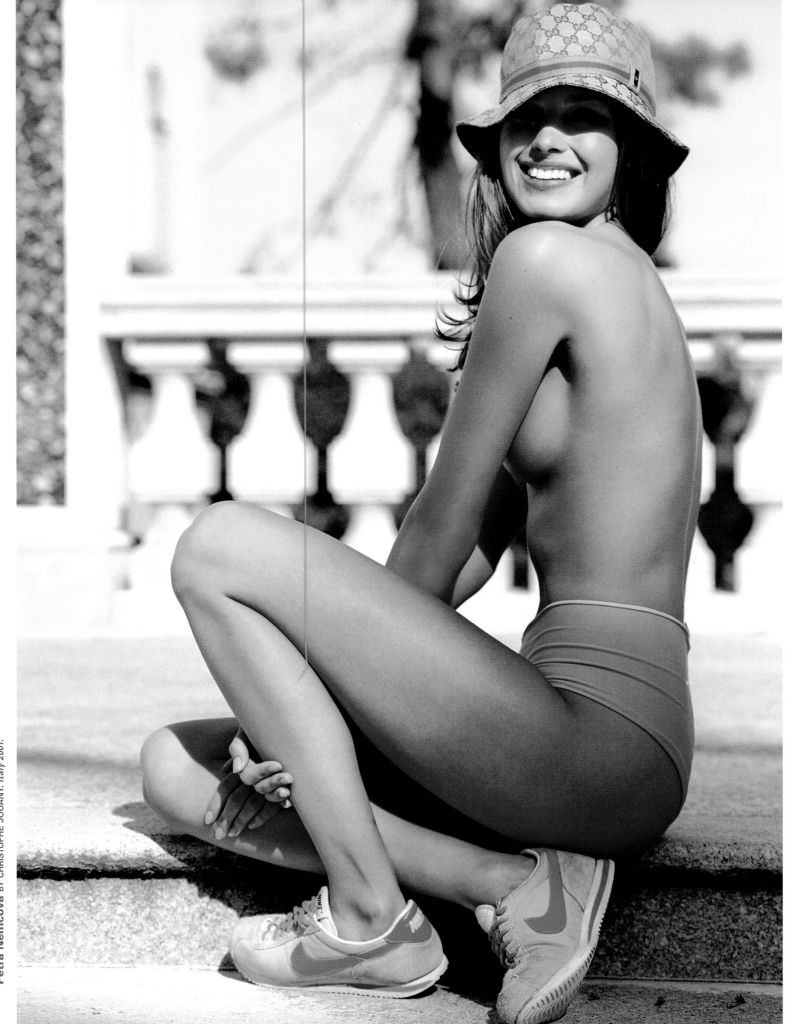

Petra Nemcova BY CHRISTOPHE JOUANY. *Italy 2001.*

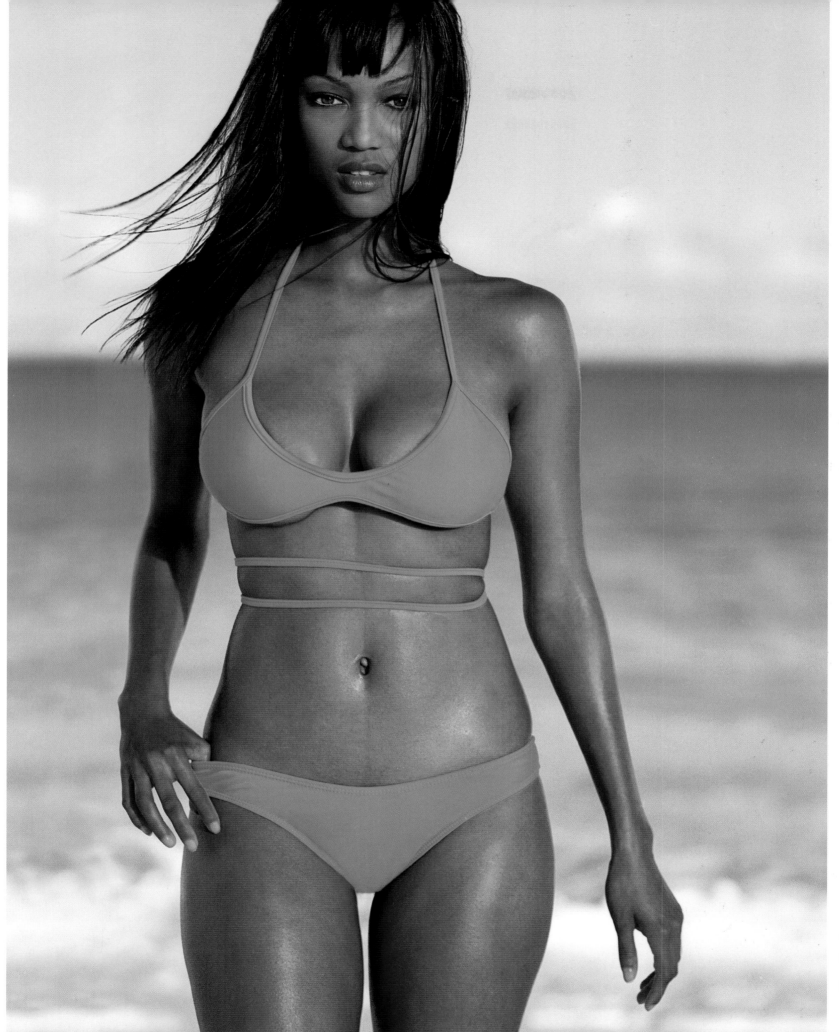

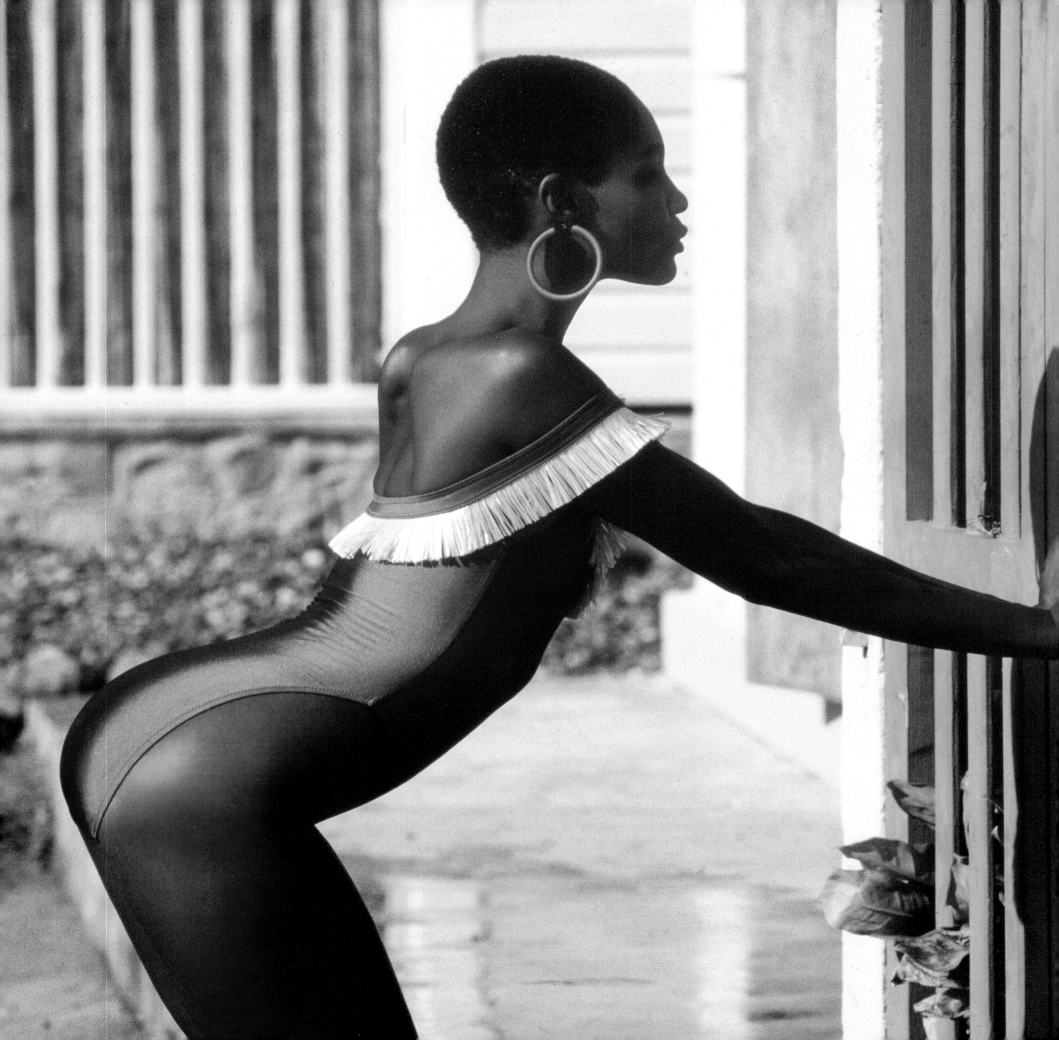

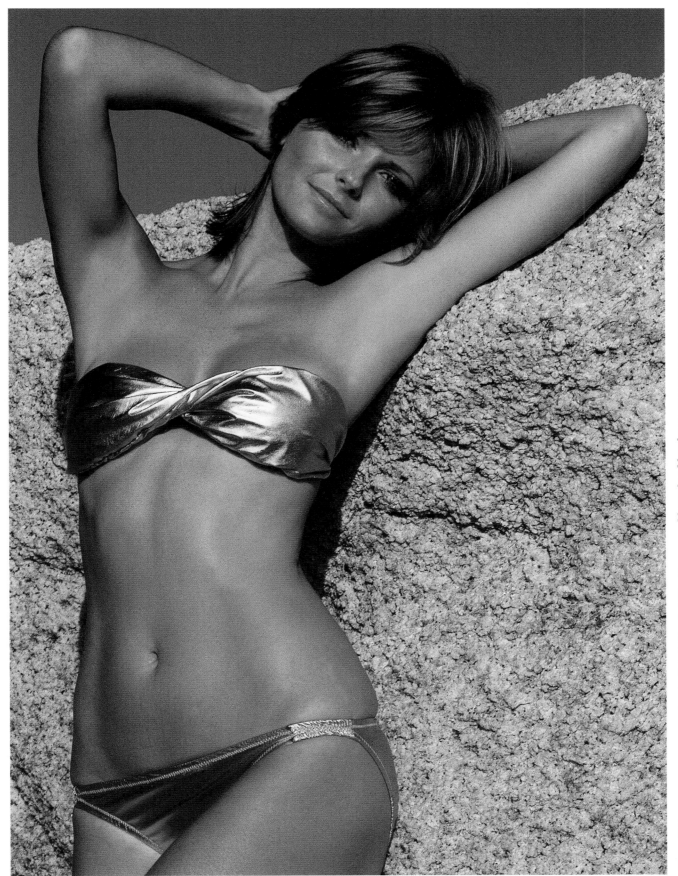

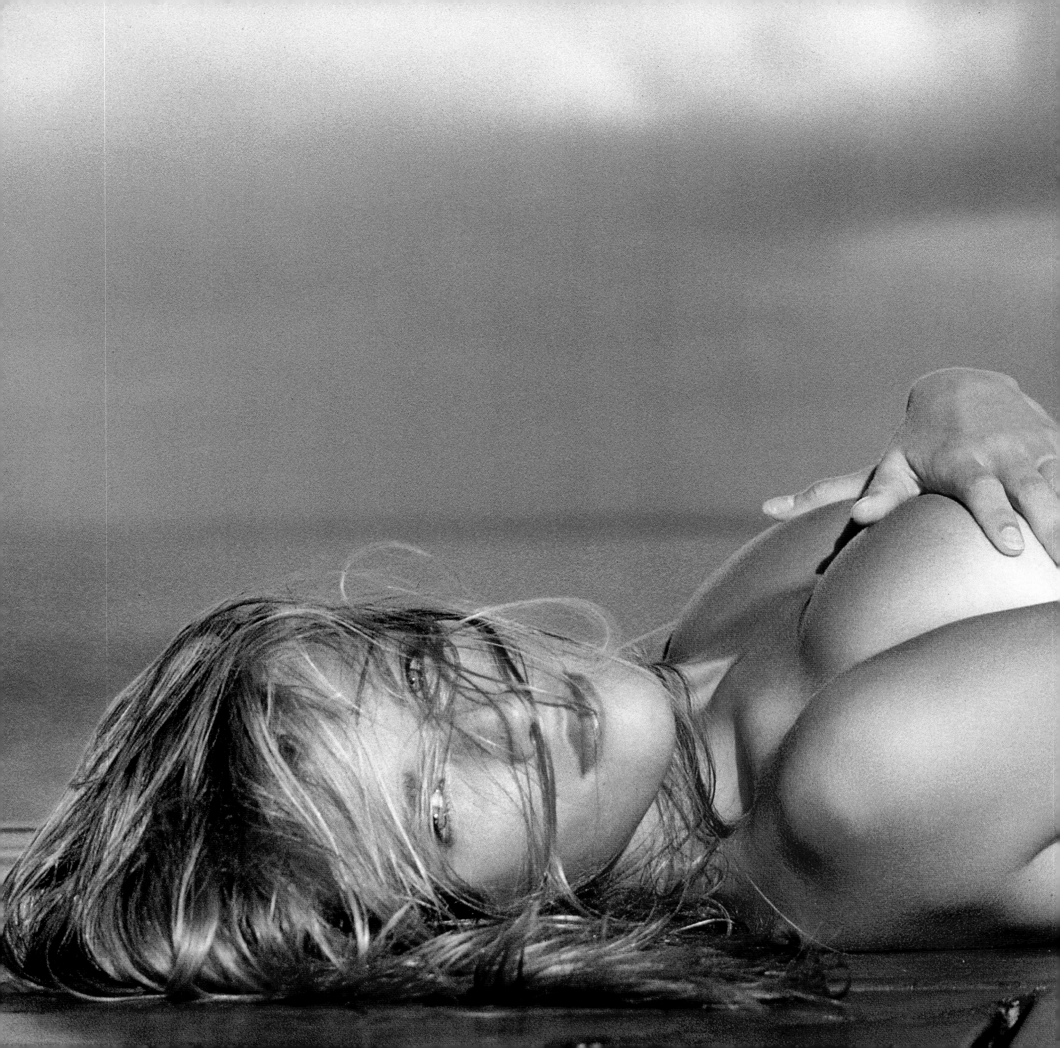

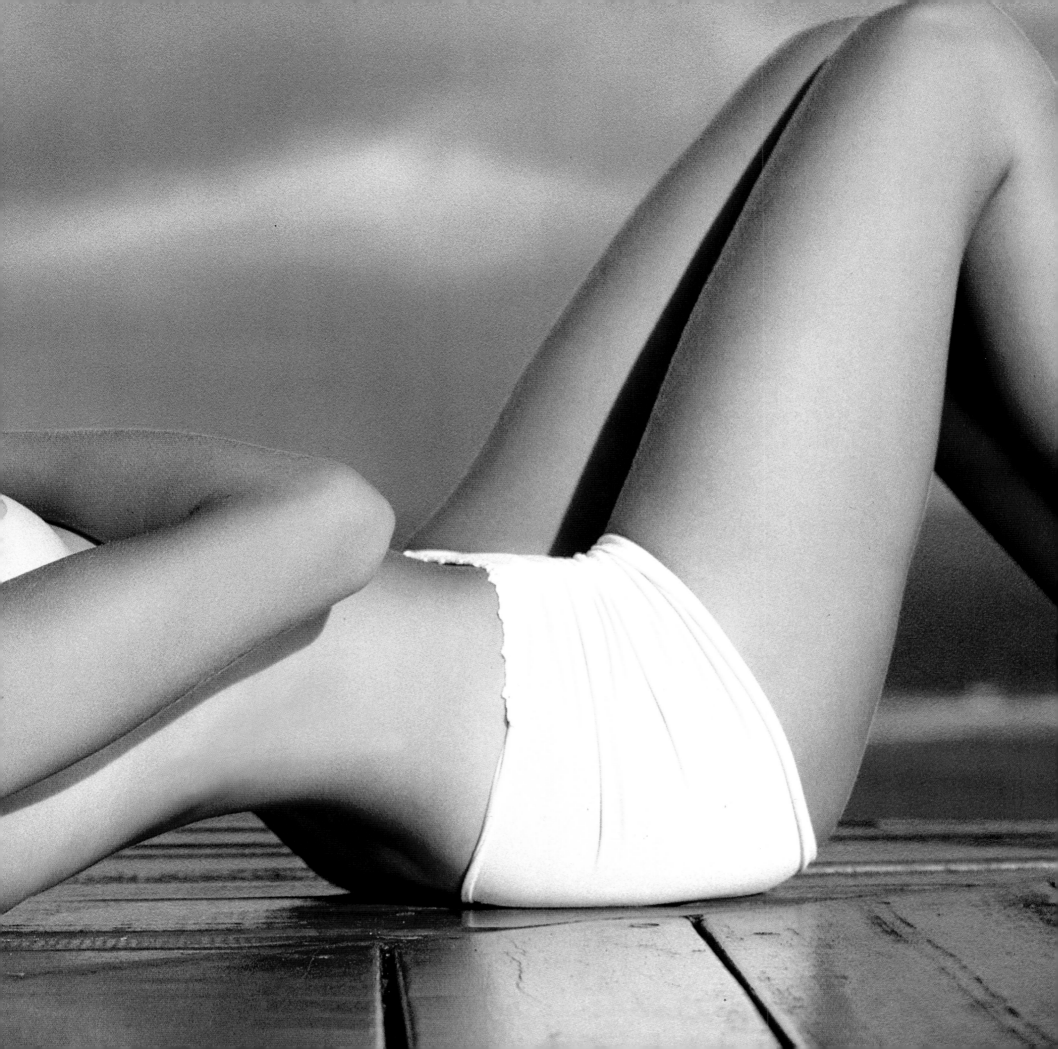

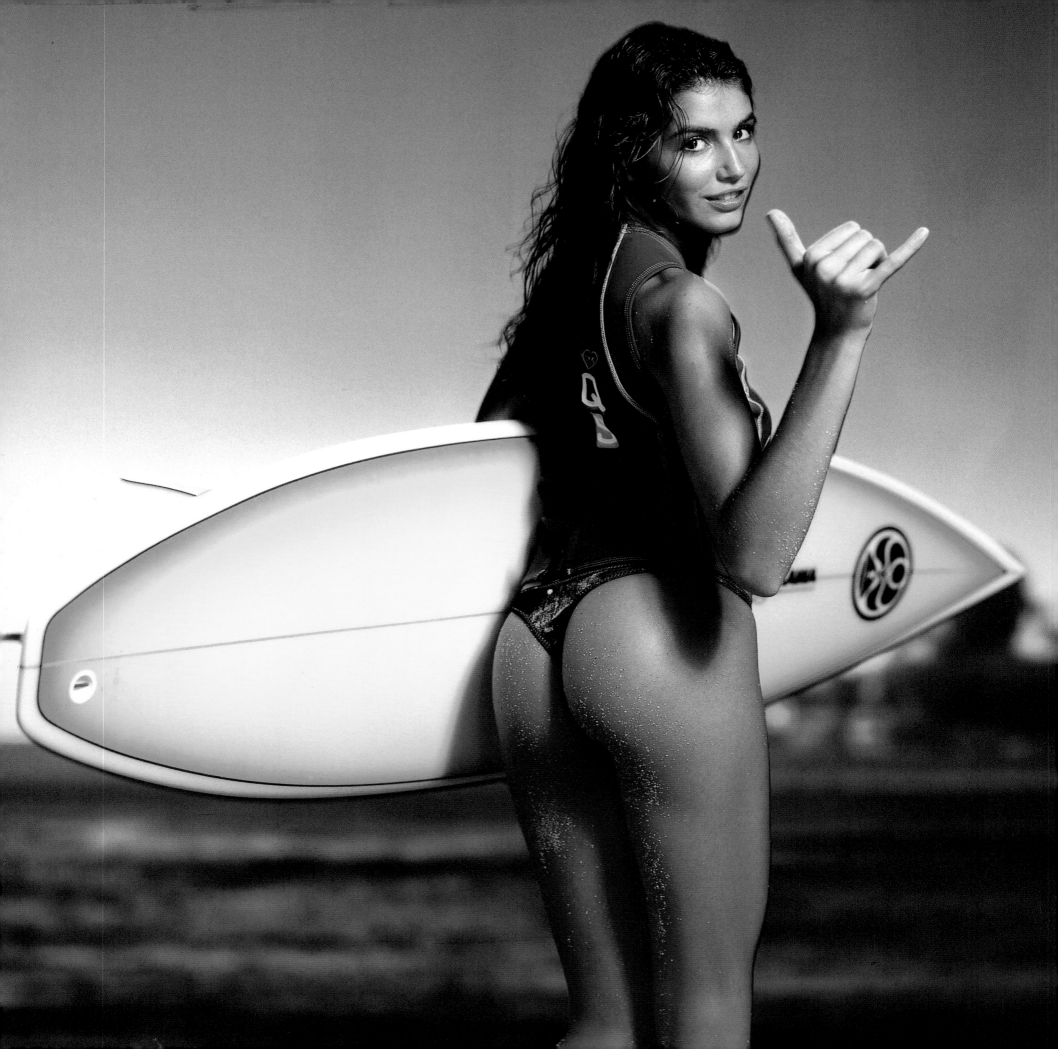

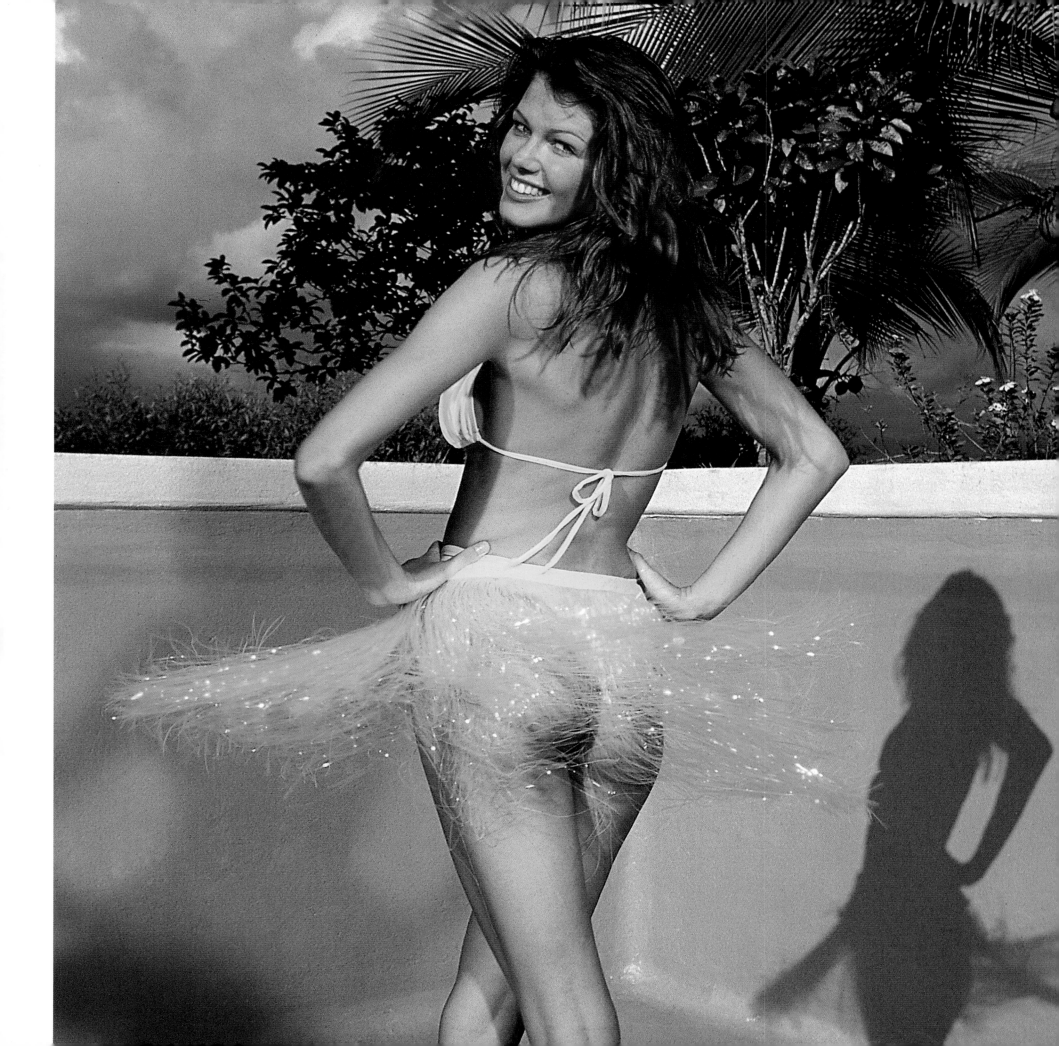

Any girl can be glamorous; all you have to

> My boyfriend thinks I missed my true calling of being a librarian.
> —PAULINA PORIZKOVA

> Through the centuries swimsuits have gone from the ridiculous to the sublime, with a few strange stops in between.
> —JULE CAMPBELL
> *SI swimsuit editor, 1964 – 1996*

o is stand still and look stupid —HEDY LAMARR

Put your hand on a hot stove for a minute, and it seems like an hour. Sit with a pretty girl for an hour, and it seems like a minute. That's relativity.
—ALBERT EINSTEIN

We've run male nudes in *Cosmopolitan*, and we still run male pulchritude, but there's nothing like a picture of a pretty girl. There's just no comparison. Everybody likes pretty girls.
—HELEN GURLEY BROWN

Self-love has very little to do with how you feel about your outer self. It's about accepting all of yourself. You've got to learn to accept the fool in you as well as the part that's got it goin' on.
—TYRA BANKS

The basic and essential human

As for evolution, I have a hard time believing that billions of years ago two protozoa bumped into each other and evolved into Cindy Crawford.
—ROBERT G. LEE

The way I looked at it,
every time I smiled,
[my husband and I] were
a little closer to that
refrigerator-freezer we needed.
—JAMEE BECKER GUILBERT
cover model, 1969

s the woman —ORSON WELLES

I'm tired of all this
business about beauty
being only skin-deep.
That's deep enough.
What do you want—an
adorable pancreas?
—JEAN KERR

In every man's heart
there is a secret nerve
that answers to
the vibration of beauty.
—CHRISTOPHER MORLEY

Lady Godiva put everything

she had on a horse. —W.C. FIELDS

Sir: It hit me like a ton of bricks!
I was utterly shocked, amazed,
disillusioned, upset, furious,
disappointed, depressed and
almost suicidal to discover that
Cheryl Tiegs was not included in
the swimsuit photographs. Not
one single shot! You have
destroyed one of my fondest
concepts of this great country of
ours: baseball, hot dogs, apple
pie and Cheryl Tiegs...

—CHRIS PRIEBE
Dearborn Heights, Mich., 1979

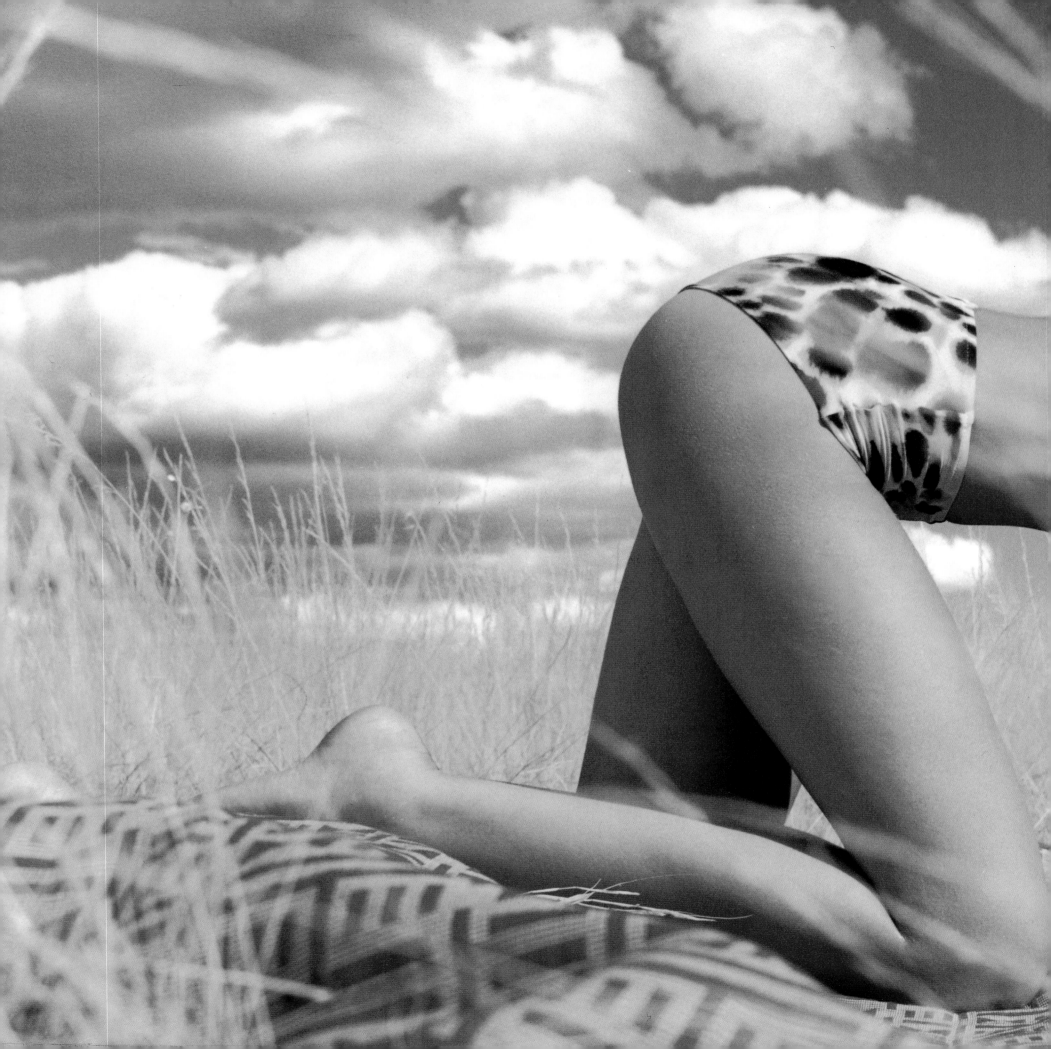

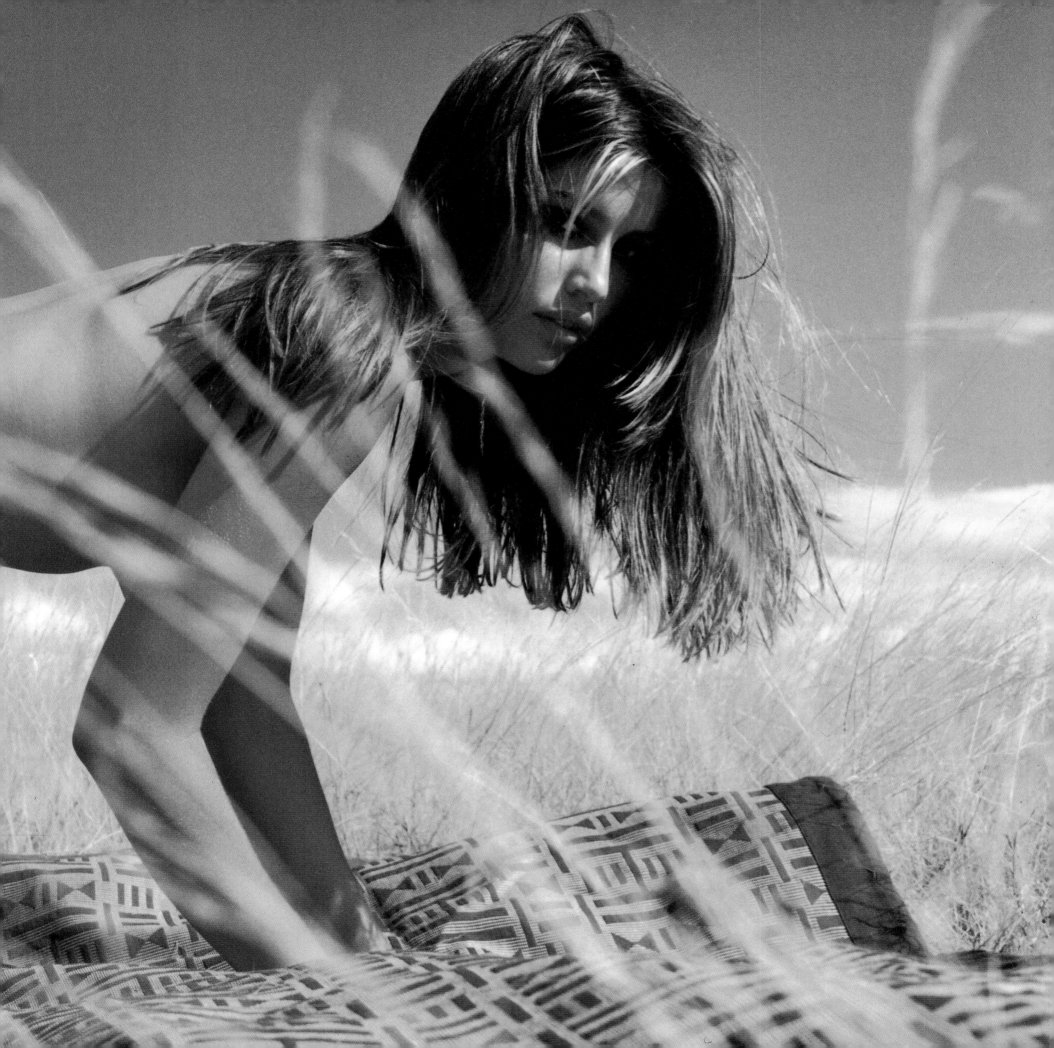

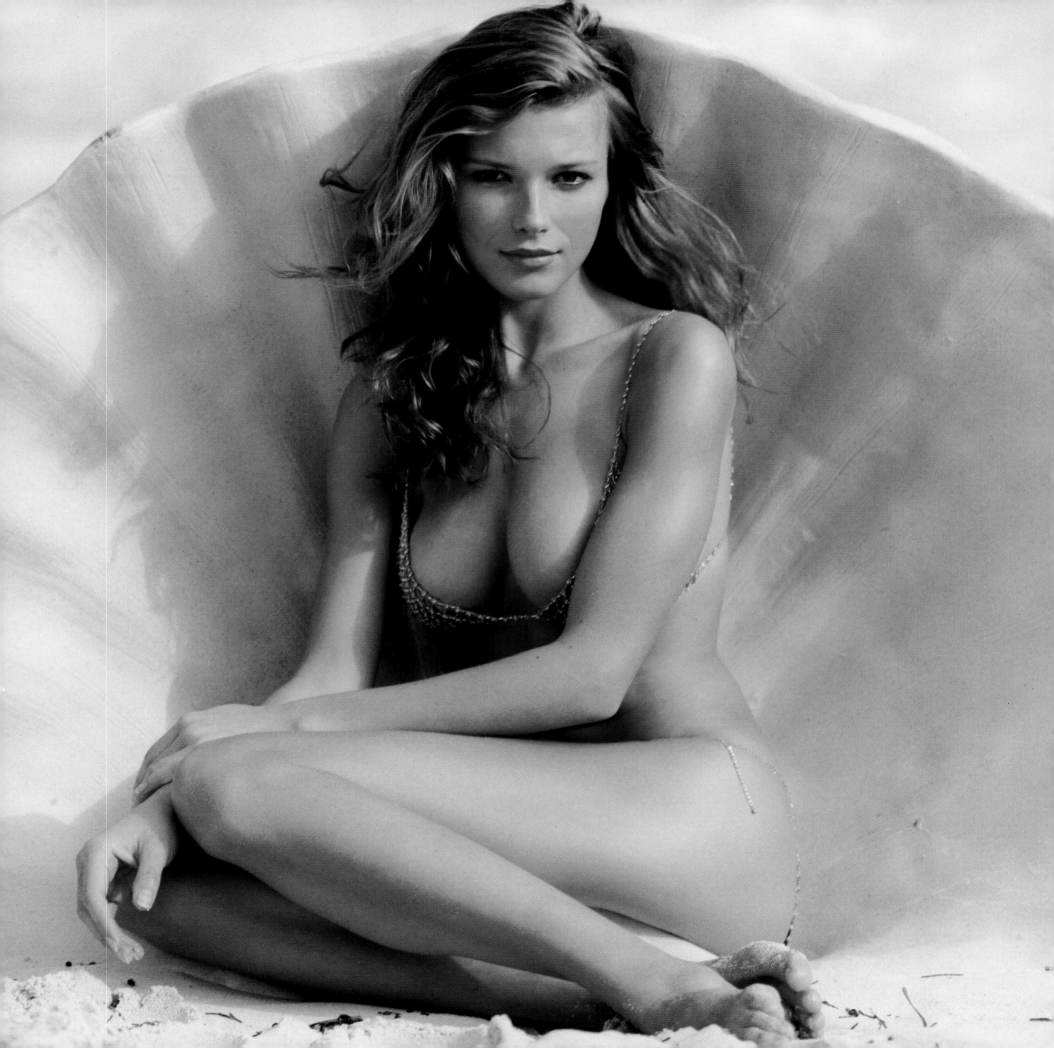

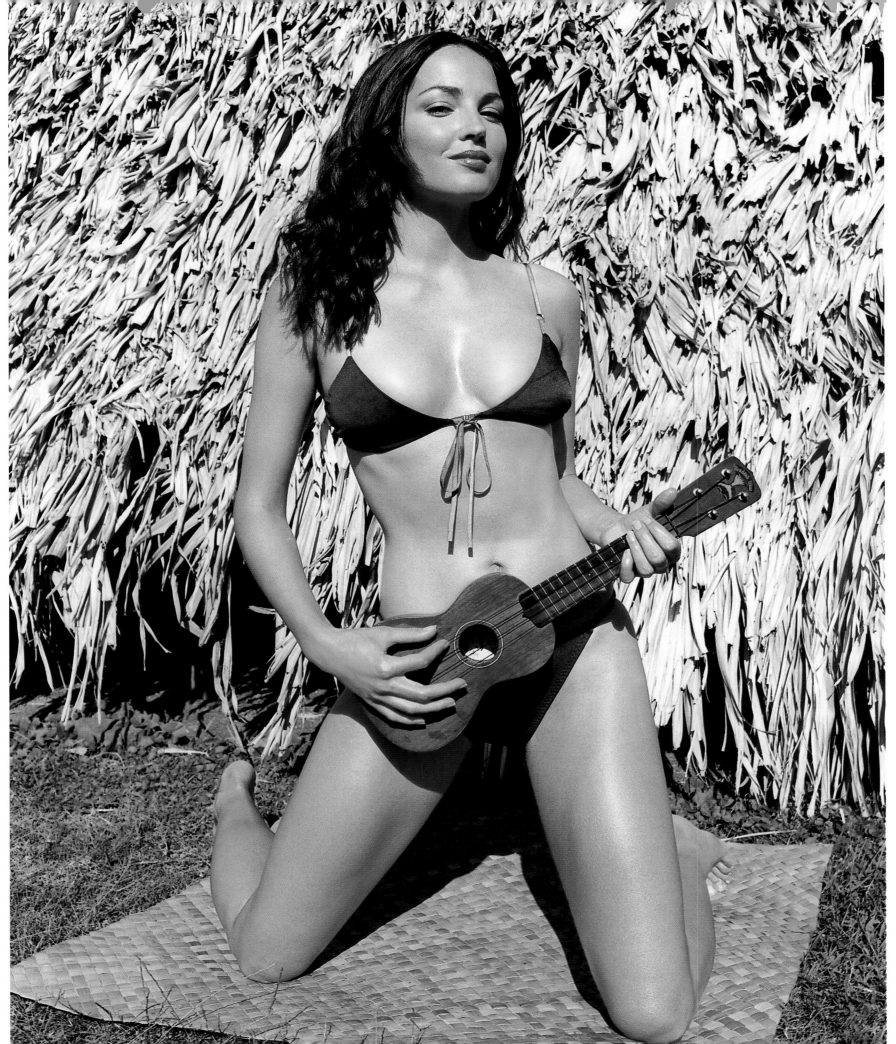

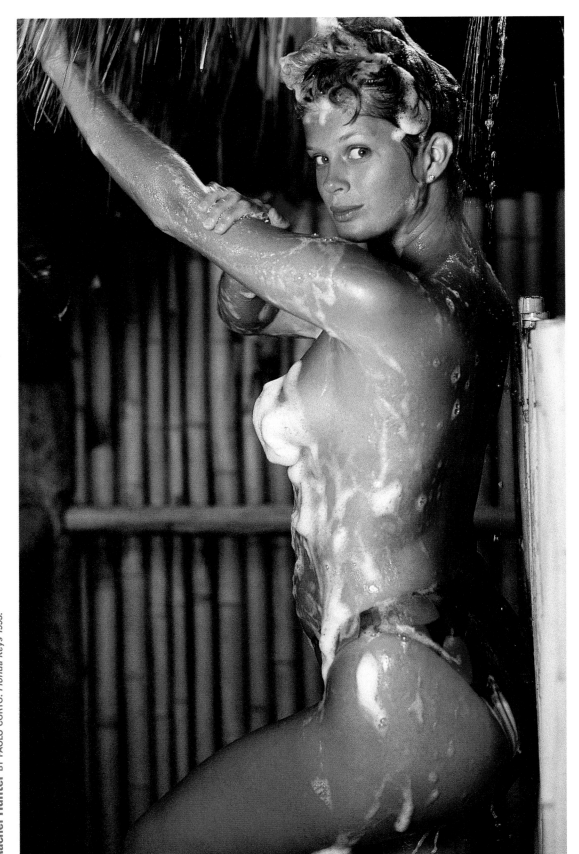

Rachel Hunter BY PAOLO CURTO. *Florida Keys 1993.*

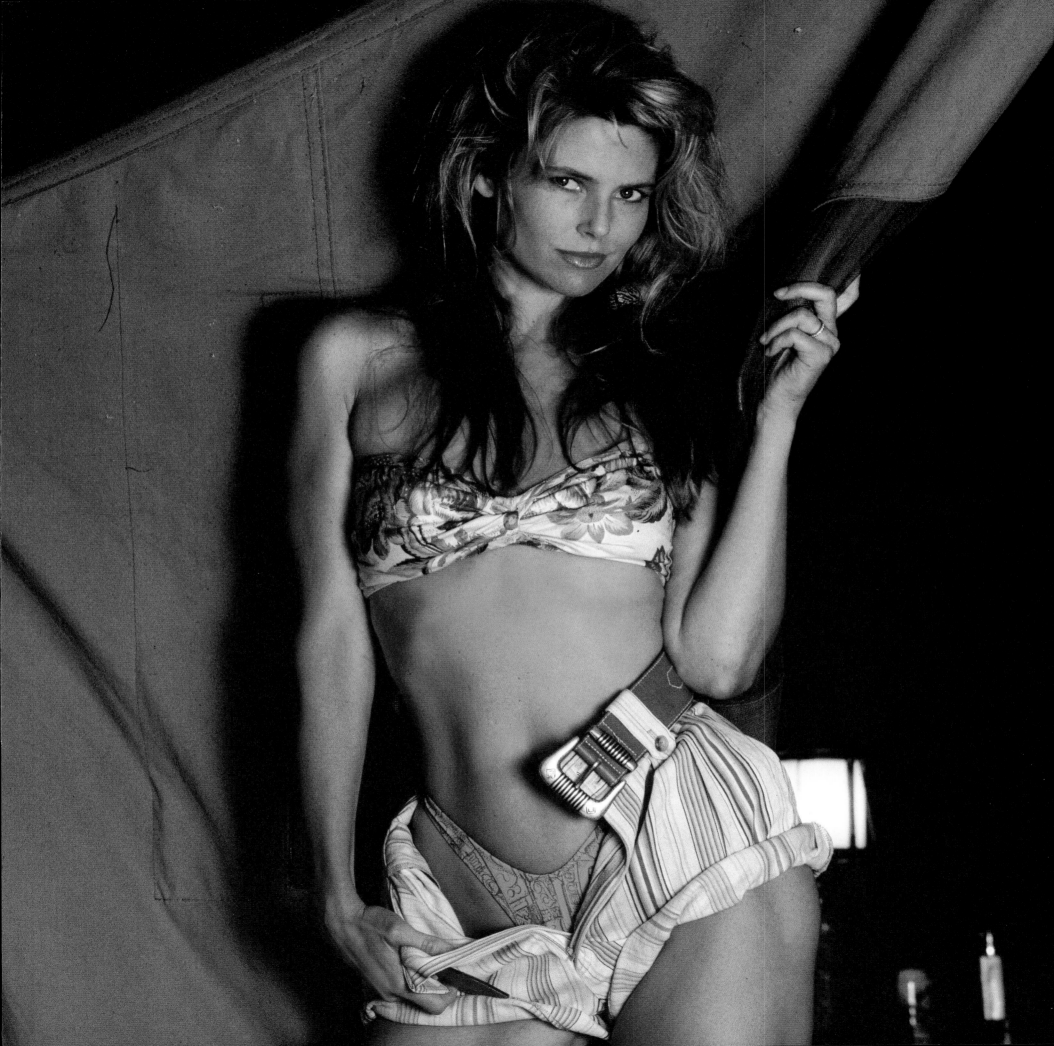

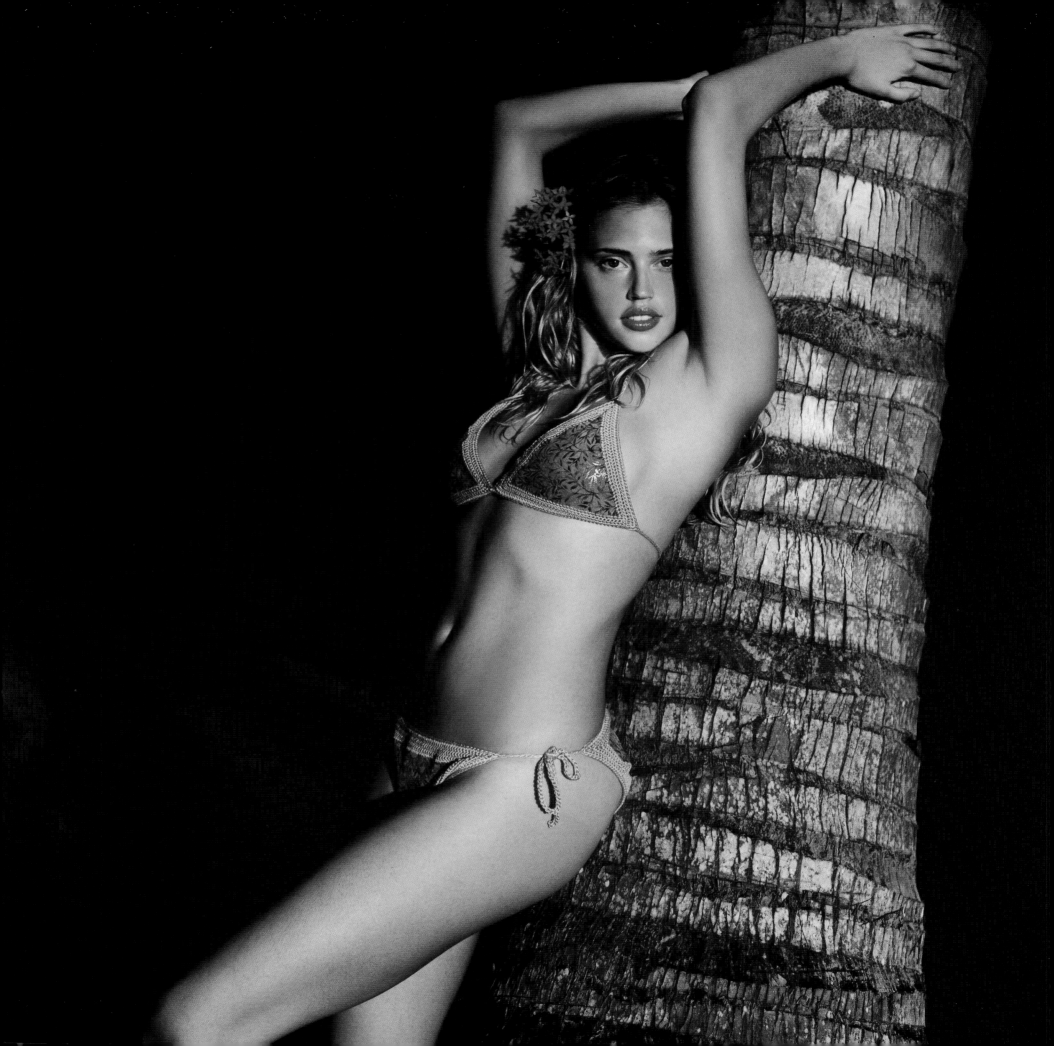

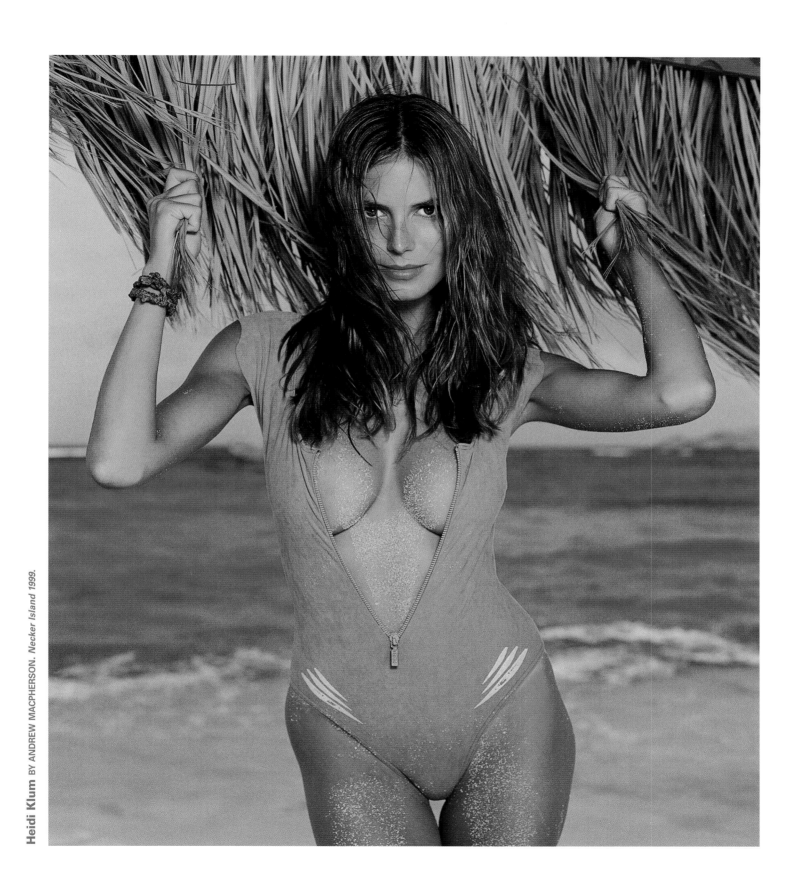

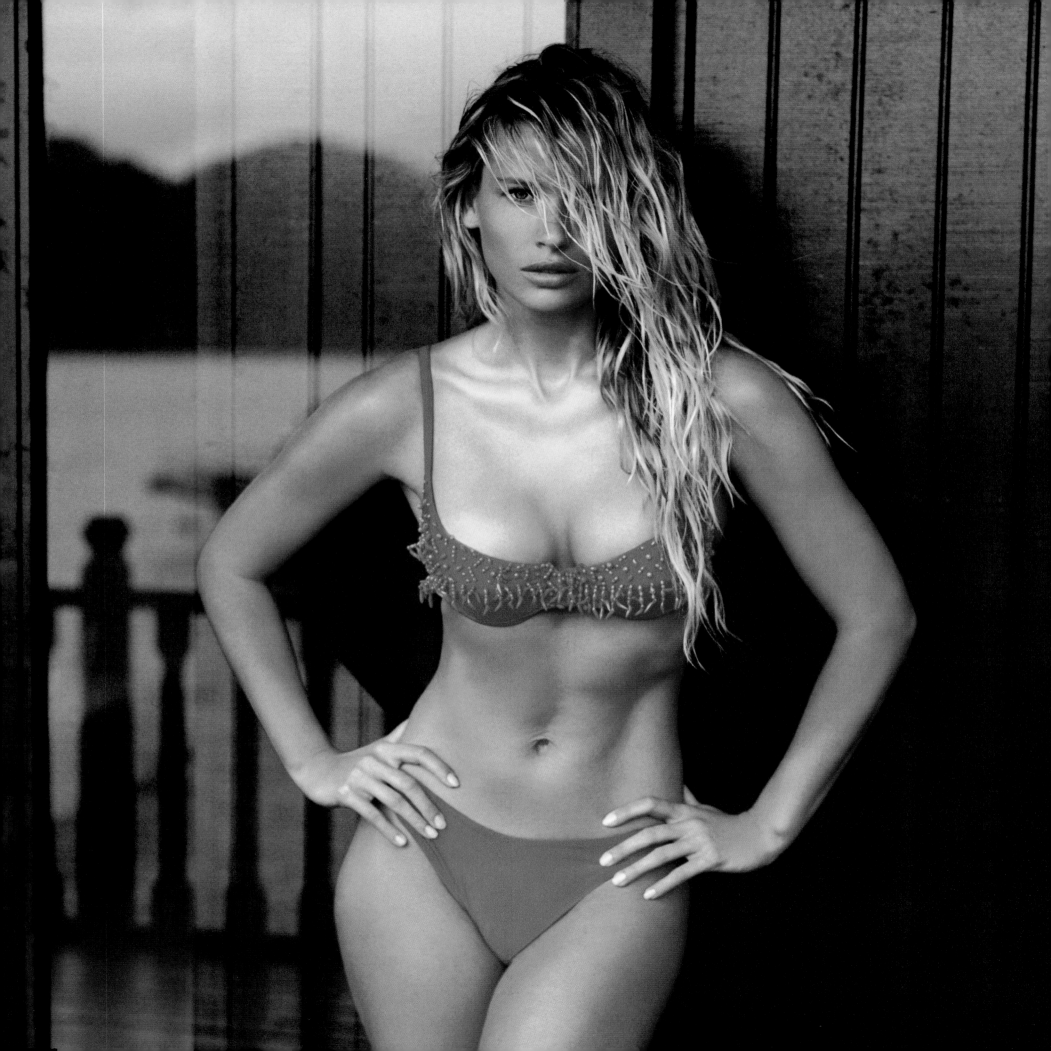

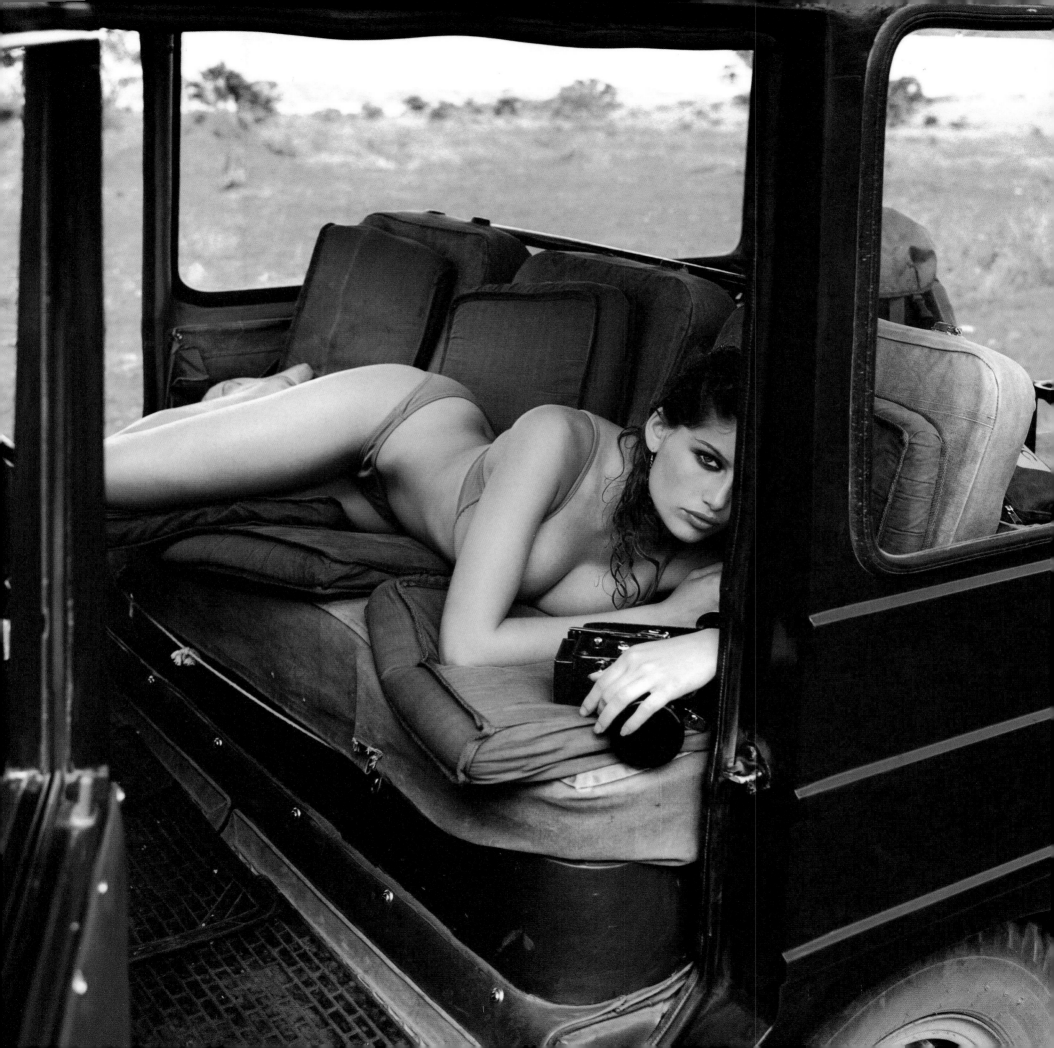

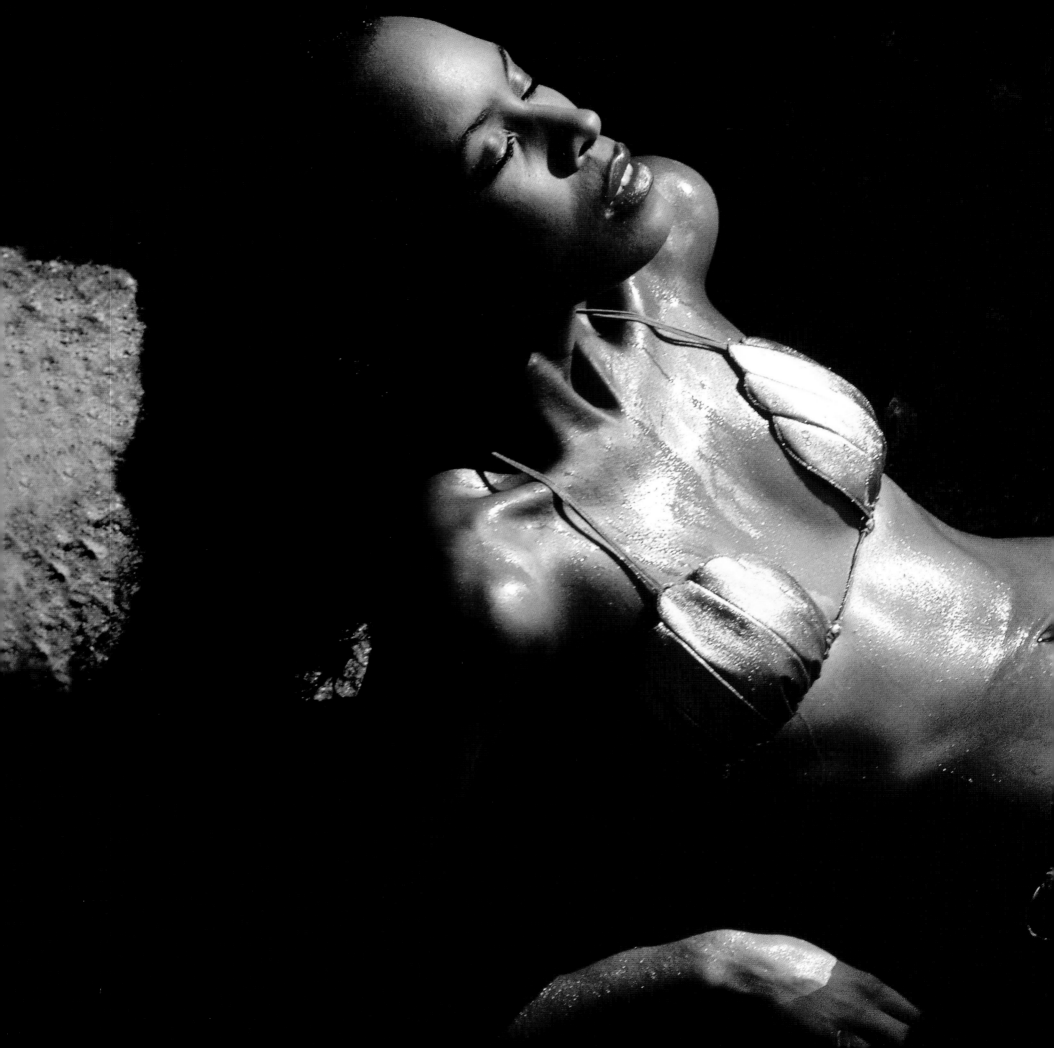

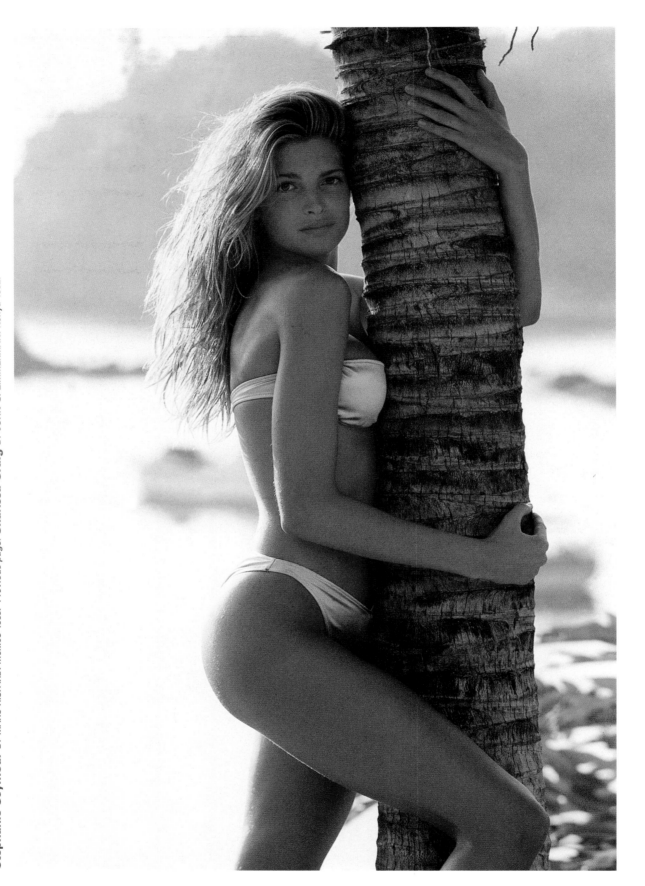

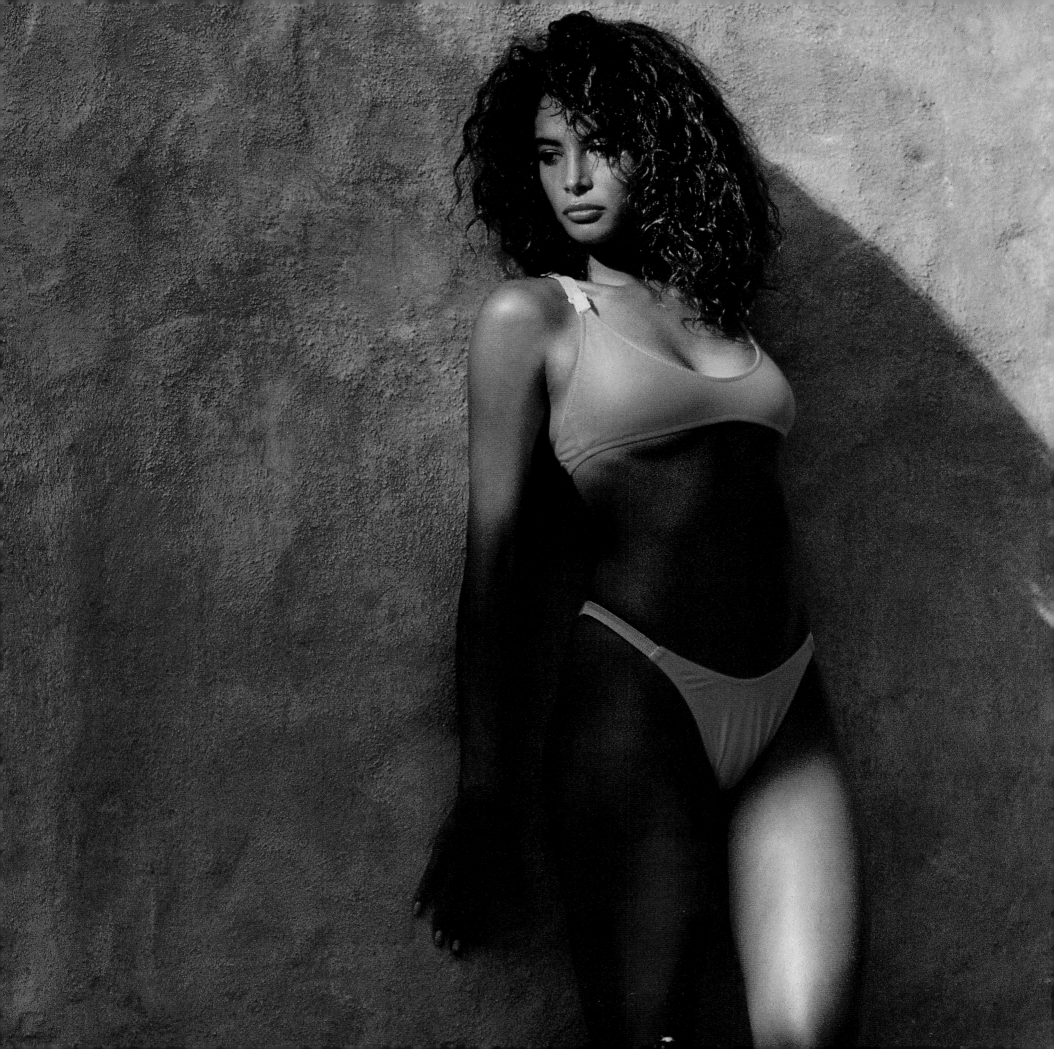

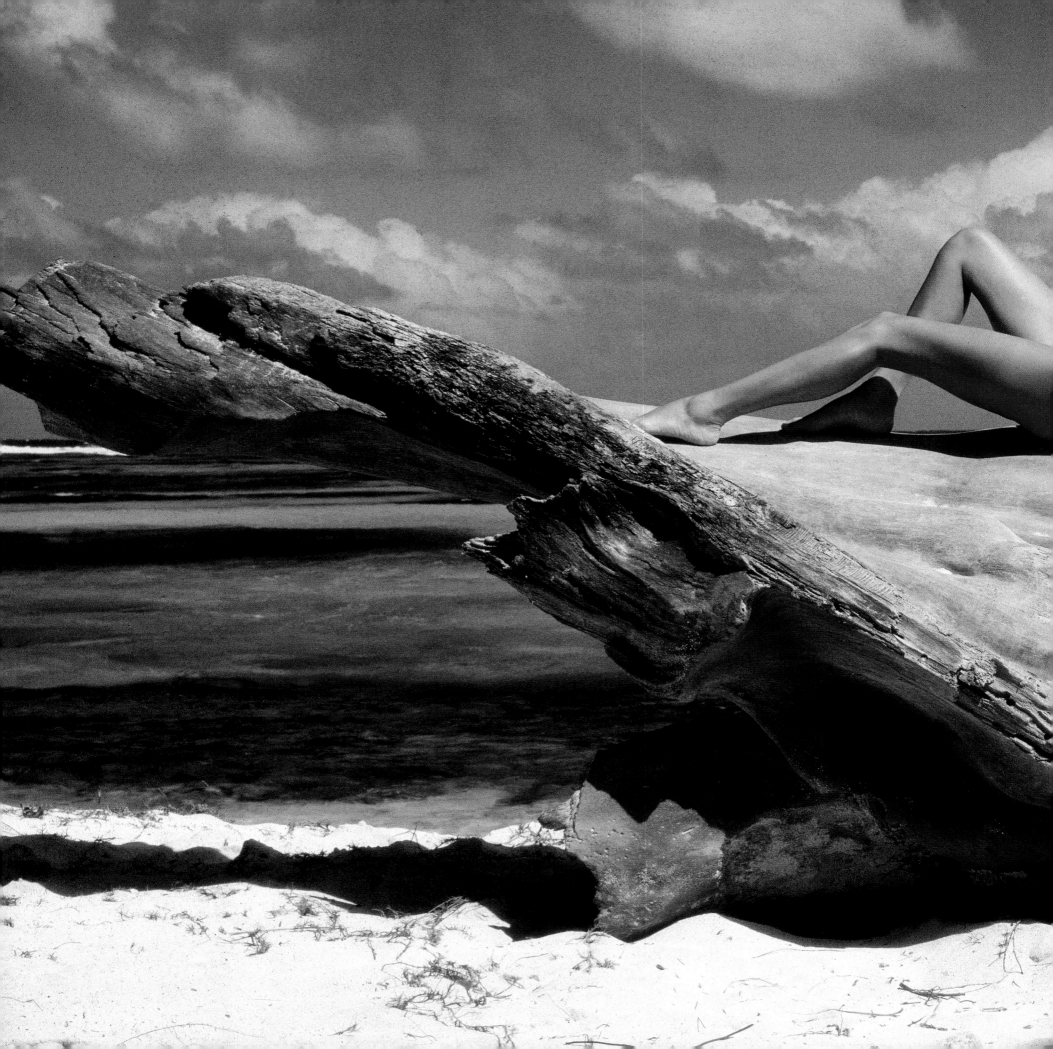

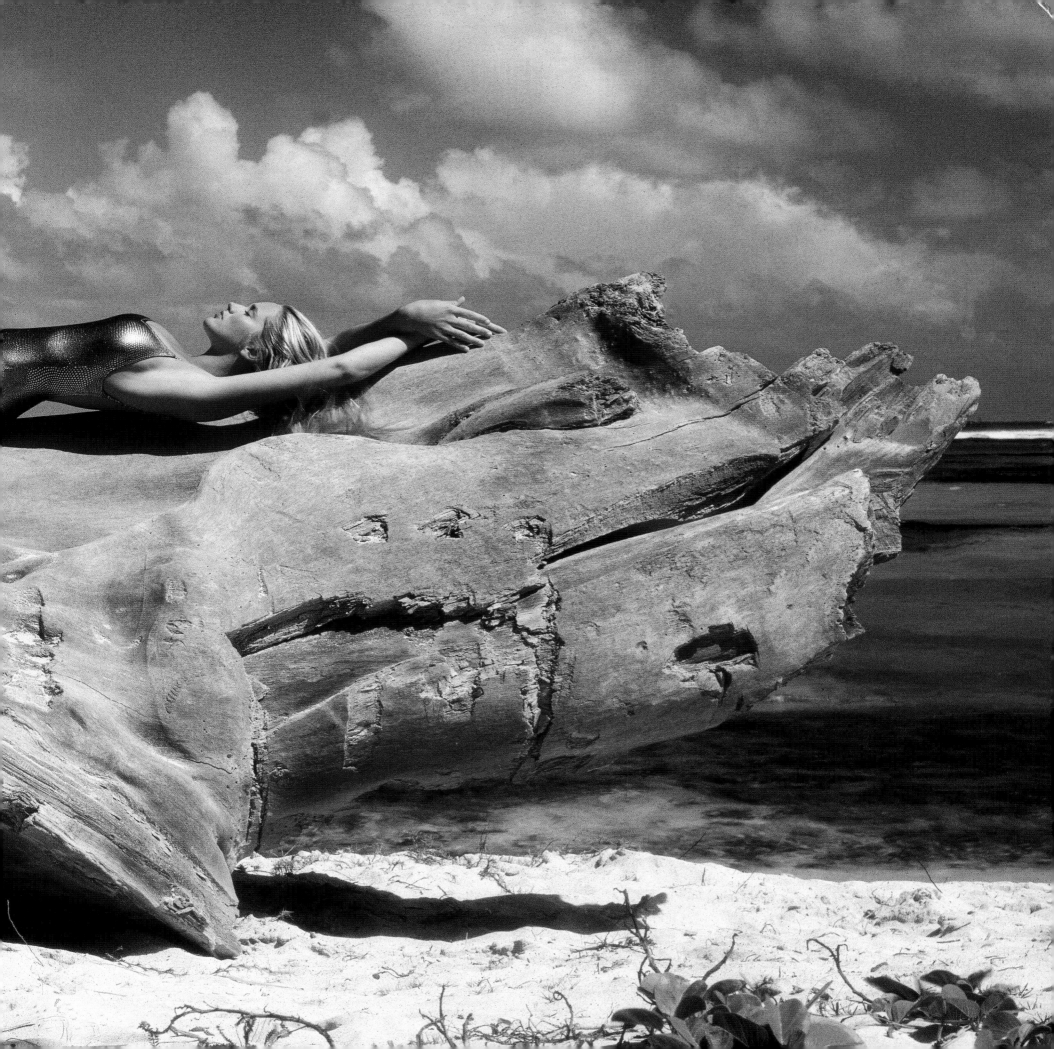

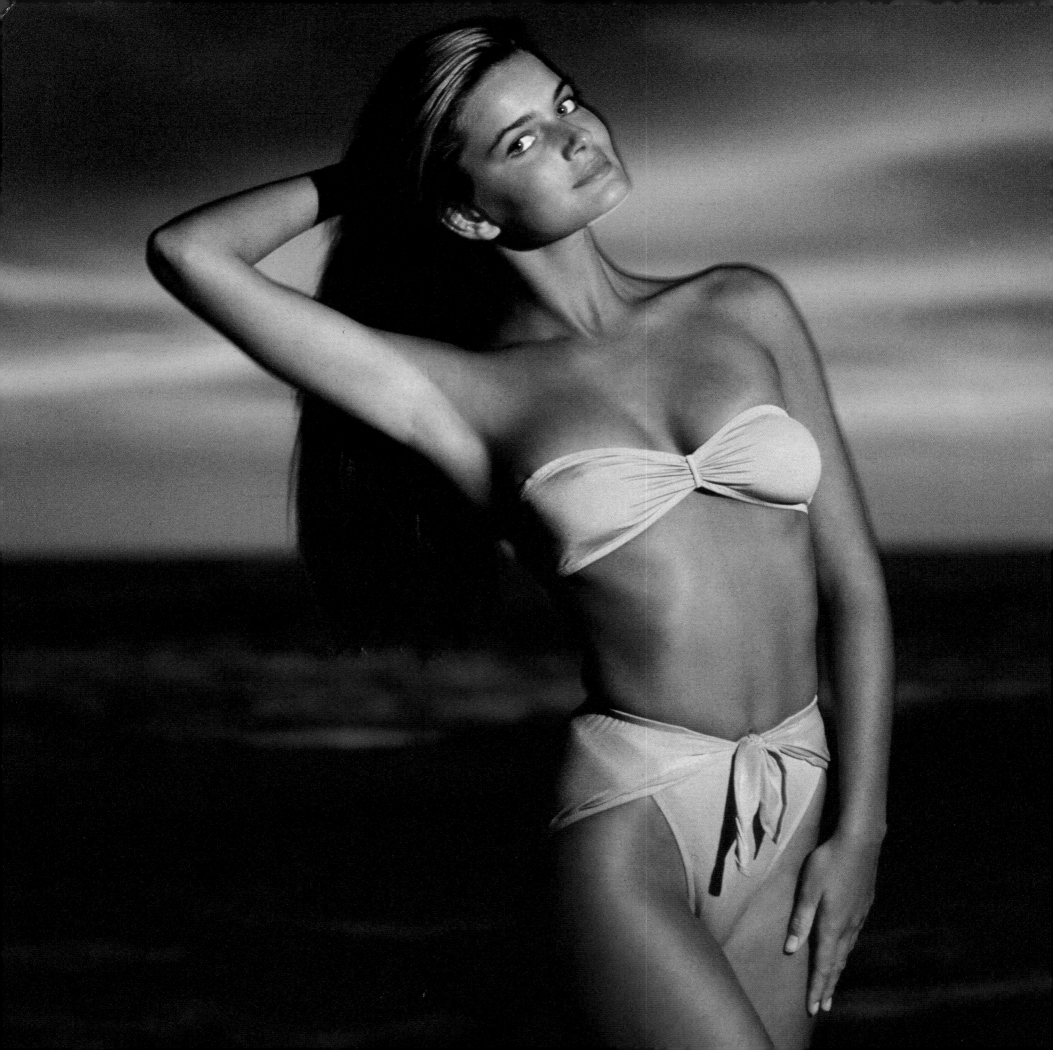

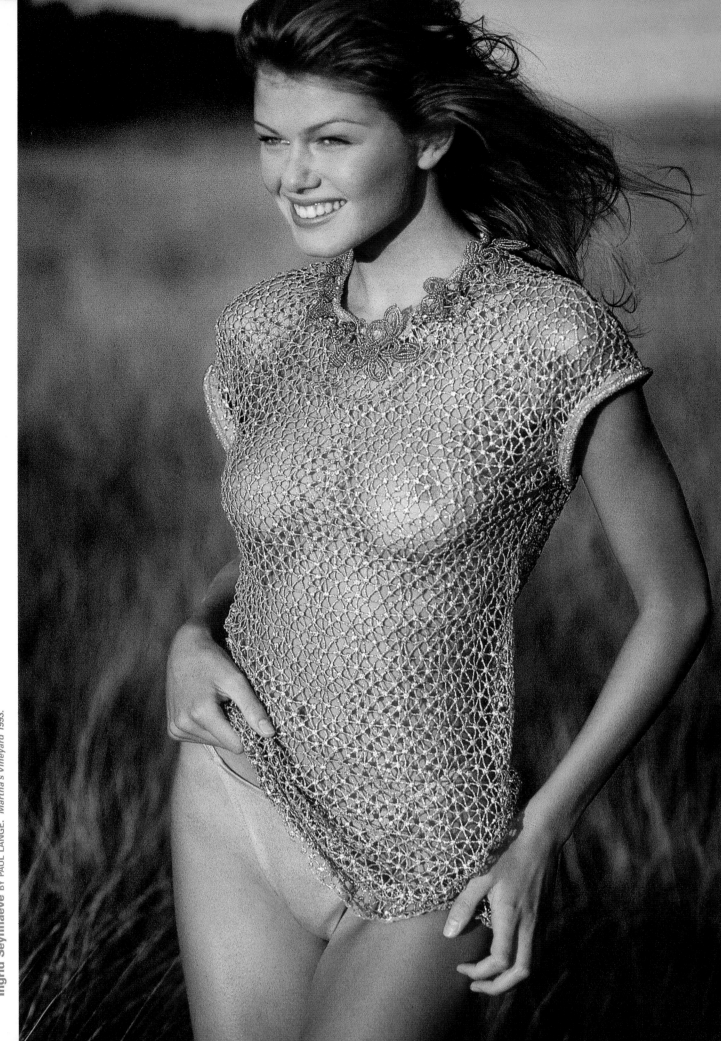

Ingrid **Seynhaeve** BY PAUL LANGE. *Martha's Vineyard 1993.*

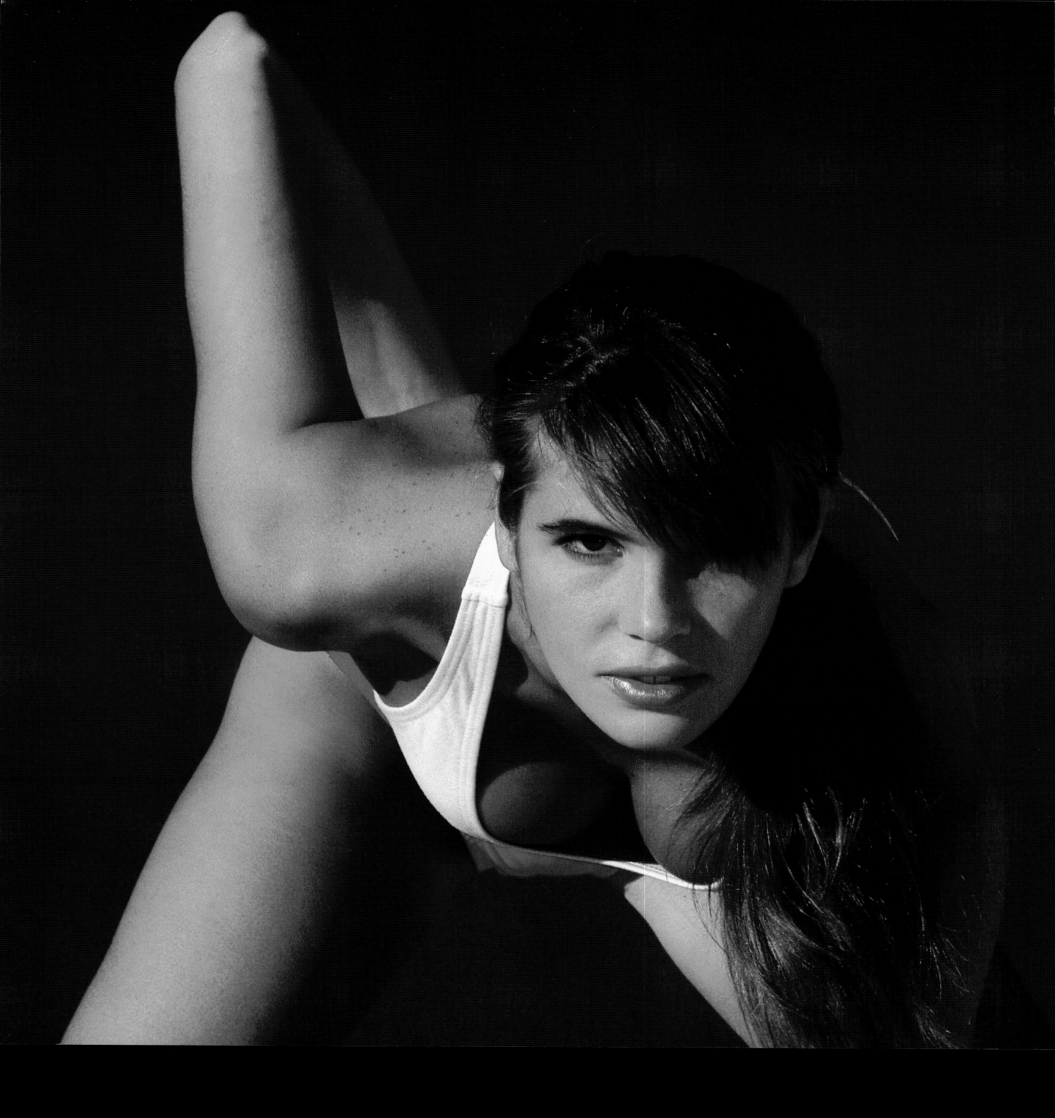

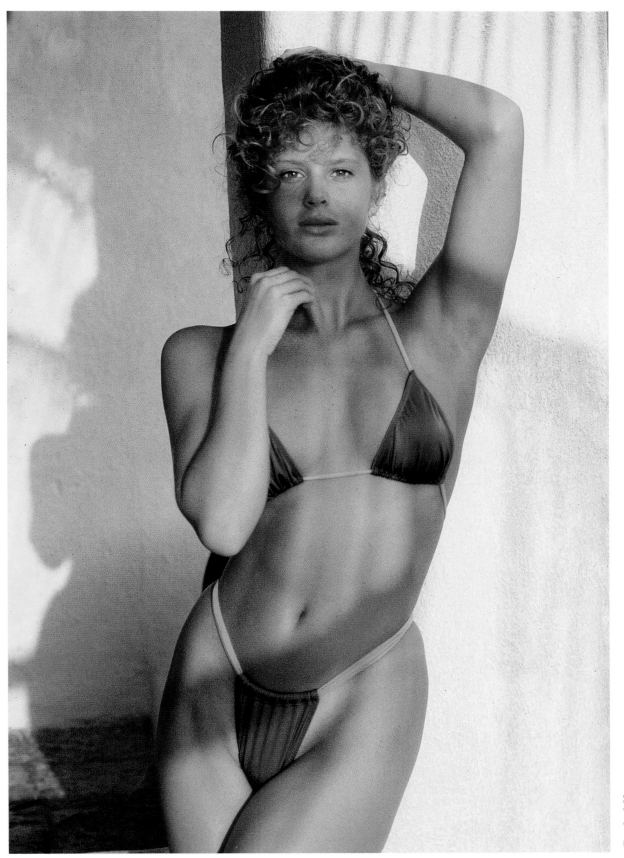

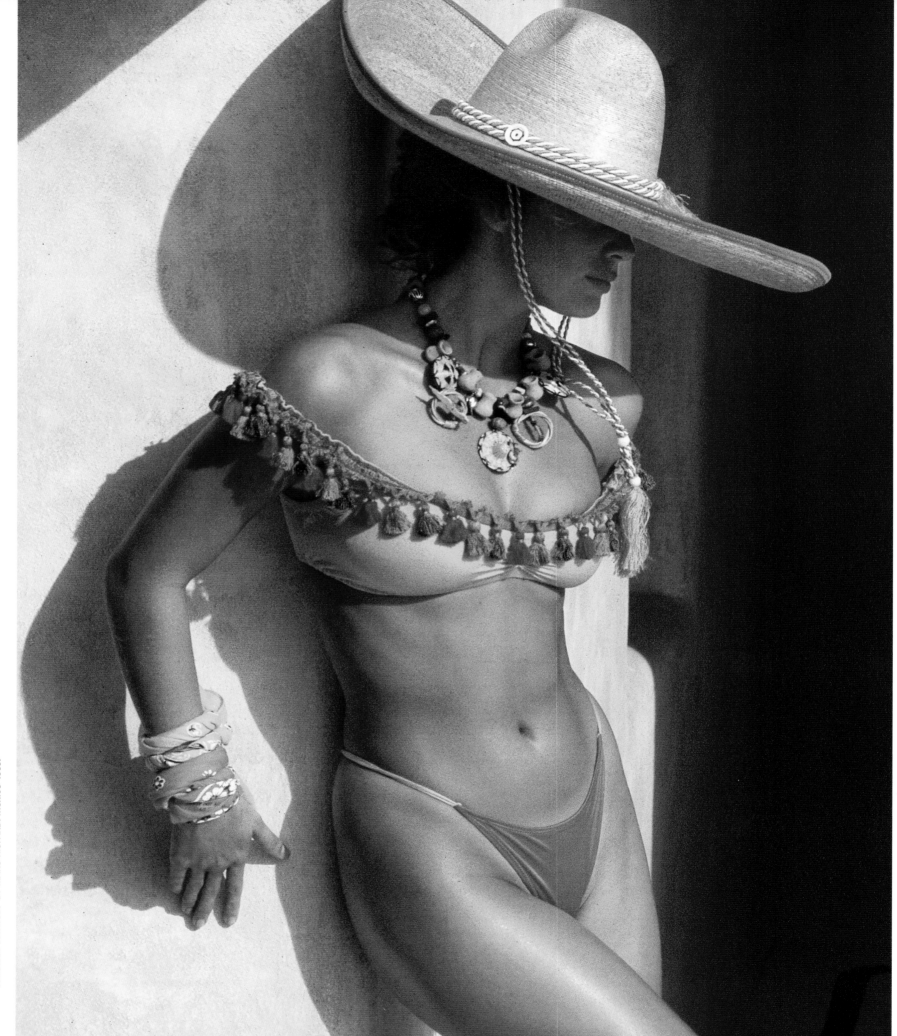

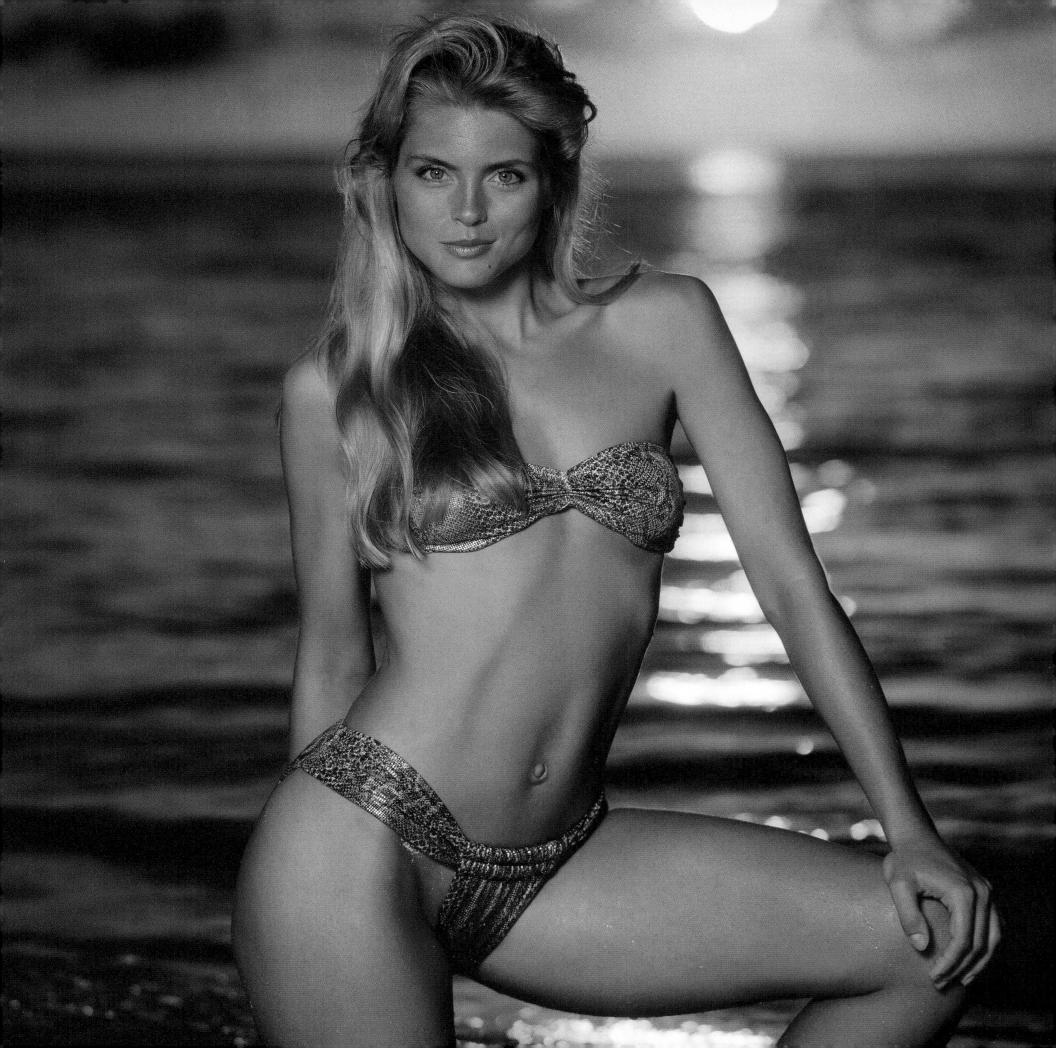

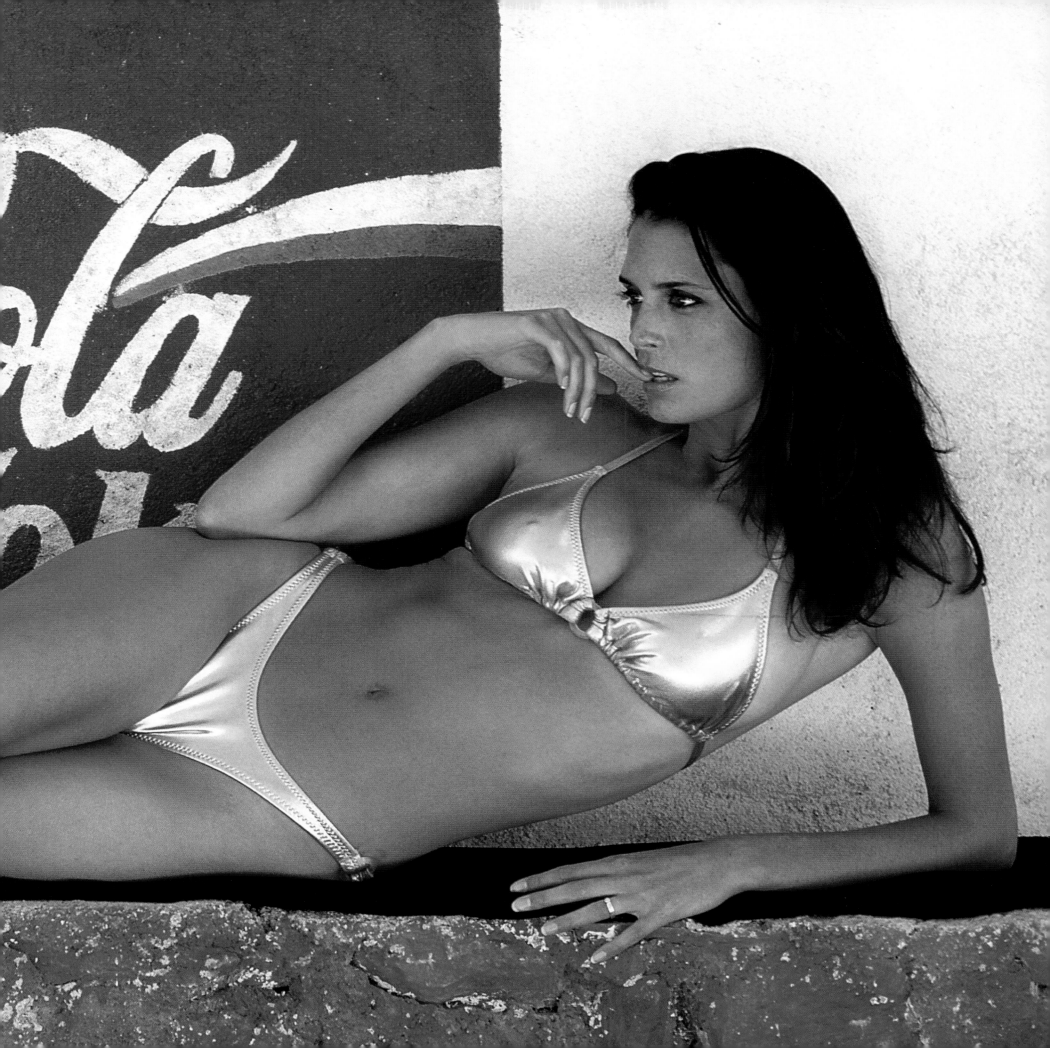

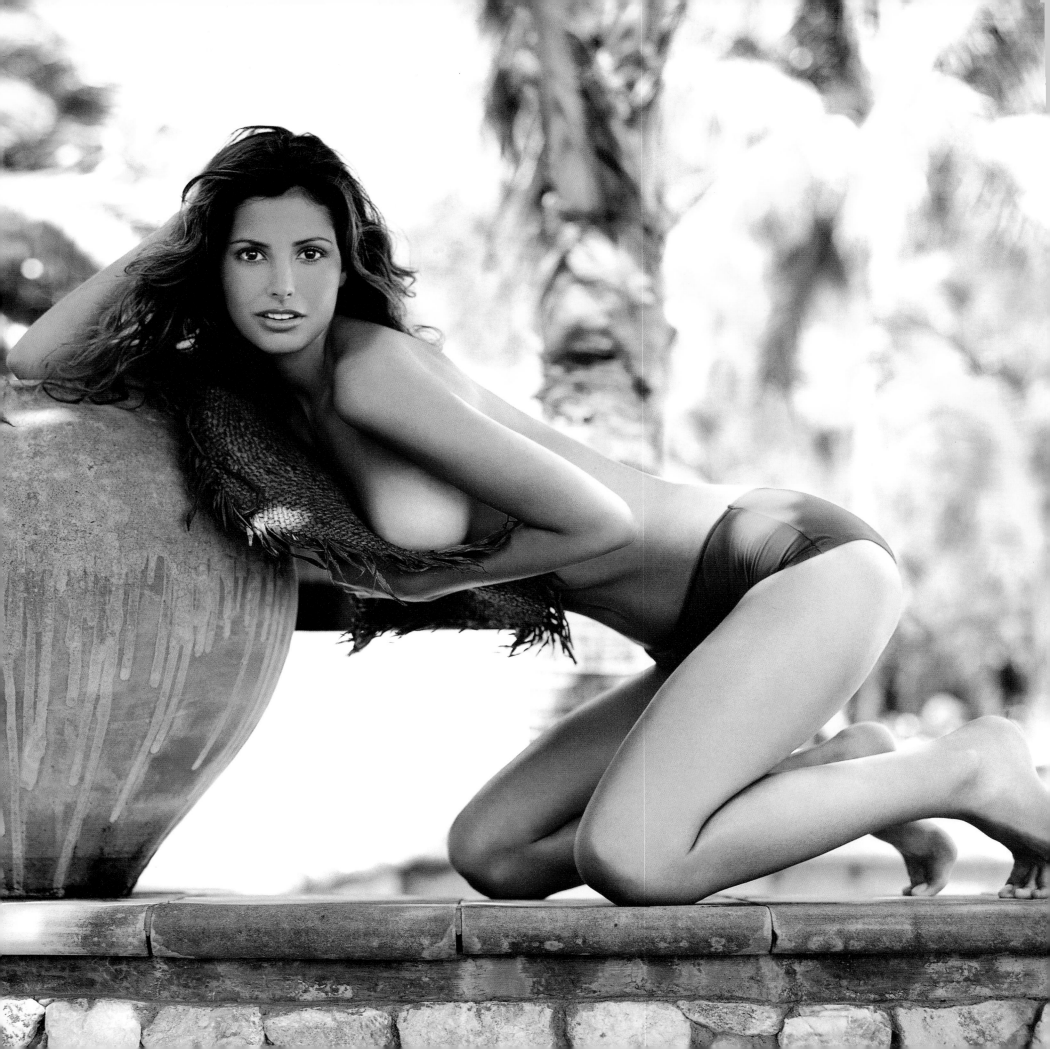

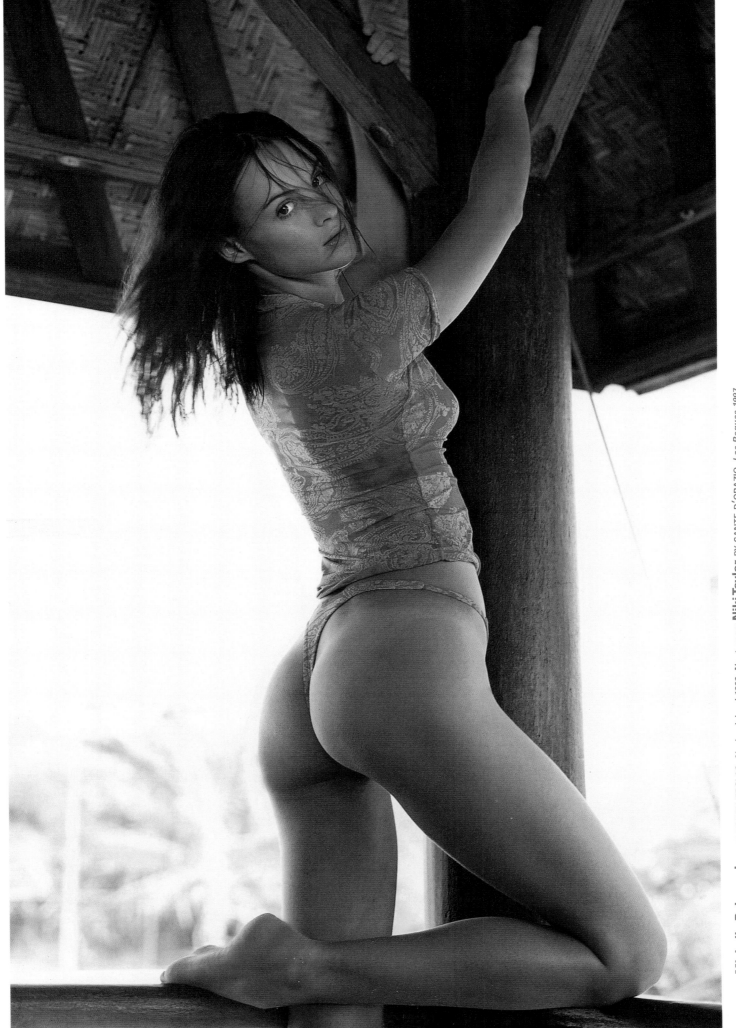

Michelle Behennah BY ANTOINE VERGLAS. Necker Island 1999. Next page: Niki Taylor BY SANTE D'ORAZIO. Los Roques 1997.

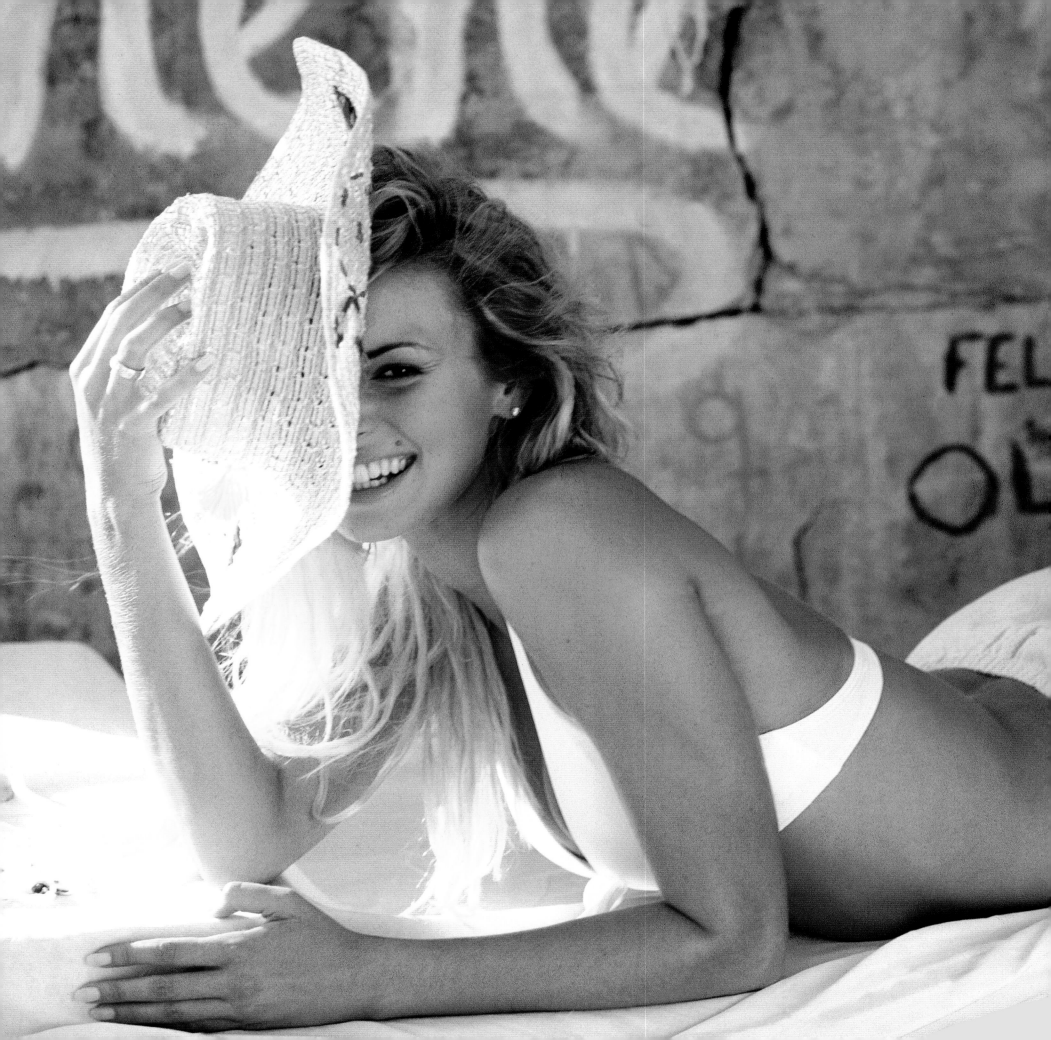

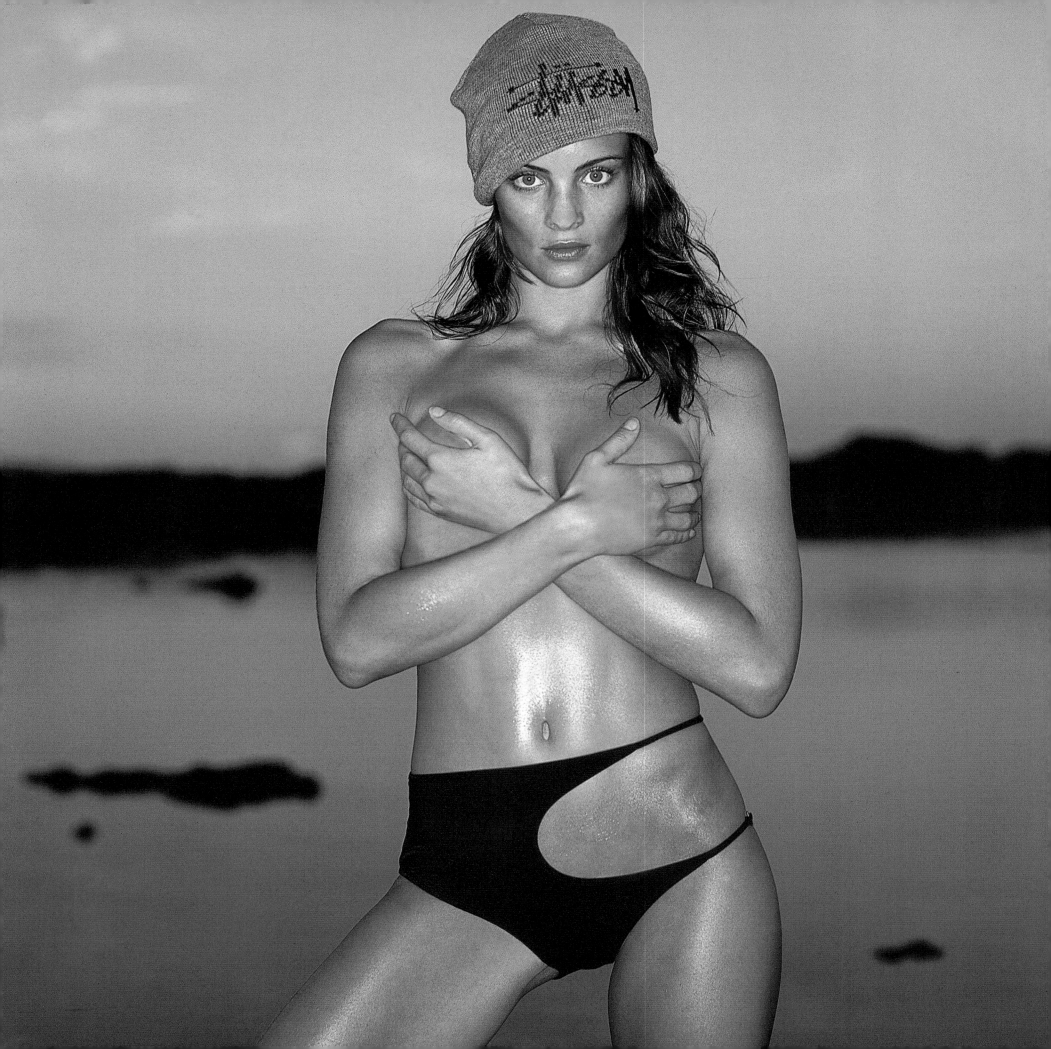

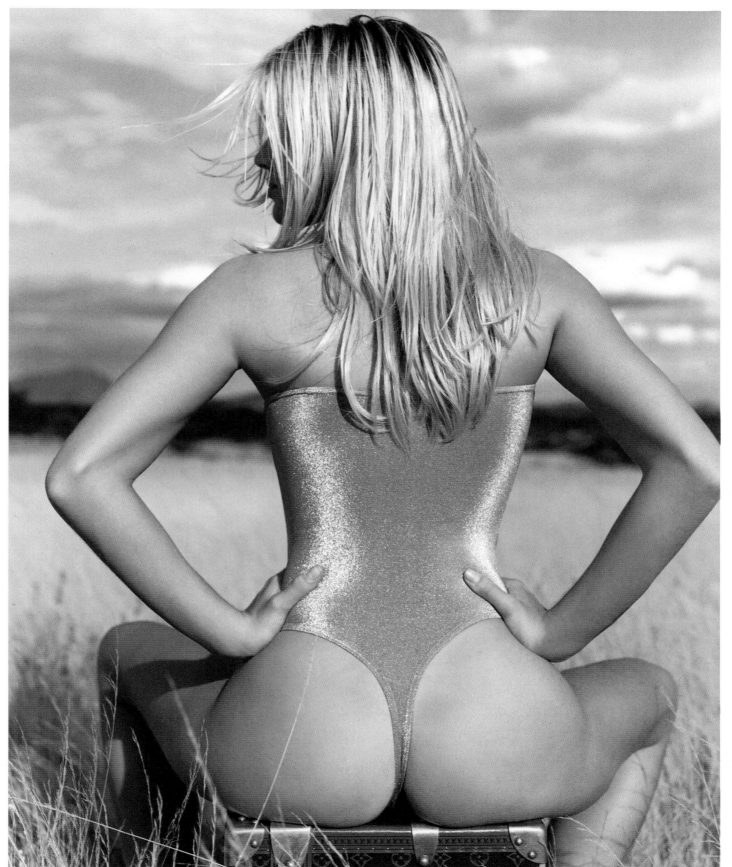

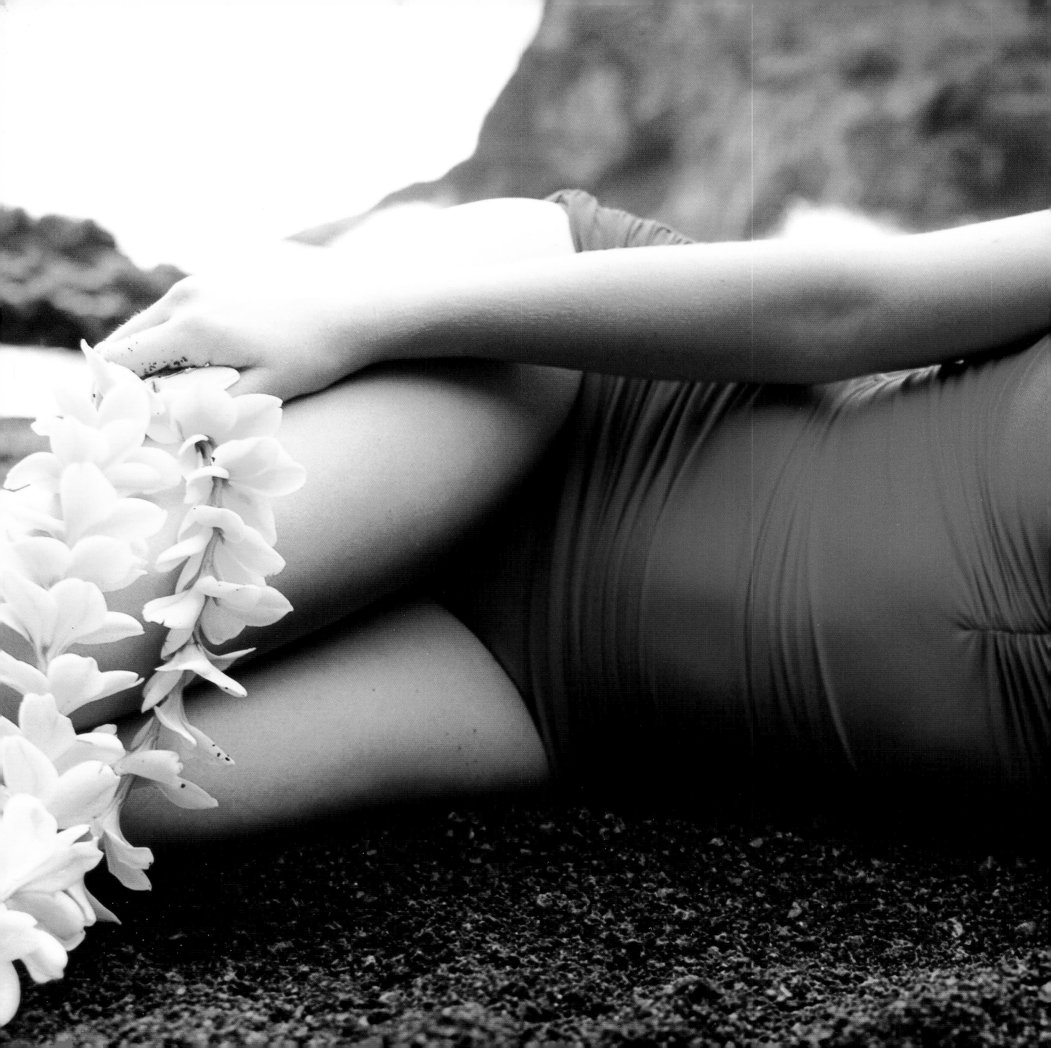

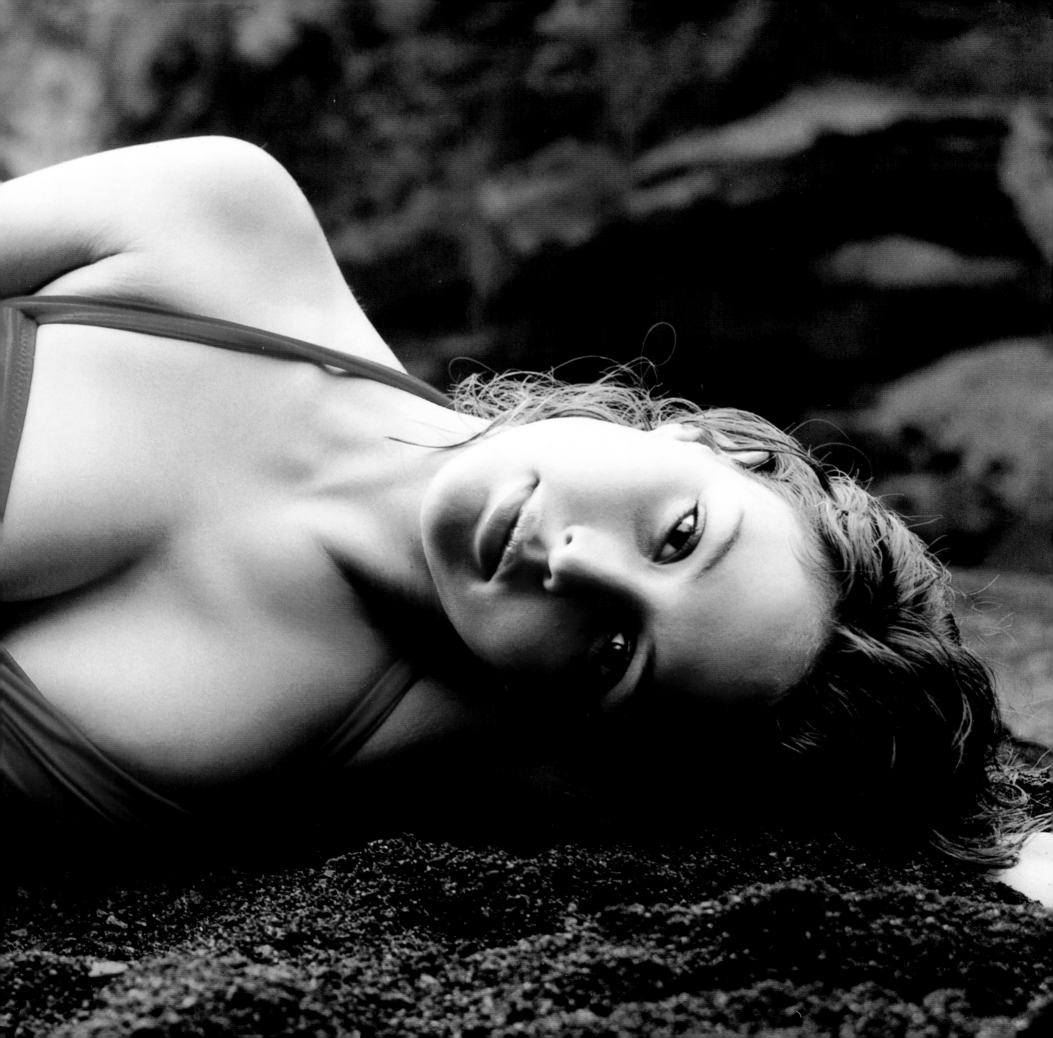

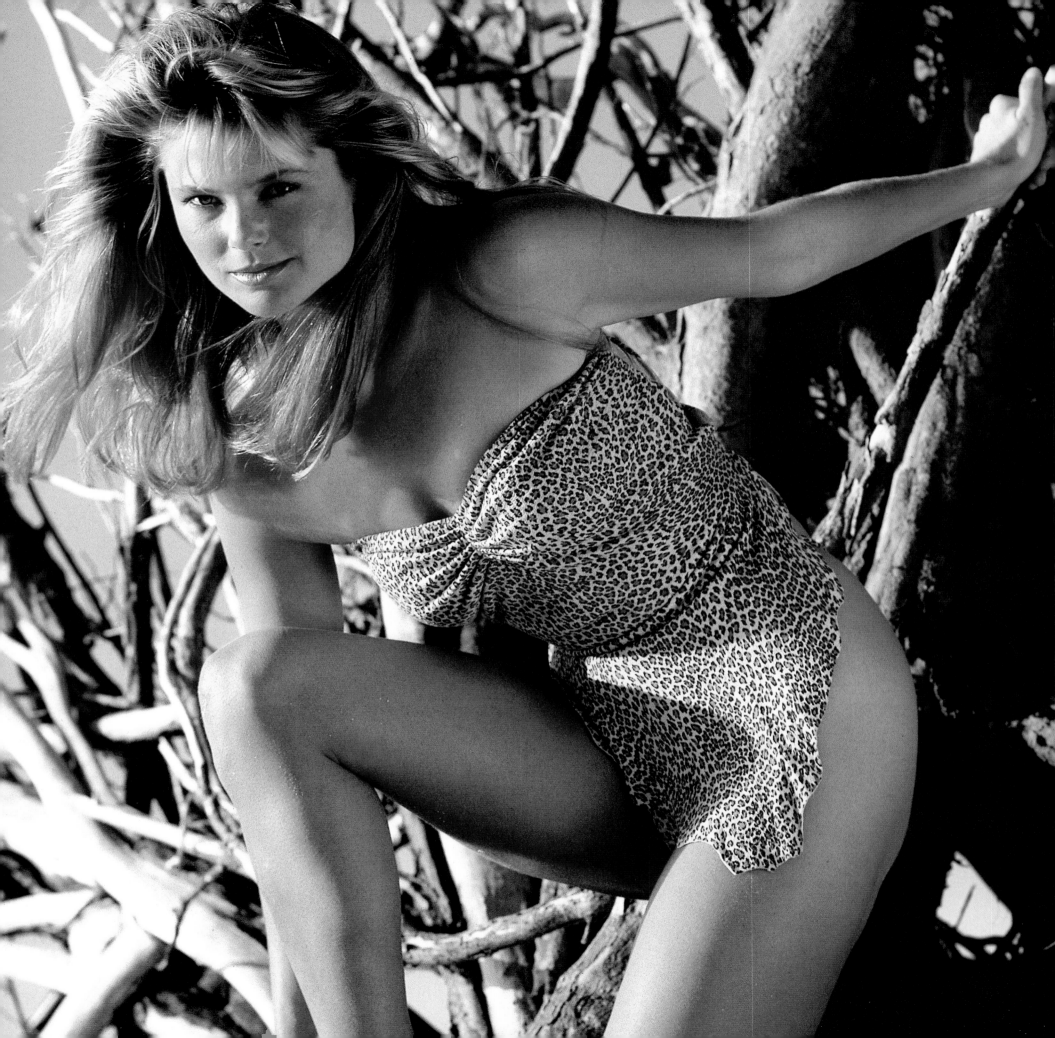

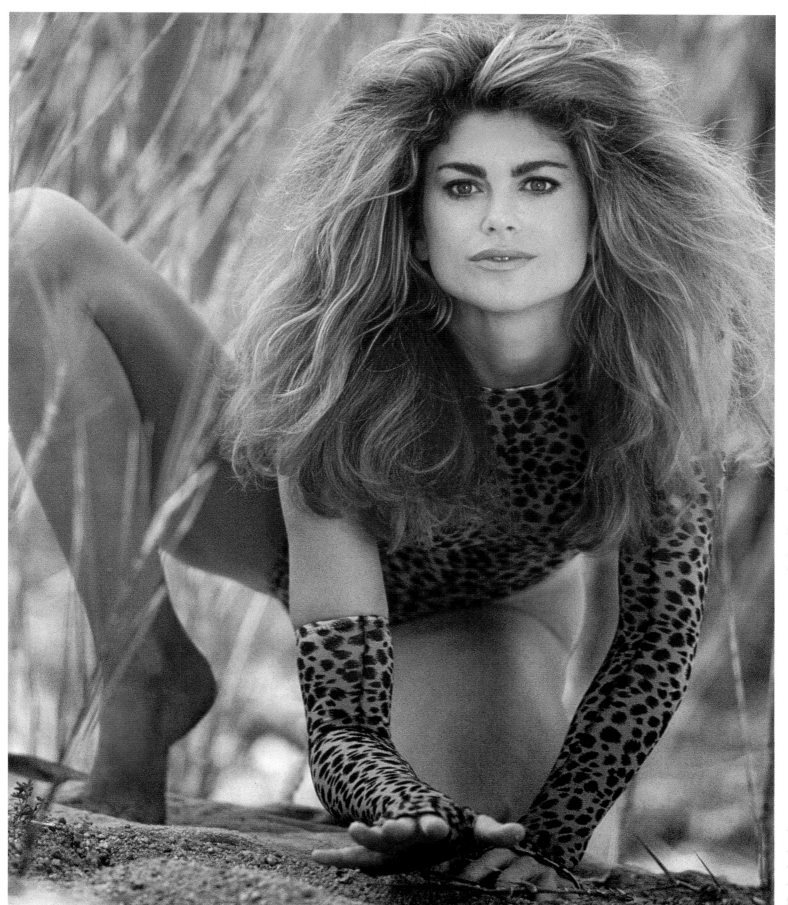

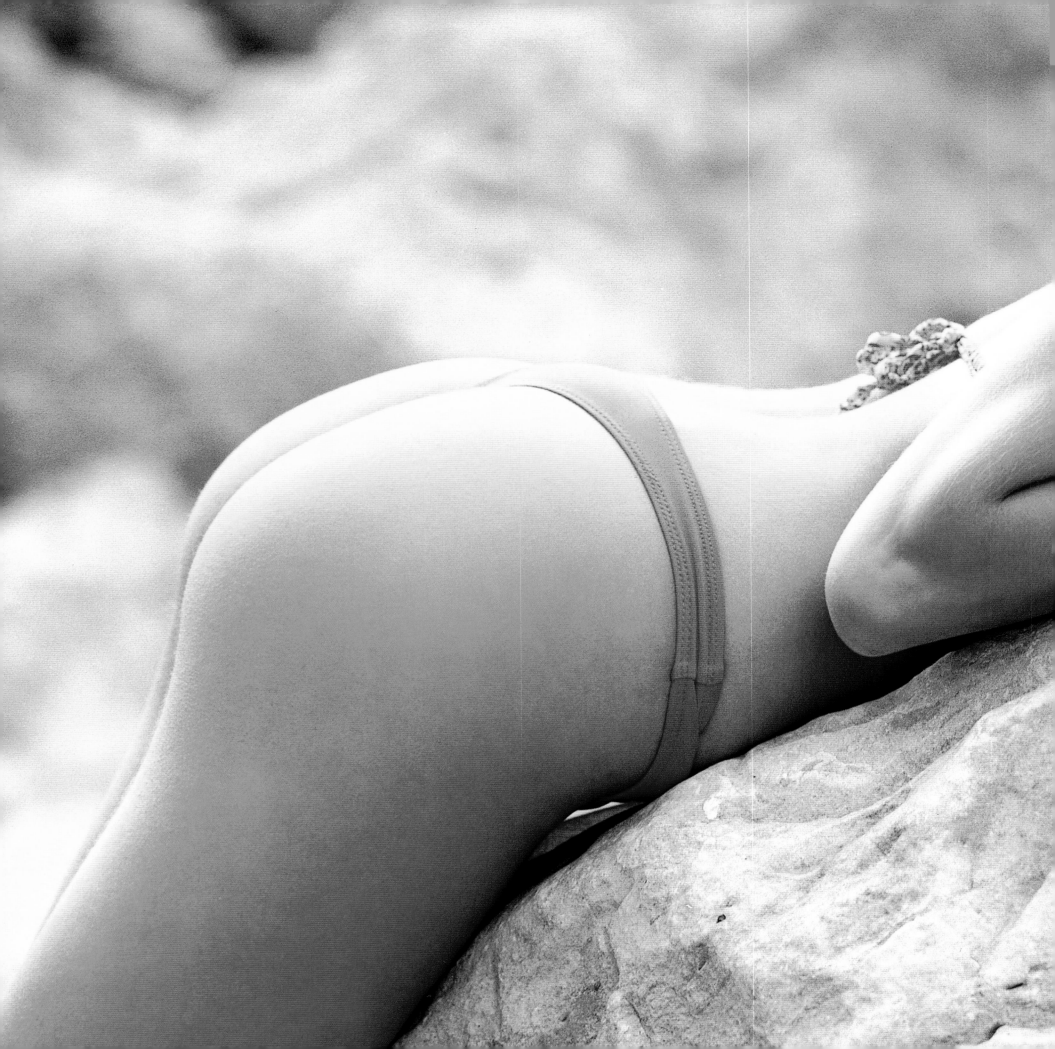

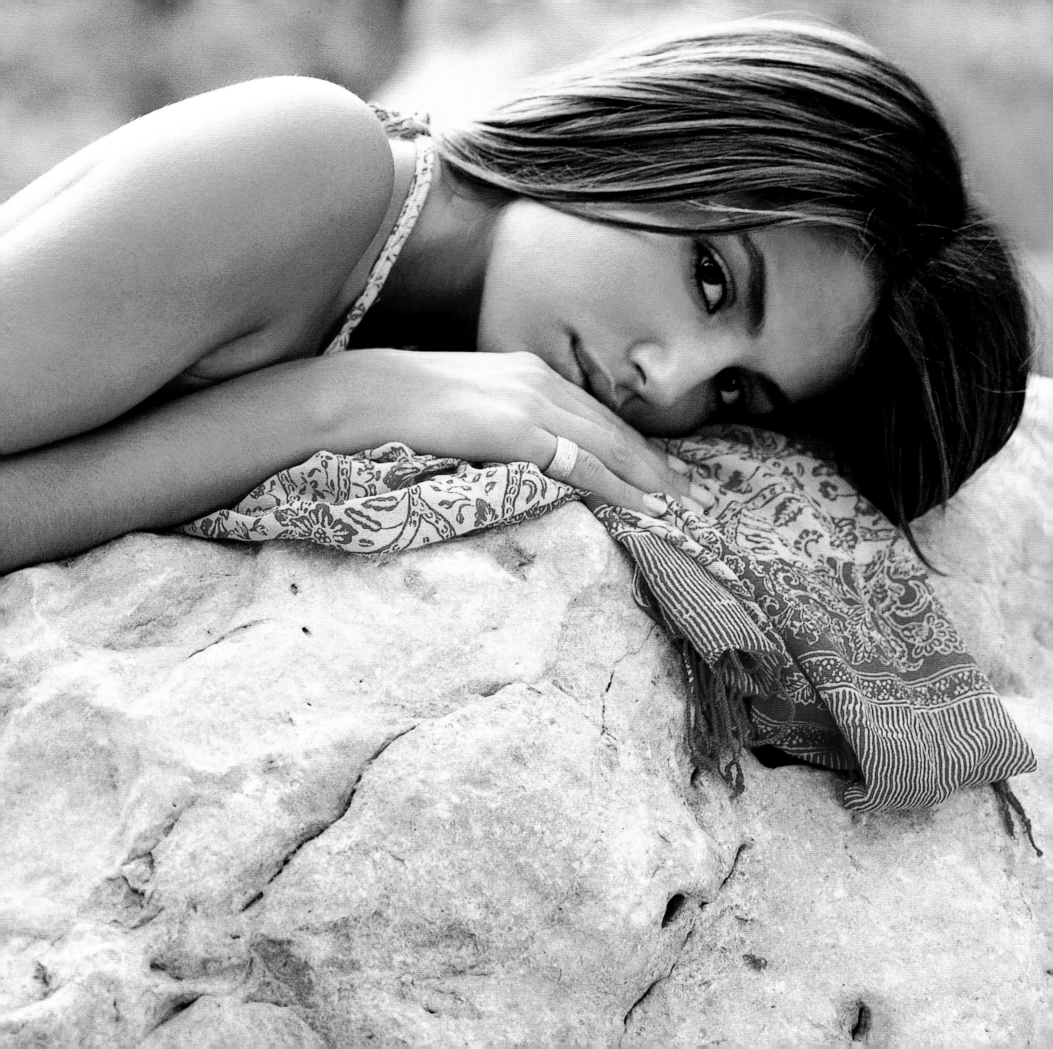

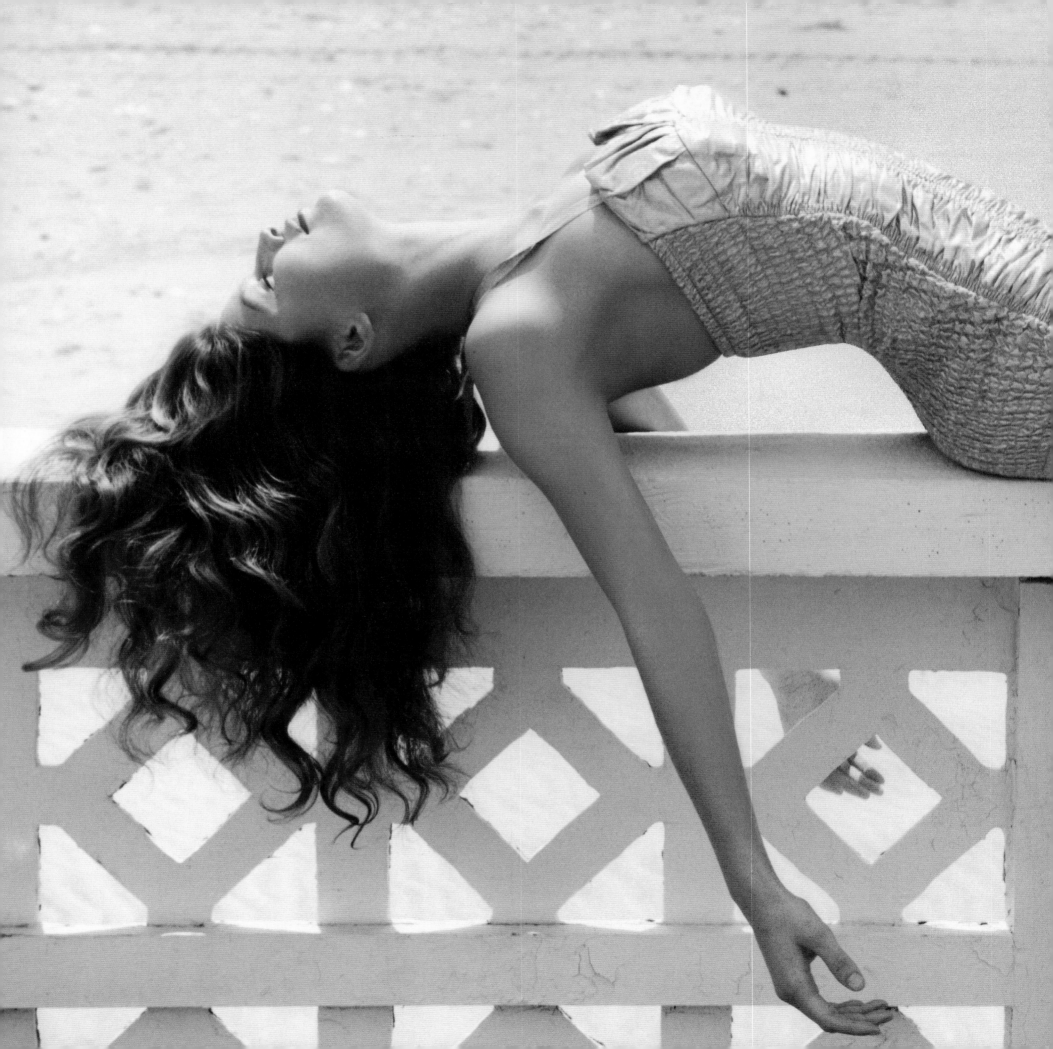

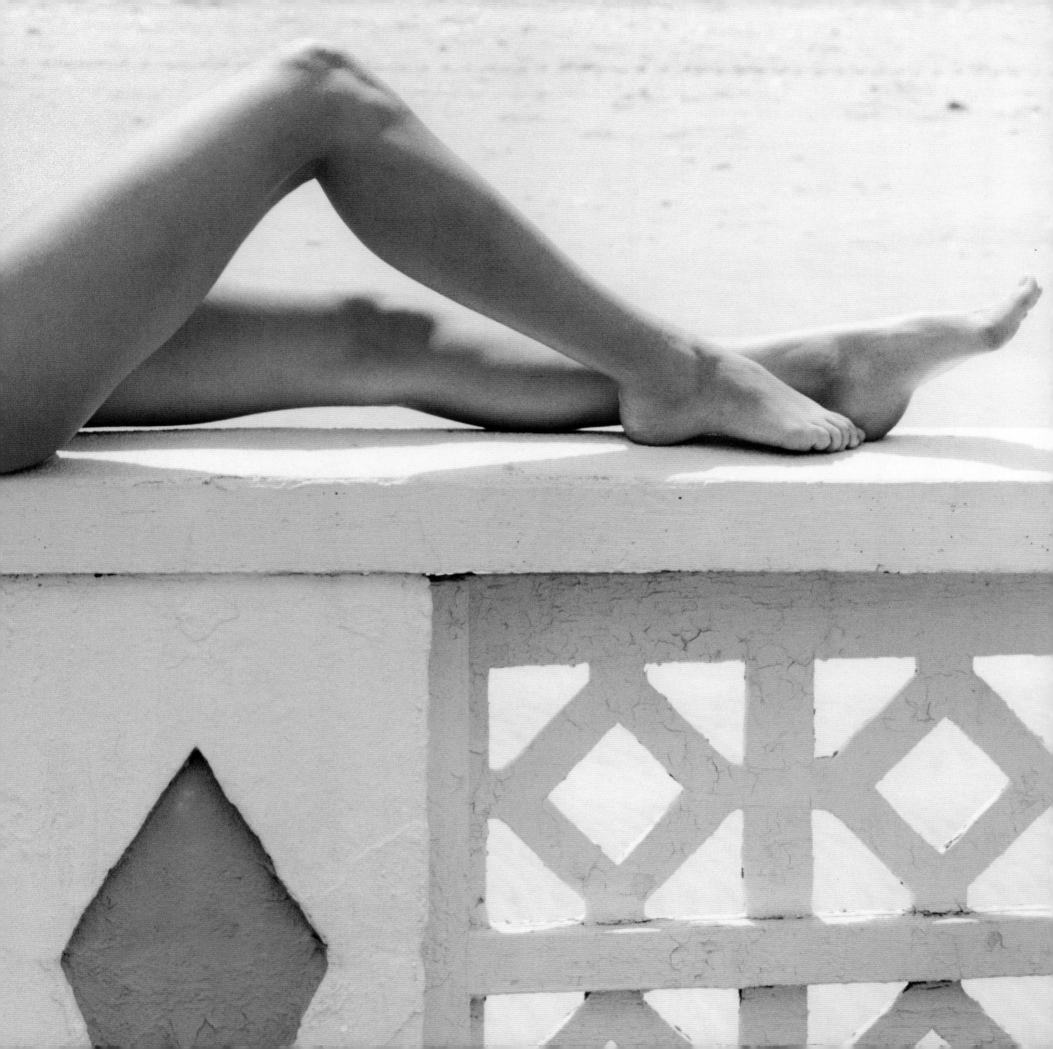

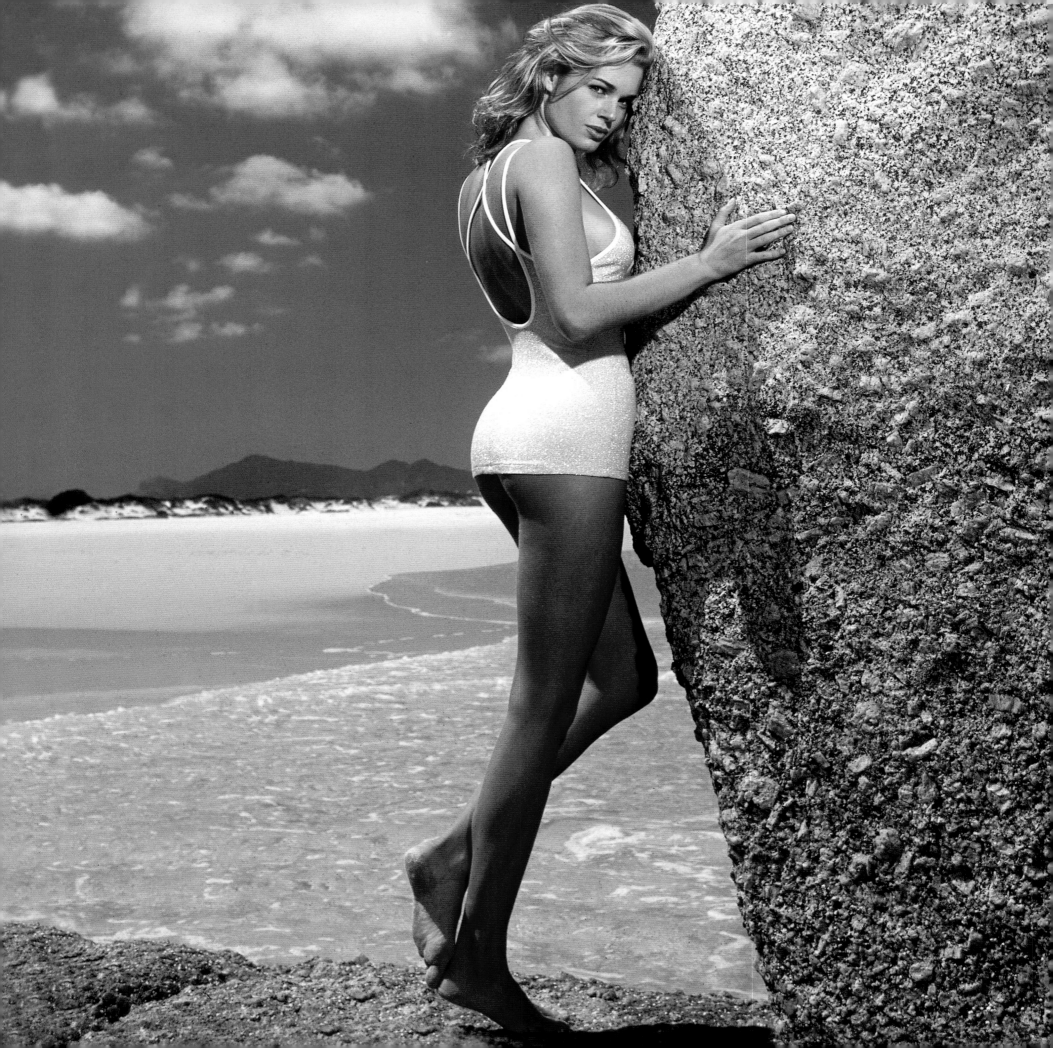

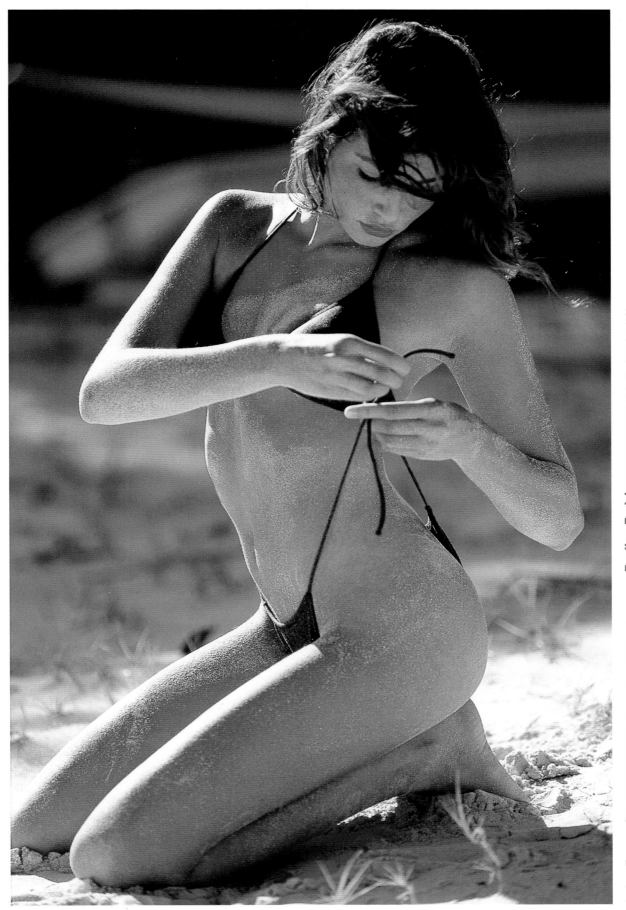

Lujan Fernandez BY HANS FEURER. *Guana Island 1999.* *Next pages:* **Paulina Porizkova** BY WALTER IOOSS JR. *Jamaica 1983*

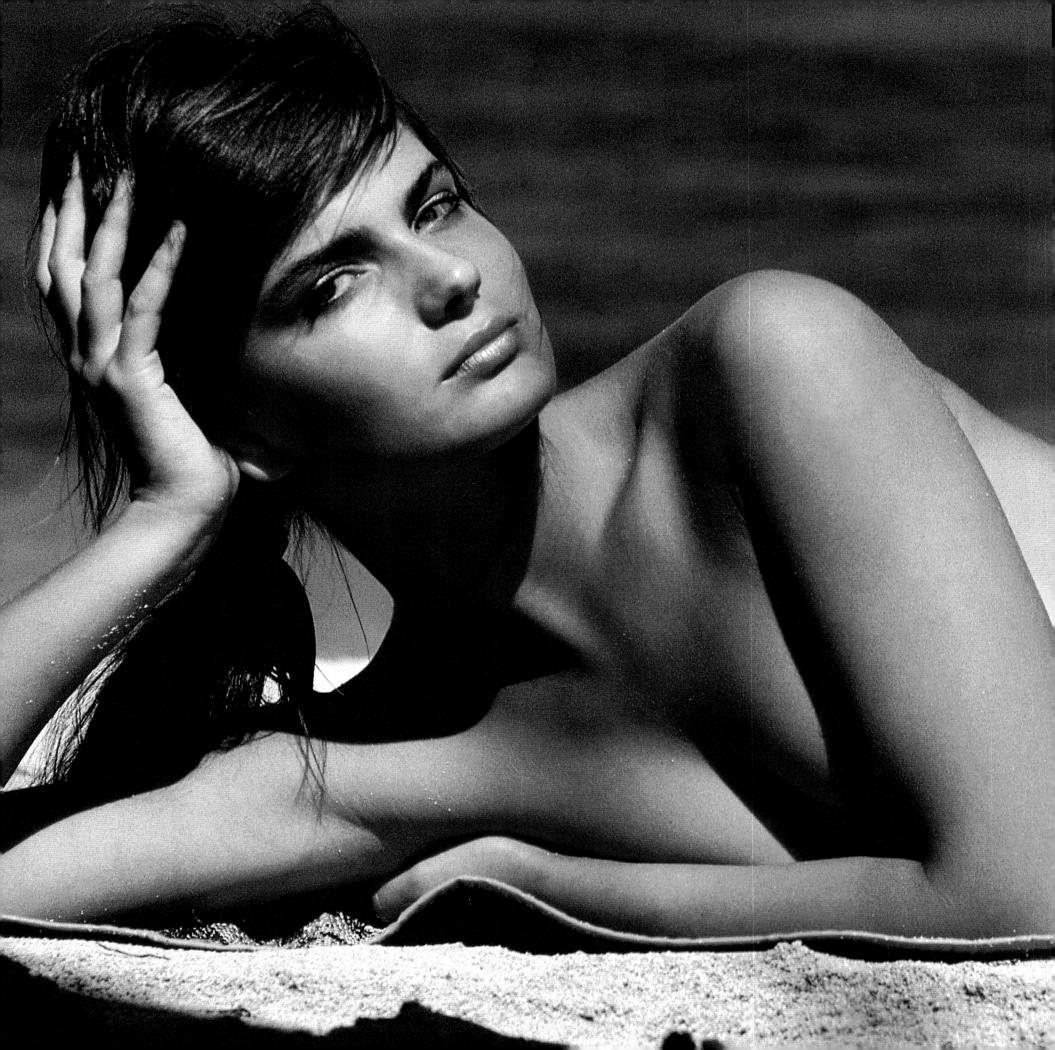

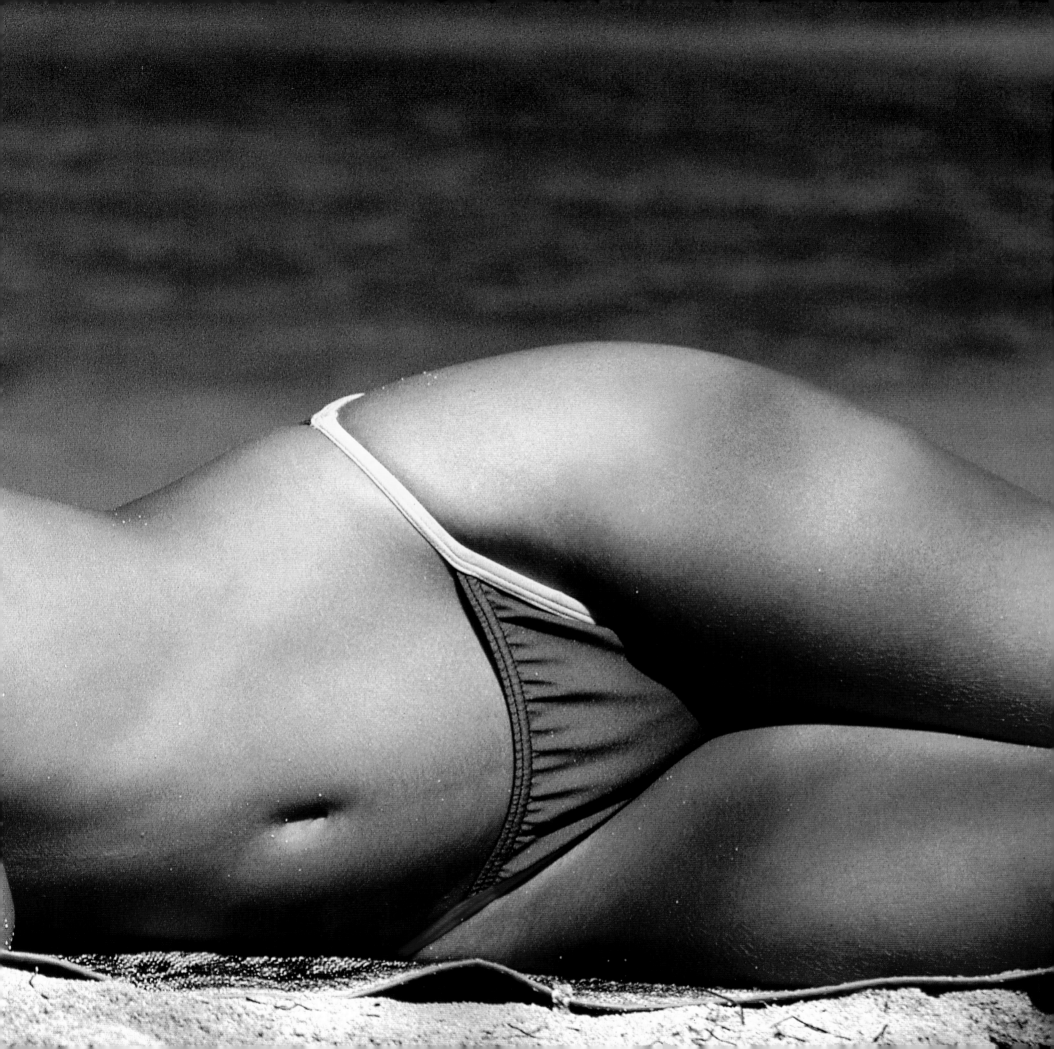

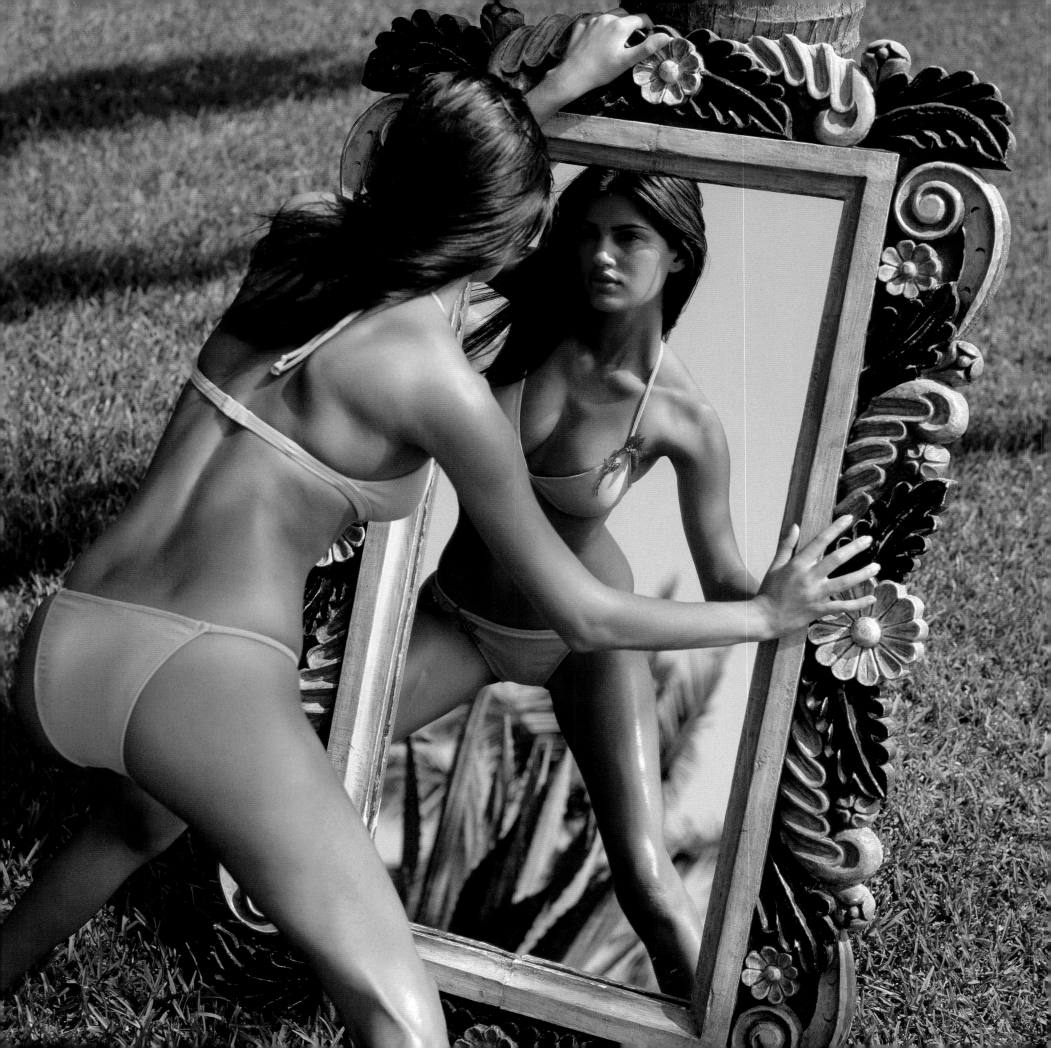

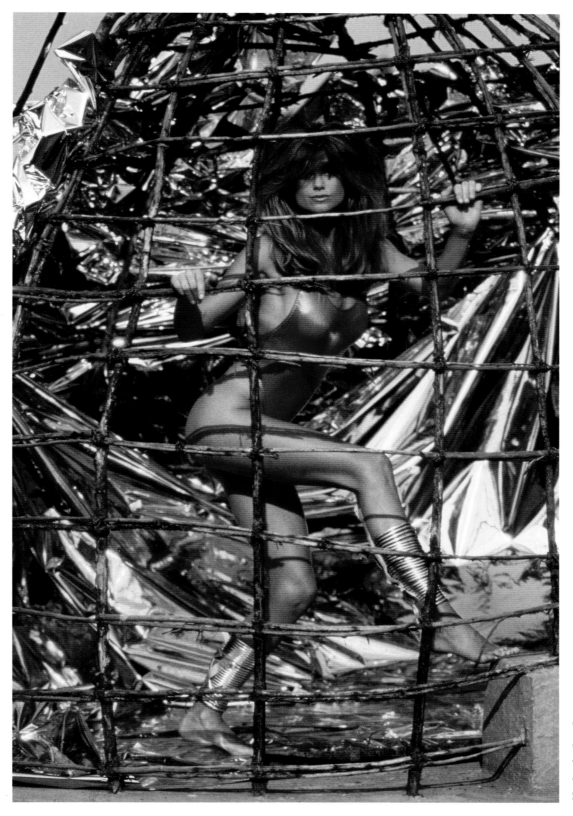

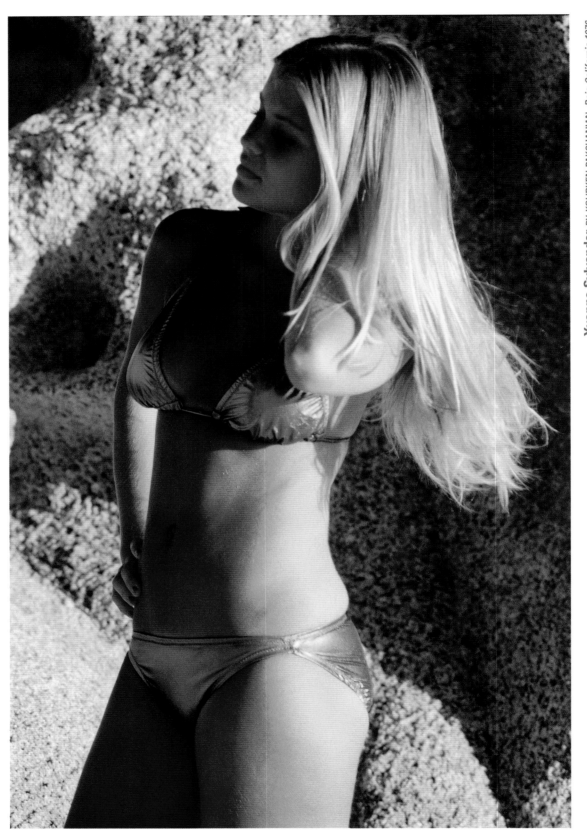

Yvonne Sylvander BY KOURKEN PAKCHANIAN. *Baja California 1976.*

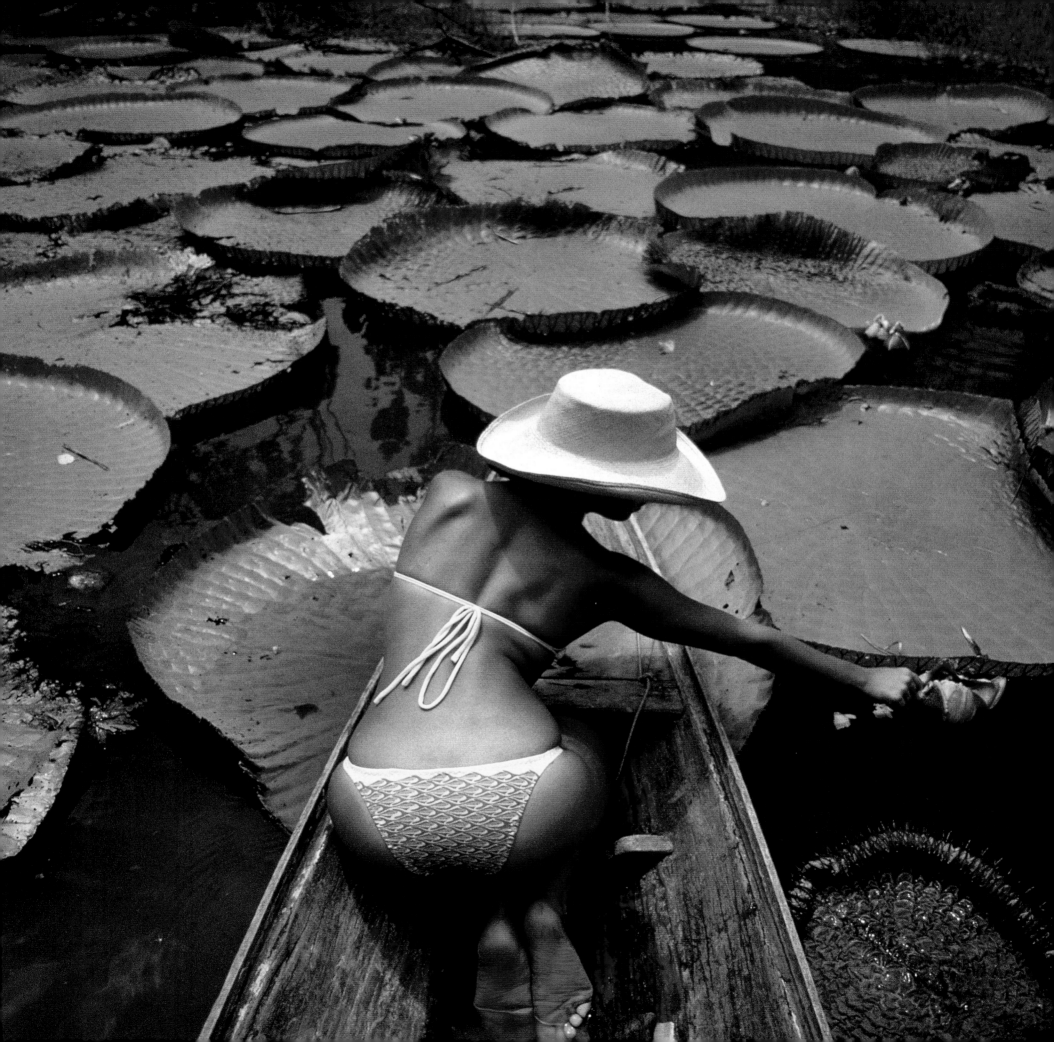

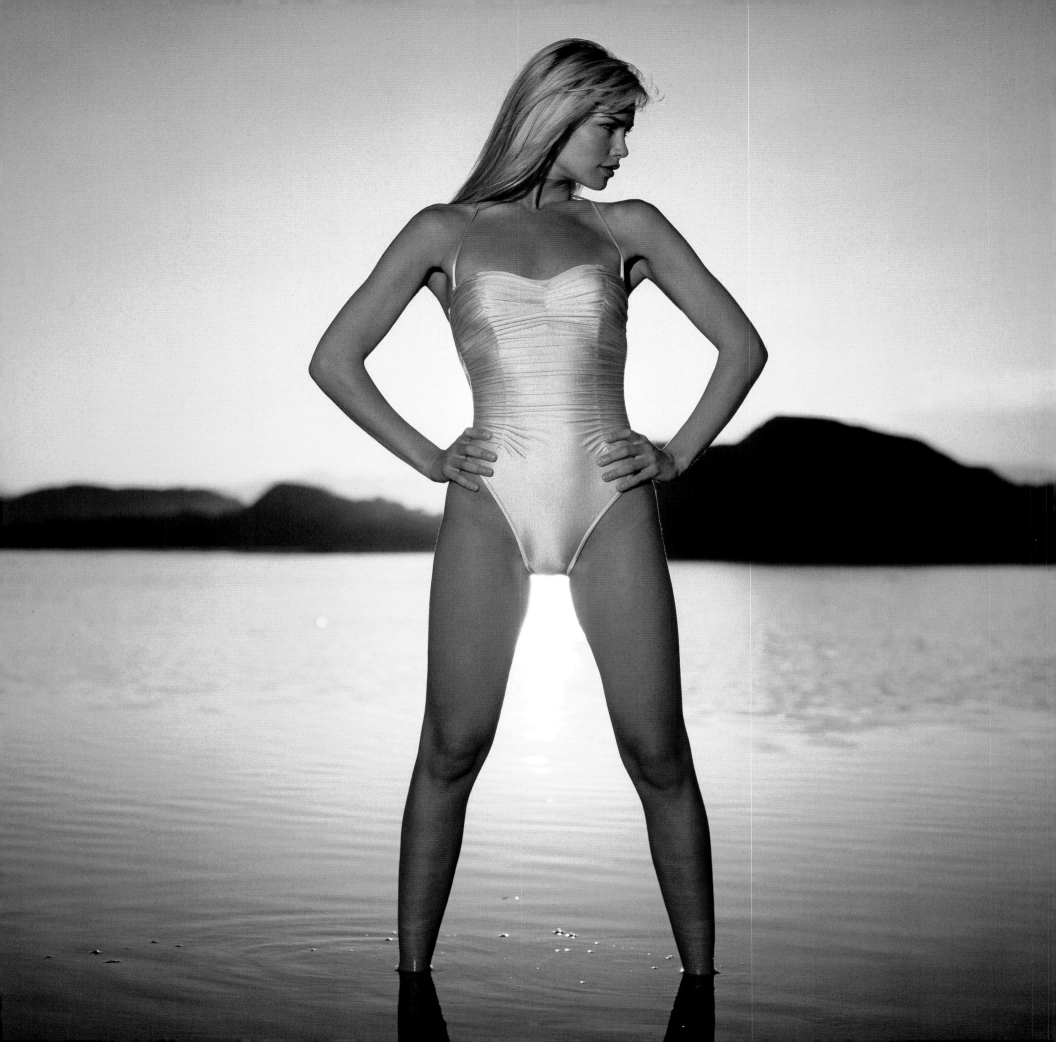

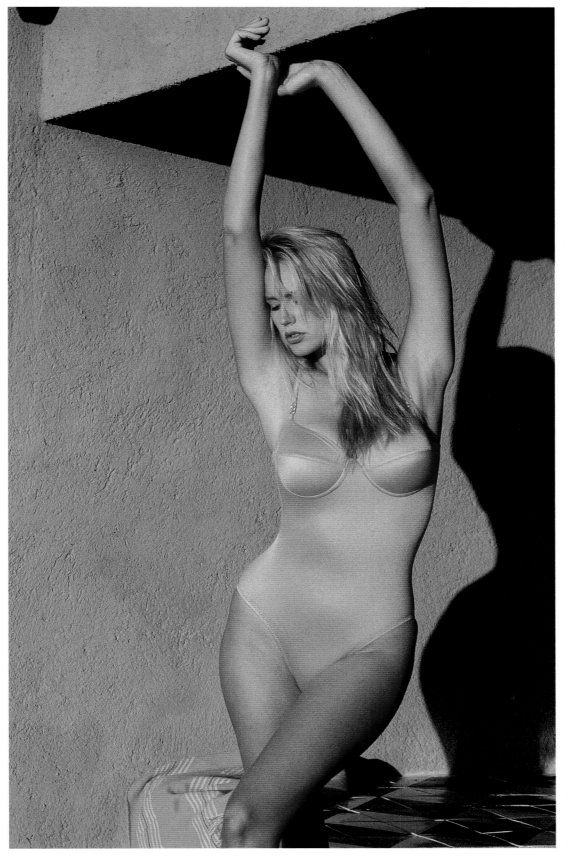

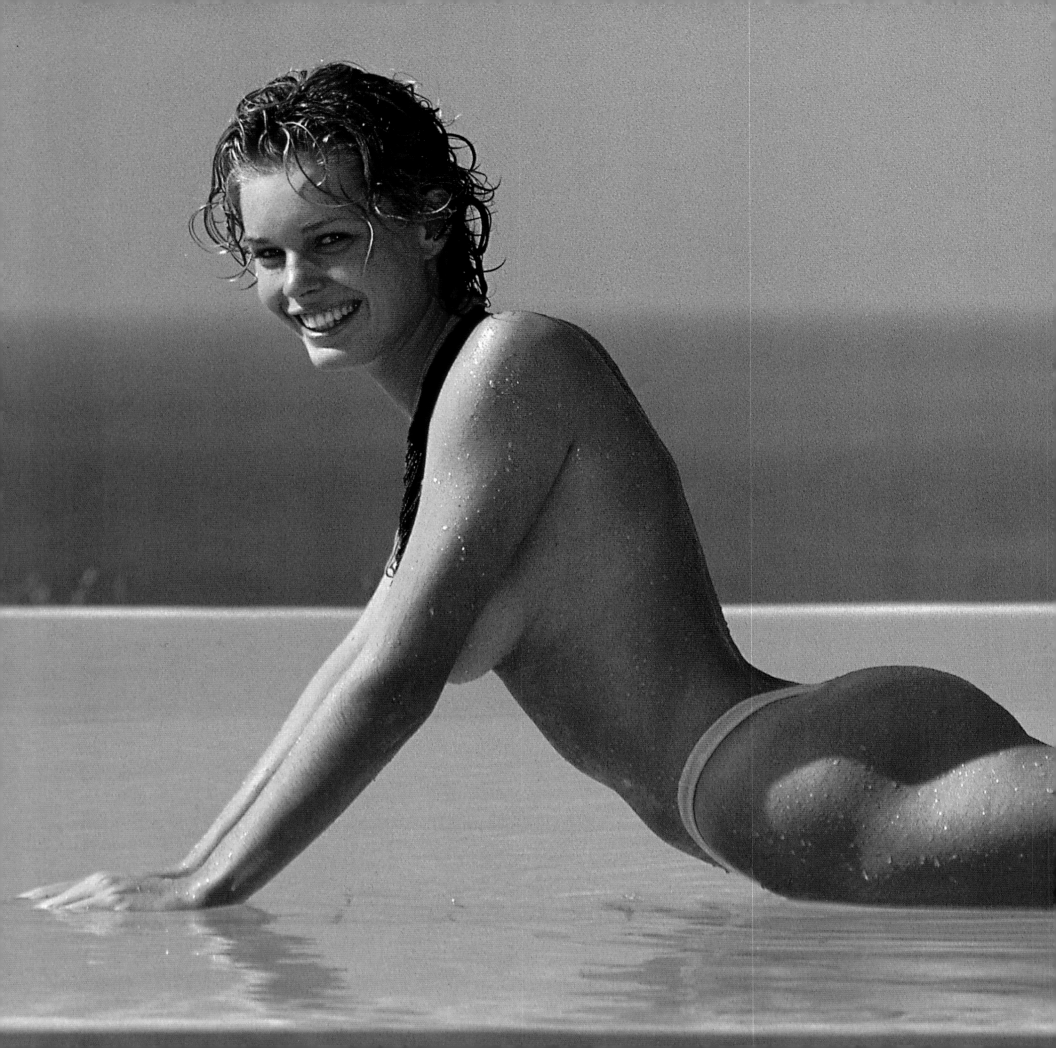

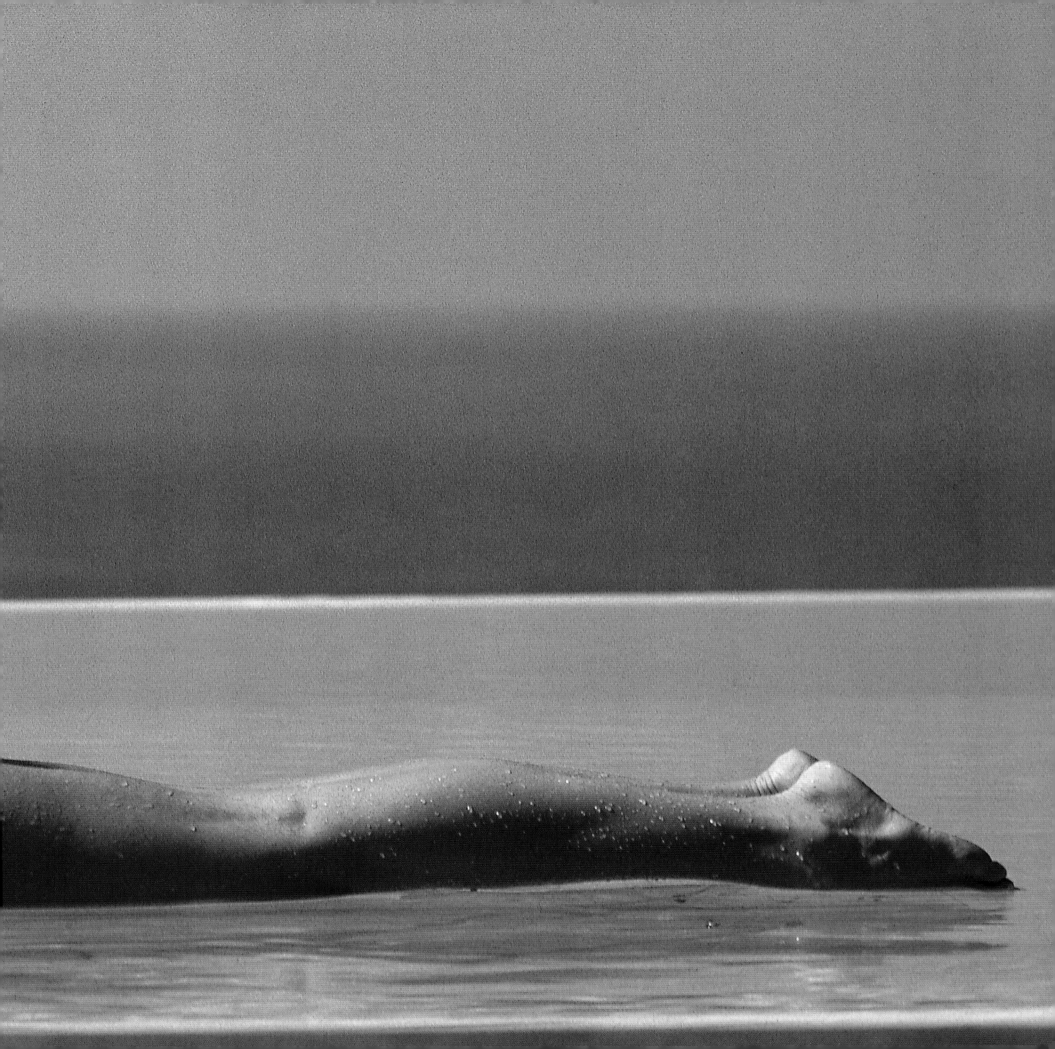

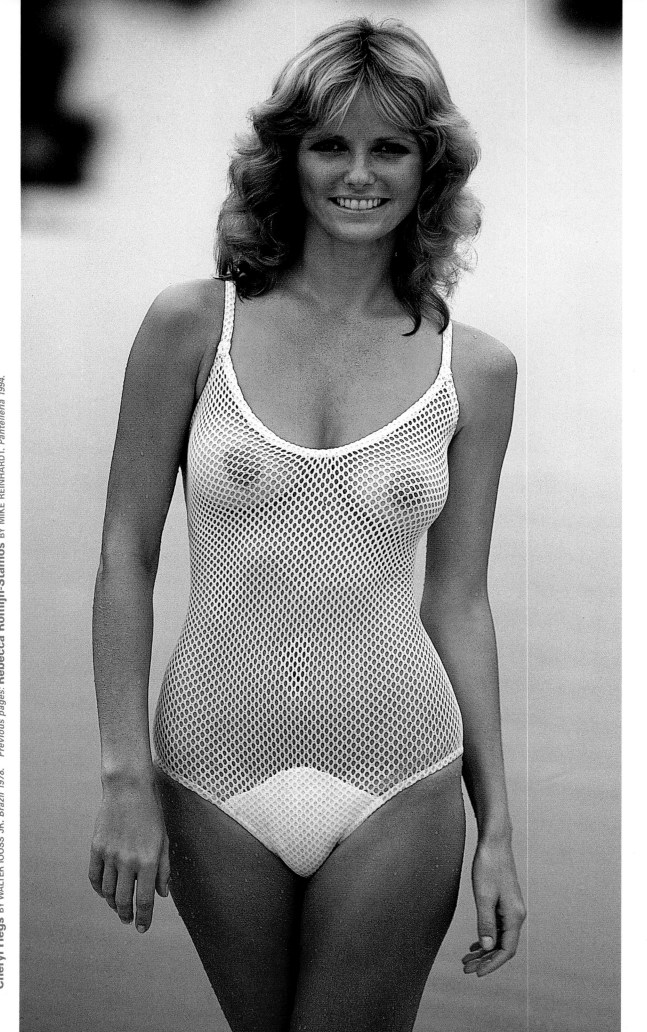

Cheryl Tiegs BY WALTER IOOSS JR. *Brazil 1978.* *Previous pages:* **Rebecca Romijn-Stamos** BY MIKE REINHARDT. *Pantelleria 1994.*

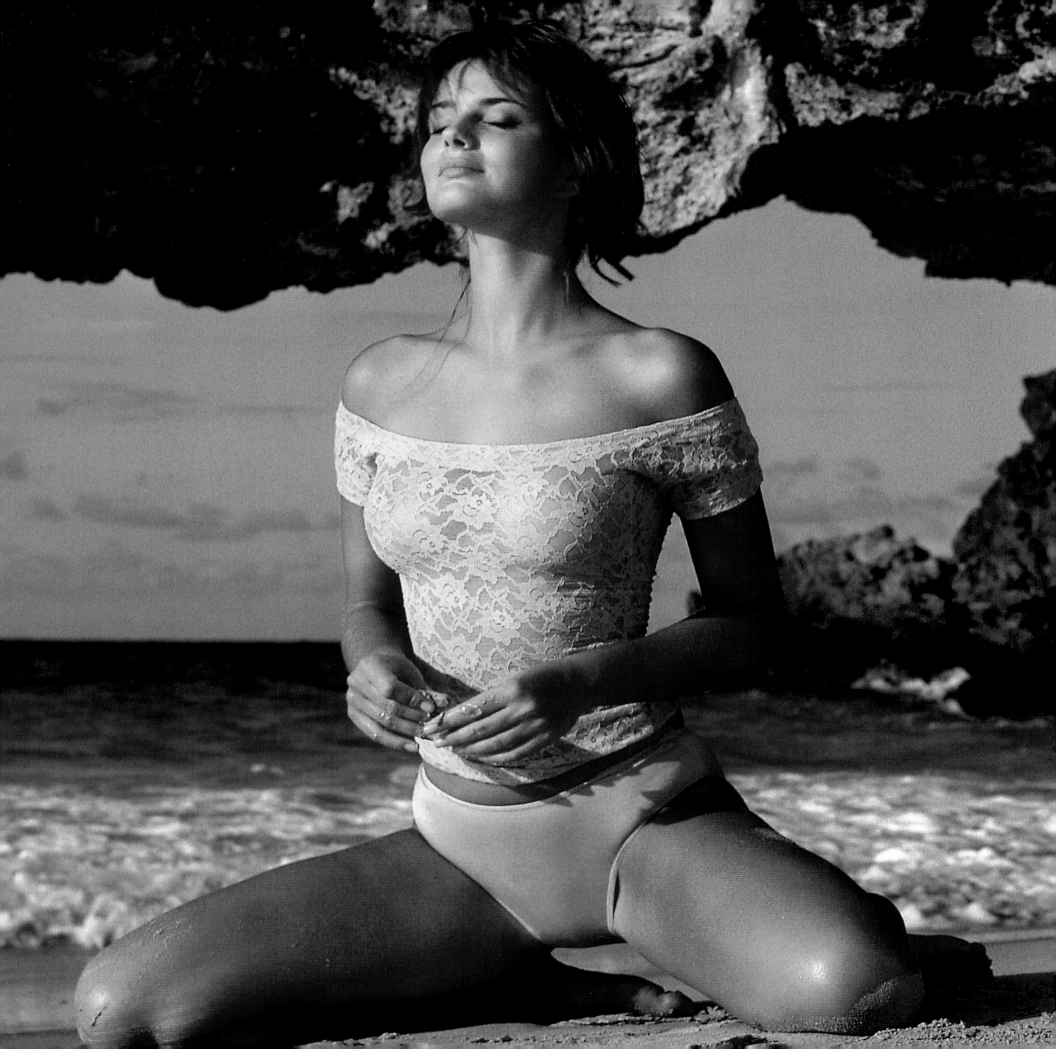

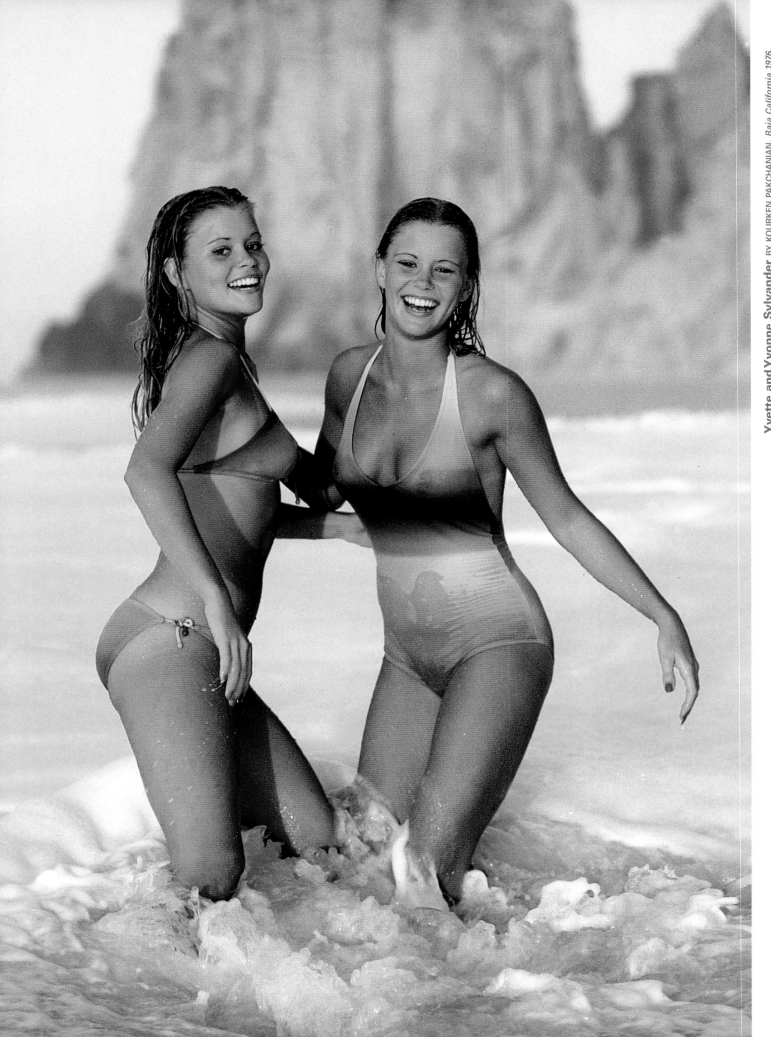

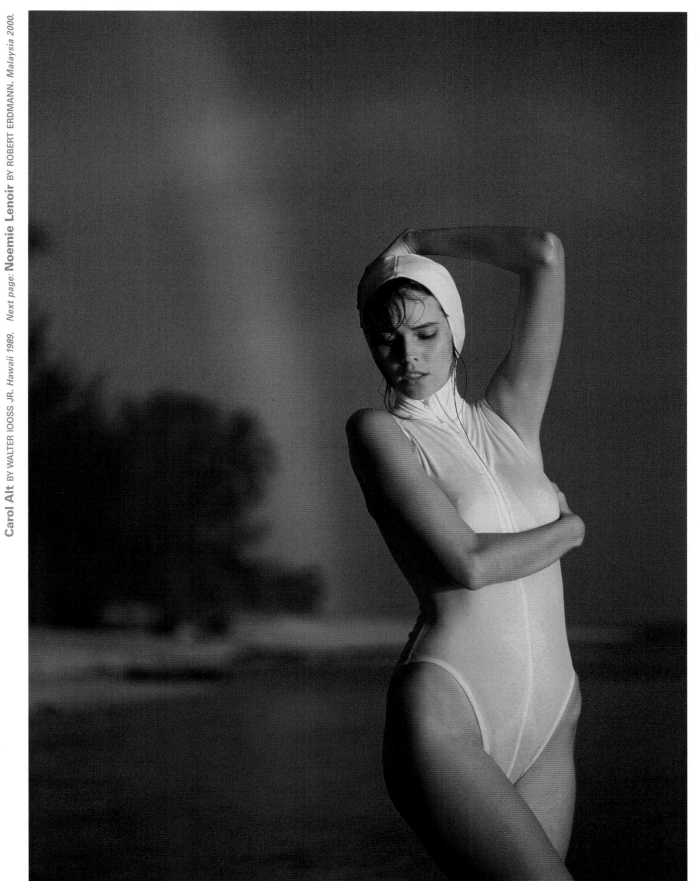

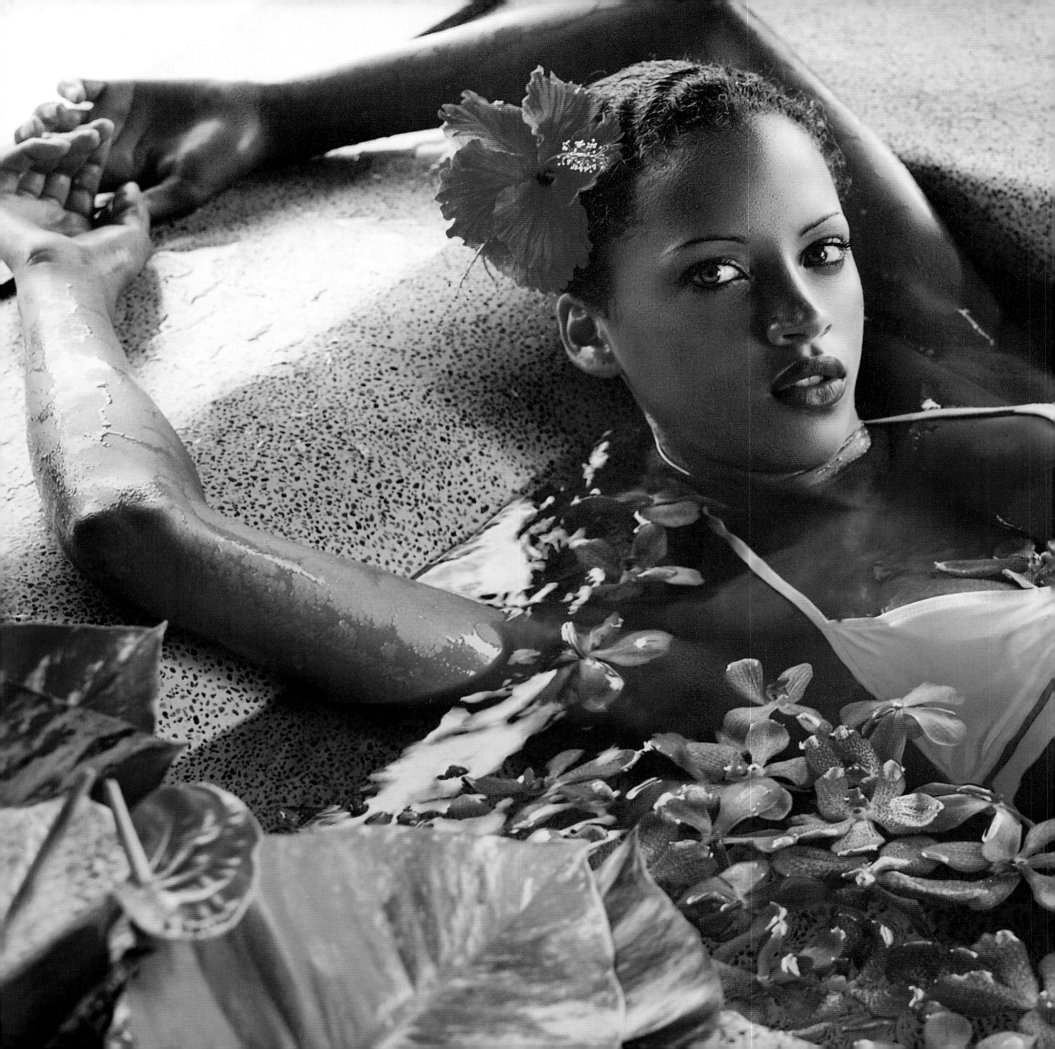

Beauty is an ecstasy; it is as simple as hunger.
There is really nothing to be said about it. It is like the
perfume of a rose: You can smell it and that is all.
—W. SOMERSET MAUGHAM

I must get out of these wet clothes and into

Sirs: Your swimsuit issue
must have increased
your circulation considerably.
It did mine, and at age 75
I need all the help I can get!
—PHILIP J. SCHACCA
West Hempstead, N.Y., 1992

I just can't stand to look plain, 'cause that don't fit my personality. I may be a very artificial-looking person, but the good news is, I am very real on the inside.
—DOLLY PARTON

a dry martini. —ROBERT BENCHLEY

My dad cleaned out
every newsstand he could
find and gave copies to
all his friends. The senior
stewardess on our flight
used to sneak behind me
while I greeted passengers,
hold the magazine over
my head and go 'That's
her' with her lips.
I could have killed her.
—SHEILA ROSCOE
1972 cover model and airline stewardess

You can't depend on your judgment whe

Sirs: Every year there are four staples in the swimsuit issue: the three that hold the magazine together and Kathy Ireland. This year there were only three. Where's Kathy?

—WIN POUND
Atlanta, 1995

God gave women intuition and femininity. Used properly, the combination easily jumbles the brain of any man I have ever met.

—FARRAH FAWCETT

our imagination is out of focus. —MARK TWAIN

I practically don't even
have any bathing suits.
I haven't been to
a beach in America since
I don't know when.
It isn't worth it. People
who recognize me
always think I don't
look that good in real life.
That's fine with me.
Let them deal
with the dreams.
—ELLE MACPHERSON

'Beauty is truth, truth beauty,'—that is all ye know

I often think that
a slightly exposed shoulder
emerging from a long satin
nightgown packed more sex
that two naked bodies in bed.
—BETTE DAVIS

All the SI bathing suit models
are muscular and lean and
authentic. They don't mind
working up a good sweat.
They're proud of the bodies
they've worked into shape.
There is nothing powdery or
gushy about them. In other
words, the women in
the swimsuit issue are not
the worst role models
a young girl could have.

—JOAN RYAN
the San Francisco Chronicle

n earth, and all ye need to know. —JOHN KEATS, *Ode on a Grecian Urn*

Sirs: I know you'll get the usual deluge of
letters from outraged mothers and narrow-minded
people about your article. The only thing I can
say is that if my son gets to be 13 or 14 years old
and doesn't look, I'll take him to a psychologist.
If my husband stops looking, I'll know he is dead.

—FLORENCE WHALEN, *Pittsburgh, 1974*

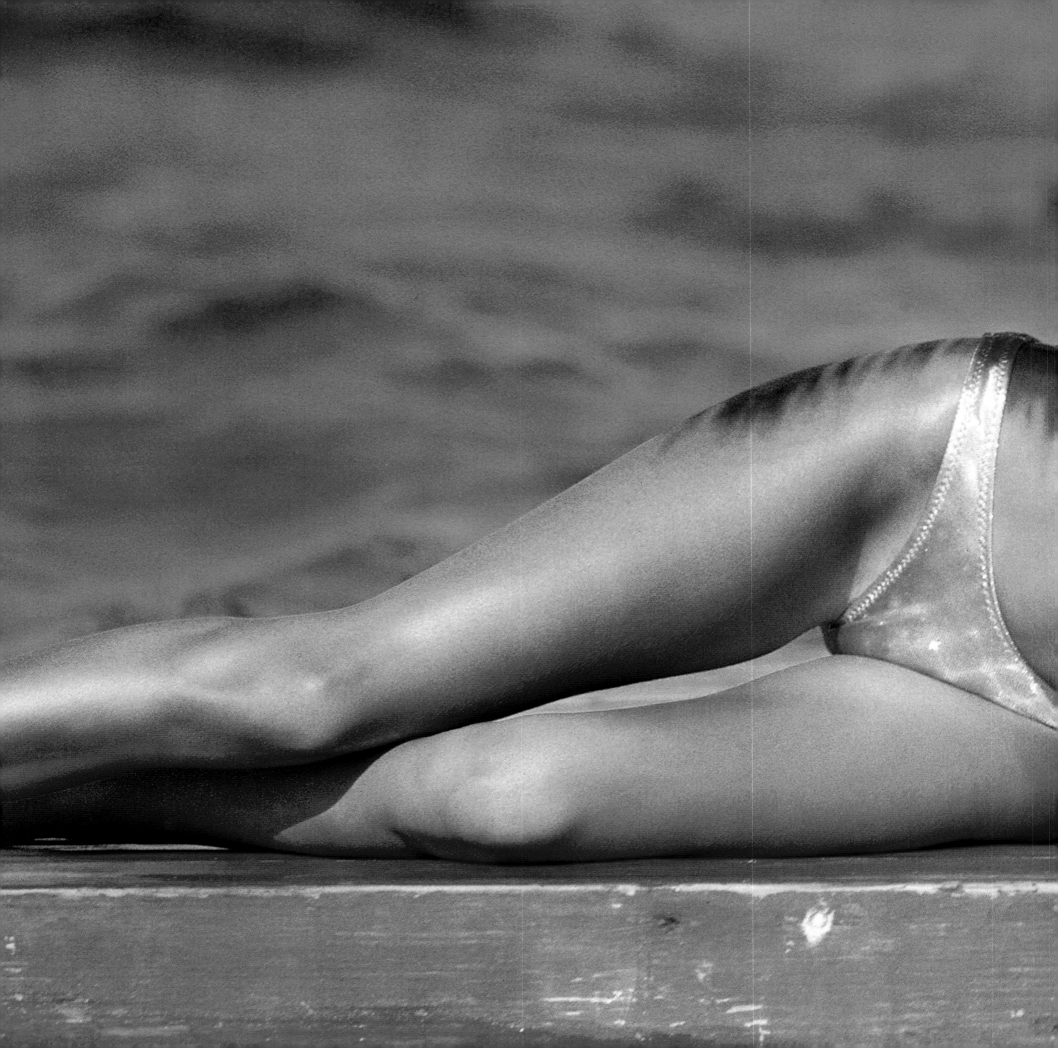

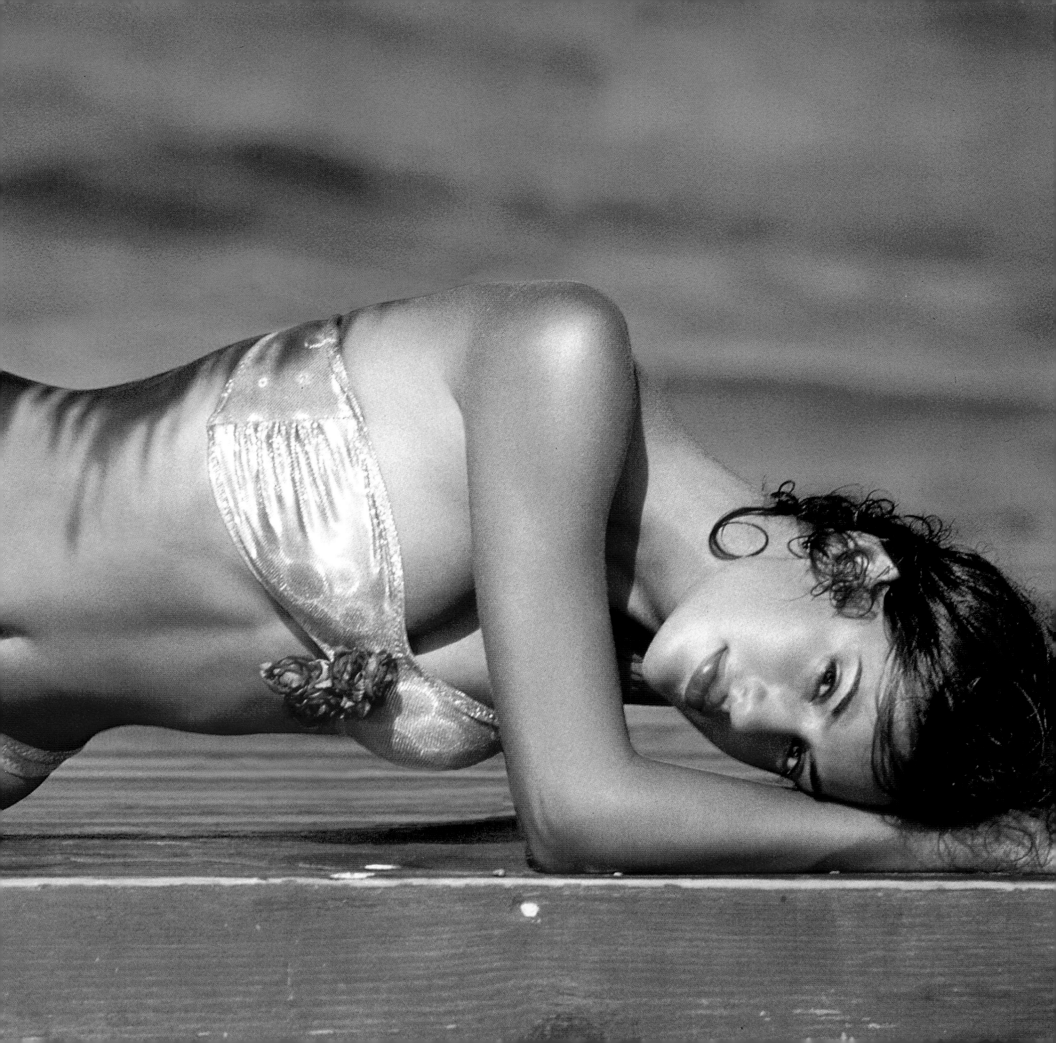

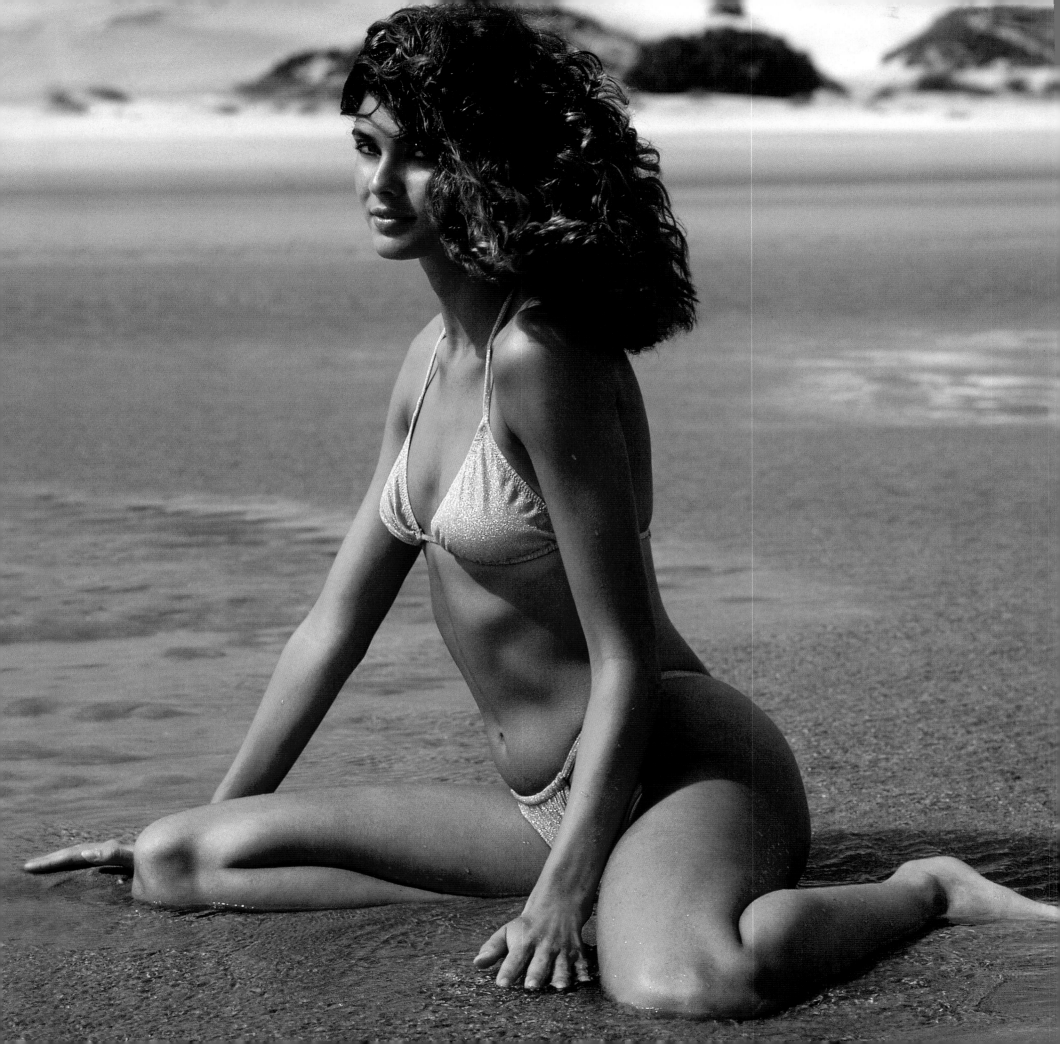

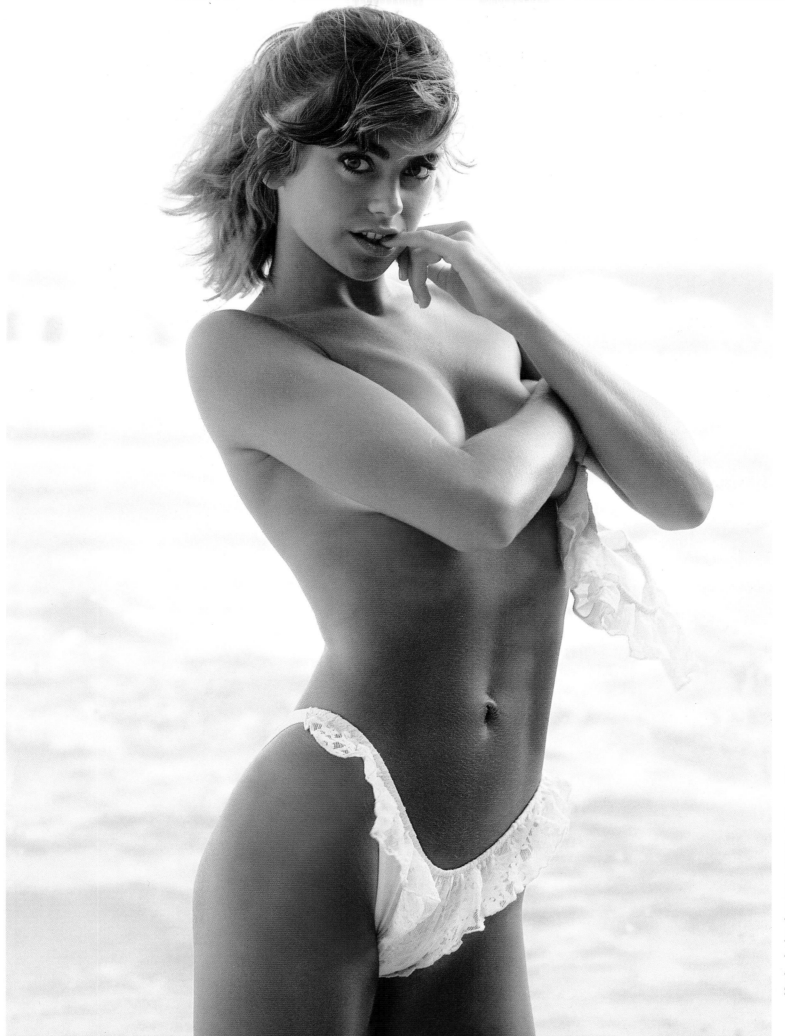

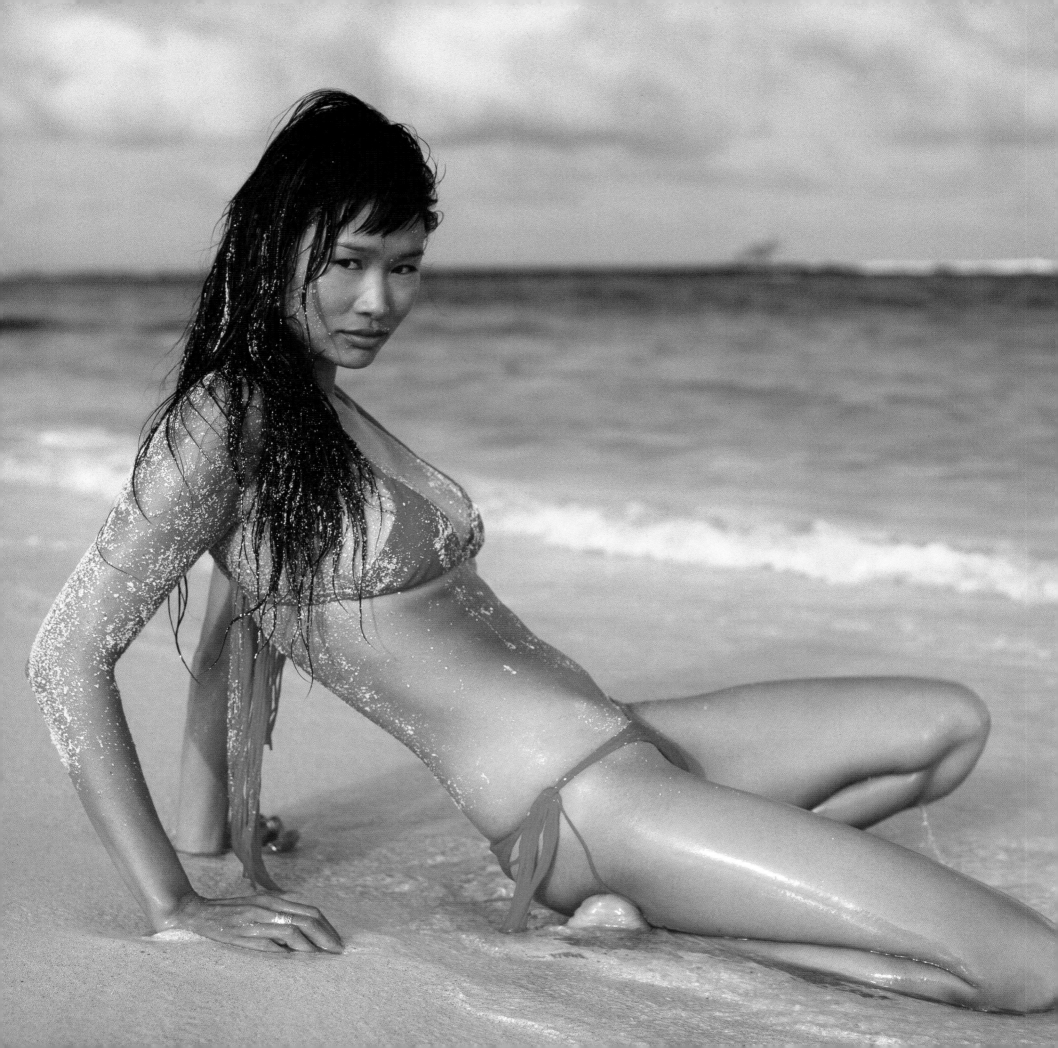

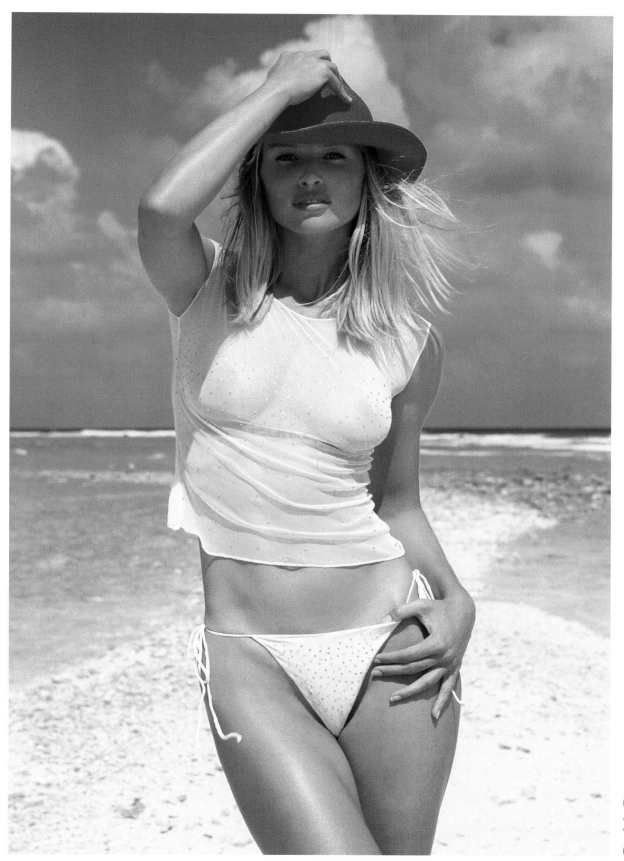

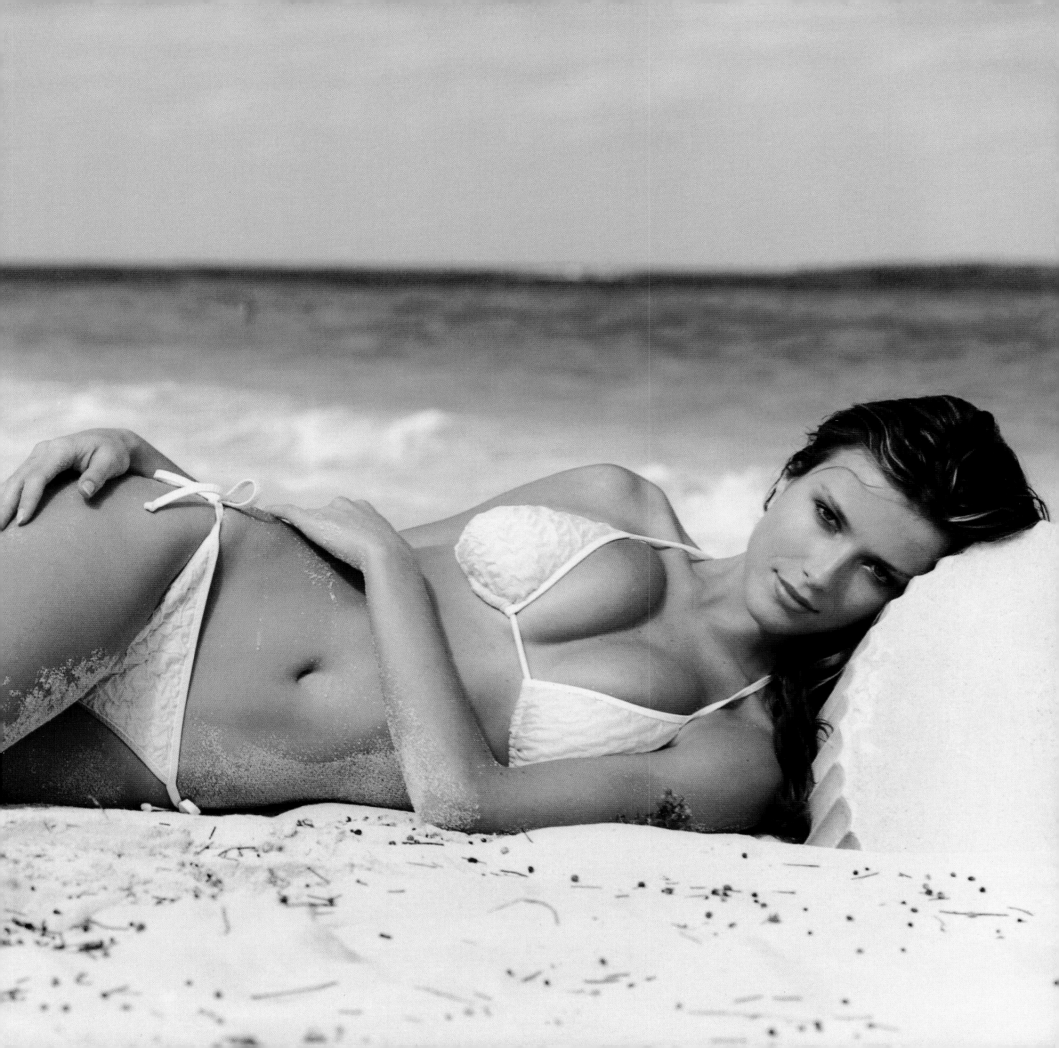

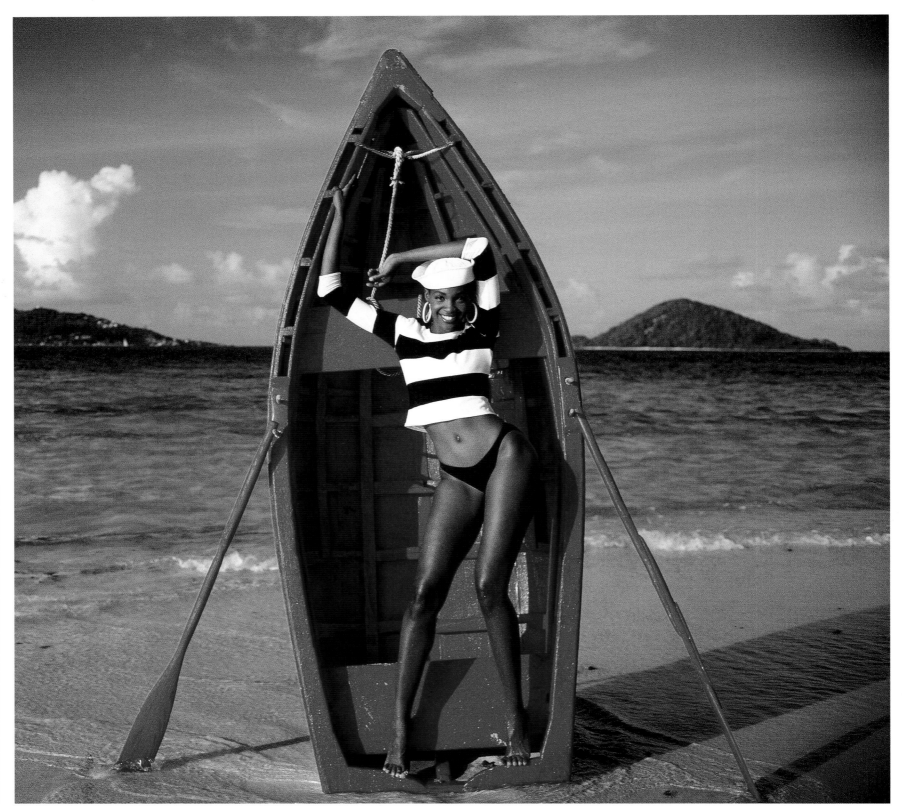

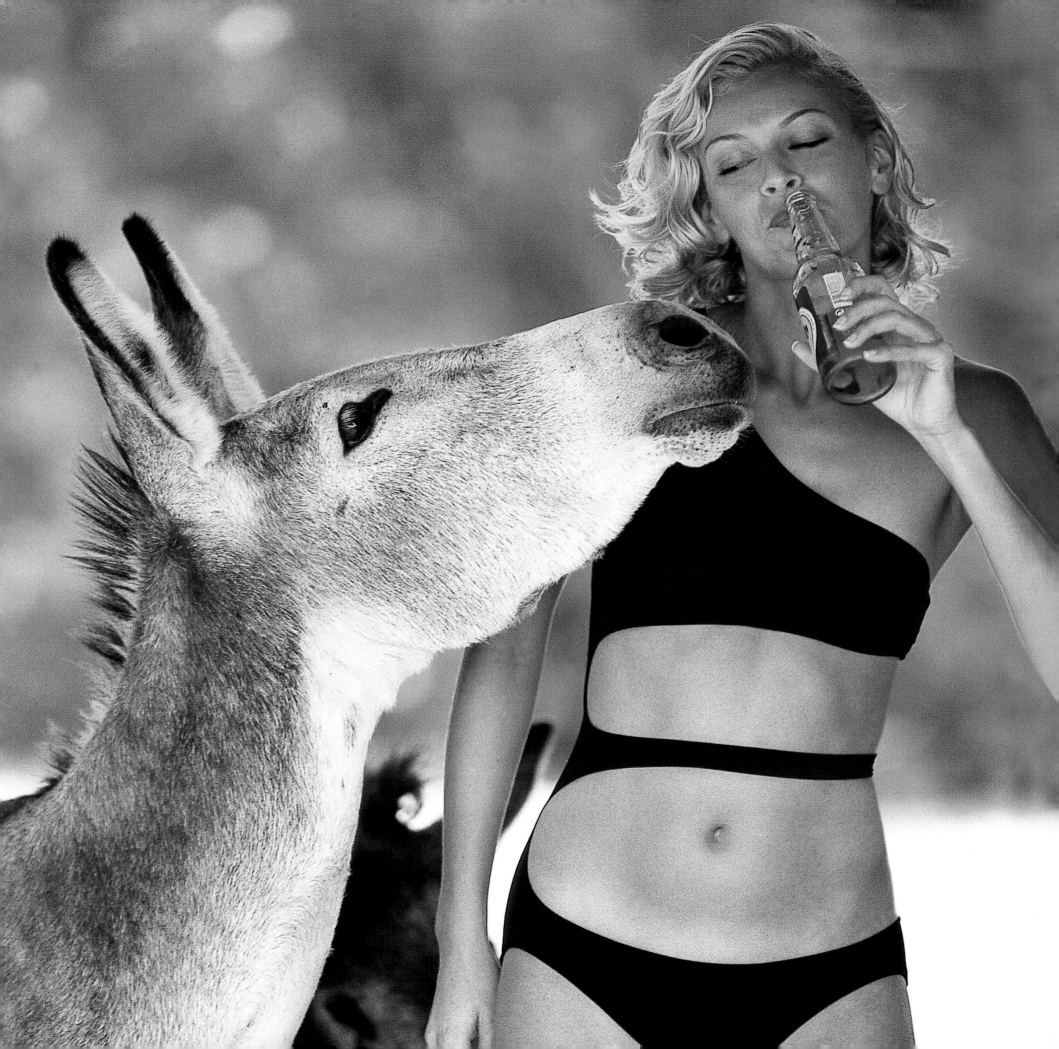

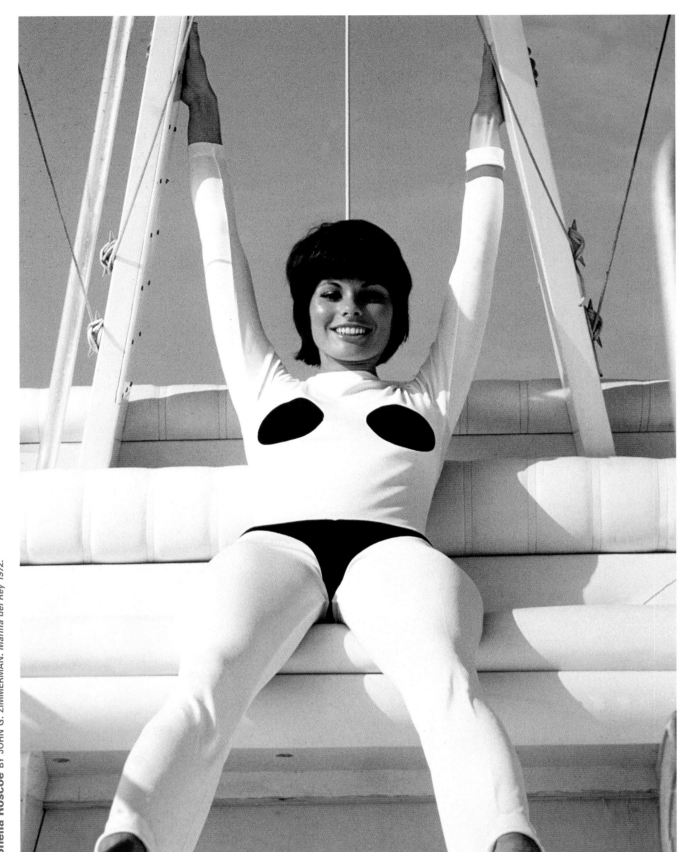

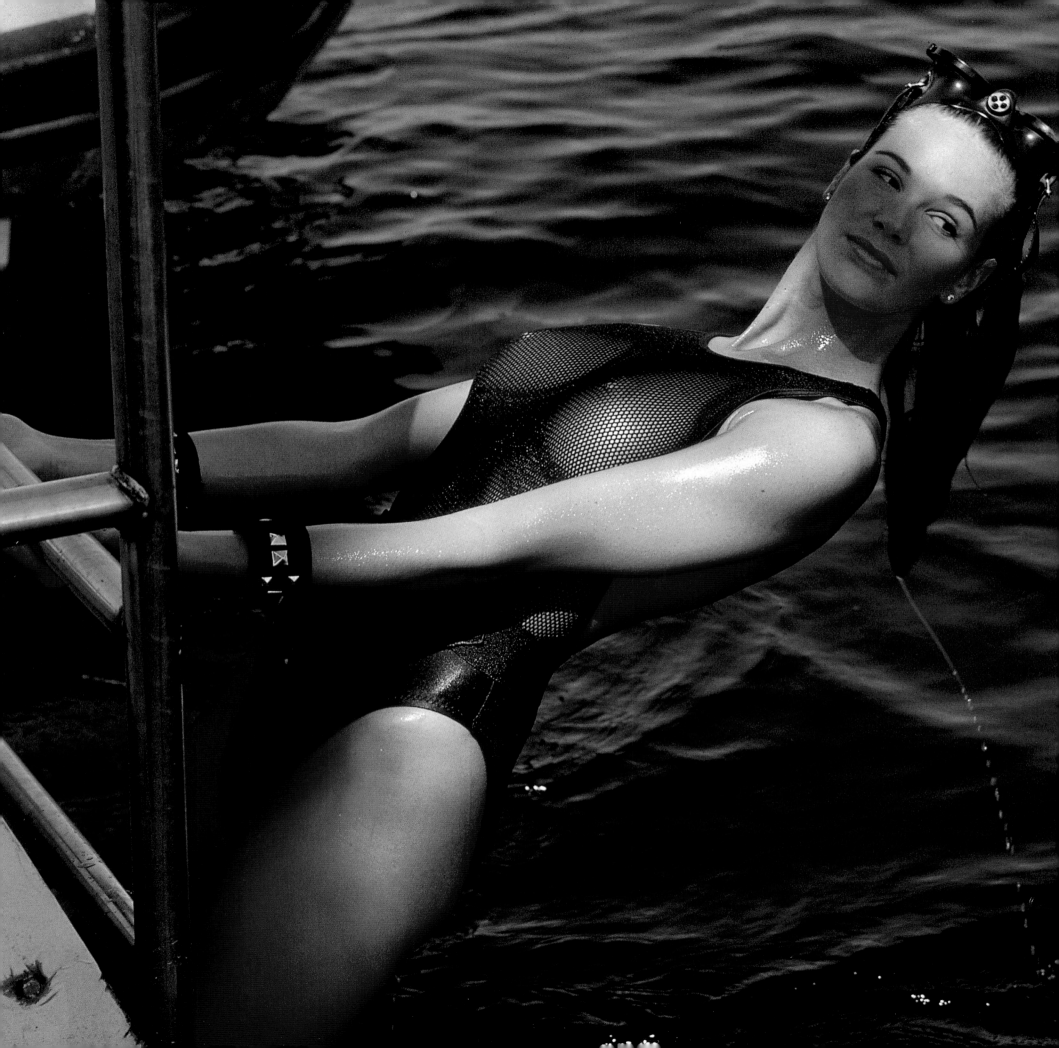

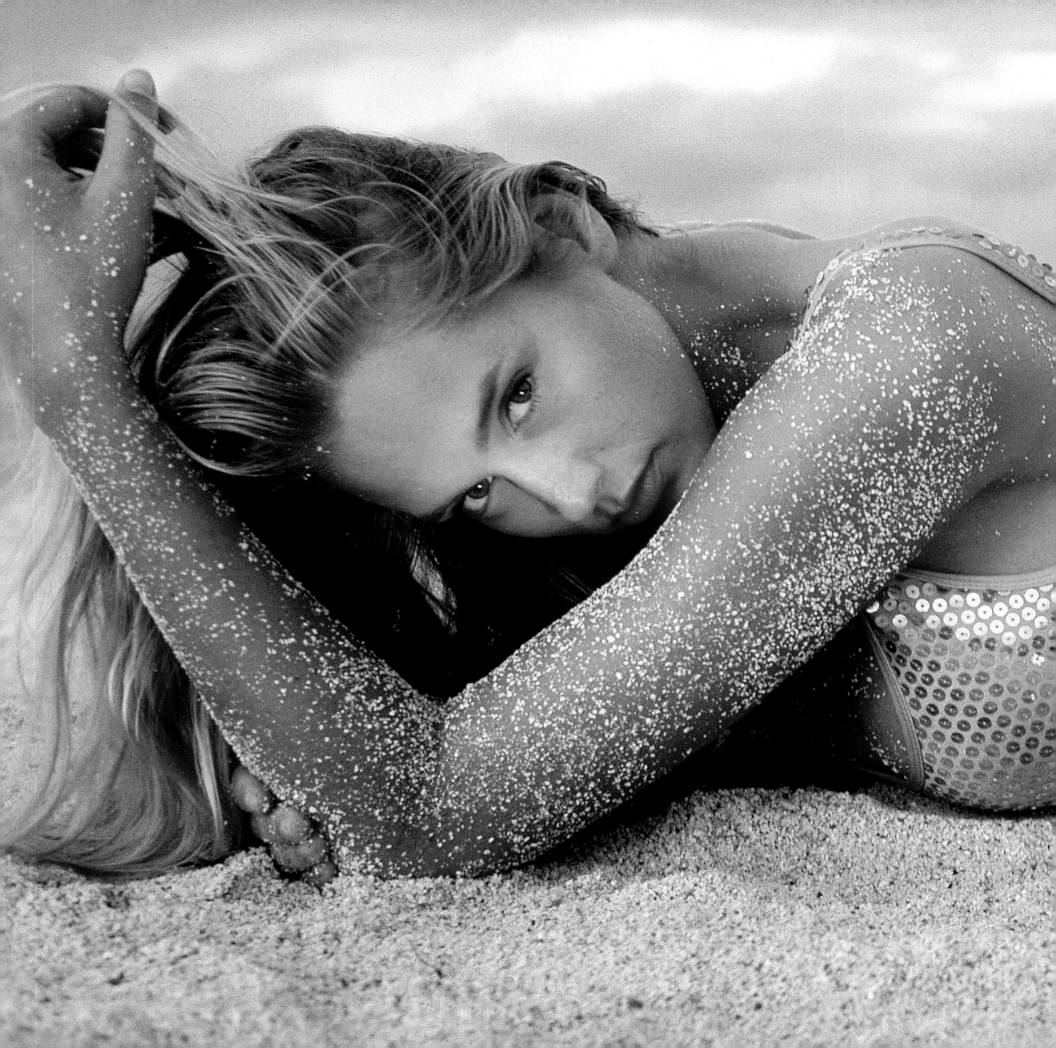

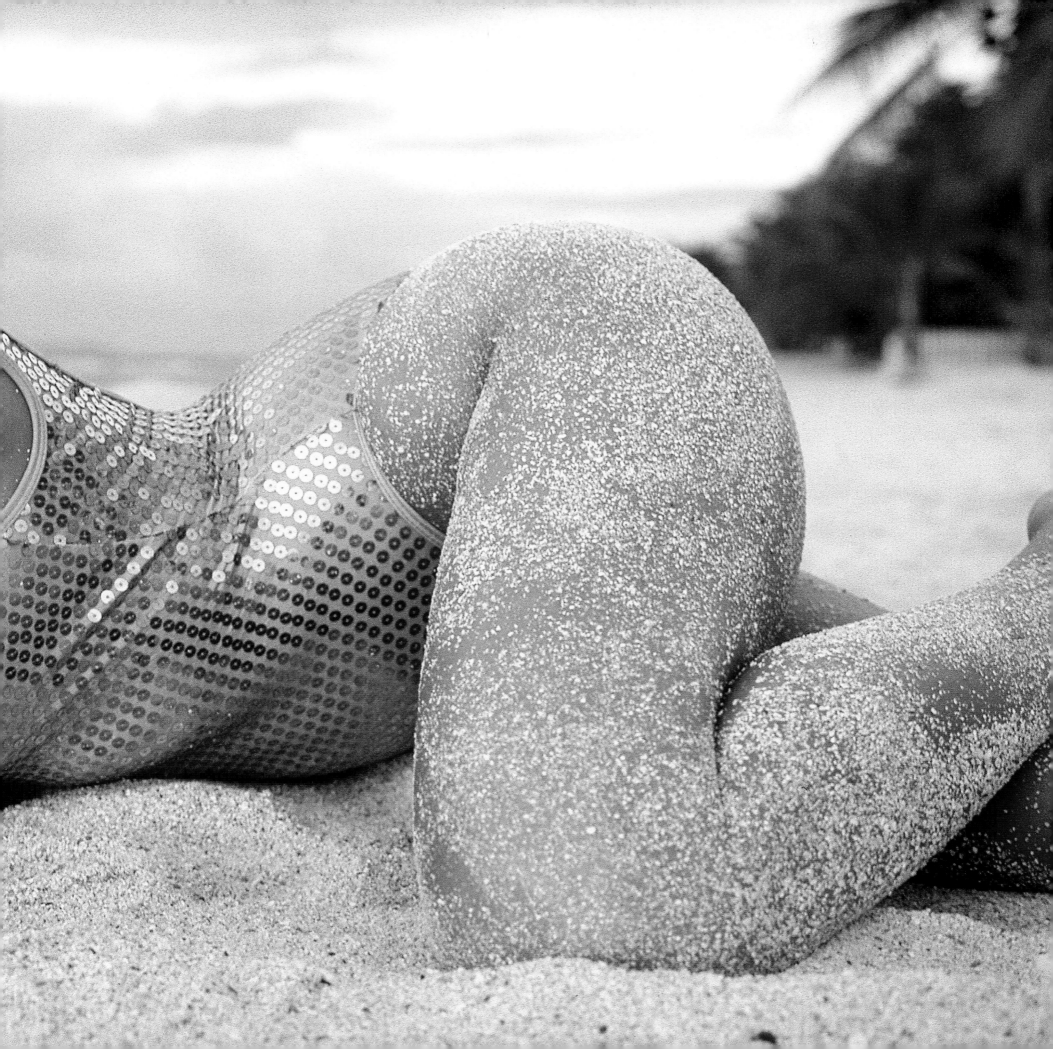

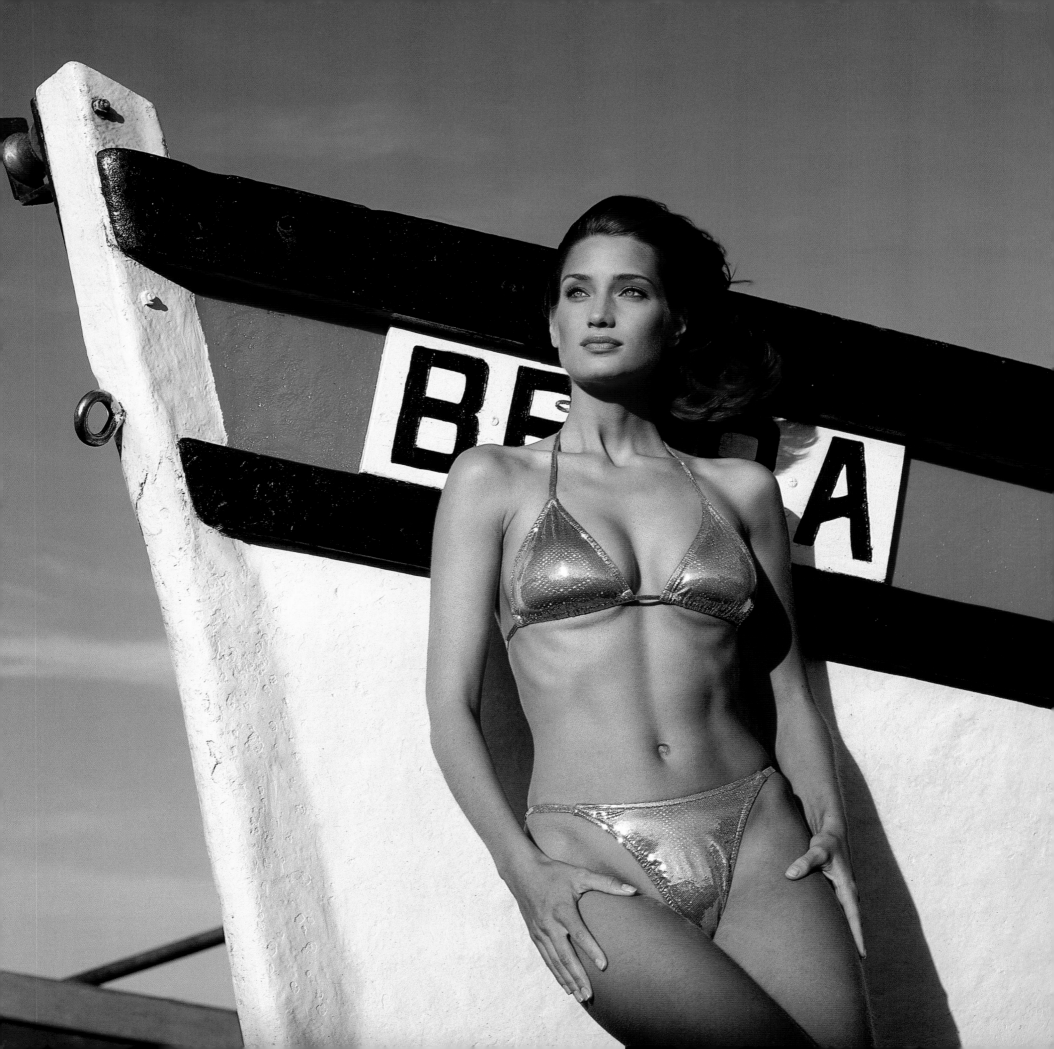

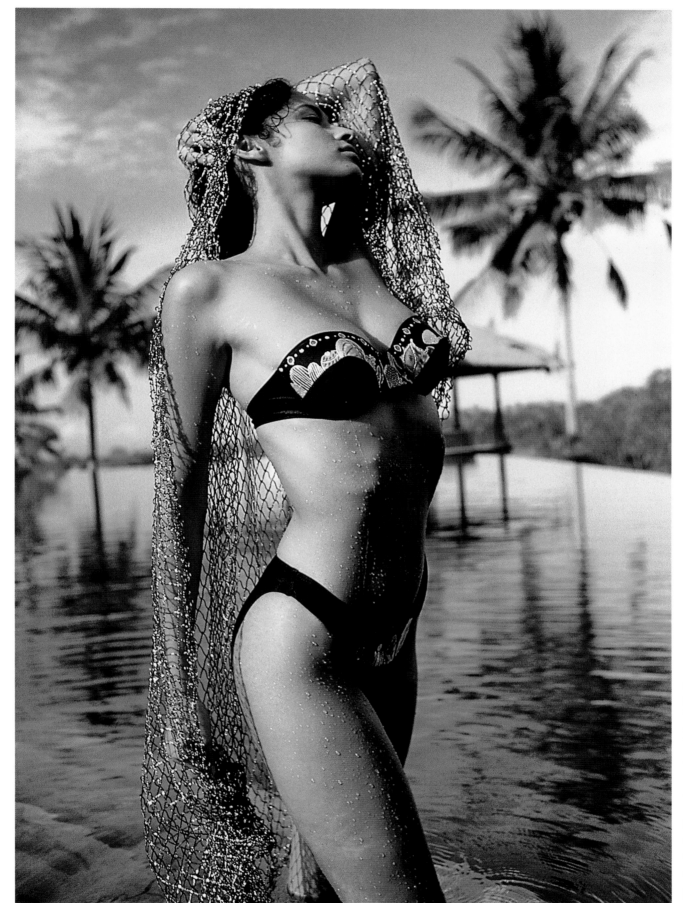

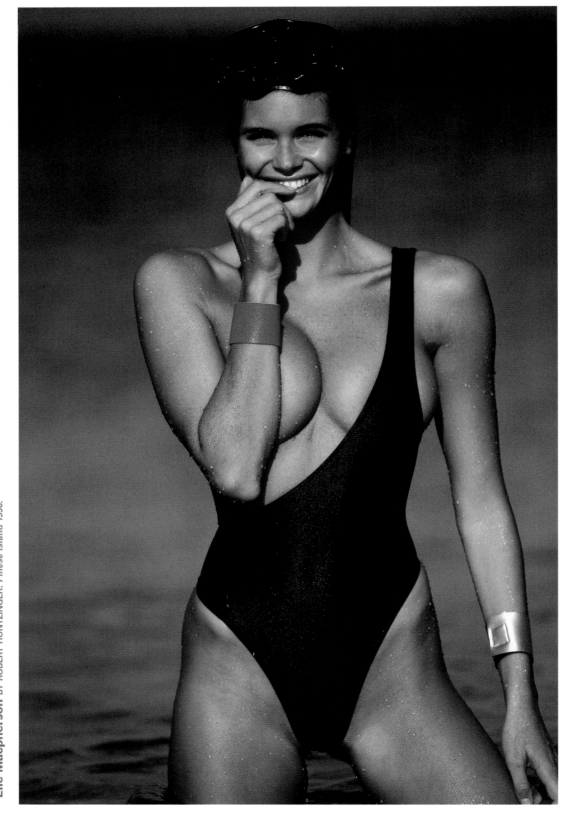

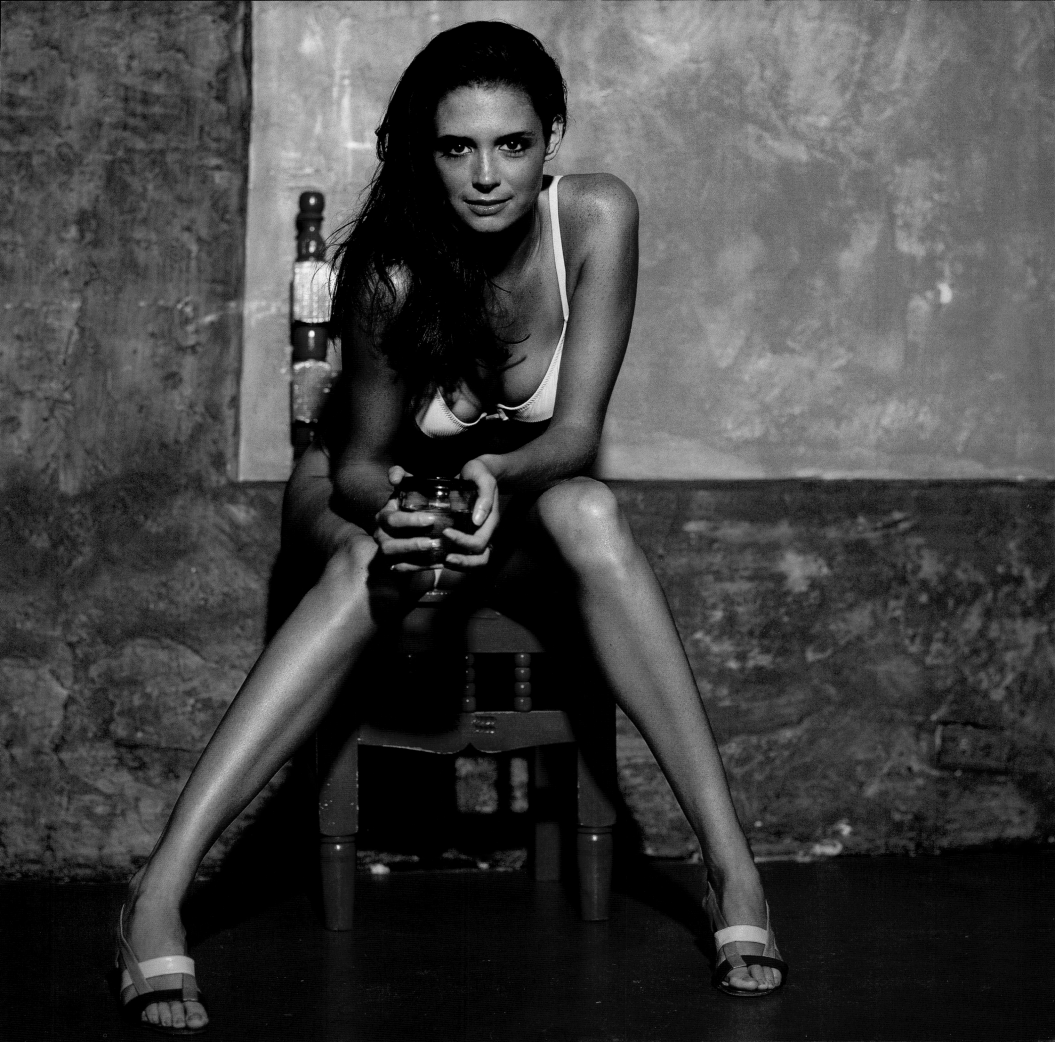

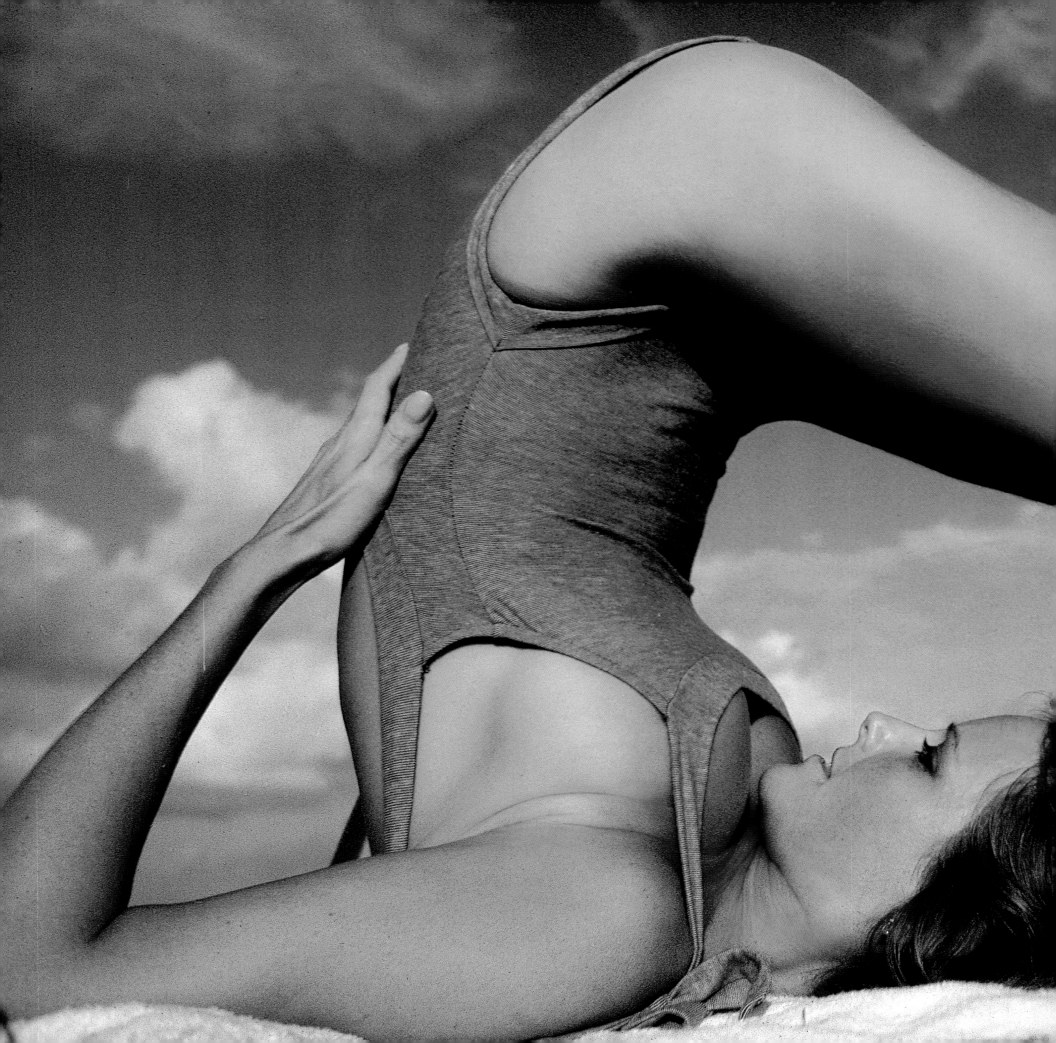

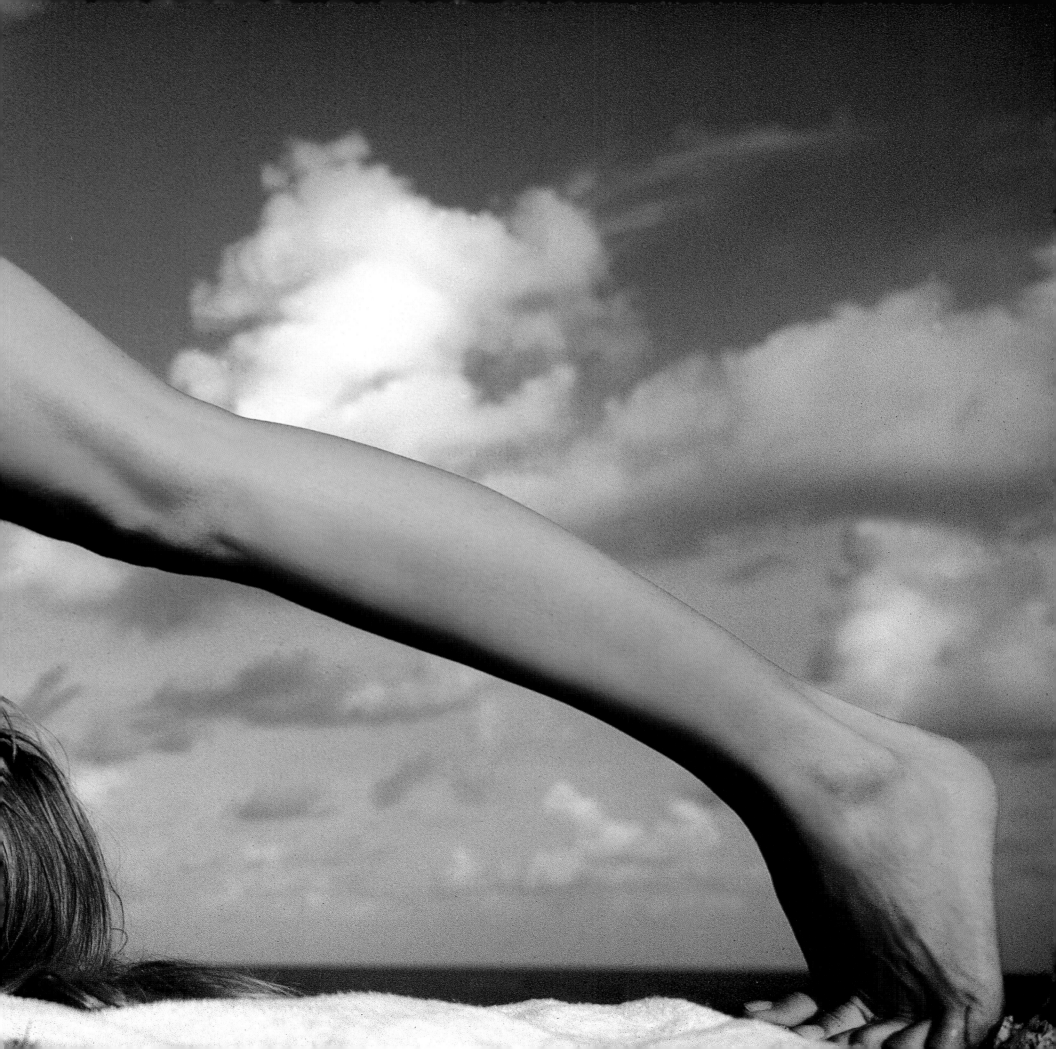

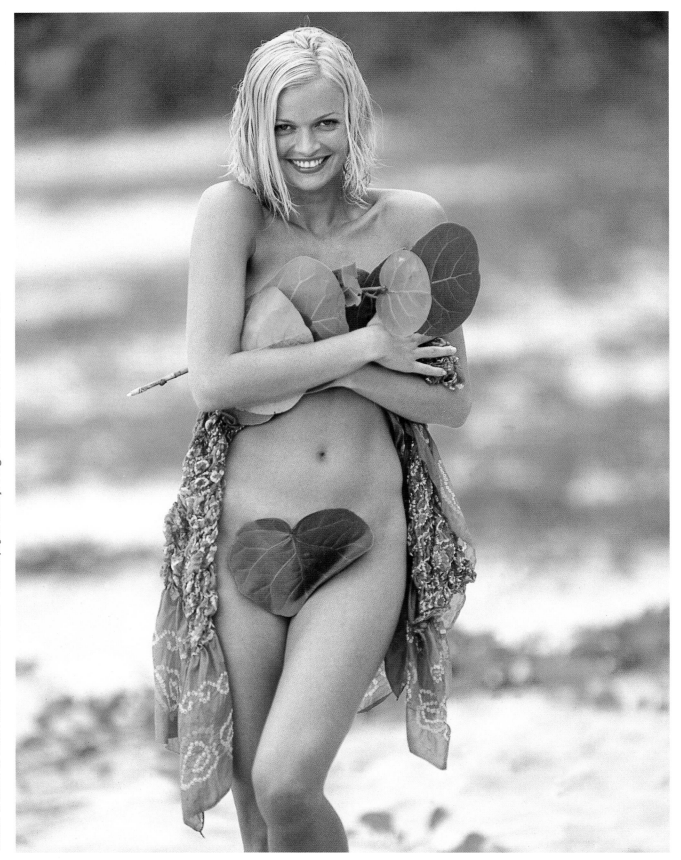

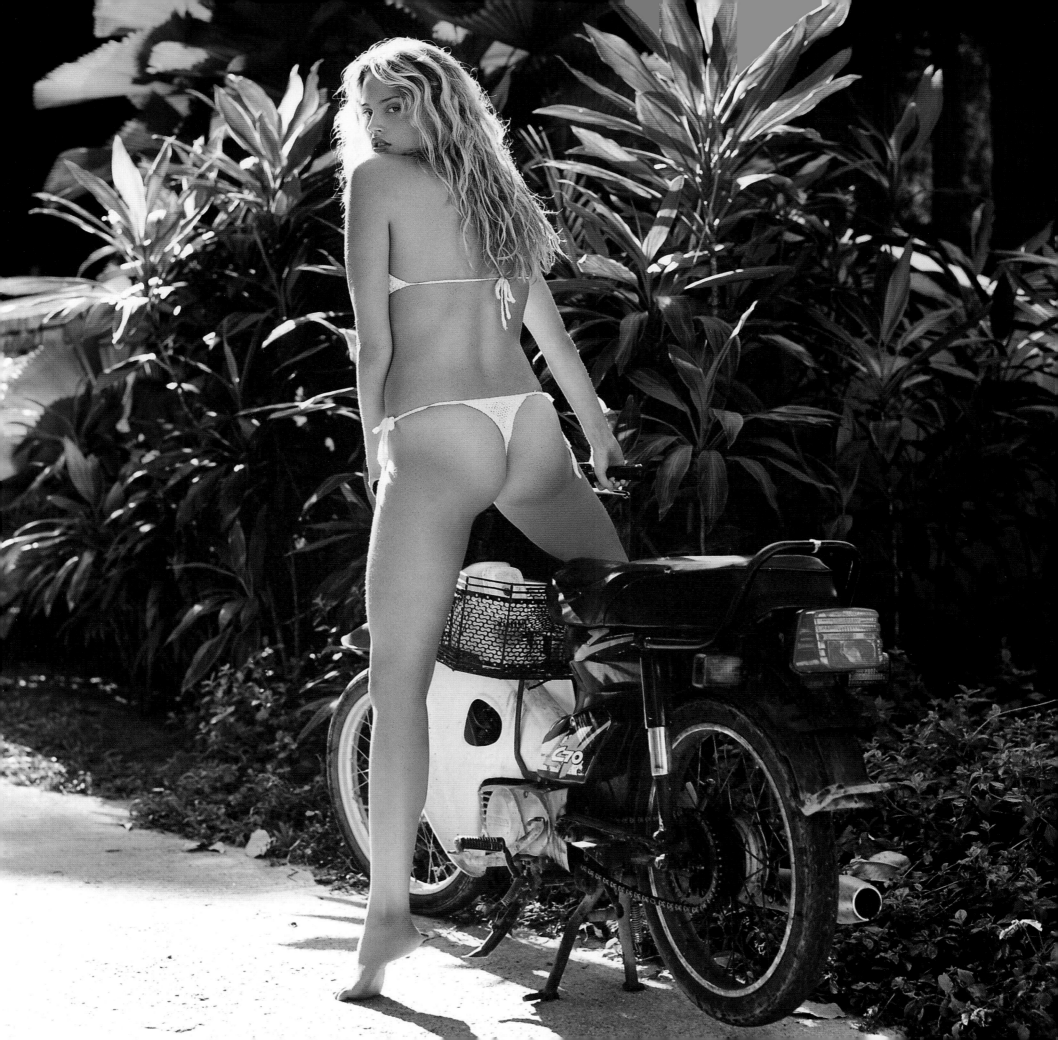

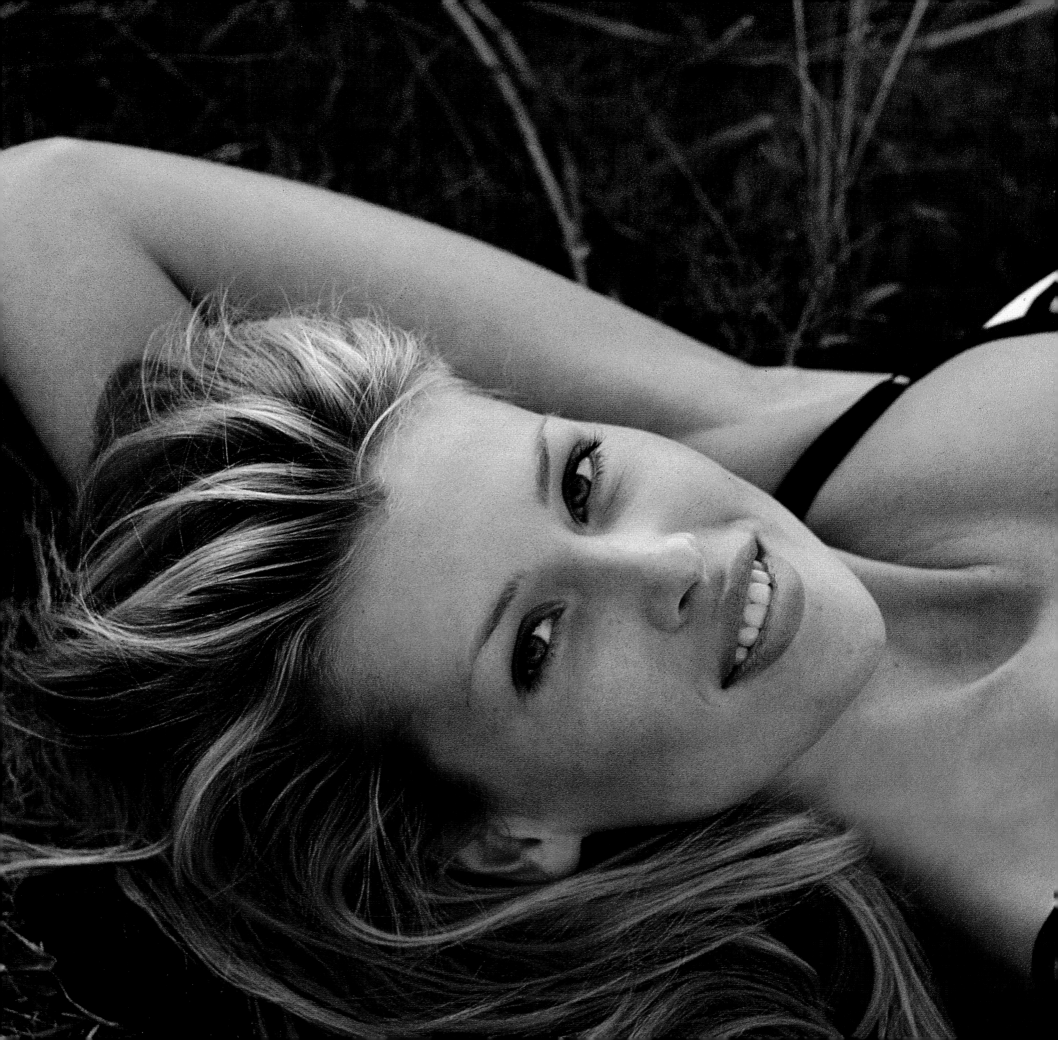

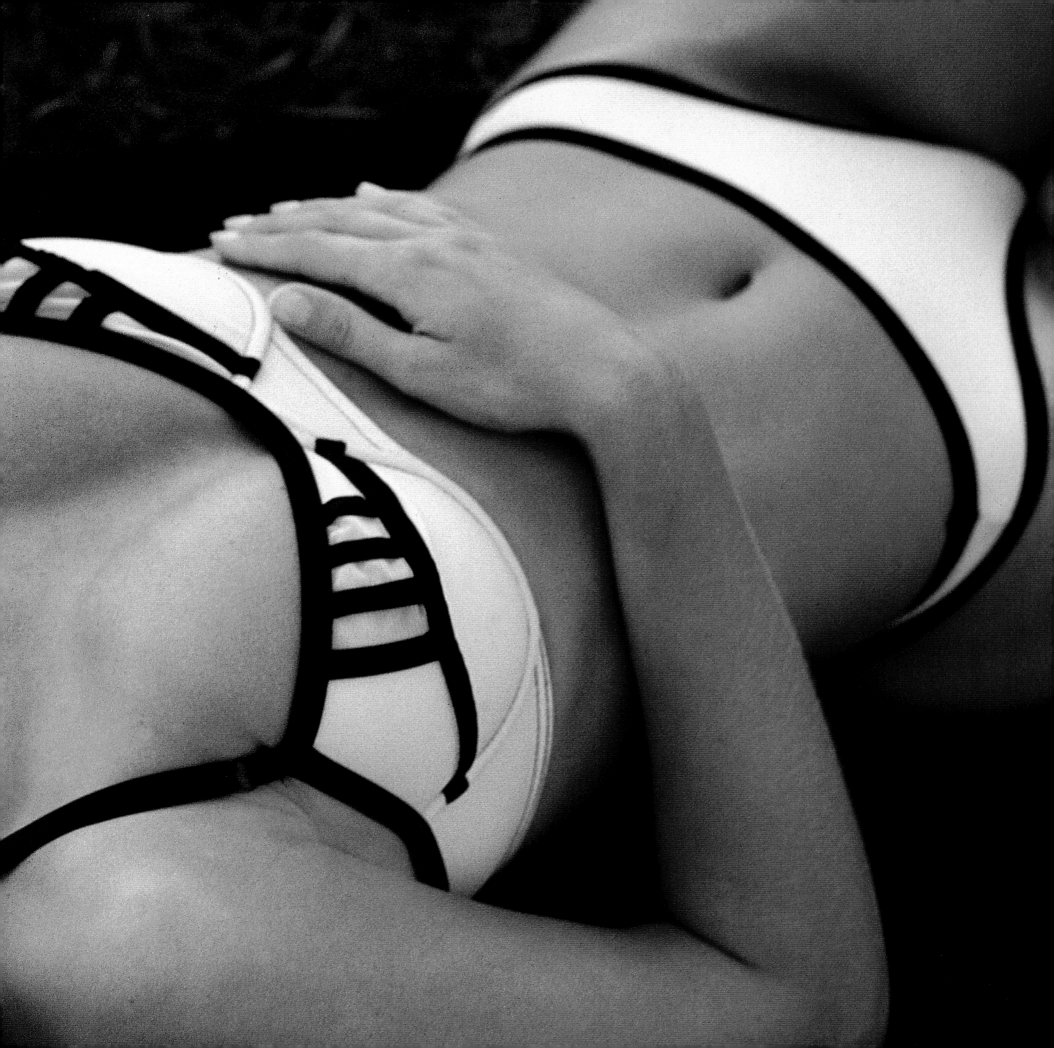

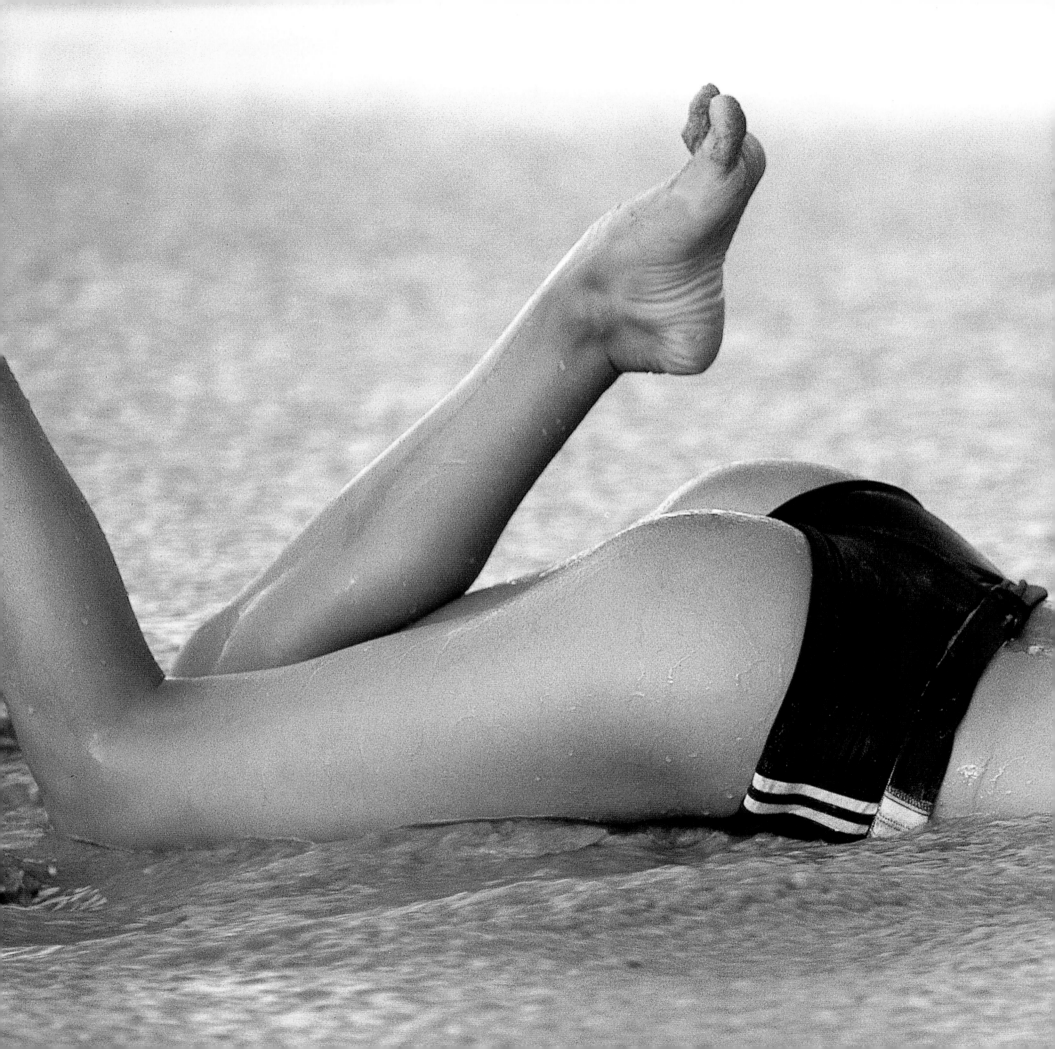

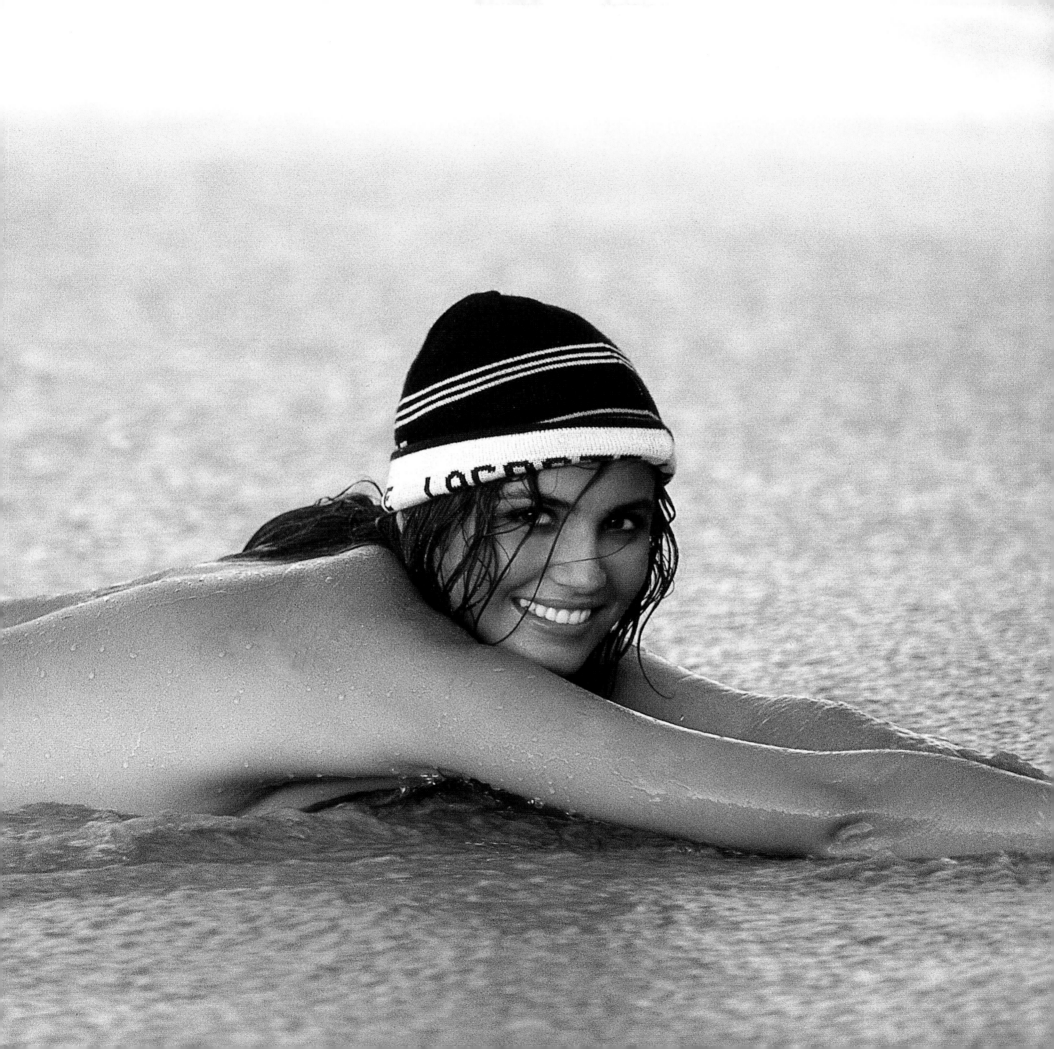

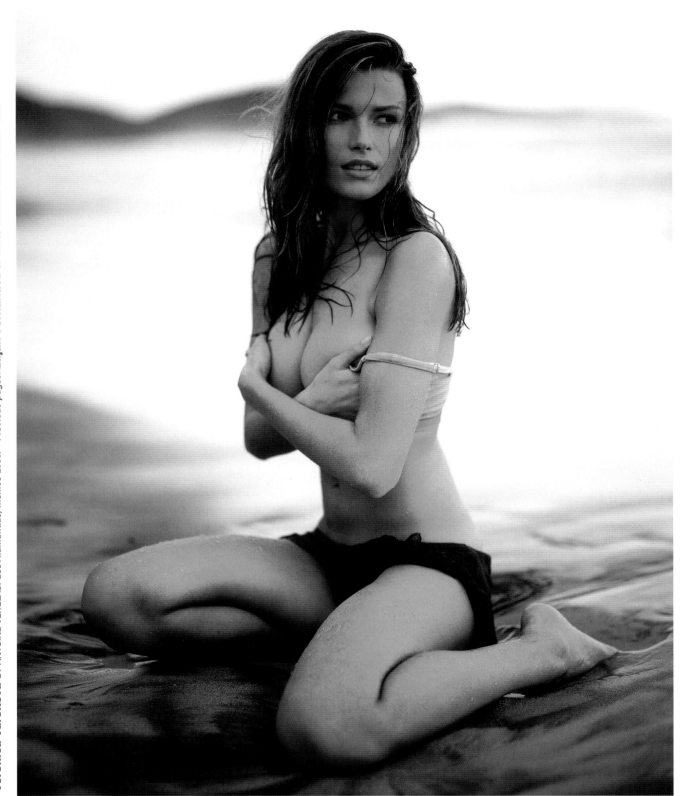

Veronica Varekova BY ANTOINE VERGLAS. *Los Alamandas, Mexico 2000.* *Previous pages:* **Lujan Fernandez** BY HANS FEURER. *Guana Island 1999.*

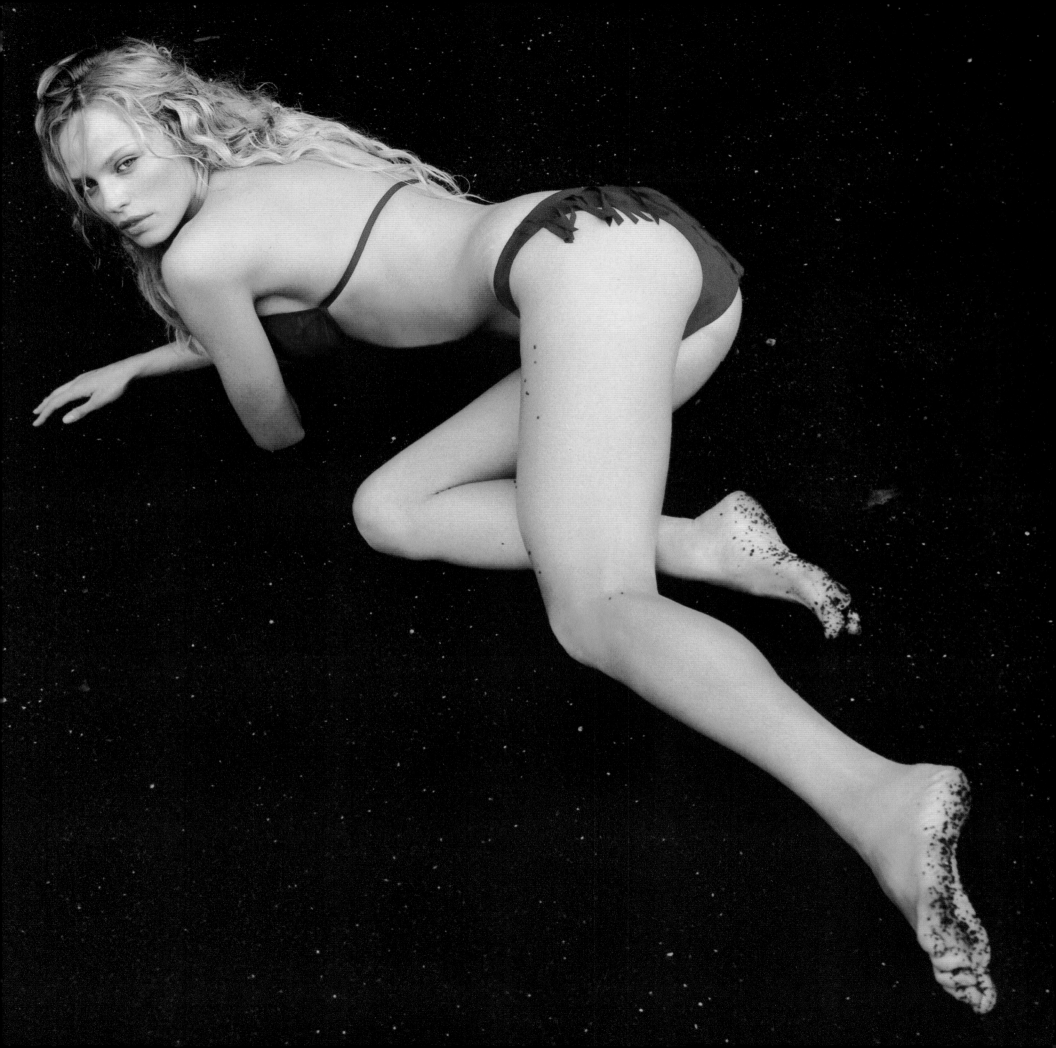

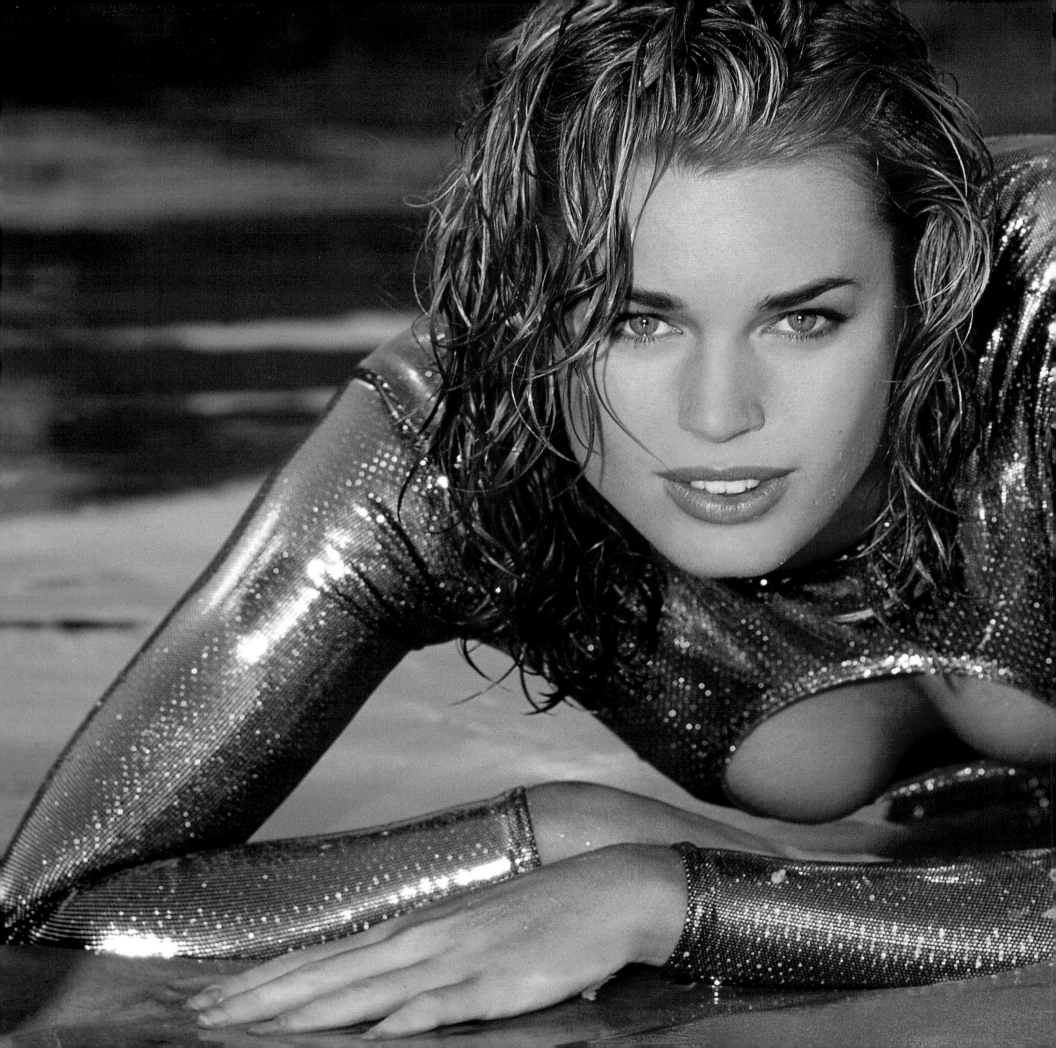

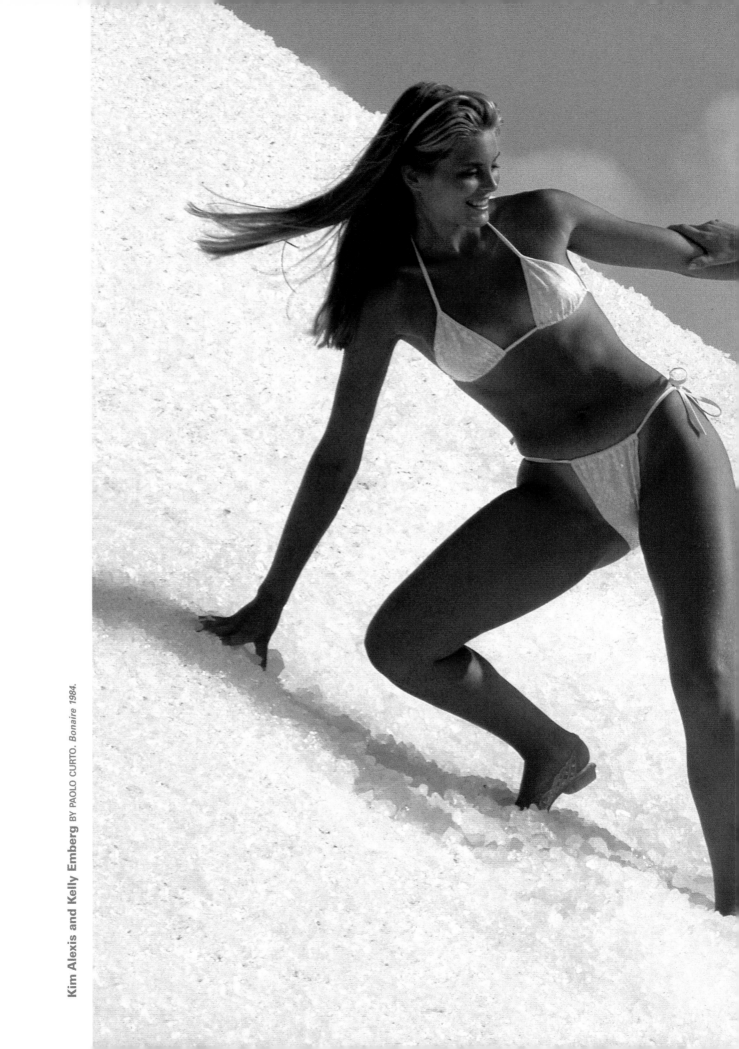

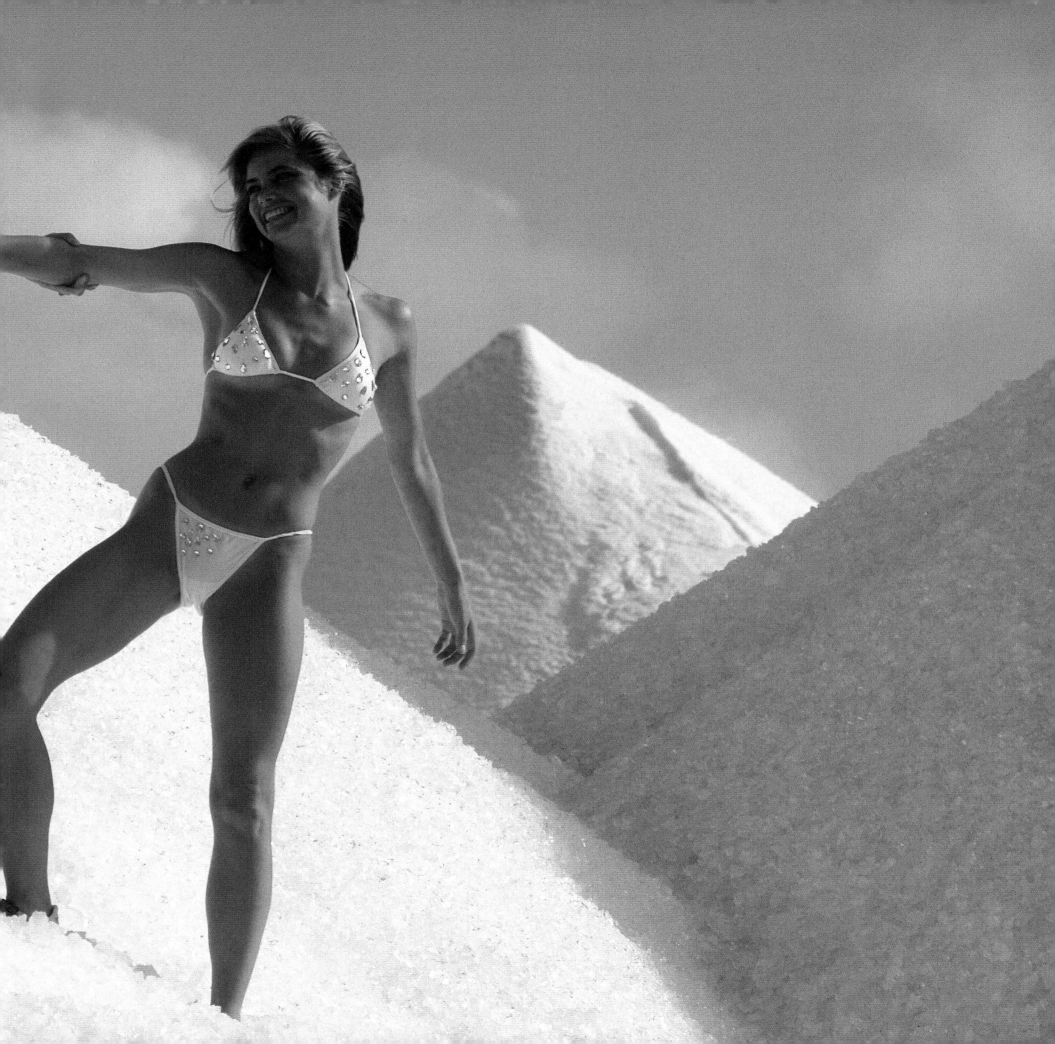

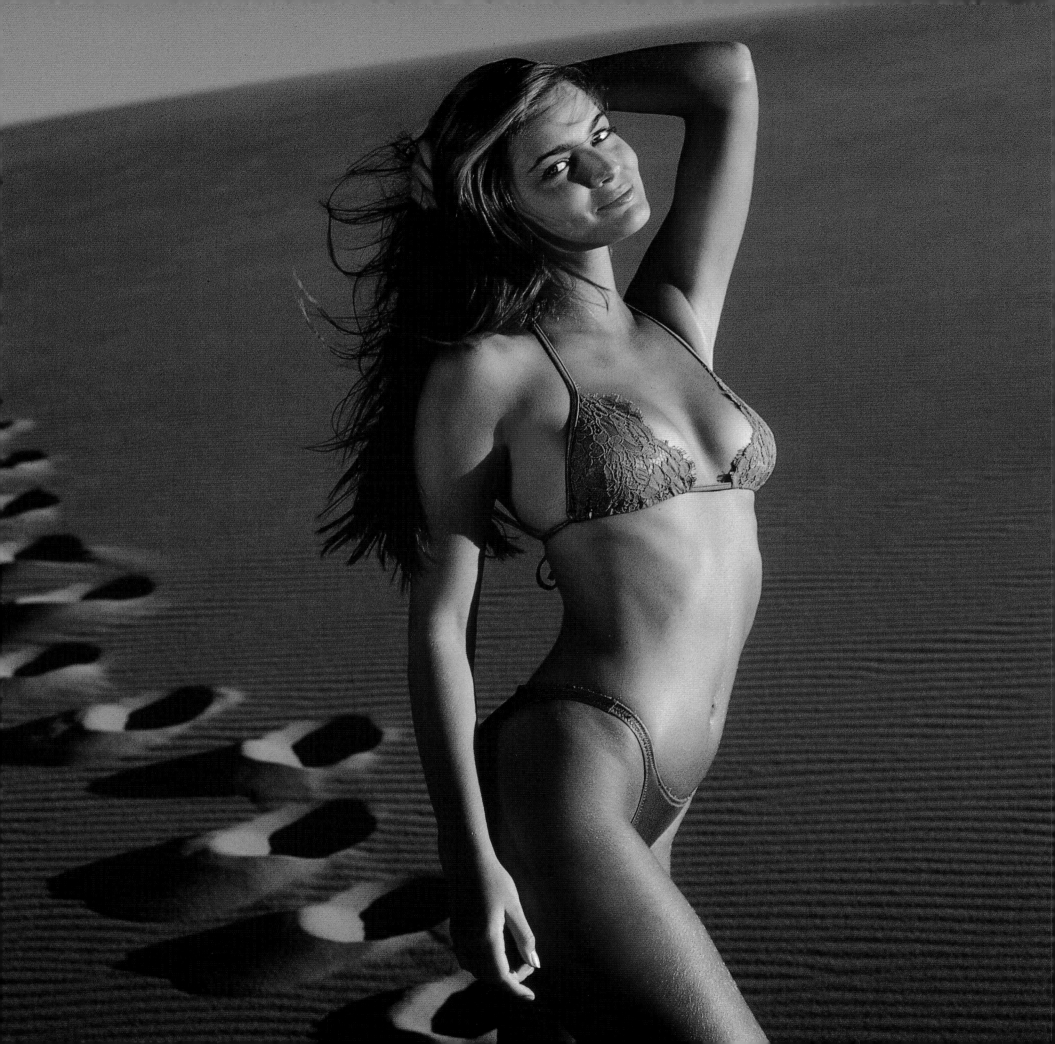

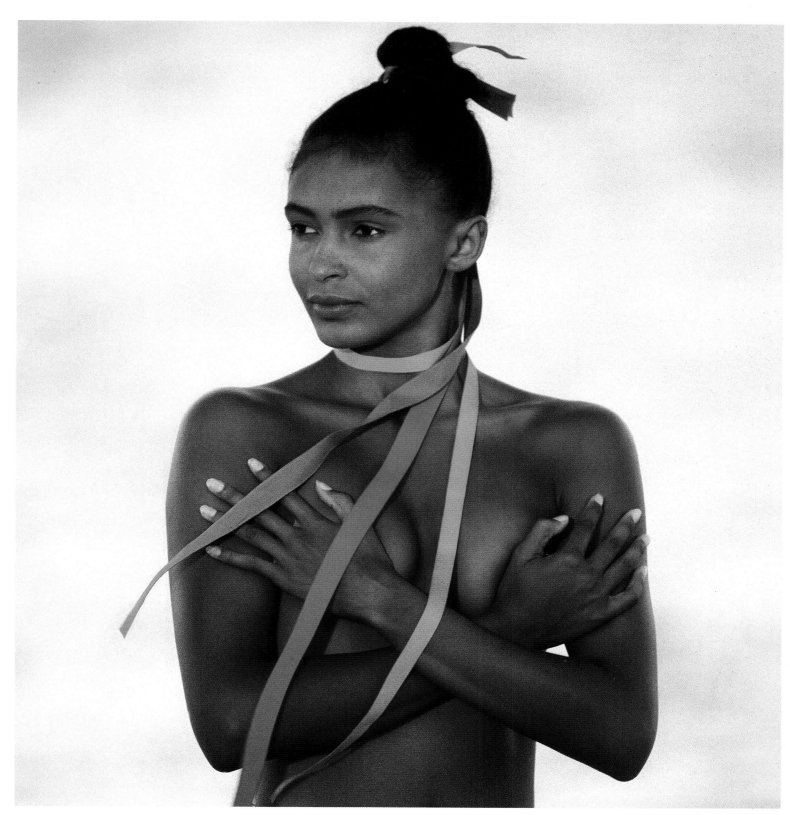

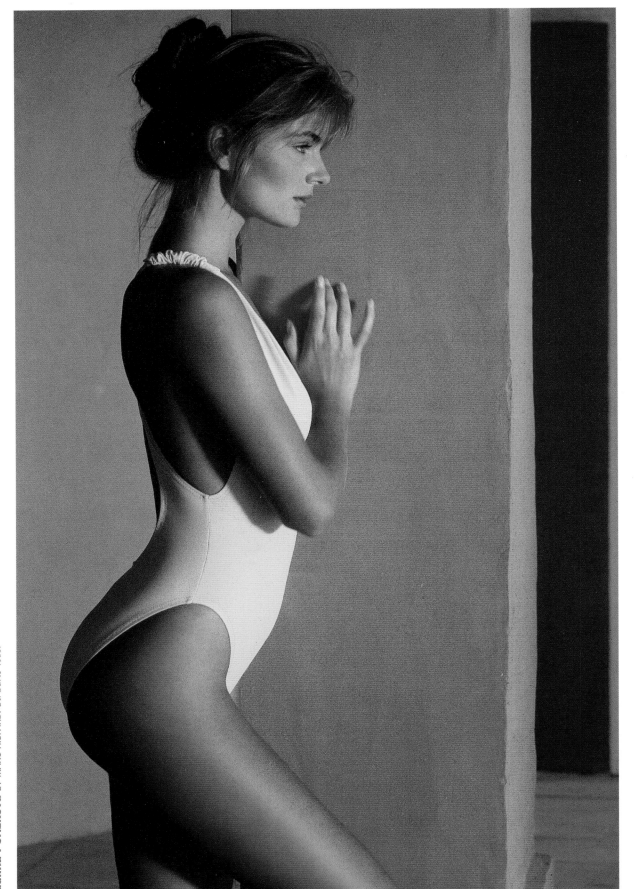

Paulina Porizkova BY MARC HISPARD. *St. Barts 1989.*

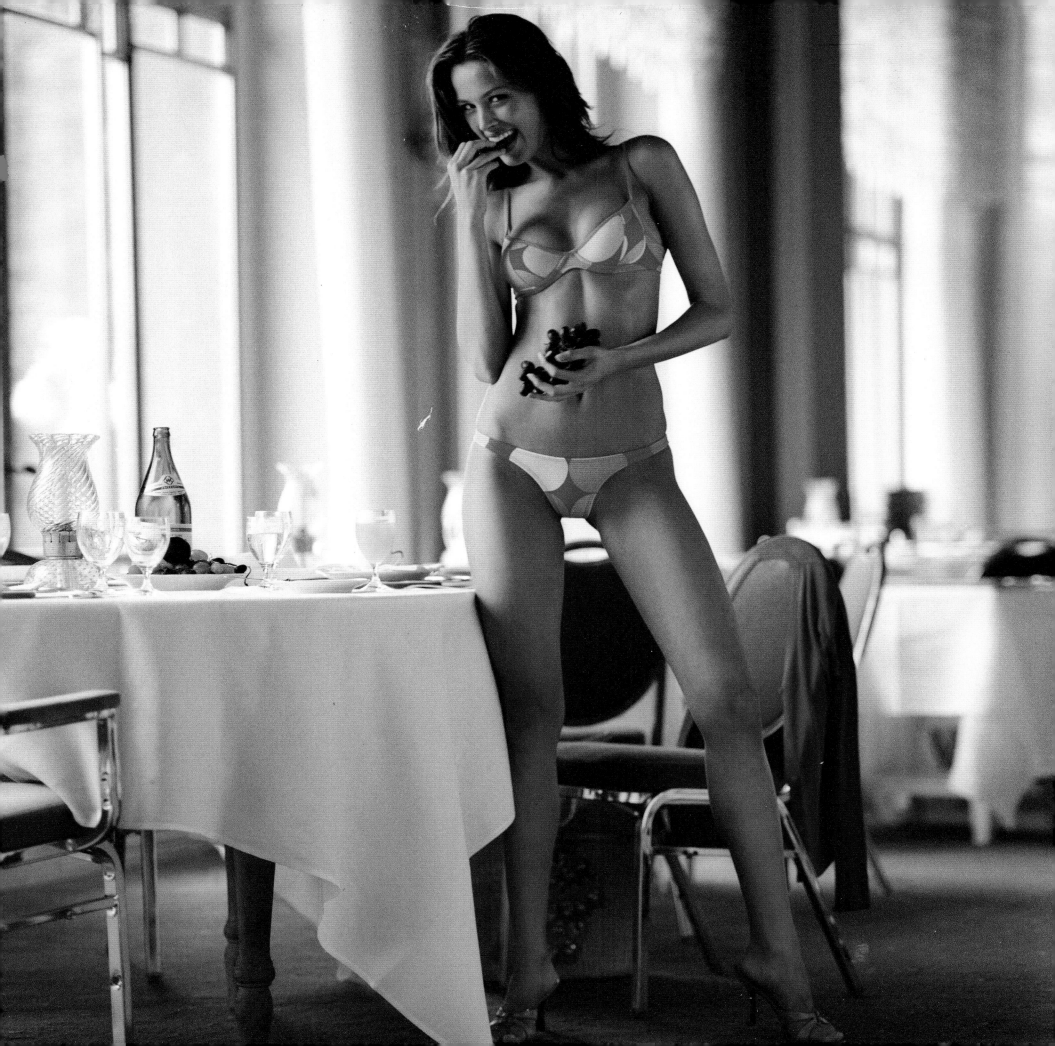

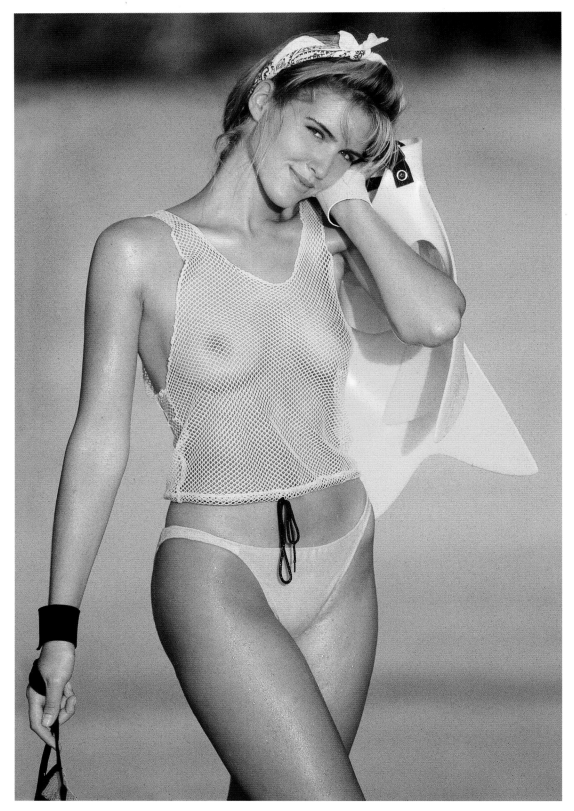

Judit Masco BY ROBERT HUNTZINGER.Caribbean 1990.

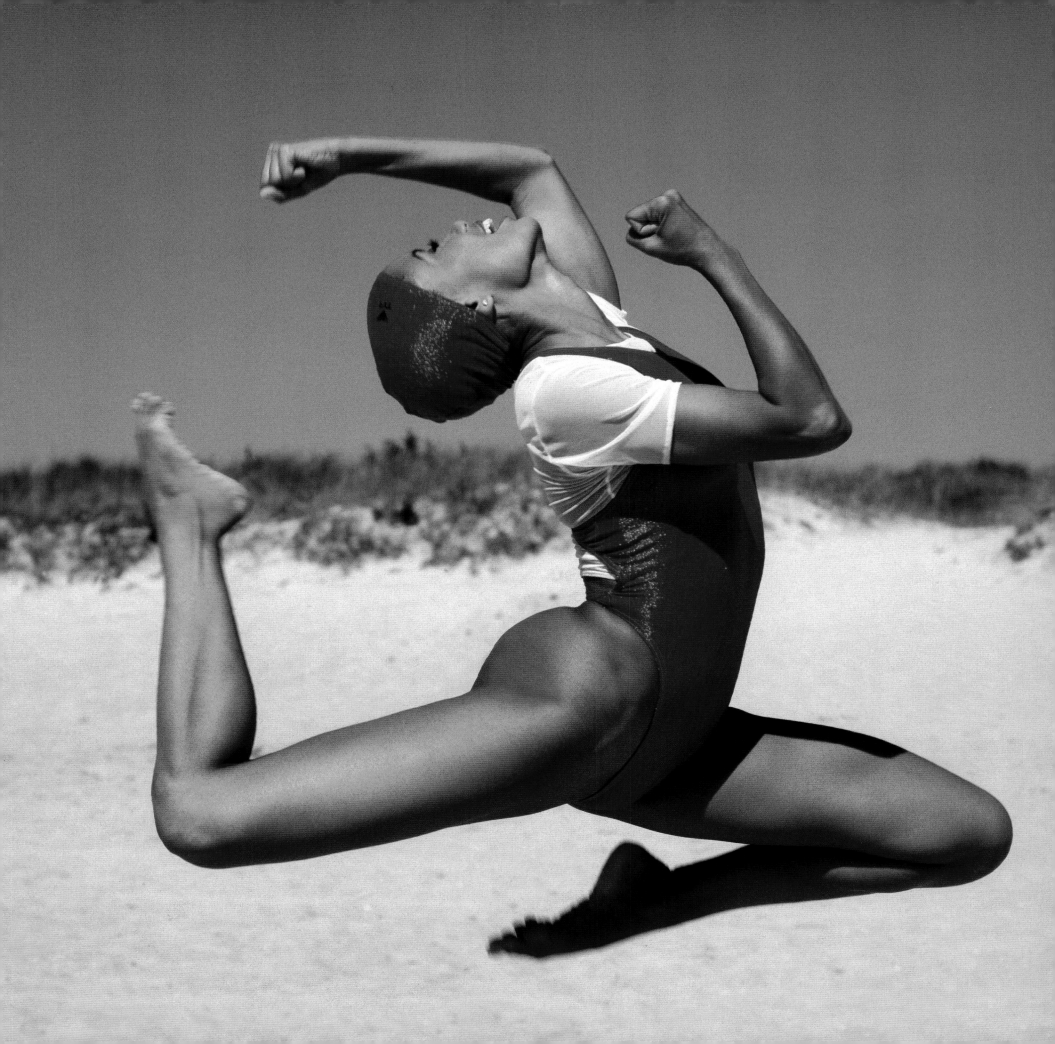

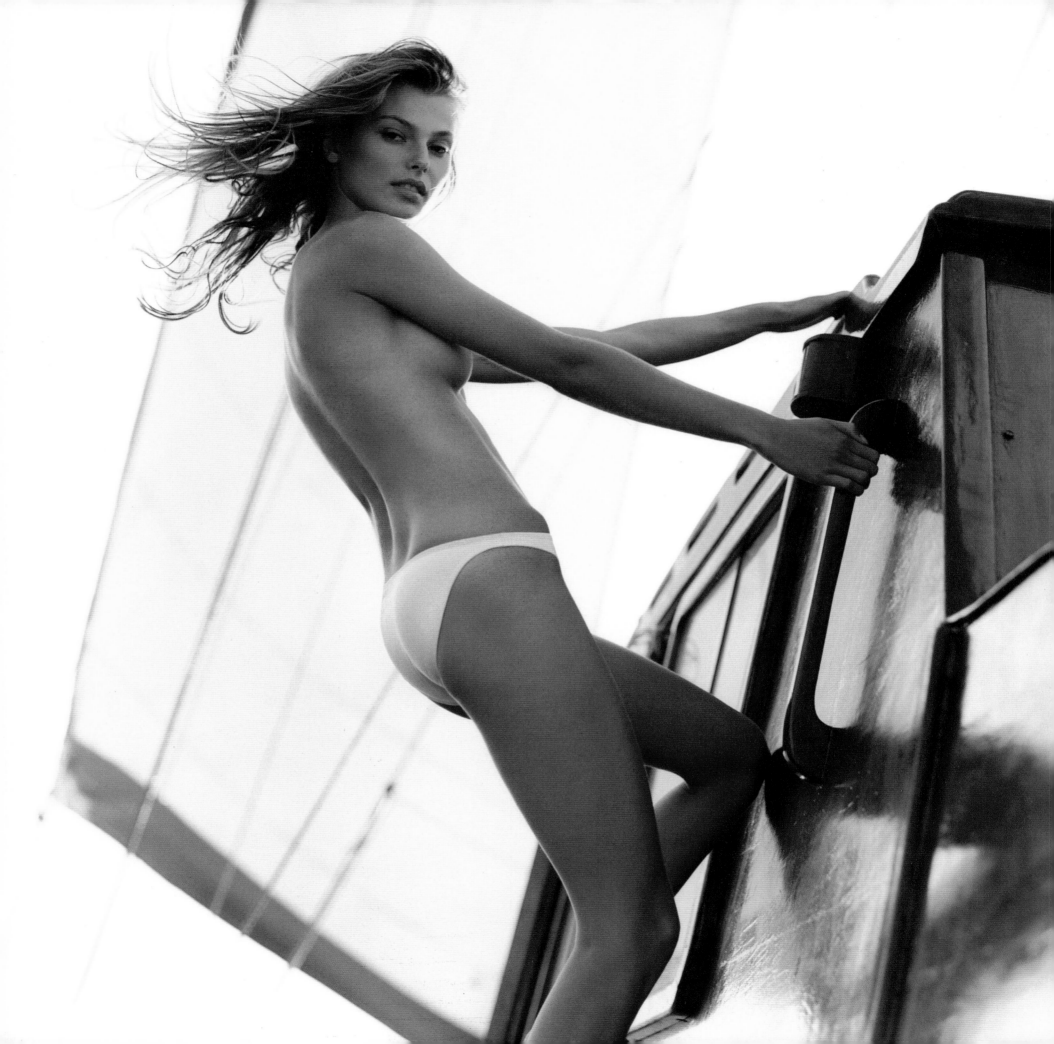

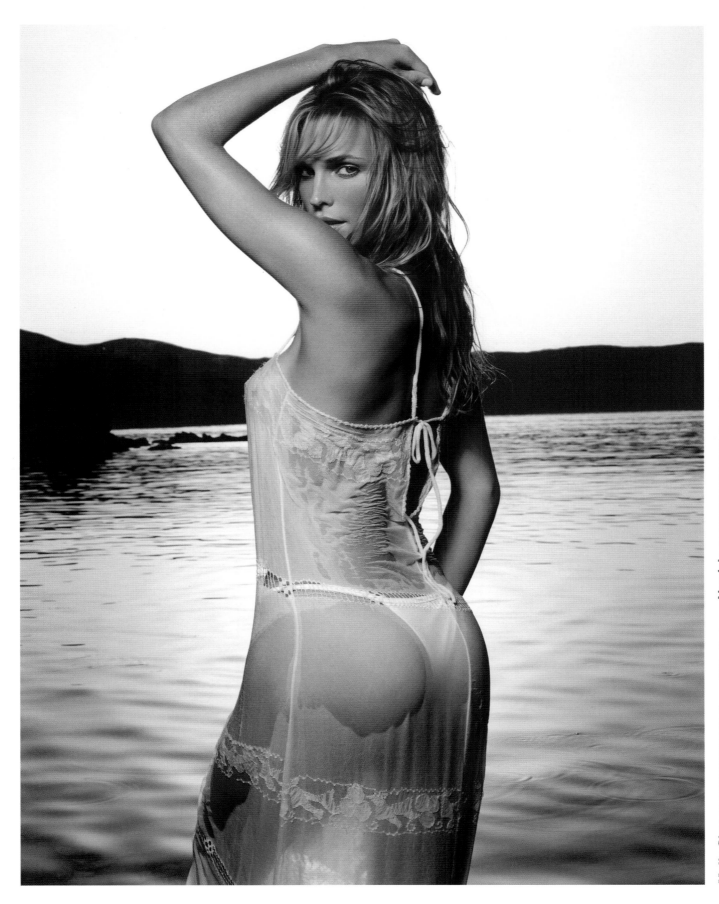

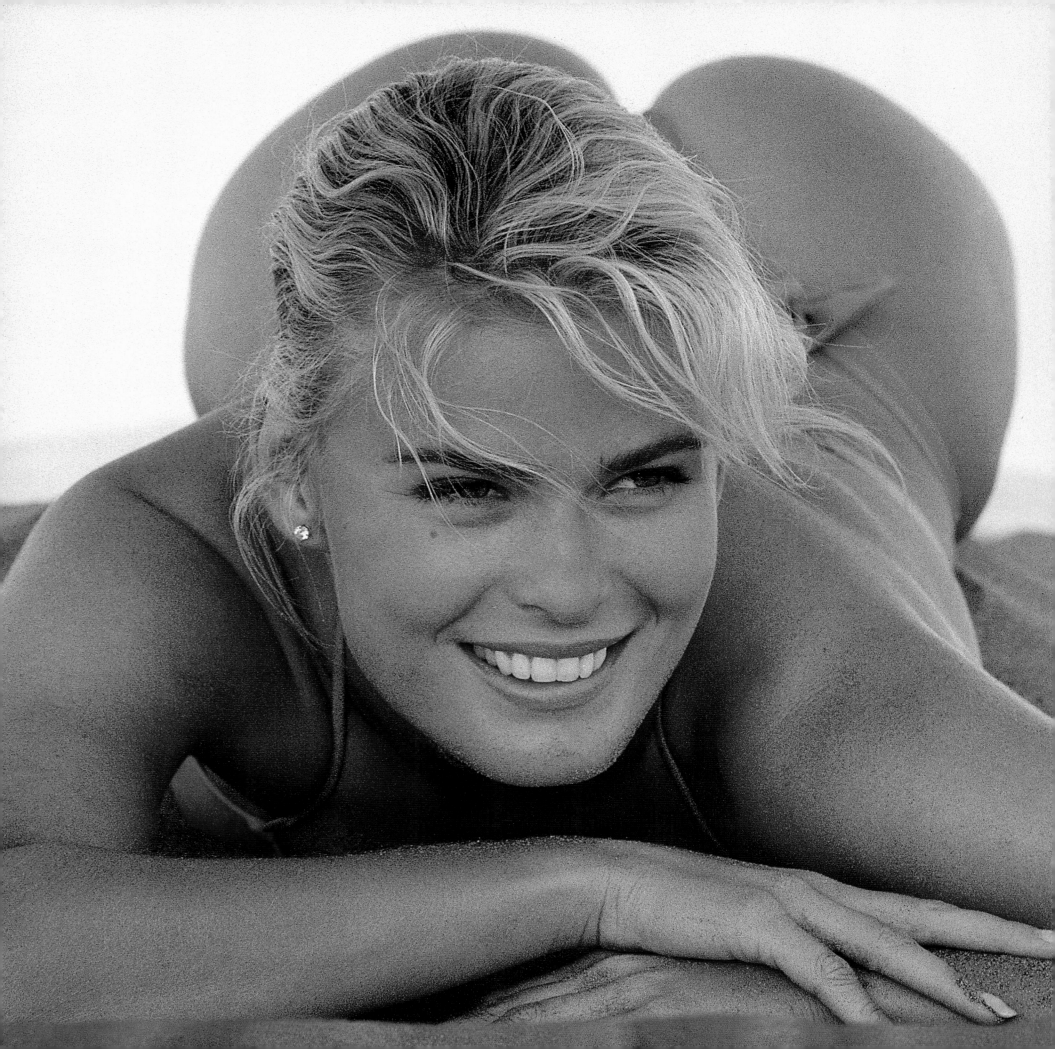

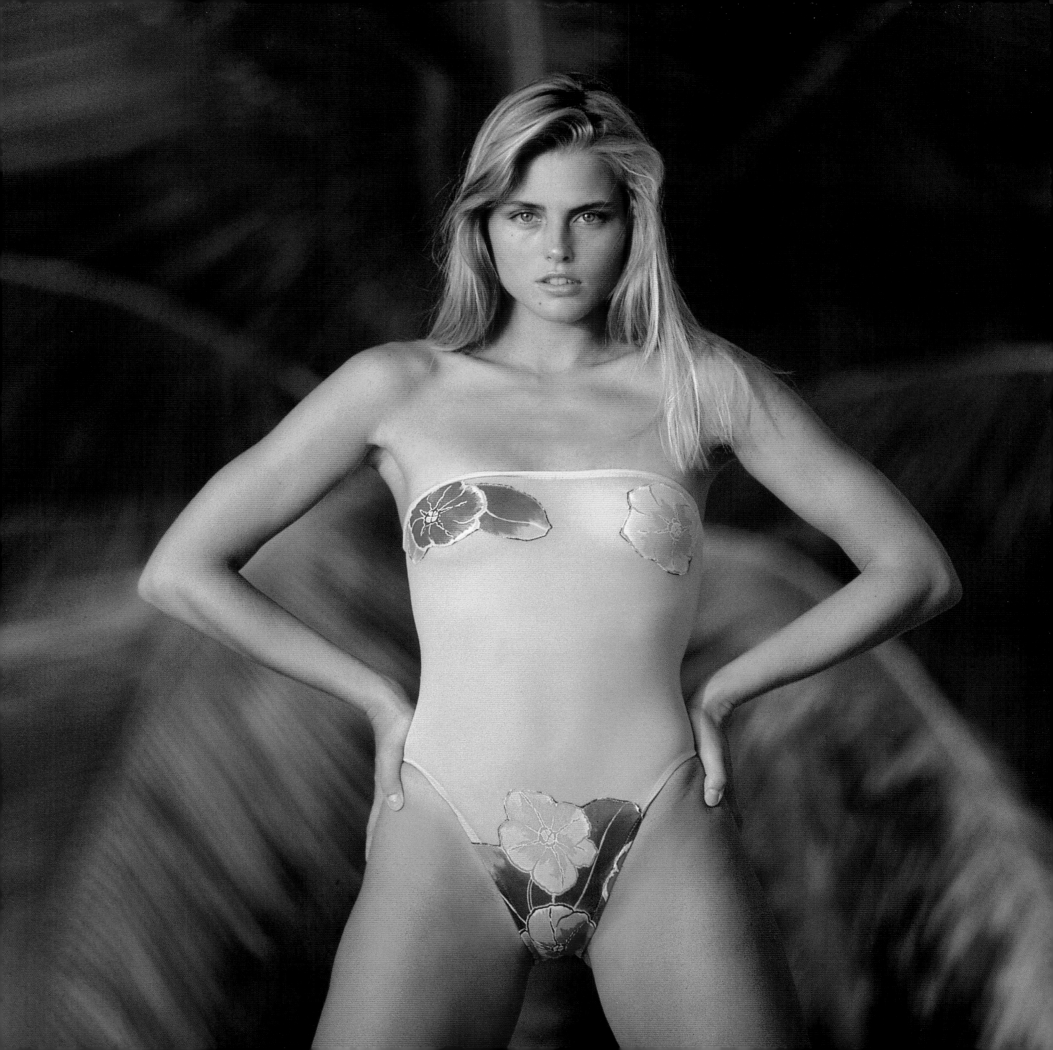

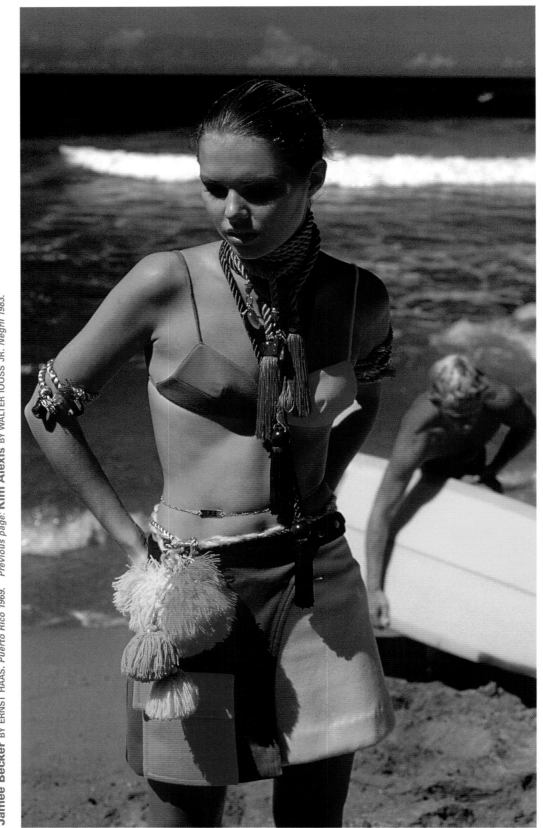

Jamee Becker BY ERNST HAAS. *Puerto Rico 1969.* *Previous page:* Kim Alexis BY WALTER IOOSS JR. *Negril 1983.*

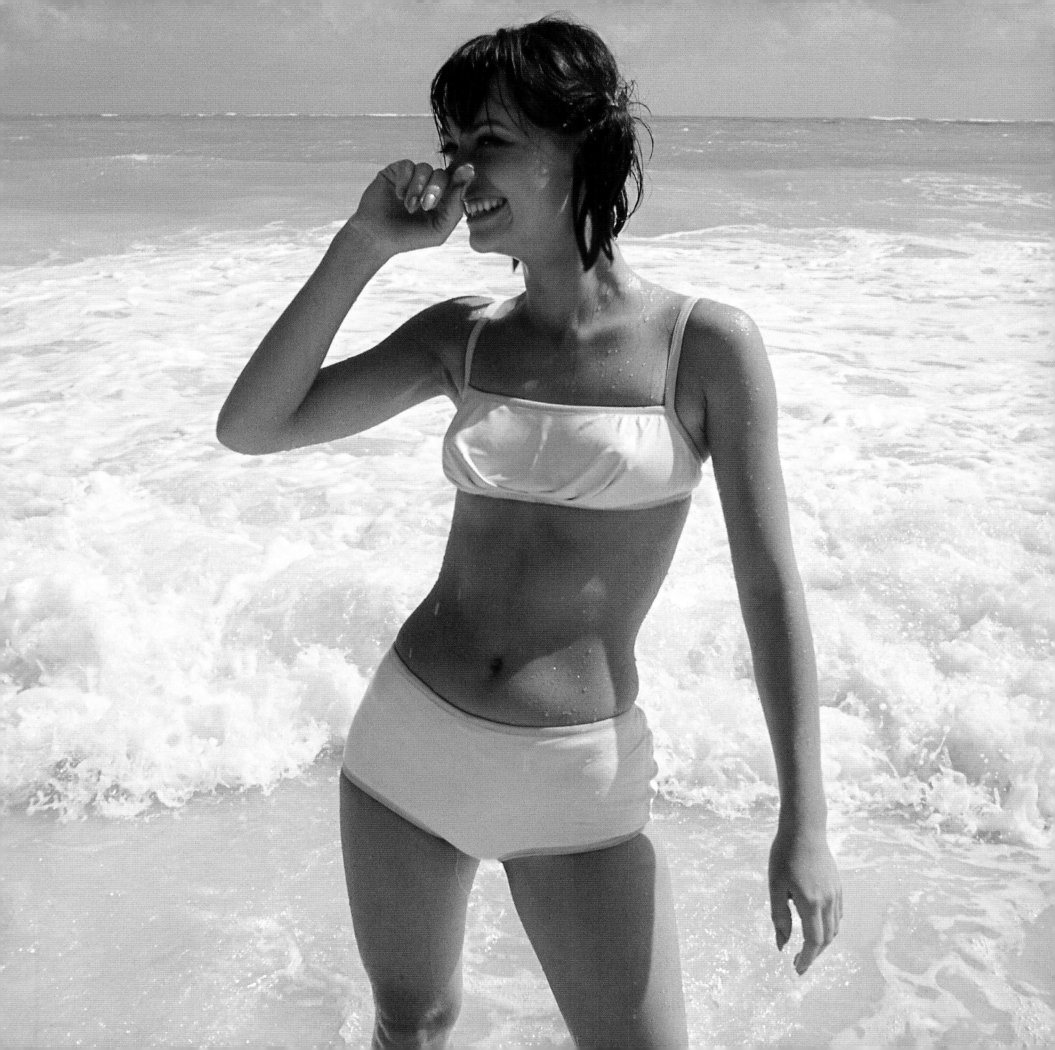

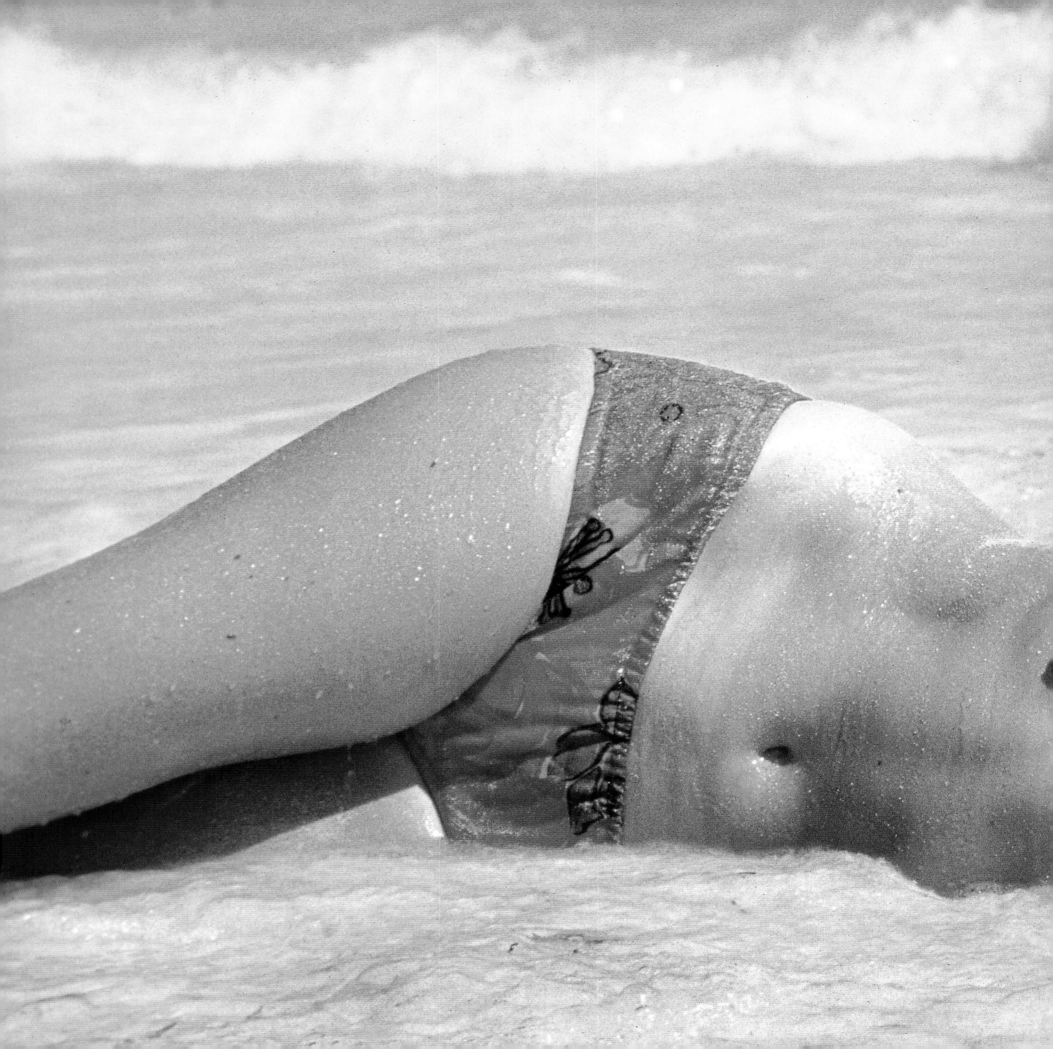

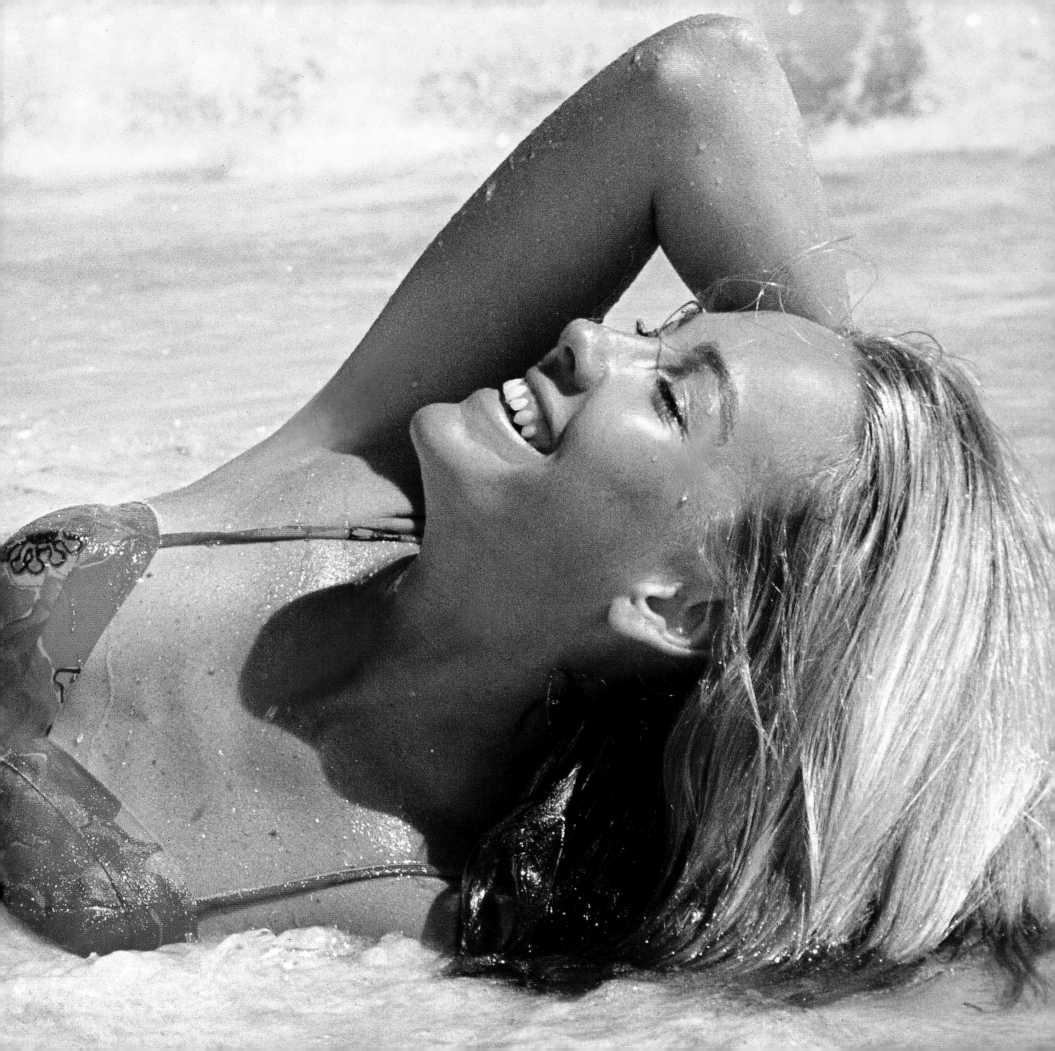

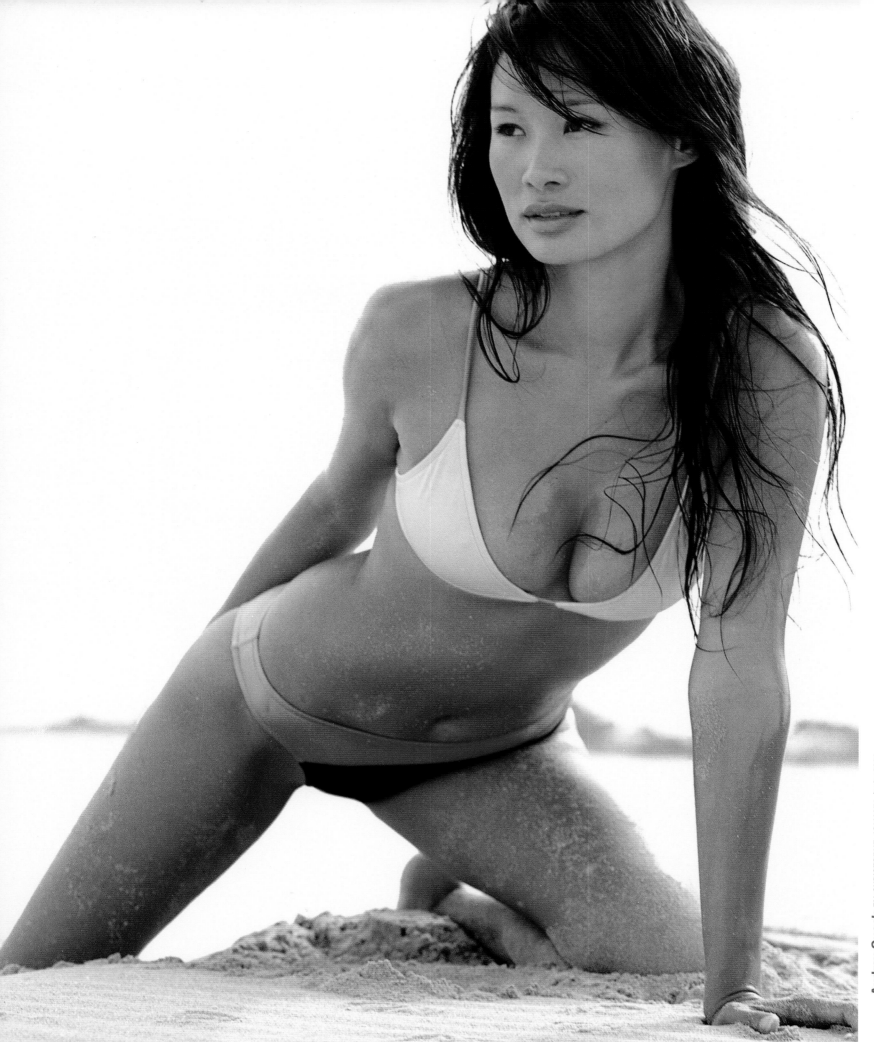

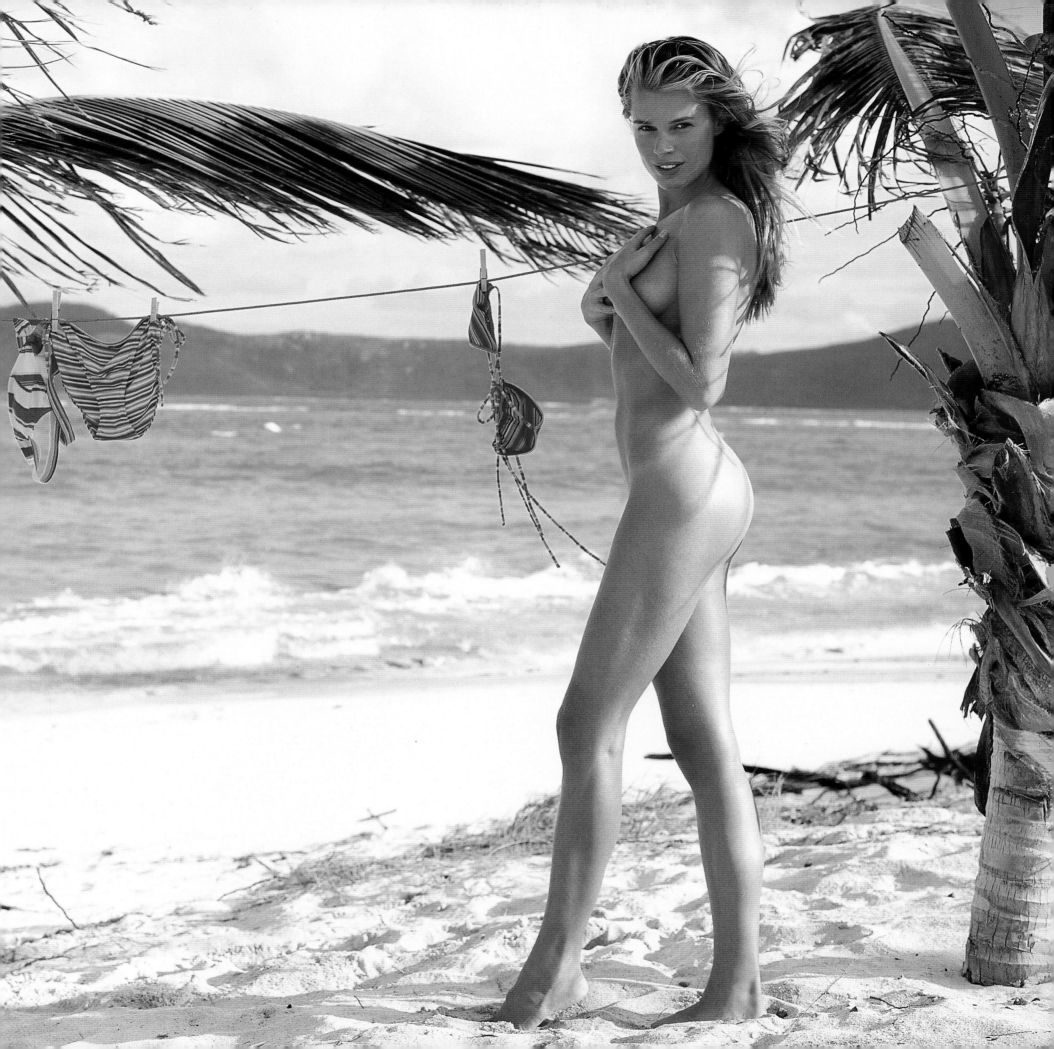

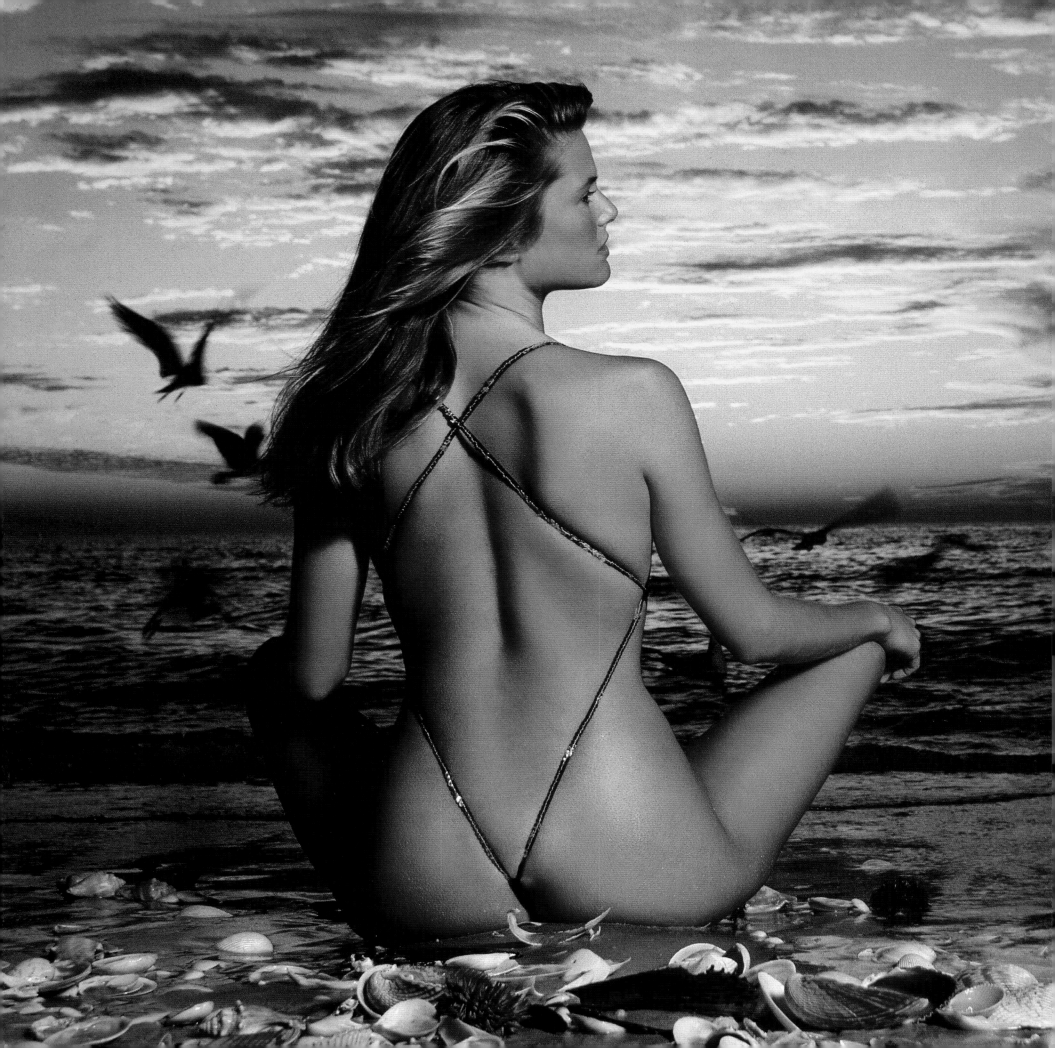

When I've got the moon
I am wishin' for the sun.
When I'm sittin' in the sun
I am wishin' for the moon.
When I've got five bucks
I am wishin' it was ten,
But if I had you to love
Then I'd never wish again!

—OSCAR HAMMERSTEIN II, *"Banjo Song"*

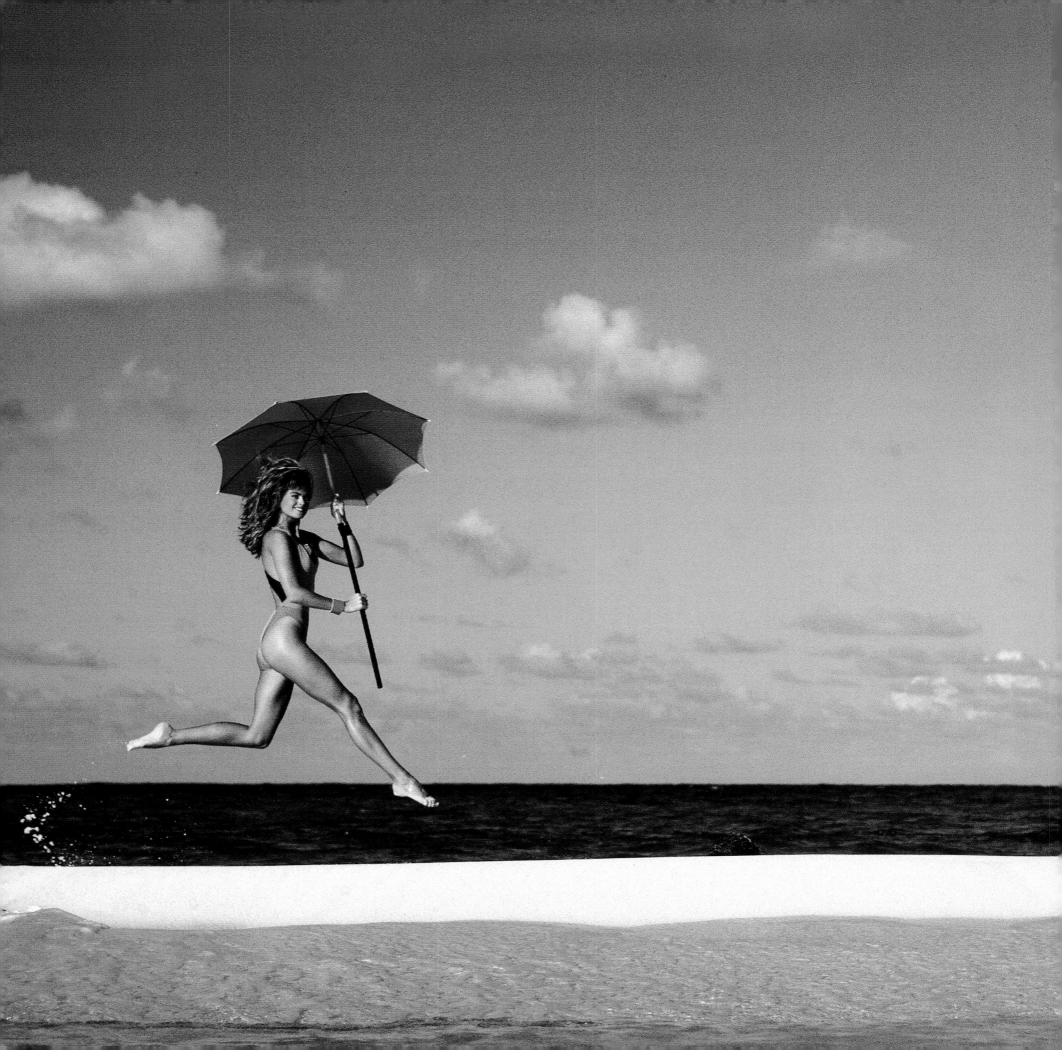